THE
ARTISTS'
AMERICA

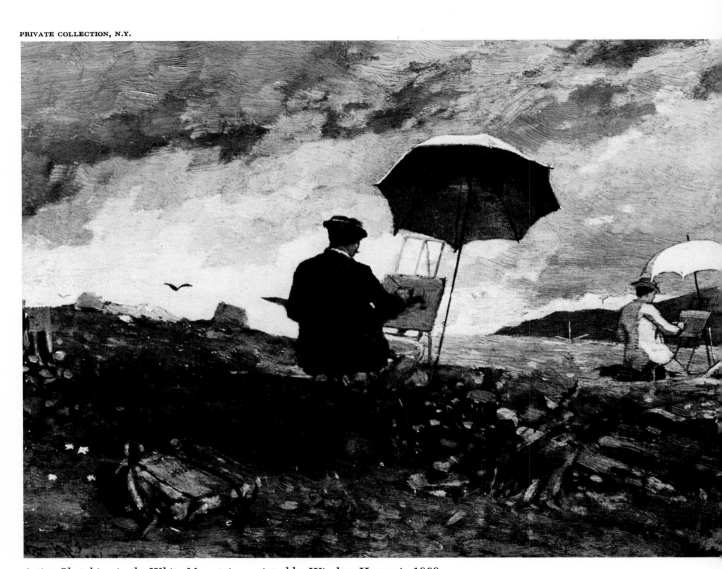

Artists Sketching in the White Mountains, painted by Winslow Homer in 1868

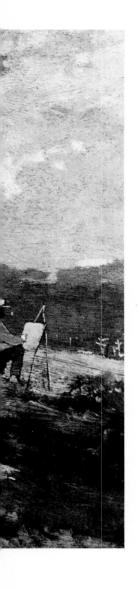

The AMERICAN HERITAGE
History of The
ARTISTS' AMERICA

By Marshall B. Davidson

and THE EDITORS OF AMERICAN HERITAGE

PUBLISHED BY
AMERICAN HERITAGE PUBLISHING COMPANY, INC., New York

BOOK TRADE DISTRIBUTION BY
McGRAW-HILL BOOK COMPANY

Staff for this Book

EDITOR
Marshall B. Davidson

ART DIRECTOR
Murray Belsky

ASSOCIATE EDITOR
Kaari Ward

PICTURE EDITOR
Peggy Buckwalter

EDITORIAL ASSISTANT
Deborah Agrest

CONSULTANT LIBRARIAN
Laura A. Lane

ADDITIONAL TEXT BY
Margot Brill Higgins

AMERICAN HERITAGE
PUBLISHING CO., INC.

PRESIDENT AND PUBLISHER
Paul Gottlieb

EDITOR-IN-CHIEF
Joseph J. Thorndike

SENIOR EDITOR, BOOK DIVISION
Alvin M. Josephy, Jr.

EDITORIAL ART DIRECTOR
Murray Belsky

GENERAL MANAGER, BOOK DIVISION
Kenneth W. Leish

Library of Congress Cataloging in Publication Data
Davidson, Marshall B.
 The American heritage history of the artists' America.

 Half title: The artists' America.
 1. United States in art. 2. Art—United States—History. I. American heritage. II. Title.
III. Title: The artists' America.
N8214.5.U6D38 1973 709'.73 73-295
ISBN 0-07-015437-6
ISBN 0-07-015438-4 (de luxe)

ISBN 07-079482-0 de luxe boxed set with The American heritage history of the writers' America

CONTENTS

INTRODUCTION

In a spirit of snobbish annoyance Henry James once counseled his readers that true art must wither in the "cruel air" of America. He was, of course, quite wrong; it did nothing of the sort. More than a century earlier the immigrant painter John Smibert had written his London agent that the future of the arts might well be in America. In the course of time that sanguine observation seems to have had more justification than James' remark. According to some qualified critics, American art today is considered the standard by which developments in other countries of the Western world are measured.

The following pages present a comprehensive view of the American scene as it has been depicted by the principal artists who have lived and worked in this country over the past three centuries or more. From such evidence we can take a fair measure of our artistic heritage; we can envisage the whole reach of American art, placed in the context of historical circumstance. We can trace its development from a tiny imported seedling into a robust, wide-branching growth of variegated character, constantly invigorated over the years by grafts of alien strains, but always sinking its roots deeper into the native earth. It has, in its turn, bred various distinctive native shoots, some of them hardy enough to recross the Atlantic and serve as vigorous grafts on the parent European stock.

In recent times it has become unfashionable in some circles to enjoy or admire a work of art because it tells a story, reports an incident, or illustrates a legend or an allegory—because, in short, it is a picture or a sculpture of or about something. Modern criticism has rather tended to call our attention away from subject matter per se and toward such abstract elements as structure, color, and texture as ends in themselves. However, it is well to remember that all art is abstract to some degree. No artist totally or precisely reproduces the reality of the world about him, even when he creates the illusion of having done so. He selects—that is, abstracts—from his subject what he considers its most significant elements and arranges and modifies these, distorts them perhaps, in ways that intensify his personal view of the matter. This has always been so, throughout the course of history, and the more clearly we understand how the artist has manipulated his resources and for what good reasons, the greater will be our satisfactions as a witness to his work, whatever its ostensible subject.

Nevertheless, with this in mind, we must remember that most of the masterpieces produced in the Western world in the past five hundred years or so have been largely concerned with representing or approximating the natural appearance of things in the form of portraits, landscapes, still lifes, or whatever. Their subject matter is important; in one way or other they do tell some kind of a story. Although at times the subject may seem remote from our own experience, the more fully we understand what it is about, the better we can appreciate the artist's message. The arts are, after all, an essential part of history, and a knowledge of history is indispensable to a true understanding of them.

In the long run, then, art and history are closely interwoven strands in the seamless fabric of our culture. Quite aside from their purely visual attractions, the paintings and drawings, the engravings and sculptures, reproduced in the pages that follow, reveal aspects of American experience that can be recalled by no other means. As we learn more about the history of American art our self-understanding increases. For generation after generation our art has been the mirror of ourselves as a people; year by year our lives and our outlooks are never less than the sum of our past.

Conditions of life in colonial America and for some years afterward did not encourage any rapid development of the fine arts. Without the patronage of royalty, a monied aristocracy, and an established church, which in other times and places provided such substantial support, the artist in this country worked under certain handicaps that were peculiar to the New World. There were neither public art museums and academies nor private collections of any consequence in these remote reaches of the Atlantic world; no art school yet provided systematic, qualified instruction for the aspiring student. To understand the refinements of his calling as these had been perfected over the long past, to get expert instruction in the traditional techniques of his craft, and to enter fully into his artistic heritage he had to turn to Europe; or he would have to work things out for himself as best he could.

Actually, a surprising number of first-rate artists did

in fact teach themselves to paint and draw and sculpt. The first outstanding painters born in colonial America, Benjamin West and John Singleton Copley, were essentially self-taught; both emigrated to England, where they established high reputations in sophisticated art circles. The next generation also included artists who attracted favorable attention overseas. When John Vanderlyn was in Paris early in the nineteenth century, it is said, he was asked by Jacques Louis David, the most prominent French painter of the time, why the best English artists were all Americans. David was no doubt thinking of West, Gilbert Stuart, John Trumbull, and, among others Vanderlyn himself. In 1808 Napoleon selected one of Vanderlyn's canvases as the best original work among the twelve hundred paintings on display at an exhibition held in the Louvre. About that time, as a token of his appreciation of the skills of Rembrandt Peale, David agreed to sit for his portrait by that young Philadelphian—a privilege he had refused all other painters. "I prefer your portraits to any others here," the Frenchman remarked.

Almost without exception the early artists who practiced in America, were they native- or foreign-born, clung as faithfully as they could to modes and standards proclaimed in Europe, as they were expected to do. Whatever was distinctively American in American art was the result of no conscious striving for new manners of expression; rather, it was a gradual development of circumstances. As one critic has observed, so far as art is concerned, America is not a political unity; it is a geographic and cultural environment. And as that environment, remote from Europe, revealed its distinctive character, it dictated its separate themes and interests and ways of representing them. Even those successive generations of American artists who flocked to Europe to learn from the cultural inspiration and the instruction they found there—even they retained the imprint of their native environment, and it underlaid their work.

As always, however, those who went abroad for training and experience returned to contribute substantially to the evolving pattern of American art, usually nudging it back toward the mainstream of European tradition. In spite of the continuous influence of European experiences, American art developed for the most part without benefit of or hindrance from those intellectual debates over theories of style such as, for example, made France a battleground of contending factions in the nineteenth century. The revolutionary changes that were wrought in French art with the advent of the impressionists, cubists, and other innovators late in that century and early in the next were somewhat slow in affecting the mainstream of American painting and sculpture. It was at the memorable Armory Show in 1913 that Americans at large first suffered the shock of those modern developments overseas almost overnight.

"Modern art" became a phrase to conjure with, a battle cry that continues to excite strong feelings ranging from ecstasy to revulsion. The violent forces loosed by that exhibition tended to weaken ties with established tradition and to fracture the visible world into kaleidoscopic patterns.

However, although we tend to make a sharp distinction between traditionalism and modernism, the only true difference between them is that we recognize the sources of inspiration more readily in one case than in the other. In the world of art the last several generations have been an age of exploration as rich in discovery and adventure as the age that first found its way about the seven seas four or five hundred years ago. Thanks to the wide-ranging eye of the camera, the proliferation of art books, the multiplication of museums, and constantly improved communications in general, our civilization is the first in history to comprehend the whole wide world of art. The modern artist can draw inspiration from the most remote and exotic cultures of history, past or present, and as well from the patterns of nuclear structure.

In this day the United States can no longer be called a New World. The barriers of time and distance are being demolished at a bewildering rate. Under the circumstances American art has become as richly diversified as will be found anywhere in the world. Of late, it seems the leading trends in the world of art have been originating on this side of the Atlantic. In fact, New York became an international capital of art at about the same time the city became permanent headquarters of the United Nations.

Our age has opened up the caverns of the mind as well as the almost unimaginable recesses of outer space; but there are no tangible images to clearly represent the fears and hopes that may be lurking in those areas of contemporary experience. Yet, in the flux of changing styles, a substantial number of influential artists continue to represent the scene about them more or less as it appears to the eye, or to the mind's eye, since each sees the world differently. The illustrations shown later in this book indicate what an abundance and variety of first-rate talents have worked in this vein in America over the past generation or so, continuing the tradition of realism that is such a durable strain in the history of American art.

Genius is the power of lighting one's own fire.

—JOHN FOSTER

ART IN A NEW WORLD

Opposite, detail of a portrait of nine-year-old Daniel Verplanck (above), painted by John S. Copley in 1771

We must reach far back in history to find the earliest views of an American subject. They might rather be called visions than representations. Long before Columbus made his first landfall at San Salvador, men had dreamed the truth of a New World "far out in the Western Ocean, beyond the limits of the known earth." They had pictured such a land and its people in their mind's eye, and prompted by vivid imagination, they had even attempted in certain "books of marvels" to show by graphic images the supposed nature of that other world. These were fabulous images for the most part, drawn from timeless legends, hearsay, and the most credulous expectancy. They were comparable to the illustrations in medieval bestiaries of such fascinating and unlikely creatures as the griffin, the unicorn, the basilisk, and other natural wonders that flourished beyond familiar horizons. The pictures have little or no artistic merit, but they recall the hopes and fears with which Europe awaited that day when the Western Ocean might once and for all loose "the chain of things" and in fact reveal the huge land of ancient prophecy.

The first confirmed reports of discoveries in the West released a stream of discussion about the New World that broadened into a torrent in the centuries to come. Several generations passed before any artist or illustrator provided eyewitness depictions to supplement the growing list of books of travel and adventure, some of which became the best sellers of their day. The reports of those explorers and voyagers brimmed with descriptions of natural wonders that seemed hardly less prodigious in their separate way than those reported in the old books of marvels. It is not easy for an artist to depict the unfamiliar with objectivity and accuracy; he brings to the task an accustomed way of looking at things that prejudices his observations.

The artists who accompanied those early expeditions did their best to record their strange surroundings in the American wilderness as they saw them, with variable results. It is difficult, for example, to recognize the bison in the earliest known pictures of one of those "wild hunch back cows," which according to sixteenth-century Spanish accounts blackened the illimitable prairies of the West, far beyond reach of the eye. Indians, as they were first represented, tend to resemble seminude, oddly ornamented Europeans whose physical proportions conform to

9

This 1554 drawing of a buffalo was inspired by Cabeza de Vaca's tale of his adventures in North America.

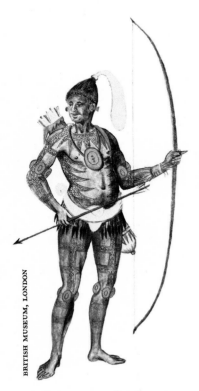

An Indian warrior, by the water colorist John White, about 1585

10

the stylish mannerisms of the day. It was a Dutch artist who, provided with some sort of evidence, handsomely engraved the first known impression of Niagara Falls, a landscape subject that has ever since beguiled artists in America. The view was used to illustrate an account of the New World (*A New Discovery of a Vast Country in America, Extending above Four Thousand Miles, between New France and New Mexico*) published in 1697 by the Recollet friar Louis Hennepin. That adventuring Frenchman earned immortal fame by discovering the great cataract while he was preparing for an epic journey down the Mississippi with La Salle. There was something singularly fitting that those almost incredibly majestic falls should have been first reported by a man with a developed flair for tall tales. In the first edition of his work Father Hennepin wrote that Niagara was five hundred feet high, about three times the actual height. He raised the figure to six hundred in the next edition. Before the book went out of print, it ran to thirty-five editions in four languages, witness to the avid interest excited by his tales throughout Europe.

The list of such voyager- and explorer-artists continued to grow as permanent settlements spread out over the land. Their depictions of the wilderness and its untamed denizens were aimed at a European audience. Until the Indians and the dark forests were pushed back a safe distance, the settlers themselves had no special wish to be reminded of what those inconveniences looked like. Overseas there were also plenty of potential colonists, traders, and speculators who were interested in getting a true visual impression of such man-made wonders as "Ye Flourishing City of New York," "Ye Great Town of Boston," and other clusters of civilization in the Western world. In 1650 one Dutch traveler named Laurens Block, probably an amateur artist, made an altogether convincing drawing of the infant settlement of New Amsterdam, already developing into a tidy reminder of the prosperous Dutch homeland. (The drawing itself is testimony to how widely diffused were the skills of drawing and painting in seventeenth-century Netherlands, when some eight thousand artists are known to have worked in that small country.) The demand produced a good number of such topographical scenes, which were for the most part engraved abroad and widely distributed. Occasionally, they were entirely fictitious representations, but even so they found a ready market among the gullible. This interest, at least, the colonists could proudly share, and they hung the engraved views in their homes along with subjects that nostalgically recalled the Old World they had quit, for better or for worse.

None of those visiting artists could be called American, and none of them compared in talent with the great masters who were working in Europe while America was forming. This was the age of Rembrandt, Frans Hals, and the Dutch Little Masters. Yet, such efforts mark significant steps in the history of art in America. The landscapes, cityscapes, and figure drawings, even in their inaccuracies, are revealing documents. Beyond that, as modest representative of the great tradition of Western art, they are fresh explorations into the world of nature and of light, which led toward the growth of realism that was the essential core of that tradition.

Strictly speaking, the history of American art—that is to say, of art produced by residents of the country—begins some time in the seventeenth century. A fair

number of artists worked in the several colonies in the 1600's—men of commendable zeal but of meagre skill. What they produced is barely distinguishable from paintings the colonists brought with them, and those were for the most part only rude approximations of the fashionable European portraiture of the time. Before and during the early years of migration to this country, court painting in England was dominated by a succession of foreign masters—by such men as the German Hans Holbein the Younger, the Fleming Anthony Vandyke, the Dutchman Peter Lely, and Godfrey Kneller, another German-born artist. These eminent visitors and immigrants, along with architects, sculptors, and craftsmen in various mediums who also came from the Continent, succeeded in loosening England's ties to its old, insular tradition and awakening the country to the new world of Renaissance thought and art, with revolutionary consequences.

The introduction of these alien concepts involved more than matters of style and design. In effect, it marked the transition from medievalism, from customs deeply rooted in tradition, to modern manners of thinking and living. For the intellectual and social life of the Western world is to this day shaped to a large degree by ideas and practices that were born—or reborn—in Renaissance Italy, that gradually spread out over northern Europe, and that late in the seventeenth century reached far out across the Atlantic Ocean to exercise a growing authority in colonial America. In time everything from table manners to diplomatic nicety, from elementary education to scientific procedure, felt the transforming influence of Renaissance thought and activity.

In painting the most obvious change was from the flat, diagrammatic representations of medieval illuminations toward a new form of realism, an illusion of three-dimensional roundness achieved by modeling with light and shade and blended colors. By and large, that basic transformation of style has influenced the tradition of painting ever since, at least until the radical innovations of the twentieth century. Along with that development went a new appreciation of the artist as a man of God-given talents, a prestigious figure who could rank as the familiar of kings, nobles, and other exalted beings. The foreign-born artists mentioned above were all painters to the kings of England; they lived in opulence and moved in the most fashionable circles; and they had more commissions from the aristocracy than they could individually handle. It is said that Sir Godfrey Kneller, for example, churned out fourteen portrait heads a day, turning over the rest of the subject to a corps of assistants—specialists who separately added the hands, the lace, the drapery, and so on.

As we shall see, the artist in America had a long struggle before he reached any such status. Preoccupied as our early forefathers were with their Puritan principles and the exigencies of life in the wilderness, they were by no means indifferent to beauty—or to display, for that matter. As early as 1637 it was complained that in their "pride" the colonists were "going as farr as they may" in ordering lace and other such finery from England. By 1670, in spite of sumptuary laws, the more prosperous settlers were sporting embroidery in gold and silver, silver buttons, and other embellishments to their colorful wardrobes—details that were often carefully noted by the artists who painted their likenesses. Just who those

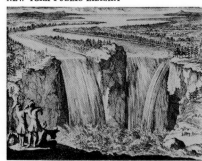

Illustrating Hennepin's account was J. van Vianen's engraving, the earliest printed view of Niagara Falls.

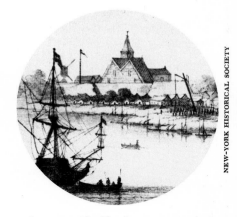

Laurens Block's drawing of New Amsterdam from the ship Lydia

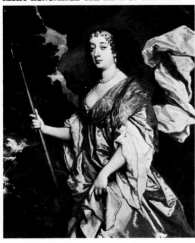

Portrait of Barbara Villiers, Lady Castlemaine, painted by Peter Lely

early artists were is rarely recorded. Occasionally an artist's name is noted in some contemporary document, but examples of his surviving work cannot usually be identified.

Nor did Puritanism or the problems of pioneering blight the creative side of human nature. Man's urge to create was conditioned but not stilled by his confrontation with a raw, new world. Yet the first strains of settlement imposed priorities that must be observed for the welfare of the struggling community. "It's more noble to be employed in serving and supplying the necessities of others," counseled one early New Englander, "than merely in pleasing the fancy of any. The Plow-Man that raiseth Grain, is more serviceable to Mankind, than the Painter who draws only to please the Eye. The Carpenter who builds a good House to defend us from Wind and Weather, is more serviceable than the curious Carver, who employs his Art to please the Fancy." In any event, the lavish patronage that encouraged the extremes of virtuosity in the courts and capitals of Europe was unthinkable in the colonies. Indeed, it was well into the eighteenth century before an American painter managed to make any sort of living solely by his brush. Conditions of life in early America did not encourage specialization in any field of endeavor. The shortage of manpower in a land rich in opportunities made versatility a necessary virtue—a virtue we as a people still prize for very much the same basic reasons.

Throughout the colonial period little if any distinction was made between the fine arts and the crafts. As it was broadly used, the word "art" referred to skilled accomplishment in virtually any field of endeavor, a meaning that has not altogether vanished from modern usage. One reads in early records of a pinnace sailing from Boston "under the conduct of Mr. William Aspenwall, a good artist"; of Lancaster, Massachusetts, choosing an "artist . . . to lay our towne bounds"; of "butchers, bakers . . . barbers, millers, masons, with all other artists" active in Connecticut; and so on. As one writer has observed, in such society the artist was not a special sort of man so much as every man was a special sort of artist. The average colonist was perforce a jack-of-all-trades, like the many-sided Paul Revere who was an artist of sorts as well as a silversmith, a courier, and a man of other varied affairs. (It was his outrageously biased but strongly persuasive engraving of the Boston Massacre that helped to kindle the fire of the American Revolution.)

So, too, for the rudimentary beginnings of American sculpture one looks to the graveyards that were soon a feature of every community, and where grim effigies of scythe-bearing skeletons and fire-and-brimstone skulls adorned the modest tombstones; or to the weather vanes of infinite variety that played against the sky atop so many dwellings and public buildings, as did the famous copper grasshopper vane made by Shem Drowne for Faneuil Hall in Boston. (Picasso once remarked that cocks—commonly used above churches to recall Peter's denial of Christ—have never been so well seen as in American weather vanes.) Also, ingenious carvers shaped ship figureheads for the growing colonial merchant marine; and such talents were used for busts and other decorations on the handsomest cabinetwork by major artisans.

Before John Singleton Copley quit Boston for good on the eve of the Revolution

to perfect his talents overseas, he found it mortifying that "people regarded painting no more than any other useful trade . . . like that of a carpenter, tailor, shoemaker, not as one of the most noble arts in the world. . . ." In spite of that complaint, Copley, the most accomplished of our early painters, became one of the first American artists to live solely by his professional earnings. (It was some years to come before American society thus supported a professional writer.) At one point, before his departure for England, while he "worked" the little cities of the Eastern seaboard taking likenesses of the local gentry, he also complained that he had so many commissions to paint portraits that he hardly had time to eat his victuals. He even found himself growing wealthy. He married a well-born woman and built a handsome mansion on Beacon Hill in Boston, close by the celebrated mansion of Thomas Hancock. But he yearned for glory beyond prosperity and left the scene, never to return, to win the fame and special distinction that he felt should be justly his and he could never achieve in a provincial setting.

Largely self-taught, and with few models of high quality to study and draw inspiration from, Copley epitomizes the problems and successes of the colonial painter. Generations before he was born and for generations after he quit the New World, there were professed artists who, with or without formal training, limned the features of their friends and neighbors as a sideline to other, workaday jobs, such as producing shop signs or diverse other decorations for home or ship. Such a craftsman may have been one "Thomas Child of Boston Painter," who was thus described when he married a local spinster in 1688. (In his will fifteen years later he called himself a "Painter Stainer.") He painted or primed the window frames and shutters for the original King's Chapel in Boston, the house, gate, and fence of a Latin schoolmaster, and twenty cannon carriages for Castle William. And, in a jingle written upon his death in Samuel Sewall's diary, there is a tantalizing suggestion that he may also have taken likenesses.

> Tom Child had often painted Death,
> But never to the Life, before:
> Doing it now, he's out of Breath;
> He paints it once, and paints no more.

However, as colonial cities grew in size and consequence, and as vessels shuttled with increasing frequency back and forth across the Atlantic, more artists and artisans from abroad—a few like John Smibert and Joseph Blackburn with established if modest reputations—joined the local ranks. Some came, worked here more or less briefly, and left; others stayed on and contributed what they had in talent and ideas to an emerging American "school" of art. John Smibert, a Scot who came to America in 1729, thought that the future of the arts was in this country, and that Boston was "the most promising field in the Colonies"; and he stayed on, to die here in 1751. He had earlier been a house painter, plasterer, and coach painter. To improve his talents, with his fortunes, he had quit London for a three-year sojourn in Italy. There he had copied the old master and, it was said, had painted for the Grand Duke of Tuscany the likenesses of several "Siberian Tartars" that had been presented to the duke by the czar of Russia. He left a

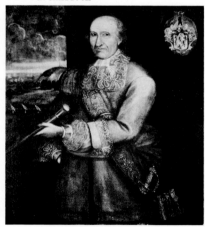

Portrait of Thomas Savage, painted in 1679 and attributed to Thomas Smith

13

record of having painted two hundred forty-one portraits during his years in America, but only a fraction of these have been identified. On one occasion a club of good fellows in Boston wished to celebrate the recovery from a long and serious illness of one of their members in good standing named John Checkly. Although the convalescent was noted for his ugliness, worsened by the ravages of a lengthy sickness, it was decided to have his likeness painted by Smibert, with an appropriate verse, composed by one of the local wits, inscribed beneath the portrait:

> *John, had thy sickness snatched thee from our sight*
> *And sent thee to the realms of endless night,*
> *Posterity would then have never known*
> *Thine eye, thy beard, thy cowl and shaven crown;*
> *But now, redeemed by Smibert's faithful hand,*
> *Of immortality secure you stand.*
> *When nature into ruin shall be hurled,*
> *And the last conflagration burn the world,*
> *This piece shall then survive the general evil,—*
> *For flames, we know, cannot consume the Devil.*

Benjamin Robert Haydon, a somewhat disillusioned English painter, once sourly observed that "portraiture is always independent of art and has little or nothing to do with it. It is one of the staple manufactures of the Empire. Wherever the British settle, wherever they colonize, they carry, and will always carry, trial by jury, horse racing, and portrait painting." It is true that by far the most numerous surviving examples of colonial art are portraits, although they were by no means all by English-born artists or of colonists of English descent. There were immigrant painters from Germany, Holland, Sweden, Denmark, France, and Switzerland who won commissions from patrons of equally variegated national backgrounds.

However, there were also those who advertised that they were prepared to undertake landscapes and other subjects as well. In 1740 the obituary of one Nathaniel Emmons of Boston reported that "some of his Pieces are such admirable imitations of nature, both in faces, Rivers, Banks, and Rural Scenes that the pleased Eye cannot easily leave them." He was, the *New England Journal* concluded, "universally own'd to be the greatest master of various Sorts of Painting that ever was born in this Country"—a matter of no great distinction as we look back at the general run of native painting at the time. Upon his death eleven years later, Smibert left thirteen "landscapes" in his studio, appraised at a mere £ 2.13. The most interesting surviving landscapes from the colonial period are those that were painted as decoration on the walls of rooms, such as the scene on the overmantel panel from Marmion, the Virginia plantation home of the Fitzhugh family. Occasionally, subjects of varied nature were painted on chests and other furniture forms. The clusters of fruit and vegetables, done in grisaille, that adorn the cupboards, or *kasten*, made for Dutch settlers along the Hudson River valley,

Detail of a wall panel from Marmion, Va., painted by an unknown artist

are probably the earliest examples of still-life painting in America.

One does not look for originality in the efforts of these more or less untrained provincial artists. They struggled against their limitations, and that they were not without appreciation in their own day is indicated by the prominence of most of their patrons, who expected them to do their best in approximating the conventions and standards of European art as they knew it. To this end English mezzotints reproducing fashionable portraits by the best English artists provided exemplary models, which were copied from black and white into arbitrary colors with any alterations that suited the sitters. Within their limits the artists showed their patrons as they wished to look, which is quite as important to our understanding of them as how they actually did look. At its best, as in the case of Copley, their work transcended the pictures they had to guide their efforts.

The Pennsylvania Quaker Benjamin West, who was Copley's exact contemporary, left America in 1760 at the age of twenty-two, before his talents had ripened to any degree, to see and study the masterpieces in Europe. The arrival in Rome of a young American student of the fine arts caused a stir of excitement in that venerable city. He was quickly taken to Cardinal Alessandro Albani, a powerful prince of the Church, whose pronouncements on art—although he was blind—were final and incontestable. "Is he white or black?" the swarthy old cardinal asked. When assured that the young man was, strange as it might have seemed, even as fair as himself, the churchman ran his fingers over West's face and proclaimed that his was an admirable head; indeed, it was the head of an artist. The next day the cardinal, heading a large entourage of connoisseurs, took West to see the celebrated *Apollo Belvedere,* the first nude statue the young man had ever seen. "My God," West expostulated, "how like a Mohawk!" When he explained that disconcerting remark with stories of the "noble savage" he had referred to, West's critical perception was praised to the skies.

After three years in Italy, West moved on to visit England, with a reputation already established as "the American Raphael." Once there, he succumbed to the advantages and amenities of life in London, and stayed on for the rest of his years. Also self-taught, he became the familiar of royalty in the tradition of Vandyke, Lely, and Kneller. Several years before his countrymen peppered the British troops with musket fire as they retreated to Boston from the battle of Lexington, West had routed fashionable London critics with his revolutionary canvases. He was appointed historical painter to King George III; he was a charter member of the Royal Academy and long served as its president; and he was hailed as a rival of the great masters of the past—an appraisal rather difficult to understand in terms of modern judgments, but one that was meaningful to his contemporaries and important as such. One dissident voice in the contemporary chorus of adulation came from Lord Byron, who referred to "the dotard West, Europe's worst daub, poor England's best"—a judgment more acceptable today than when it was made. In any case, his reputation and his generous, powerful presence attracted to his studio three generations of American students, who returned to their homeland with developed skills that established fresh standards in postrevolutionary America, as will be seen.

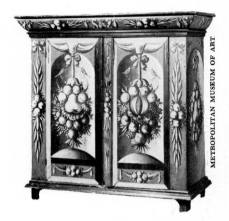

Detail (below) of an 18th-century oak and gumwood kas shown above

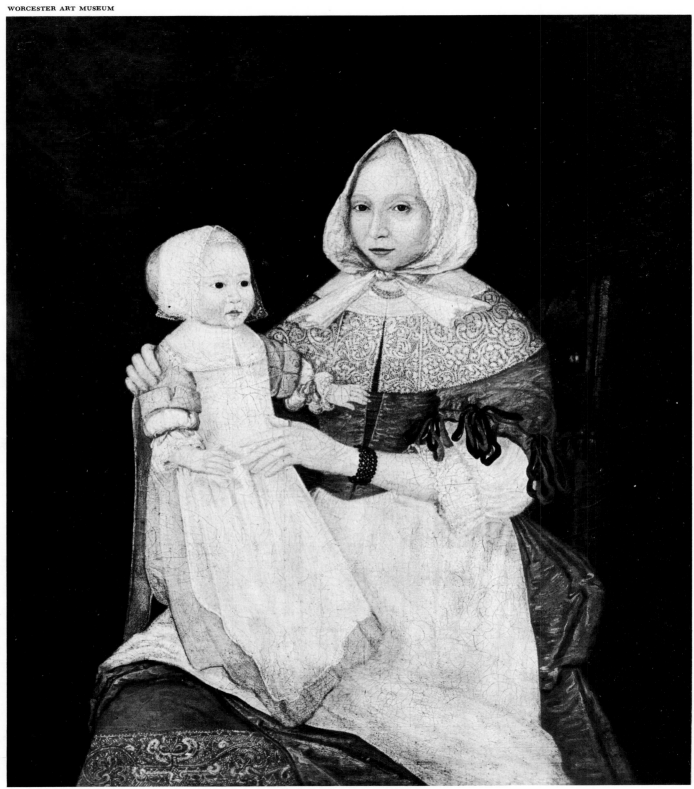

Mrs. Freake and her baby daughter Mary, painted about 1674 by an unidentified artist

LIMNERS' LIKENESSES

America's first artists remain all but nameless. The earliest of the surviving examples of their work, painted in the second half of the seventeenth century, are likenesses of assorted colonial personalities, some of whom are otherwise scarcely noted in contemporary records. Only the most diligent genealogist might have recalled Mrs. Freake and her baby Mary if some unidentified limner had not preserved their images, at once so solemn and so sweet, for posterity. In picturing his subject as a relatively flat pattern of shapes and colors, the artist followed an old convention. To create a realistic illusion of depth and roundness by modeling the figures in light and shade was beyond his technical competence, and it was clearly not his intention. Thus to reduce the three-dimensional reality of the world to an almost linear diagram was a timeless manner of representation—a way of seeing, actually— that lingered on in provincial England from the Middle Ages; it was a survival of the ancient practices of the illuminators of medieval manuscripts. In much the same manner the twenty-one-year-old "princess" Pocahontas, elaborately and incongruously garbed in European finery, was depicted by another unknown artist in 1616 during the ill-fated visit to England with her "worshipful" husband John Rolfe. (She died the next year in that chill and alien clime, before she could return to her native Virginia.) To this day primitive and folk artists continue to show the world about them in similar fashion. Modern artists, otherwise as disparate in their styles as Henri Matisse in France and Ben Shahn in America, have reverted to flat, more or less two-dimensional patterns to express their fresh, innovative visions of the world about them. But the limner of the Freake mother and child worked in traditional manner, using the same techniques that, as a journeyman-craftsman, he may have employed for decorating shop signs or for coloring the flat carving of chests and other furniture forms over which his effigies were hung.

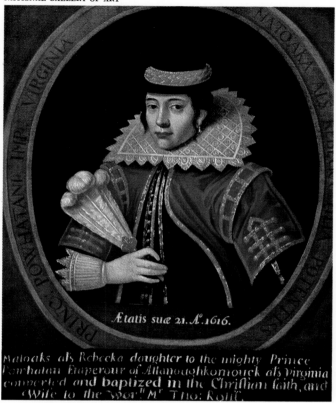

Pocahontas (Rebecca Rolfe), painted in England in 1616

Detail of a flat-carved and painted chest, made in New England in the 17th century

The dead as well as the living provided early colonial limners with opportunities to practice their craft and to add to their income. Describing a funeral in 1698, Samuel Sewall noted that the "Horses in Mourning" had painted escutcheons on their sides and Death's heads on their foreheads; hatchments and badges were also painted for the occasion. Cotton Mather tells of the Reverend John Wilson who, in all humility, refused to have his likeness recorded. "What!" he said, "Such a poor, vile creature as I am! Shall my picture be drawn? I say no; it never shall." However, his friends wished to have an effigy taken of the pious soul for the edification of future generations, and it was done. After Richard Mather, one of the founders of New England, died in 1669, young John Foster, a man of varied accomplishments, who had graduated from Harvard two years earlier (and who had been baptized by Mather), contrived the earliest known American portrait in a woodcut. When Foster died in his turn, at the age of thirty-three, in 1681, he left some "Cutts and Colours" in his estate, and another contemporary record refers to him as the "cunning Artist," indicating he may have painted pictures as well. Some part of his estate was probably paid to the unknown artisan who fashioned his handsome if macabre tombstone, an early example of our native sculpture.

Above: woodcut of a man, possibly King David, playing a harp; from an almanac printed at Cambridge in 1684

Below: tombstone of John Foster in the graveyard at Dorchester, Mass.

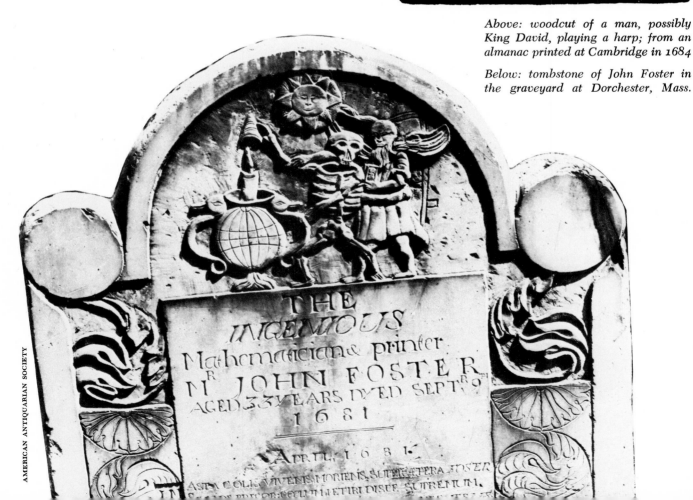

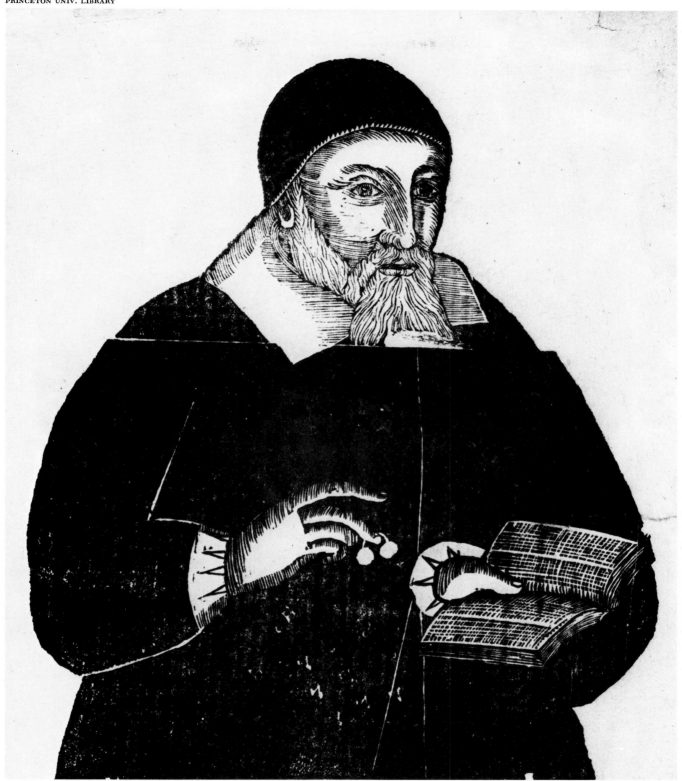

A woodcut portrait of Richard Mather, made about 1670 by John Foster

Peter Schuyler, the first mayor of Albany, N. Y.

Along the Hudson River valley, one English Puritan wrote, the Dutch settlers kept their houses "cleaner than their bodies and their bodies cleaner than their souls." The floors of their homes were indeed so cleanly scoured that a French visitor to the colony was afraid to spit on them. And in such dwellings hung pictures, many brought from abroad, of a variety—genre, still life, and so forth—unknown in New England. Here, too, local artists were early at work limning the features of their fellow settlers. In the first decade of the eighteenth century some unknown painter produced a heroic portrait of Peter Schuyler, Albany's first mayor. It was Schuyler who took five Iroquois sachems to London in 1710 (where they attracted enormous attention), hoping to impress the chiefs with the might and majesty of Queen Anne in order to secure their support in war against the French and their Indian allies to the north. The likeness of this doughty frontier warrior is still largely two-dimensional, but his commanding character is nevertheless impressively revealed. Thirty years later young Magdalena Douw was pictured almost as though she were a charming paper doll. For obvious reasons the painting is often called *The Girl with the Red Shoes*. Like other early colonists, the Dutch brightened their furniture with painted designs; unlike the typical New Englanders, they were not averse to religious subjects. The bench shown below has a scene of the Last Judgment, only dimly perceptible in the reproduction, with appropriate verse painted in Dutch script admonishing that "there is still time to leave folly" before God's final judgment.

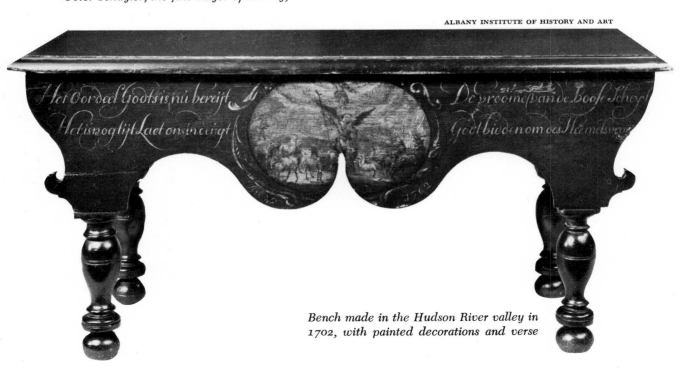

Bench made in the Hudson River valley in 1702, with painted decorations and verse

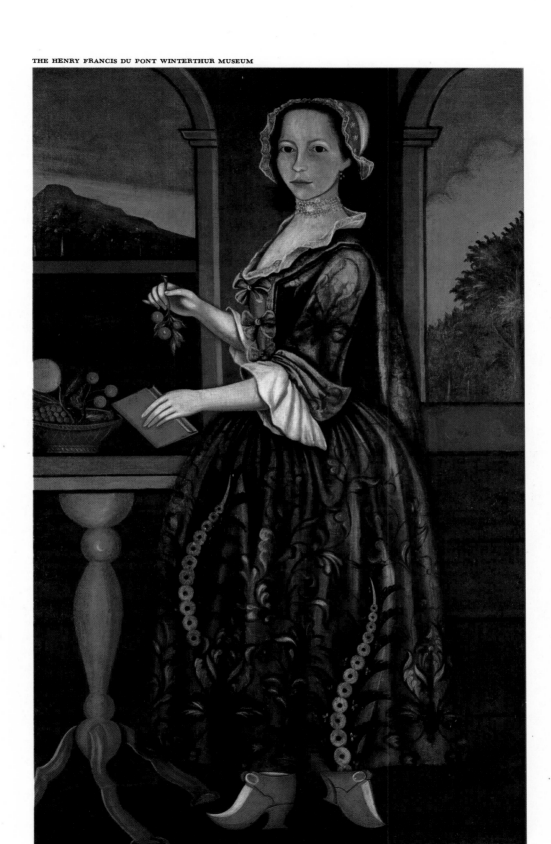

Magdalena Douw (Mrs. Harme Gansevoort), probably painted in Albany about 1740

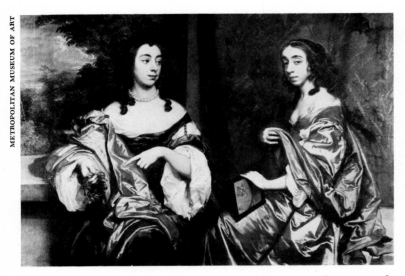

The Duchess of Beaufort and the Countess of Carnarvon, by Peter Lely

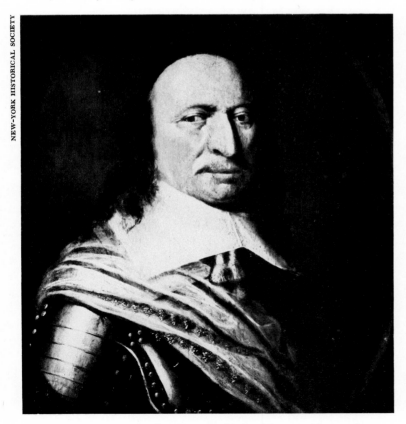

Peter Stuyvesant, painted in New Netherland by a resident artist

Even though it is usually impossible to identify the so-called untrained professionals who recorded the likenesses reproduced on the last several pages, it is safe to assume that they were all practical artisans who lent their limited talents and techniques to such painting and staining jobs as came their way, portraiture at times included among miscellaneous other less adventurous assignments. Long before their time the artists of the Italian Renaissance had revolutionized the art of painting, released it from the bind of medieval conventions, and, by the discovery of perspective and by subtle modeling of shades and colors, created an illusion of three-dimensional reality in their pictures. Those radical developments were gradually introduced elsewhere in Europe. The traditional insularity of England delayed the growth of such influences there, and the remoteness of America further slowed progress in the colonies. Throughout the seventeenth century English court painters were men imported from the Continent who had been trained in the new styles—such as Sir Peter Lely, earlier a guild master in Haarlem, who came to England to succeed the Fleming Sir Anthony Vandyke as the country's leading painter and who soon routed all native competition with his highly successful, flattering, and aristocratic images. Apparently, the first European-trained artist to practice in America was Henri Couturier, who came from Amsterdam about 1660 and became burgher of New Amsterdam in 1663, and who may have painted about then the portrait of Governor Peter Stuyvesant in armor. Here, in any case, is an early example of solid Dutch realism, the head blocked out convincingly in broad lights and discreetly arranged shadows. At approximately the same time in Boston a somewhat mysterious Captain Thomas Smith, a mariner, painted a self-portrait in very much the same Dutch-derived idiom, cruder in execution but with a similar emphasis on depth and roundness that contrasted sharply with the flat outlines of the Freake limner. The account book of Harvard College shows that in 1680 the school "pd. Major Tho. Smith for drawing Dr Ames [the Reverend William Ames] effigies" £4.4, witness that his particular talent was appreciated in august circles.

22

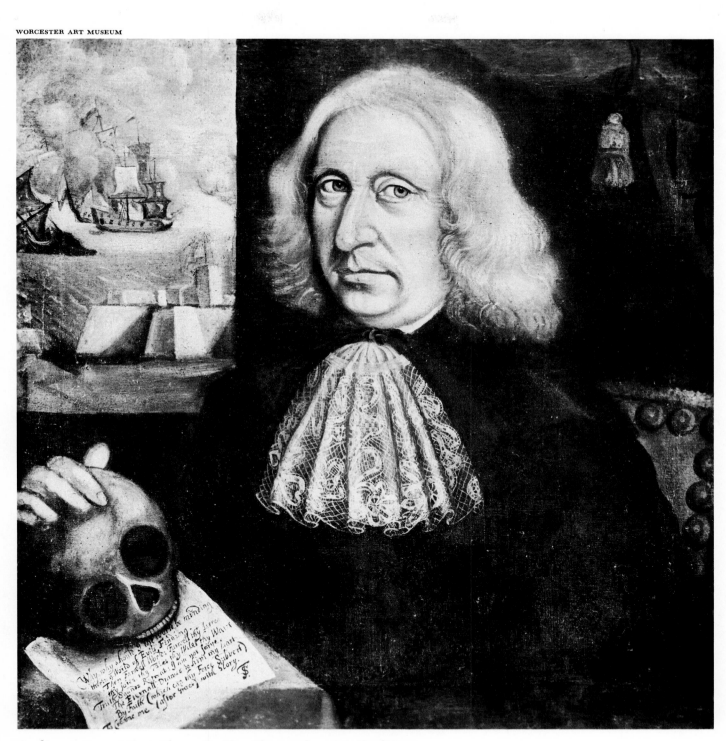

A self-portraiture of Capt. Thomas Smith, with a naval scene in the distance

23

COLONIAL CULMINATION

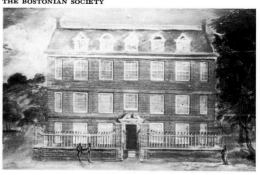

The William Clarke House, built in Boston about 1712, exemplified the new architectural concepts, derived from Renaissance precedents. The emphasis on symmetry and formal order, the use of classical motifs and details, would dominate colonial building for generations to come. In that same year Gustavus Hesselius, a cousin of Emanuel Swedenborg, arrived in America from Sweden, bringing with him a fair understanding of the international court style as it was practiced overseas. His *Bacchus and Ariadne*, painted a decade or so later, is the earliest known attempt by a colonial artist to depict the ideal world of ancient poetry. In drawing his figures for this and other paintings Hesselius may have been influenced by the familiar sight of half-naked Indians, who occasionally emerged from the surrounding wilderness to camp near his quarters in Philadelphia. When he went directly to the Indian for his subject, as in his portrait of the Delaware chief Lapowinsa, one of a pair of such portraits made for John Penn in 1735, he succeeded with a completely realistic likeness— the first convincing and sympathetic image of an Indian by any American artist. Again in the year 1712 the English artist-naturalist Mark Catesby arrived in Virginia to record other aspects of the American wilderness with comparable realism, anticipating the climactic efforts of Audubon by a full century.

Opposite: the Delaware Indian chief Lapowinsa, painted by Hesselius

Top: the William Clark mansion, built by him in Boston about 1712

Center: ivory-billed woodpecker, hand-colored engraving by Mark Catesby, published in 1731–32

Bottom: Bacchus and Ariadne, painted about 1720–30 by Hesselius

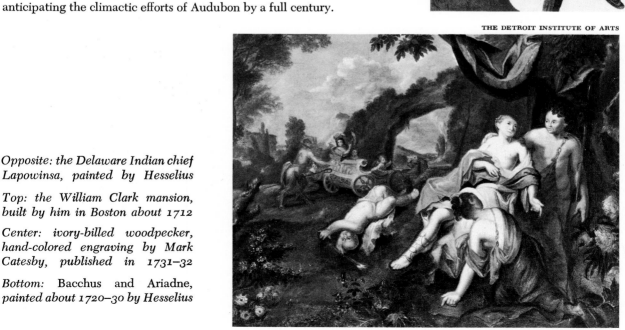

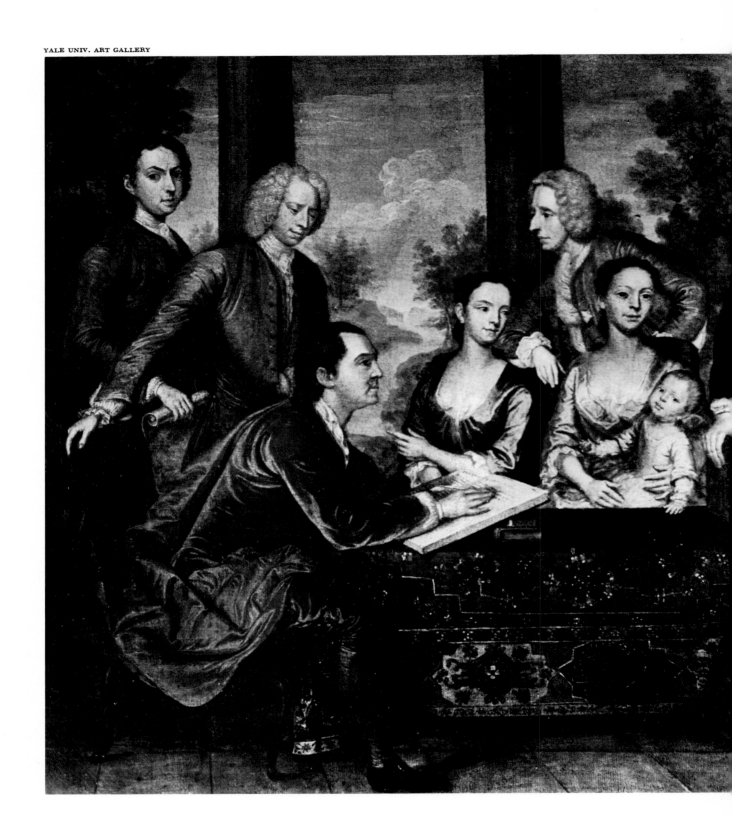

The arrival in Boston of the Scottish painter John Smibert in 1730 was hailed by one local rhymester as the dawn of a new cultural day in that little city. Smibert, who had started life as a house painter, undoubtedly was the most sophisticated artist to come to America from overseas before the Revolution. He had already painted at least one hundred seventy-five portraits in London, and had made copies of old masters during a visit to Italy. George Berkeley, Dean of Derry, had then persuaded him to come to America to serve as professor of art and architecture in a new college that never materialized. However, when the dean's party arrived at Newport in 1729, Smibert promptly produced what was to be his most memorable work, a group portrait of Berkeley and his friends and family, including the artist himself—a work such as New England had not before seen. The occasion of the tribute he received in Boston was a display there of this canvas along with the collection of paintings, prints, and casts of ancient sculptures (including one of the *Venus de Medici*) that he had acquired abroad; it was the first art exhibition known to have been held in America. The collection itself served as a school for American artists—John Singleton Copley, Washington Allston, and John Trumbull among them—for more than a generation after Smibert's death. (Between times Smibert designed Boston's market, known to history as Faneuil Hall, "the cradle of liberty.")

Three years before Smibert's arrival Peter Pelham, a competent engraver in mezzotint, had come to Boston from London. His fine portrait of Cotton Mather, engraved the following year, is the first known American mezzotint, a handsome, full-face likeness of that important person. Pelham married young Copley's widowed mother and, before his death in 1751 (the same year as Smibert's), helped his stepson master the elementary problems of picture-making.

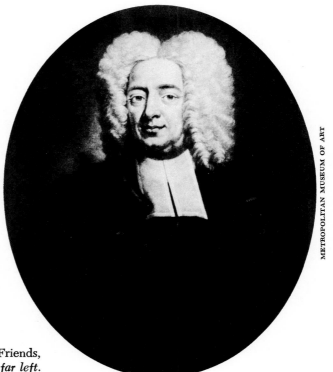

Above: Dean George Berkeley with his Family and Friends, *by John Smibert; the artist pictured himself at the far left.*

Right: mezzotint portrait of Cotton Mather, illustrious son of Increase Mather, engraved by Peter Pelham, 1727

27

When the amiable and witty Maryland diarist, Dr. Alexander Hamilton, visited Newport in 1744, he was taken to the home of "one Feykes [Robert Feke], a painter." He had "exactly the phizz of a painter," wrote Hamilton, "having a long pale face, sharp nose, large eyes with which he looked upon you stedfastly, long curled black hair, a delicate white hand, and long fingers." Feke was, concluded Hamilton, "the most extraordinary genius" he had ever met, a man who painted pictures "tolerably well by the force of genius, having never had any teaching." Aside from these observant comments and the evidence of his surviving work, Feke remains a mysterious figure in the history of American art. He may have been born about 1705 on Long Island. His earliest dated work, his most ambitious, a group portrait of the Bostonian Isaac Royall and his family, is inscribed, "Finisht Sept. 15th 1741 by Robert Feke"— a painting obviously influenced by the Berkeley group by Smibert, whose studio Feke visited. That is the first positive evidence that he existed at all. His portrait of the Reverend Thomas Hiscox, painted in 1745, is a forceful likeness that fixes an observer with an inescapable intensity of vision. He went on to paint some of the most finished creations of the early colonial style. Then, about 1750, after having produced some seventy portraits, which rank him high among the most proficient and sensitive colonial artists before Copley, he disappeared from the scene, leaving a confused legend behind him. Among other things, it is said that he was a mariner and that he "left the house of his youth, and was several years absent on voyages abroad, in one of which he was taken prisoner and carried into Spain, where, in the solitude of his prison, he succeeded in procuring paints and brushes, and employed himself in rude paintings, which, on his release, he sold and thus availed himself of the means of returning to his own country."

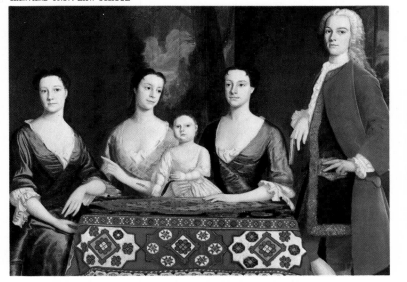

Left, top: the Rev. Thomas Hiscox, painted by Robert Feke in 1745

Left: Isaac Royall and his family, a group portrait by Feke, 1741

Opposite: Robert Feke, a self-portrait

28

John Greenwood, Boston-born and in his youth apprenticed to an engraver and decorative painter, quit his native city in 1752 at the age of twenty-five and went to Surinam. He had already learned the art of portrait painting, and, according to the account of his son, "was considered quite a genius." A few years later he produced *Sea Captains Carousing at Surinam,* one of the most candid, amusing, and unusual of colonial pictures, clearly more interesting as a social document than as a work of art. The artist depicts himself passing out of, and very nearly at, the door; Mr. Jonas Wanton of Newport, snoozing and being baptized; Captain Ambrose Page, next to Wanton, quite as sick as the artist shows himself to have been and using Wanton's pocket as a vomit bag; Captain Nicholas Cooke (later governor of Rhode Island) with a broad hat and a long pipe, talking at the table with Captain Esek Hopkins (later commander of the Continental Navy), who wears a cocked hat and holds a wine glass; and Mr. Godfrey Malbone of Newport being instructed in a dance by Captain Nicholas Powers, among other carousers, including two bibulous Dutchmen. By the clock it was 2 A.M. Surinam was a port of call on the Yankee sea mechants' circuit.

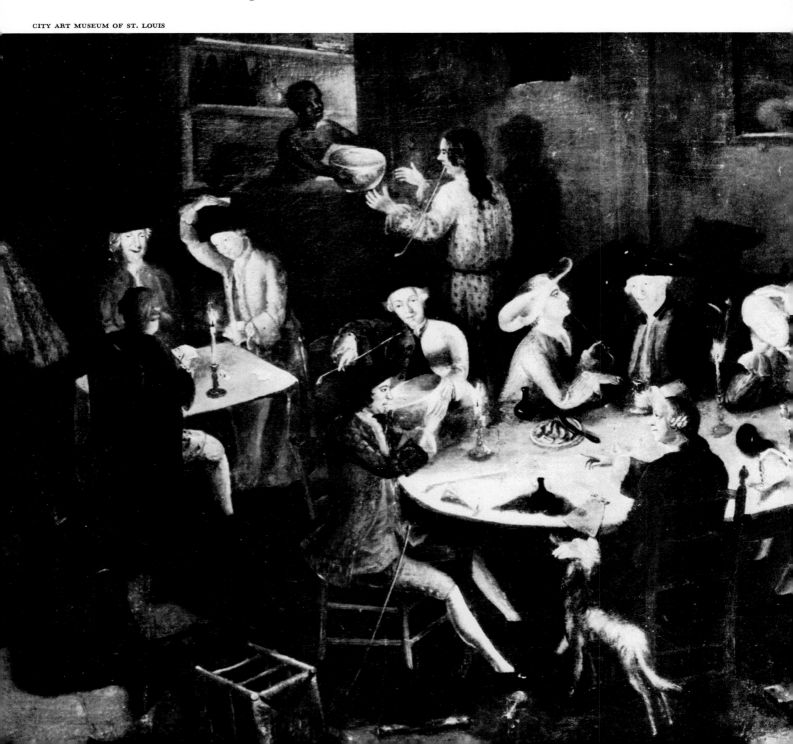

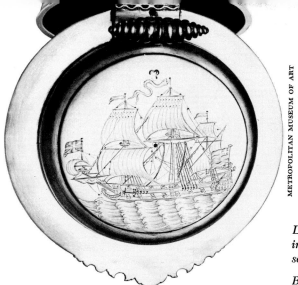

*Left: Engraving on the lid of a silver tankard show-
ing the ship Nassau in which Capt. Giles Shelley
sailed to Madagascar to gather pirate's treasure.*

Below: Greenwood's picture of a revel in Surinam

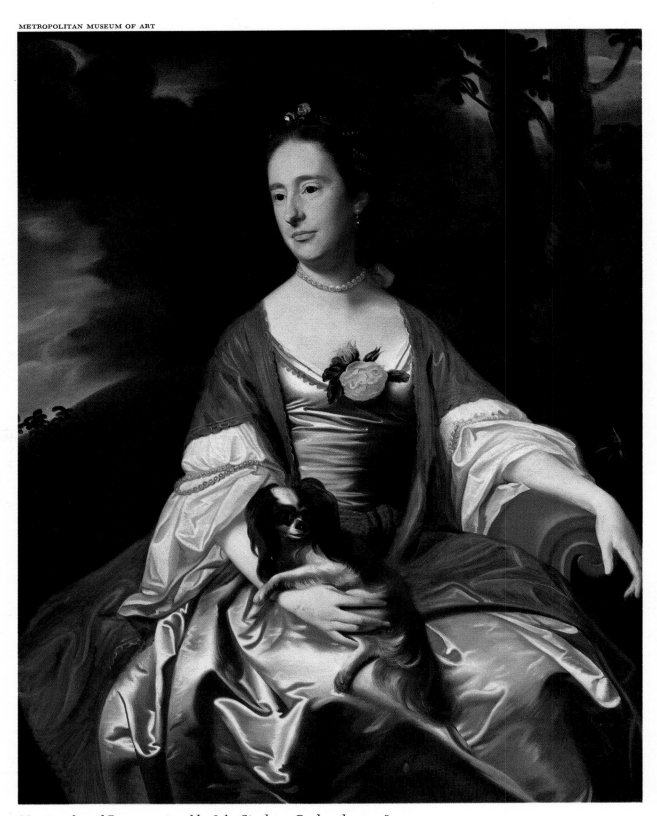

Mrs. Jerathmael Bowers, painted by John Singleton Copley about 1763

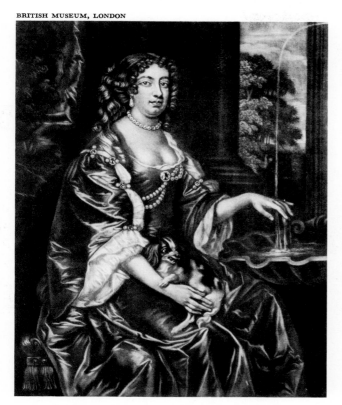

English print of Catherine of Braganza, about 1705

Lady Caroline Russell, after Reynolds, about 1759

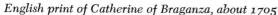

Colonial painting came to full flower in the work of John Singleton
Copley. Aside from the advice he may have received from Smibert and
Peter Pelham, he was self-taught. Like so many other colonial artists,
Copley occasionally copied the composition and details of European
engravings to achieve his purposes. In his portrait of Mrs. Jerathmael
Bowers, a lady of substantial fortune, he borrowed everything but the
face of his subject from an English mezzotint of Lady Caroline Russell after
a painting by Sir Joshua Reynolds. Reynolds, in turn, had referred to
a much earlier print of Catherine of Braganza, widowed queen of Charles II,
to complete his own composition. Such practices were hardly
unprecedented or discreditable; in fact they follow a venerable tradition
in the history of art. Copy or not, Copley's portrait is handsomely
executed and foretells the ultimate refinements of his colonial work.
When, a few years later, at the age of twenty-eight, he submitted a
portrait of his half brother Henry Pelham for an exhibit of the Society
of Artists in London, Sir Joshua Reynolds could hardly believe a young
provincial was capable of such excellence. It was more than good enough
for the exhibit, and the renowned English artist sent word to Copley that
it was "a very wonderful performance." With the advantages of example
and instruction he would have in Europe, Reynolds remarked, Copley
would become "one of the first painters in the world." On the merits of that
painting Copley was elected to membership in the English Society of Artists.

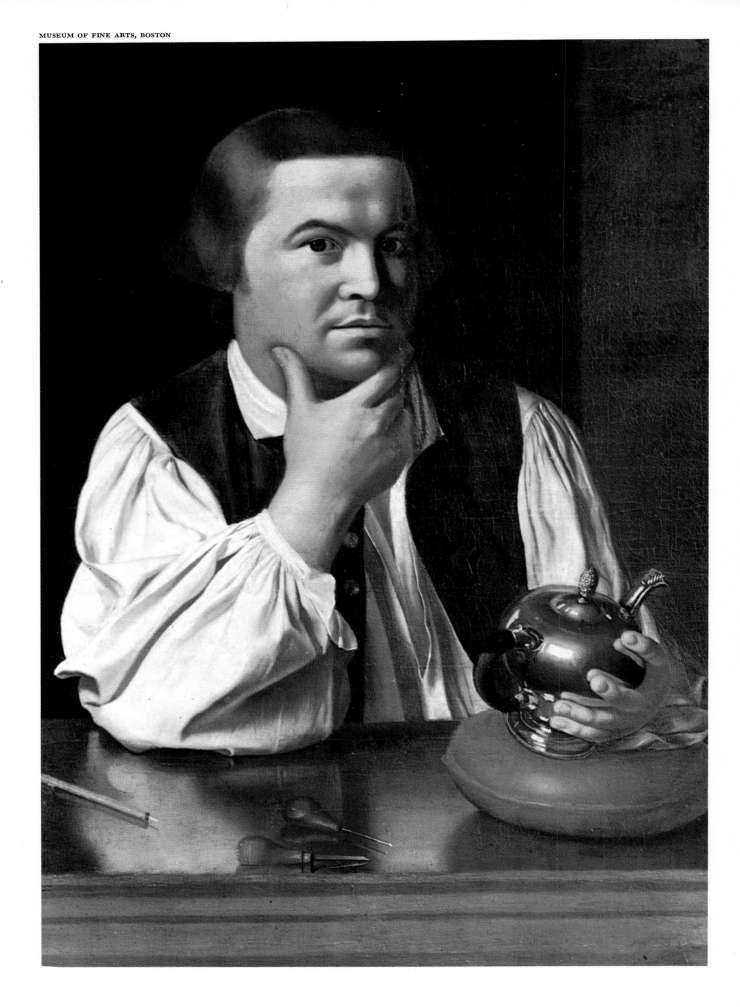

Sir Joshua Reynolds urged Copley to cross the Atlantic to see and study, for the first time in his life, the work of the great European masters. As he pondered over the decision, Copley was approaching the peak of his artistic powers, quite remarkably without benefit of such vital and enlightening experience. No other colonial painter had his skill in putting on canvas the character and personality of his subjects; an illusion of living reality and immediate presence, rather than simply the representation of a person. As John Adams wrote of Copley's portraits, "you can scarcely help discoursing with them, asking questions and receiving answers." So it is, one feels, in confronting the shirt-sleeve portrait of Paul Revere (painted about 1768–70), pausing meditatively in the fashioning of a silver teapot, his necessary finishing tools ready at hand. The colorful textures of fabrics, skin, hair, mahogany, and silver are almost palpable, as they are in the works of Vermeer, de Hooch, and other realistic Dutch masters of the previous century. Copley's attention to the details of his canvas could be tedious for the sitter. "He painted a beautiful head of my mother," reported one contemporary, "who told me that she sat to him fifteen or sixteen times! six hours at a time!" However, his gifts were increasingly recognized by the gentry along the colonial seaboard, Copley's commissions grew in number and in consequence, and he prospered. "I am now in as good business as the poverty of this place will admit," he wrote in 1767. "I make as much money as if I were a Raphael or a Correggio. . . ." America has had no titled aristocracy, but a family portrait by Copley's brush has come to be virtually the American equivalent of an ancient coat of arms. However, in June, 1774, for all his local success, and as war clouds gathered over the colonies, Copley sailed from America to improve his skills and establish his reputation in a wider world.

Opposite: Copley's portrait of Paul Revere

Right: one of Copley's anatomical studies, drawn from European books, about 1756

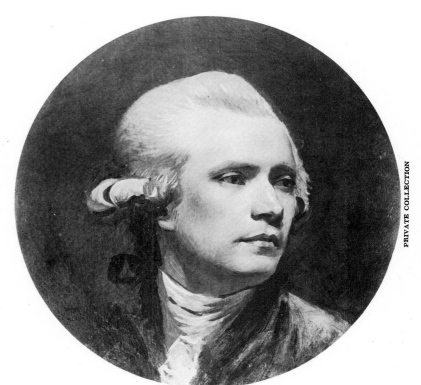

Self-portrait of Copley, painted about 1776–80

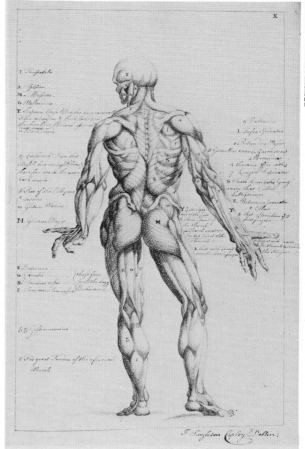

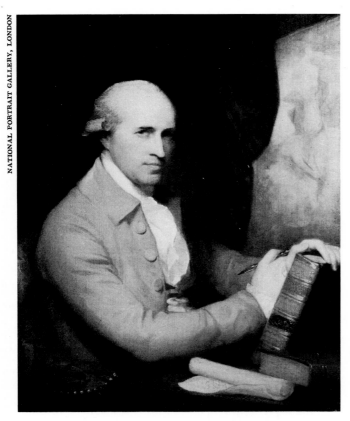

TRIUMPH

OVERSEAS

A portrait of Benjamin West by Gilbert Stuart

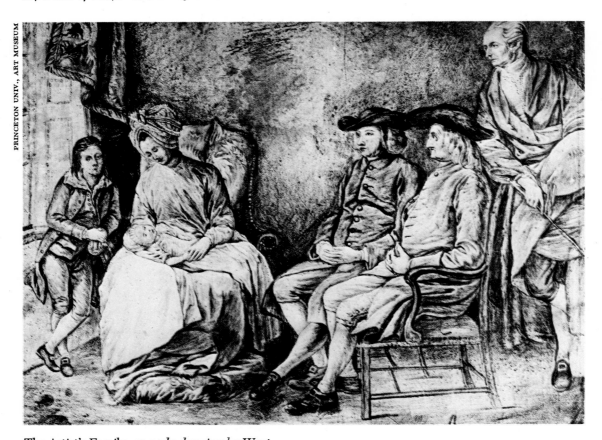

The Artist's Family, *an early drawing by West*

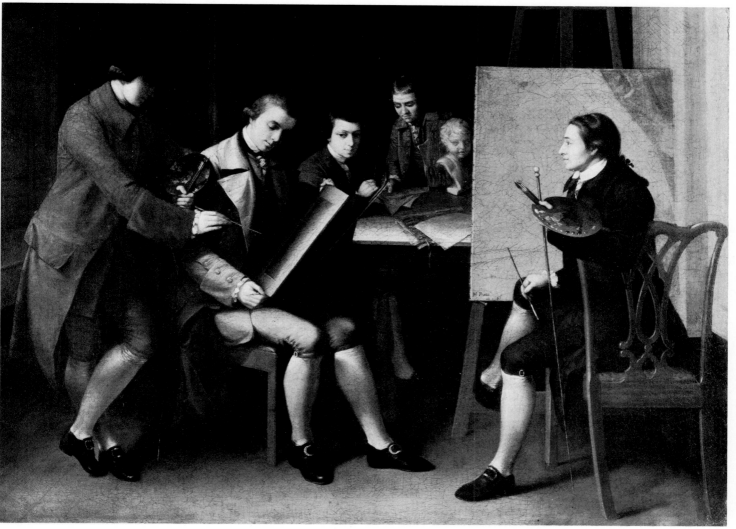

The American School, *by Matthew Pratt, 1765; Benjamin West instructing young artists in his London studio*

When Copley arrived in London (via Italy) in 1775, his contemporary, the Pennsylvania Quaker Benjamin West, had been there for a dozen years and had already been named historical painter to George III. West's early training had been even more rudimentary than Copley's. According to undying legend, West made his first brushes by snipping hairs off the family cat (leaving the animal in patches) and drawing them through quills; and he learned about making colors from Indians of the nearby forests. In any event, his precocity was such that he was encouraged to go abroad for study, which he did in 1759, heading first for Rome. He remained in that ancient capital for three years, studying the masterpieces to be seen there, before leaving for a visit to London. That "visit" extended through the rest of his life until his death in 1820. In England, West's rise to prominence was phenomenal. By the time he was twenty-five he had reached the top of his profession. Attracted by his mounting reputation, hopeful colonial artists flocked to his studio for aid and advice, which West unstintingly provided. His home, indeed, became a veritable school for American painters.

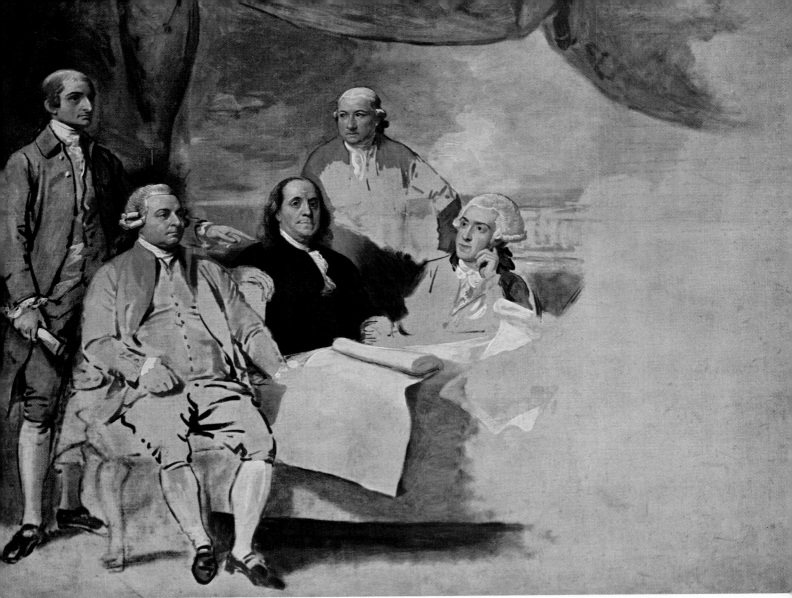

West thought of portraiture as hack work, and longed to paint episodes of ancient history, stories that would tell of antique virtues. With friendly support from the king he initiated a series of such subjects (though his knowledge of historical matters was hardly profound) that set a vogue for neo-classicism, years in advance of work in such vein by the French artists, who would carry the style to its ultimate perfection. For the first time England had a painter who led the avant-garde of European art. According to firmly established convention, heroes of modern history were also shown in classical garb. When, in 1771, West proposed to depict the death of Wolfe at Quebec with the British general in modern dress, both the king and Reynolds begged him to refrain from such a radical departure. West persisted, nevertheless. When the picture was shown it was an immediate, spectacular popular success. Large crowds gathered to see and admire it. The king even asked the artist to paint him a duplicate, and Reynolds declared, "West has conquered . . . I retract my objections." Engravings of the subject won enormous favor far beyond England's shores. West had set off another revolution, just as his countrymen were about to set off a revolution of their own across the Atlantic. He quickly followed that triumph with *Penn's Treaty with the Indians,* one of his most memorable accomplishments. His unfinished canvas showing the American commissioners of the peace treaty with England (the English representatives were never painted in) demonstrates his basic talent in its most congenial vein.

38

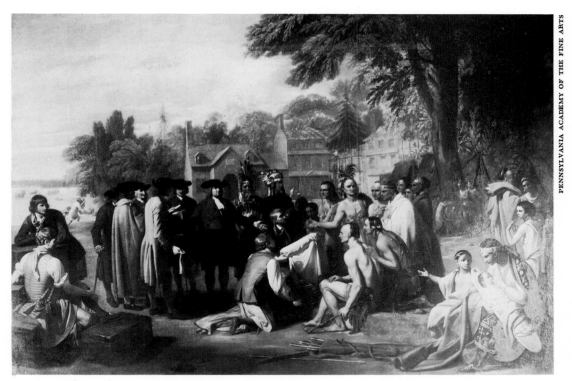

Above: Penn's Treaty with the Indians, *painted by West, 1772*

Opposite: an unfinished painting by Benjamin West showing John Jay, John Adams, Benjamin Franklin, Henry Laurens, and William Temple Franklin at the peace conference with England in September, 1783. The British commissioners would not pose.

Below: The Death of General Wolfe, *1759, by West, 1771*

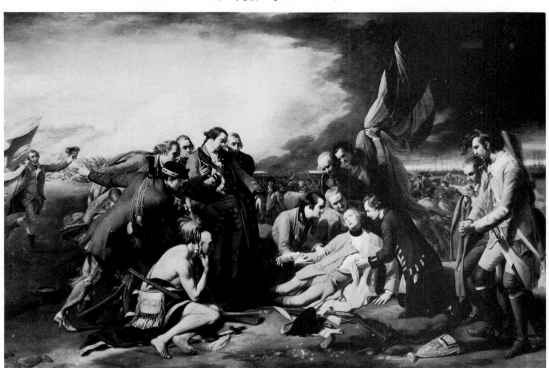

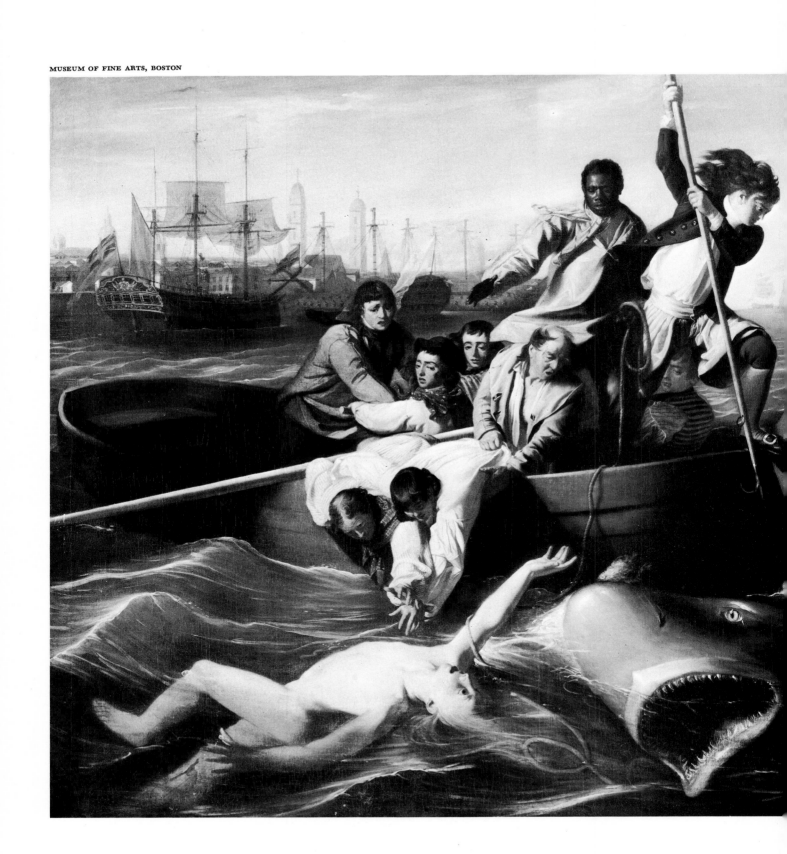

Right: head of a Negro, by Copley, 1777–83, possibly a sketch for the picture below

Below: Watson and the Shark, *painted by John Singleton Copley in London, 1778*

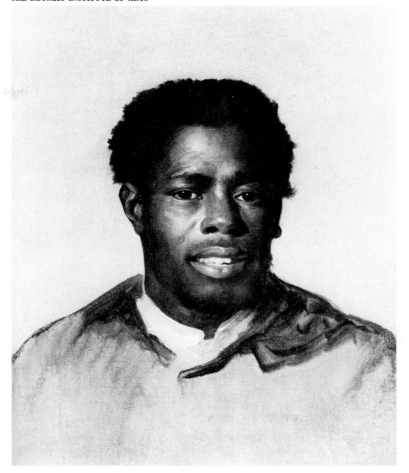

After a stimulating and productive sojourn in Italy and way places, Copley arrived in London late in 1775. As West had promised he would do, he immediately introduced his compatriot to the right circles. And as Reynolds had foretold, by his own native genius, fortified by his experience on the Continent, Copley quickly established himself as an important figure in the English art world. Like West, he too aspired to paint historical subjects, themes his colonial patrons had not encouraged him to develop. In America, he had complained at one point, "was it not for preserving the resemblace of particular persons, painting would not be known in this place." Three years after his arrival in London he was commissioned by Brook Watson, a friend (later lord mayor of London), to record a ghastly scene from Watson's youth when, in 1749 he had been attacked by a shark in Havana Harbor, losing a leg in the episode. When Copley's reconstruction of the scene was shown at the Royal Academy it created a sensation; the London *Morning Post* hailed it as among the "first performances" of the exhibition. That painting, with all its dramatic horror, was a foretaste of what would later be termed the "romantic agony," the expression of tragic emotion for its own sake; it anticipated by more than forty years Géricault's *The Raft of the Medusa,* which seemed revolutionary to French audiences when it was first shown at Paris in 1819. Like West, Copley never returned to America. Before they died in the fullness of their years, both had made substantial contributions to the English school of painting.

41

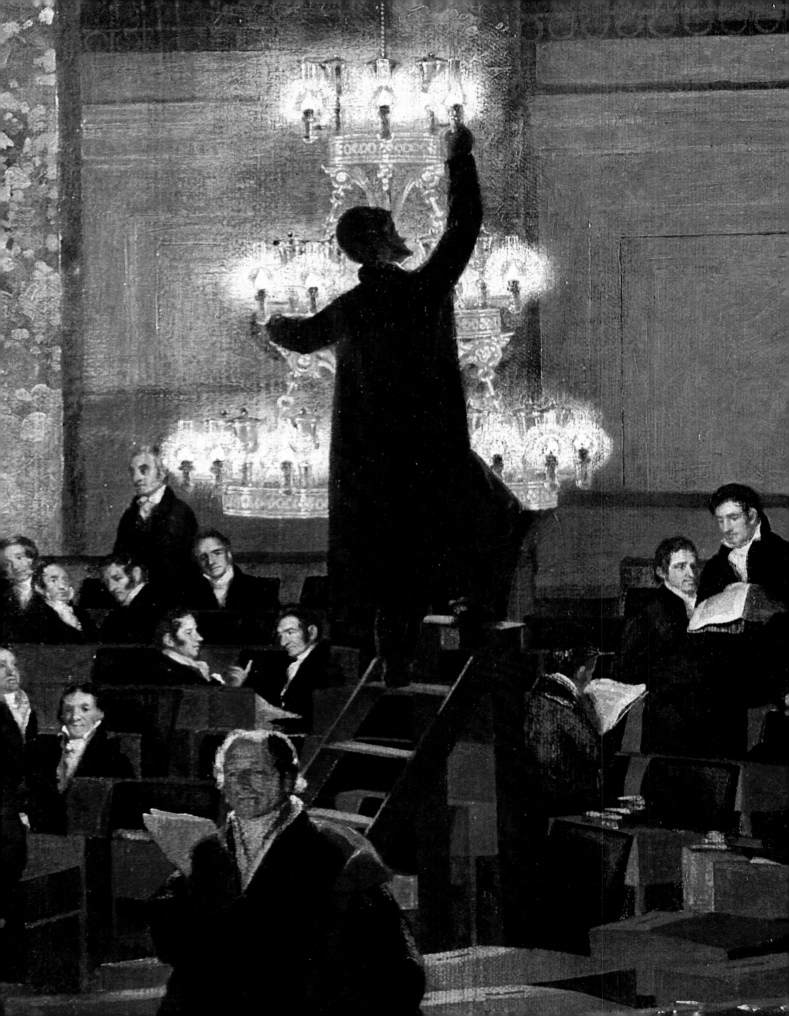

The business of a few generations of painters, in this country as in all others, is to prepare the way for their successors.

—HENRY INMAN

EARLY REPUBLICAN ART

Opposite, detail of Samuel F. B. Morse's painting of The Old House of Representatives *(above) at lamp-lighting time, 1822*

The American War of Independence was not a doctrinaire revolution that sprouted from the minds of philosophical rebels; it was an "outdoor" revolution that grew from seeds sown by circumstance. There was no lack of philosophical assertions on the part of the aroused colonists, but they were used less to incite a course of action than to rationalize the flow of events. Actually, the colonists were free long before they became independent. America's separation from England was, after all, deep in the nature of things, as Edmund Burke pointed out to parliament; and what the "Laws of Nature and of Nature's God" would put asunder, neither men of patience and good will nor all the king's men and all the king's horses would be able to put together again, although they tried in different ways to do as much. But it took a long and wasteful war that hardly anyone wanted to prove beyond all doubt that America was, and of a right ought to be, both free and independent—a point, as John Adams recalled in his later years, that had been firmly settled in the minds and the hearts of the American people before a shot was fired.

When the bloody business was over, there were men, like the lexicographer Noah Webster and the geographer Jedidiah Morse, who in a spirit of rampant nationalism called upon their countrymen to assert their new independence in all the ways of life. The United States must be "as independent in *literature* as . . . in *politics*," proclaimed Webster, "—as famous for *arts* as for *arms*." It was dishonorable, he admonished, "to waste life in mimicking the follies of other nations and basking in the sunshine of foreign glory." In *The American Geography* (1789) Morse earnestly sought to impress upon the minds of the youthful the idea of "the superior importance of their own country."

However, despite the grievous wounds that had been opened by the conflict, the ties with England were not easily severed—ties, by and large, of a common ancestry, a common tongue, and a common culture. The custom of returning "home" to Britain for advanced studies in the various professions continued unabated after the formal bonds of government were forever broken. That flow of students even increased after the peace. "I hardly know how to think myself out of my own country," wrote Abigail Adams from London shortly after the Revolution, "I see so many Americans about me." Among those countrymen

43

she saw, there were no doubt tourists and merchants as well as students. Affluent Americans continued to make the grand tour of Europe to widen their horizons, with London a principal port of call, as they had in colonial days. Others went for more practical reasons. In 1784 William Pynchon of Salem, Massachusetts, observed that "all who can cross the Atlantic seem determined to go and procure their goods from England." That same year the imports from Great Britain were almost five times greater than American exports to that country—greater, indeed, than they had been before the war.

In London Benjamin West's star was steadily rising. Even during the Revolution he continued to enjoy the favor of George III (as long as the king was in his senses), despite the fact that he did not always disguise sympathetic feeling for his rebellious countrymen in the king's presence. (Late in his days West referred to the monarch as "the best friend I ever had in my life.") In 1792, upon the death of the venerable Sir Joshua Reynolds, and with the king's support, West succeeded to the presidency of the Royal Academy; and during the war and after the peace, as earlier, young American artists crossed the Atlantic to study with the renowned expatriate. West had originally planned only a passing visit to England. However, success anchored him there for the rest of his life, but neither he nor his wife of fifty years ever quite overcame a nostalgia for their homeland. Mrs. West was so homesick she kept trying to grow corn in her greenhouse, with no great success.

The list of West's American students is long and impressive. Besides Charles Willson Peale and Matthew Pratt, who returned to the colonies before the Revolution, and aside from Gilbert Stuart, John Trumbull, Ralph Earl, and others, the roster included such memorable names as Rembrandt Peale, Samuel F. B. Morse, Robert Fulton, Washington Allston, among still others who counted for much in the subsequent development of American art. In all but name West's London studio was indeed the first American academy of painting. However, neither schooling with West nor exposure to European conventions stamped these "graduates" with a common style or manner. Rather, upon their return to America their work exhibited a decided individuality, ranging from Stuart's suave characterizations of the new republican aristocracy to Earl's persistently severe homespun likenesses of the Connecticut gentry. Around this diverse group developed a native school of portraiture that has left us a memorable gallery of "old masters" from the early days of the Republic. But beyond that, these men were ushers of a new phase in American painting, and their influence may be traced in the output of the next generation—in the work of artists who were too young to remember the Revolution or to have known West in his heyday, but who had the advantage of solid professional training.

In America the prevailing attitude toward the arts was somewhat ambivalent during the days of the young Republic, a point sharply reflected in various comments by John Adams. "The age of painting and sculpture has not yet arrived in this country," he once wrote a French sculptor who was considering a visit to America, "and I hope it will not arrive very soon. Artists have done what they could with my face and eyes, head and shoulders, stature and figure, and they

Roger Sherman, shoemaker, Signer, judge, revolutionary leader, painted by Ralph Earl about 1775–77

have made them monsters fit for exhibition as harlequin or clown [he was in fact painted innumerable times by an assortment of artists]. . . . I would not give sixpence," he concluded snappishly, "for a picture of Raphael or a statue of Phidias." When he first sat for Gilbert Stuart for his portrait his condescension so irritated the artist that he refused to go on with it. However, in a different mood, one closer to his essential character, Adams also wrote that he wished he had the leisure and tranquillity to "amuse" himself with the study of the arts— painting, sculpture, architecture, and music—conceding that "a taste in all of them is an agreeable accomplishment." He patched up his differences with Stuart and the two old men even became friends. "I should like to sit for Stuart from the first of January to the last of December," Adams wrote to his son, "for he . . . keeps me constantly amused by his conversation."

Stuart's conversational gifts and the charm of his manner were legendary in his own lifetime, and his particular genius was widely acclaimed. He was the son of a Rhode Island snuff grinder (he used snuff copiously all through his life), and like West and Copley before him he was something of a child prodigy. Almost from the start he enjoyed a mounting success, which was not hindered by his quick tongue, his ready wit, and his fiercely independent spirit. In England when he was asked where he was born he explained that the site was "six miles from Pottawome and ten miles from Poppasquash," an answer he expected would confuse and intrigue his interrogators at least as much as if he had said Narraganset. His considerable income from eager patrons was, however, no match for his extravagances. After his studies with West he set up his own studio in London, but soon had to quit that city for Dublin to avoid the very real horrors of the debtors' prison (he owed £80 for snuff alone)—and then, a short while later, to quit Dublin for America for the same tawdry reason. This was in 1792, when Stuart was thirty-seven years old. He claimed that he returned to America to paint a portrait of George Washington, which in fact he did several times over, and in doing so created a standard image of the Father of His Country that has been endlessly reproduced ever since. If Washington should return to earth he would have to resemble Stuart's portraits to be recognized.

Stuart had brought back from England a style of portraiture derived from the fashionable creations of Sir Joshua Reynolds and Thomas Gainsborough, the great English masters, but highly individualistic in its character—and completely different from all colonial precedents. Whereas Copley labored long and lovingly over the sheen and texture of silks and damasks, Stuart typically concentrated on the head of his sitter, dashing off a resemblance in quick, nervous strokes of pigment (often with an unsteady hand), without preliminary outlines or details and with little concern for the rest of the figure or background. One early critic remarked that Stuart could not, in fact, paint "below the fifth button"; Stuart himself said that he left such accessory paraphernalia to the tailor.

Portraiture remained the dominant art form of Stuart's generation. According to Paul Svinin, a Russian painter who worked for his government in Philadelphia early in the nineteenth century, Americans, being disposed to vanity, had a weakness for bequeathing their likenesses to posterity. "For that reason," he continued,

Portrait of John Adams at ninety, painted by Gilbert Stuart in 1825

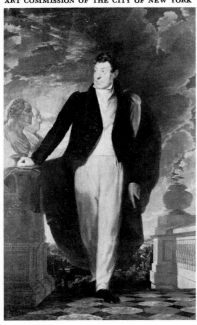

The Marquis de Lafayette, Samuel F. B. Morse's famous portrait, 1825

"portrait painters are constantly in demand and are very well paid. The most wretched paint-slinger receives no less than $20 for a bust portrait, and some men get as much as $100." There were so many artists wandering about the country copying faces that, as Stuart quipped, if you kicked your foot against a dog kennel, out would come a portrait painter. Thomas Sully, who had studied with West and also had some guidance from Stuart, painted more than two thousand six hundred pictures in his lifetime, the bulk of them portraits. However, in America as in Europe, the winds of change were blowing with increasing violence against the patterns of the past. American artists were returning from their European experiences with new concepts. The commanding figures who had led the colonies to independence and on through the critical years that followed the Revolution were rapidly vanishing from the scene when Washington Allston returned in 1818 from his second long sojourn abroad. For a new generation Allston brought, even in his figure paintings, a mood of mystery and magic that replaced the clarity and repose of earlier American work, a mood intensified in the imaginative landscapes that comprise his best-remembered canvases.

He came home with a towering reputation. "He has commenced where most of us leave off," Benjamin West once said of Allston's work. Samuel Taylor Coleridge, the English poet and critic whom Allston had known so well in Rome, thought that "he was gifted with an artistic and poetic genius unsurpassed by any man of his age." This was the extravagant opinion of an opium-eater, but one with which Allston's cultured American contemporaries were inclined to agree. Allston attempted what Stuart could never have achieved. In the course of his European travels he had discovered with delight the great Venetian painters of the sixteenth century. "In some of them," he recalled, ". . . there is not the slightest clue given by which the spectator can guess the subject. They addressed themselves, not to the senses merely, as some have supposed, but rather to that region . . . of the imagination which is supposed to be under the exclusive domination of music. . . . In other words they leave the subject to be made by the spectator, provided he has the imaginative faculty—otherwise they will have little more meaning to him than a calico counterpane." In that observation was the germ of the revolutionary developments among French painters of later days. Allston was too much a man of his times to attain quite such lyrical indifference to subject matter in his own work, but his best-realized paintings do indeed evoke reveries that transcend his overt topics.

The cultural elite appreciated Allston's aspirations, but the American public at large was not ready for radical departures from traditional practices. Allston's plight was, in fact, symbolic of the artist's dilemma in this country at that time. The radiant young genius, born of a patrician South Carolinia family, and who had been his class poet at Harvard, had undertaken to become an artist over the objections of his parents, who considered painting an unsuitable occupation for a gentleman. His successes were indisputable, but in his quest of ultimate perfection Allston overstrained his capacities and far outran popular taste. In spite of his earlier accomplishments both at home and abroad, his talent dissolved in nervous confusion after he returned from Europe to Massachusetts. His career

ended in an anticlimax. "I know no more melancholy sight than he was," wrote the sculptor William Wetmore Story to James Russell Lowell, "so rich and beautiful a nature, in whose veins the south ran warm, which was born to have grown to such a height . . . stunted on the scant soil and withered by the cold winds of that fearful Cambridgeport."

That old lament of the harsh cultural climate of America continued to echo down the years. Allston's contemporaries John Vanderlyn and Samuel F. B. Morse suffered similar misfortunes, which were explained in similar fashion. Fired by a familiarity with the best European painting, their imagination and ambitions exceeded what, for the moment, America was prepared to ask and pay for. Vanderlyn was the first American to look to France rather than England for his training. He spent the best part of twenty years in Europe, and won some distinction there. But when he returned home for good he found himself out of place in the relatively provincial American scene, and, as his countrymen refused to share his vision of art, his spirit and his talent withered. He died penniless and embittered.

Morse started his career as the protégé of Allston, who by his own well-bred example had persuaded Morse's dubious and anxious parents that an artist could be both moral and a gentleman. (Washington Irving thought Allston was one of the noblest, purest, and most intellectual beings he had ever met. Besides that, the artist was the brother-in-law of William Ellery Channing, which guaranteed him gentility and integrity by association.) One of the early paintings Morse produced in London was received with extravagant praise when it was hung in the exhibition of the Royal Academy. Flushed with ambition and confidence, he wrote home that he aspired "to be among those who shall reveal the splendor of the fifteenth century . . . ; my ambition is to be enlisted in the constellation of genius now rising in this country; I wish to shine not by a light borrowed from them but to strive to shine the brightest."

To accomplish this Morse would eschew portraiture and landscape painting and, like Allston, devote himself to "the intellectual branch of the art," by which he meant historical painting. By this, in turn, he obviously meant pictures illustrating legends, anecdotes, and literary allusions. "I must return *a painter*," he explained to his parents, who about that time found they could no longer support their son in London. To come back then, he complained, would mean to throw away the talents Heaven had given him "for the higher branches of art," and drive him into being "a mere portrait painter." However, return he did, to paint, among other things, a substantial number of very fine portraits indeed. Although he enjoyed prosperous seasons and painted prominent people, including John Adams, President James Monroe, William Cullen Bryant, and Marquis de Lafayette, the financial returns were not consistently ample, the satisfactions not commensurate with his spiritual needs. Guided by his inner lights, Morse had set the terms on which he would accept recognition and admit success as an artist, and these his countrymen were not prepared to meet. In the end he quit painting altogether and gave himself over to experimenting with photography and to perfecting the electric telegraph, which won him the fame he could not achieve by his brush.

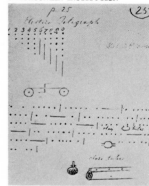

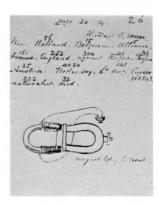

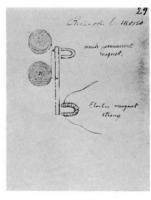

Diagrams of the earliest design of the electric telegraph invented by Morse

Actually, the American climate was not so harsh for artists those days. A growing number of Morse's contemporaries who were not burdened with his exalted notions about the true nature of art enjoyed very decent rewards. Charles Willson Peale painted successfully, off and on, until his death in 1827 at the age of eighty-six; and his son Rembrandt Peale sent one of his own paintings (*The Court of Death*) on an exhibition tour that brought returns of $9,000 in little more than a year. For those who studied the public taste and realistically responded to it, there was work enough.

For a long time, even after he had laid aside his brushes, Morse was unwilling to concede any incongruity in his own notions. He labored with the hope of educating the world around him to higher standards of taste. He would lead his fellow artists in the promotion of their own interests, direct public attention to the dignity of their calling, and thus, perhaps, serve his country as well as by exercising his own divinely inspired talent. With militant enthusiasm he had helped form and, in 1826, he had assumed the presidency of the new National Academy of Design, an organization of working artists that would exhibit contemporary American arts, offer instruction and awards, and set professional standards of excellence.

The principle that artists could and should operate in a union of professional interest brought Morse into head-on collision with the earlier-established American Academy of Fine Arts, an organization controlled and patronized largely by well-to-do laymen, and with its venerable president, Colonel John Trumbull. (Trumbull, still another ex-pupil of West's, was well-born and influential, and he shamelessly used his connections and his post as president of the Academy to eliminate from attention any young artist whose career threatened his own.) Morse's first presidential address at the new organization was, as well, quickly challenged by a broadside from the highly respectable *North American Review*, which took a firm and stern stand concerning the presumptions of artists. Painting and sculpture, that journal pronounced, were not "among the necessities of life. Much as they improve and adorn society, a taste for them is not even the necessary

Rembrandt Peale's The Court of Death *of 1820 was remarkably successful throughout its tour of the country.*

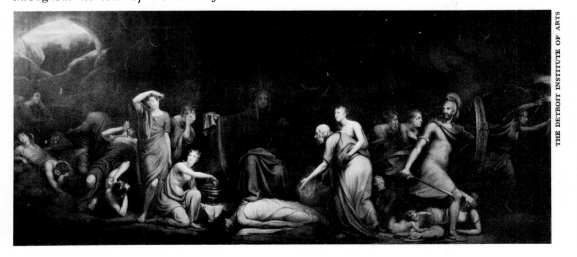

accompaniment of a high degree of civilization." And, in another blast: "We would not have the arts degraded even in favor of the artists. . . . We can hardly hope that the masterpieces of ancient art are ever to be surpassed here or in Europe. The forms and occupations of society are growing every day less favorable to the highest efforts of the imagination. We live in an age of utility. . . . In this cultivation of reason, the imagination loses its power . . . painting, and sculpture, do not belong to such an age. . . ."

So spoke the voice of a growing mercantile and industrial establishment. But in spite of such reproaches Morse's academy took root and became one of the most important influences in American painting for years to come, as Trumbull's institution was obliged to close its doors. In a letter to a contemporary critic, one of the founding academicians wrote: "I told you, sir, the business of a few generations of artists in this country, as in all others, is to prepare the way for their successors; for the time will come when the rage for portraits will give way to a higher and purer taste." Change was in the air. If it was not necessarily to a "purer" taste, it was toward a class of painting, provided by a considerable body of men with respectable skills, that was well adapted to the tastes of a burgeoning democracy. In the years that followed, as William Cullen Bryant observed, the artists "appealed from the patronage of the few to the general judgment of the community, and triumphed."

One of the young men who had gone to serve an apprenticeship with West in 1784 was William Dunlap, who late in his life compiled an invaluable account of all the American artists he had known, talked or corresponded with, or heard about. His two-volume *History of the Rise and Progress of the Arts of Design in the United States,* first published in 1834, is a rich trove of intimate details, particularly relating to those men of the early republic whose work is illustrated in this chapter. No one could have written of those formative years of American art with greater authority than this engaging one-eyed playwright, novelist, artist, and gossip. He had known many of the principals personally, either in London or later at home, and he was a tireless recorder of his experiences. He corresponded and talked almost endlessly with his contemporaries to fatten his files of information about men he had not met. Dunlap could recall the time when all too often the artist enjoyed little or no distinction. He mentions an occasion in the closing decade of the eighteenth century when two artists were excluded from a ball in Albany since the rules forbade admitting "mechanics." He also remembered that John Trumbull once denied a group of art students admission to the American Academy, advising them that gentlemen (his wealthy friends), not students, paid the bills of that organization. "Beggars are not to be choosers," he reminded them haughtily. But as he wrote, Dunlap could exult that in the course of his adult life he had seen the fine arts come of age in this country; he had witnessed vital developments from which new and broader concepts of art had evolved; he had watched the rise of the professional artist to an ever-higher status in American society. "Now," he wrote in his book, "in consequence of that conduct which flows from their knowledge of the dignity and importance of art, [artists are] looked up to by the best in the land."

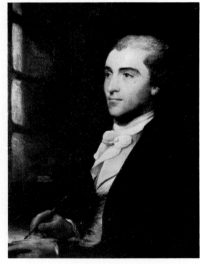

In 1871 Gilbert Stuart executed the head of this portrait of John Trumbull in a London jail; the rest was later filled in by Trumbull.

49

Mrs. Perez Morton, an unfinished portrait by Gilbert Stuart, painted about 1802

When Gilbert Stuart fled Ireland in 1792 his highly
distinctive style was fully developed. Once back
in his homeland, he enjoyed immediate recognition,
which only mounted over the years to come. Almost
everyone who was anyone in the new nation sat for
him. The most beautiful women, the most influential
men, the wealthiest patrons—most of those who
constituted what long ago was dubbed the Republican
Court and almost a thousand subjects all in all—
went to that errant, bibulous, witty, and talented
man to have their likenesses taken. A friend wrote
Dolley Madison that Stuart was "all the rage" in
Washington. "He is almost worked to death and everyone
is afraid they [may?] be the last to be finished.
He says: 'The ladies come to me and say: "*Dear*
Mr. Stuart, I'm afraid you must be very tired. You
really must rest when *my* picture is done." ' "
Stuart was an unpredictable and impatient artist.
"He paints very fast," reported Svinin, a Russian visitor
to America, "and his portraits are more like excellent
sketches than like completed paintings." In such
portraits Stuart left far behind the linear colonial
tradition of painting. He confessed he never did
learn to draw, but with his swift brush he modeled in
the colors from his palette. He did not bother
finishing the self-portrait, at about the age of
thirty, originally intended for his wife. Sketched in
oil on a scrap of canvas, its few quick strokes
demonstrate the man's genius for catching a startling
likeness with the slightest of means. His portrait of
Mrs. Perez Morton, also unfinished, exhibits the
impatient excitement with which he could dash off a
likeness. In this case the artist and the lady were
filled with ardent admiration for one another, and
exchanged compliments in verse, only thinly veiling
their sentiments. Mrs. Morton (Sarah Wentworth Apthorp
Morton) was celebrated for her literary talents as
well as for her beauty; contemporaries spoke of her as
the "American Sappho." "Stuart," she wrote the
artist, "thy portrait speaks with skill divine. . . . 'Tis
character that breathes, 'tis *soul* that twines round the
rich canvas, trac'd in living lines." And the
artist responded, "T'was heaven itself that blended
in thy face, the lines of Reason with the lines of Grace."
On another, quite different occasion the artist was
faced by a discontented husband who complained that
Stuart's portrait of his homely but rich wife was
not beautiful enough. "What damned business is this of
a portrait-painter," the artist retorted, "—you bring
him a *potatoe*, and expect he will paint you a peach."

REPUBLICAN FACES

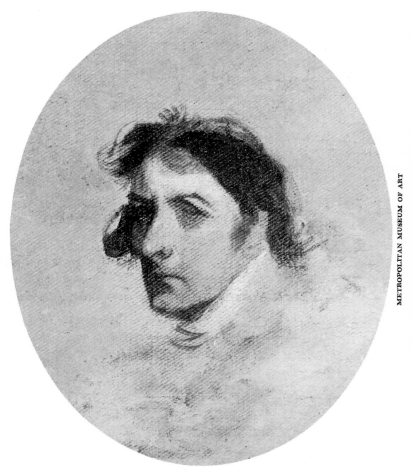

Stuart's unfinished self-portrait, about 1786

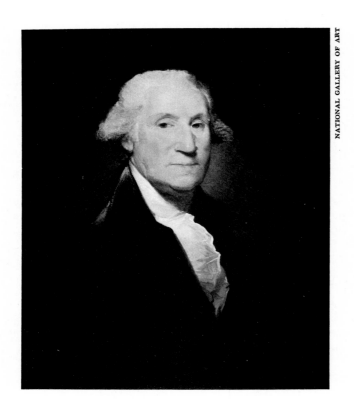

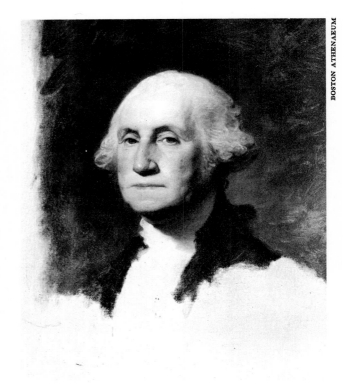

Left: Gilbert Stuart's Vaughan portrait of George Washington

Above: the Athenaeum portrait

Opposite: the Landsdowne portrait

In *A Picturesque Voyage in North America,* Svinin, the Russian traveler mentioned earlier, observed that America was "glutted with bust portraits of Washington from the brush of this man [Stuart] . . . every American considers it his sacred duty to have a likeness of Washington in his home, just as we have images of God's saints." On three different occasions, somewhat resignedly, the Father of His Country sat for Stuart; three different types of portraits resulted. The first painted, the so-called Vaughan type, shows the right side of the great man's face. In the second, or Landsdowne, portrait, Stuart tried, somewhat unsuccessfully, to picture Washington at full length in a stately pose. The third, or Athenaeum, portrait, although unfinished, was the artist's favorite version. It was commissioned by Martha Washington, but Stuart would never release it. When he was short of funds he made replicas from it for sale as a source of quick income. He called them his hundred dollar bills. His daughter recalled that toward the end of his life Stuart could mechanically dash off such copies at the rate of one every two hours. He made more than seventy of them, and could have sold many more.

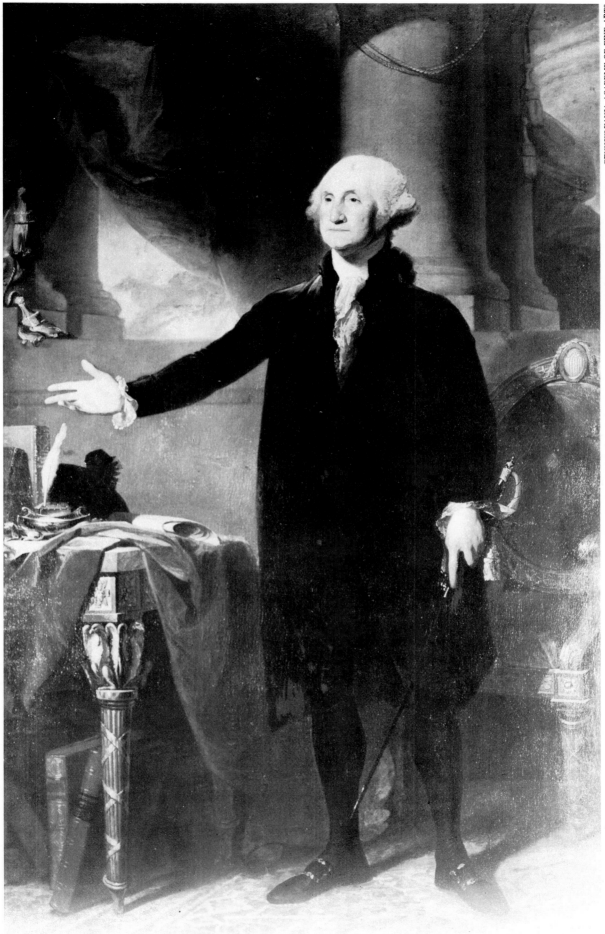

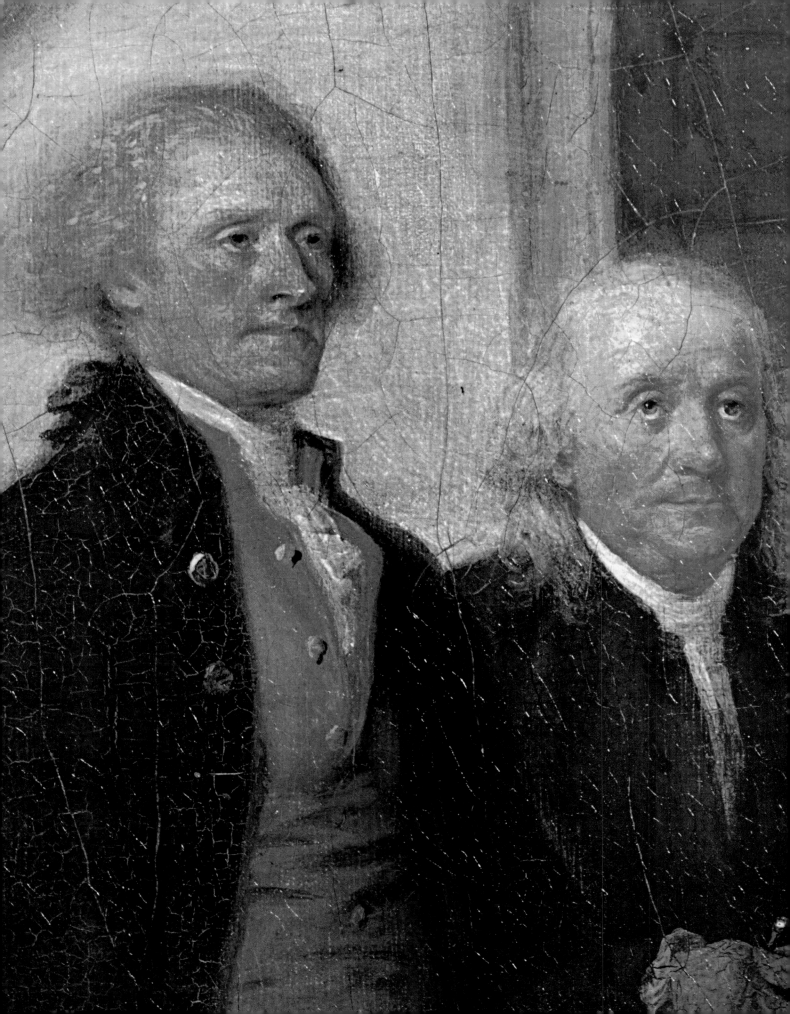

The paintings of John Trumbull bring us close to the founding fathers of the new nation. He knew many of the outstanding patriots and painted most of them from life. Although he was an artist of versatile talent, Trumbull is best remembered for his series of paintings portraying these men and the other heroes of the Revolution. He was the youngest son of Jonathan Trumbull, revolutionary governor of Connecticut, who strongly urged him not to pursue art as a career. But young Trumbull had been deeply impressed by a visit to Copley in Boston, where he saw that successful painter elegantly dressed and living in a handsome house on Beacon Hill amid his newly completed portraits. And, as his tutor at Harvard observed, the youth had "a natural genius and disposition for limning." With the outbreak of the Revolution, Trumbull served briefly on Washington's staff, but soon quit the army in a huff because of a minor clerical error in the dating of his commission. He then went to England to study with West. It was in London that, at the suggestion of West and with subsequent encouragement from Thomas Jefferson, he began his notable series of historical paintings. Jefferson and John Adams helped him to select twelve decisive episodes in the creation of the new nation. The most ambitious of these was his reconstruction of the deliberation concerning the Declaration of Independence. To help Trumbull, Jefferson supplied him with a sketch drawn from memory. For the rest, Trumbull took extraordinary pains to obtain portraits of all the Signers. He painted Jefferson in Paris and Adams in London, and to get likenesses of the others he traveled up and down the Atlantic seaboard from New Hampshire to South Carolina. He finished the work in London from 1786 to 1797. Like other painters of the period, Trumbull hoped to profit from the sale of engraved copies of the work. A print of the *Declaration* was, in fact, made years later by Asher B. Durand, who thereby established his reputation. (This young man later became an outstanding landscape painter.) In his mid-sixties Trumbull was commissioned by the United States government to paint an enlarged replica of this scene and three others in his historical series for installation in the Rotunda of the Capitol. Unfortunately, these late copies are rather heavy-handed and did the aging artist's fading reputation little good.

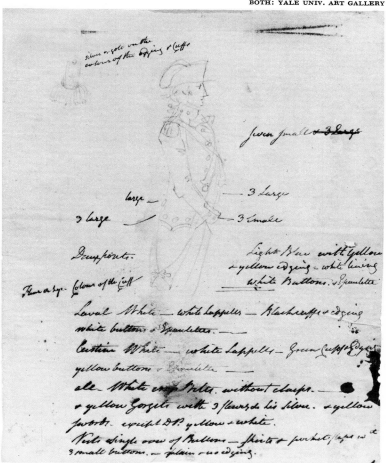

Above: one of numerous studies by John Trumbull to document his subsequent paintings

Opposite: detail of Trumbull's original version of the Declaration of Independence *(below), painted in London between 1786 and 1797, depicting two of the Signers, Jefferson and Franklin*

Paul Revere

John Adams

One of the most prolific portraitists of the people of the new republic was Charles Balthazar Julian Fevret de Saint-Mémin, an exiled French marquis who came to the United States in 1793 and soon turned professional artist to support his impoverished family. Except for a brief return to France, he remained in America until 1814. Before he left this country for good, Saint-Mémin had, among other pictures, turned out almost a thousand profile likenesses of prominent and not so prominent citizens from Boston to Charleston. In 1796 an advertisement in Philadelphia called attention to "a Physiognotrace, an Instrument of late invention in Europe," which was in effect a mechanical device for transcribing profiles. Using such an instrument, Saint-Mémin quickly drew his outline, then with pencil and crayon rendered the features of his subject to complete the portrait. (With a similar contrivance, below, in 1802 an operator at the Peale Museum in Baltimore cut 8,880 profiles in a year, for which he charged eight cents apiece.) Using another contraption, a pantograph, Saint-Mémin reduced the scale of his drawings and made engraved copies in miniature size. As ingenious an any home-bred Yankee, he had taught himself the art of aquatinting (see pages 132–135) by reading an article in an encyclopedia. He was the first American to practice in this beautiful medium. His mechanized procedures achieved a standard of accuracy in recording the semblance of actuality that was not equaled until the development of photography a generation later. The names listed in the catalogue of these tiny, delicately executed prints read like a voluminous Who's Who of early nineteenth-century America. Saint-Mémin also traced likenesses of painted Indian chieftains from the upper Missouri River, with their scalp locks and pigtails and with their strings of blue beads in their ears. He also drew the only known contemporary view of Robert Fulton's steamboat, the *Clermont*, in 1810, which was later reproduced in France by lithography. In 1814 the artist finally returned to France to be director of the museum of Dijon until his death in 1852.

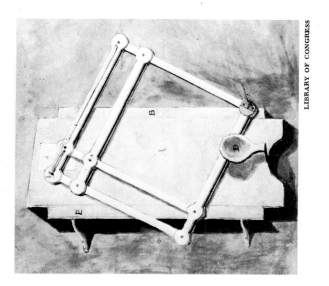

Mrs. George Clinton (Cornelia Tappen)

Gov. George Clinton

George Raleigh Dearborn

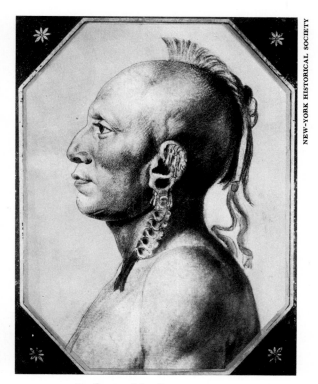

Cachasunghia, Osage warrior

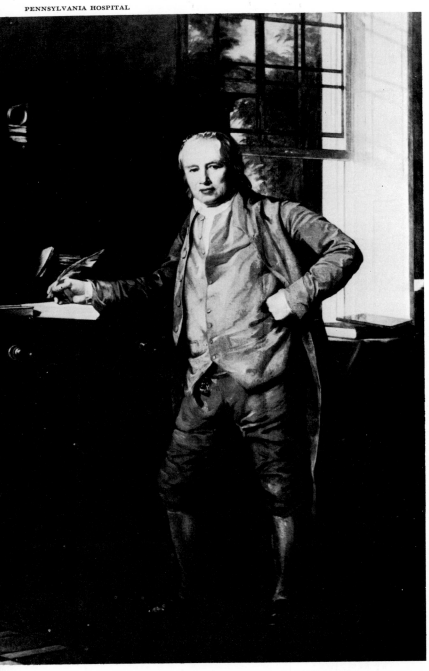

Thomas Sully's portrait of Samuel Coates at his desk in an office of the Pennsylvania Hospital, 1812

Ralph Earl, a somewhat dissolute bigamist, spendthrift, and drunkard from New England, reached London a few years after Stuart, and there, he claimed, he studied "under those distinguished and most celebrated Masters in Painting, Sir Joshua Reynolds, Mr. West, and Mr. Copley." Whatever his experience in England actually was, it did little to modify the simple, rather naive and rigid but explicit style he had developed before he left America. It was a style that was all his own and that, with his careful attention to the detailed surroundings of his subject, made Earl a popular portraitist in Connecticut, where he did most of his work before he died "of intemperance" in 1801. In his descriptive portrait of Elijah Boardman he depicted that dry-goods merchant, with full regard for visual truth, before his bookcase of leather volumes (whose titles can be read), and his bolts of cloth of varied patterns neatly displayed in the background. In 1807, early in his career, Thomas Sully, son of English theatrical parents, visited Stuart in Boston and watched him work—"a situation," he recalled, "I valued more, at that moment, than I shall ever appreciate any station on earth." Sully proceeded to become one of the leading American portraitists of his generation, completing 2,631 paintings (according to his records) before he died at the age of eighty-nine. It has been said that he saw an aristocrat in everyone he portrayed. His fluent portrait of Dr. Samuel Coates (manager and later president of the Pennsylvania Hospital), which he painted in 1812 in five days, is characteristic of his best work. Chester Harding, a handsome, genial giant of a man, came out of the West, self-taught and of great personal charm. His grandfather had cautioned him that charging $40 for one of his portraits was little better than swindling, and urged him to settle down as a farmer and a respectable man. But he established himself successfully as a portraitist, first in Boston, where he had more work than Stuart, then briefly in London, where the huge "backwoodsman" enjoyed the favor of the aristocracy. When he returned to America, he found more commissions than he could fill. His portrait of Chief Justice John Marshall he considered a good picture. "I had great pleasure in painting *the whole* of such a man," he recalled. Here the simplicity and directness of Harding's style is clearly manifest.

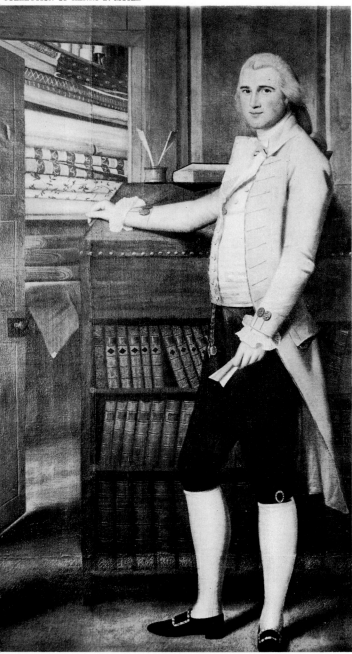

Portrait of Elijah Boardman, painted by Ralph Earl, 1789

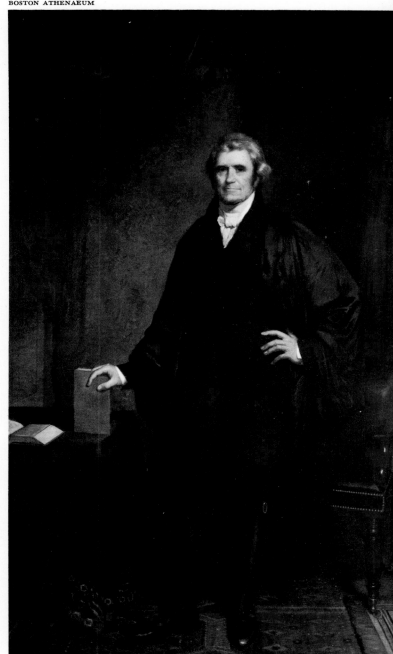

Chief Justice John Marshall, painted by Chester Harding, 1830

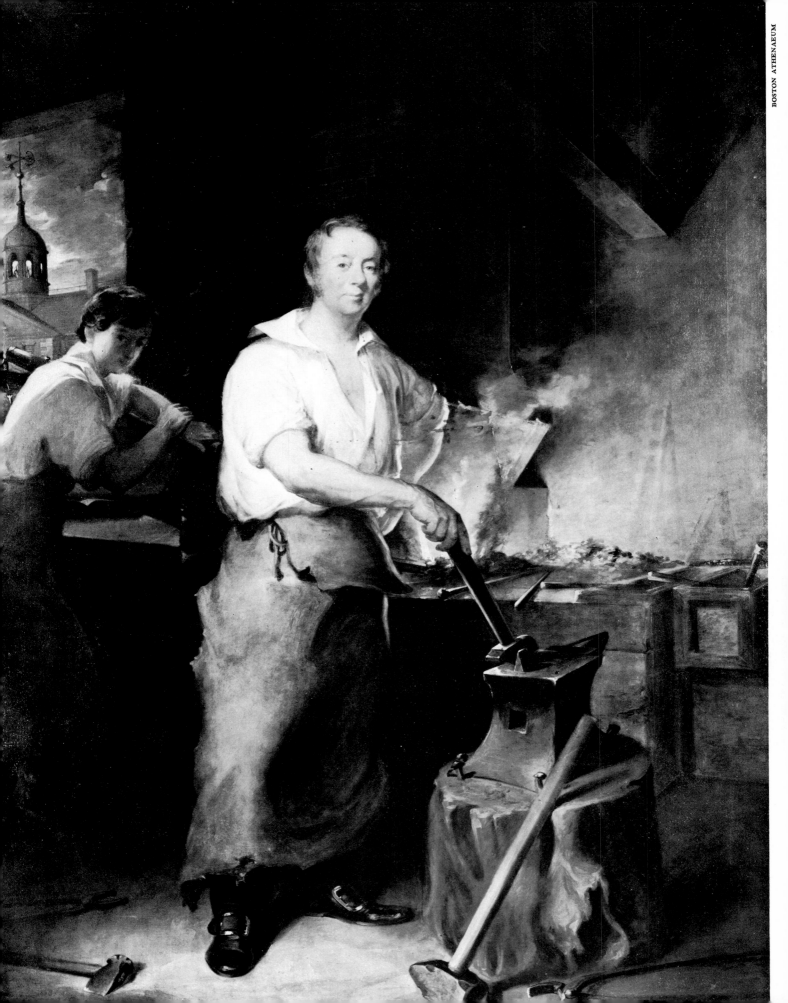

During the first decades of the nineteenth century portrait painters seemed to spring up like natural growths of the American soil, getting their training where they could, here or abroad, or, commonly enough, training themselves, as did Harding and others. John Neagle, a former ornamental and coach painter's apprentice, had, like Sully, visited Stuart's studio, and married his stepdaughter. His most exceptional portrait was commissioned by Pat Lyon, a Philadelphia blacksmith and locksmith who had been unjustly imprisoned for an alleged bank robbery (on the suspicion that only his skills could have opened the locks involved in the crime). After Lyon was freed from the Walnut Street jail, with an award for damages done him, and as he prospered, he had Neagle paint him in his leather apron at his forge. "I do not wish to be painted as I am not: *a gentleman*," he told the artist. In the background Neagle showed the prison where Lyon had been incarcerated. Neagle's slightly older contemporary Samuel Lovett Waldo found diversion for some years in painting studies of another Pat who was also not a gentleman: "Old Pat," known as "the independent beggar," and a familiar sight of the New York streets. At the second exhibition held by the Boston Athenaeum, Waldo's likeness of the tattered old man, with a soup bowl and a gnawed bone on the table before him, was one of the four paintings chosen for purchase by that institution.

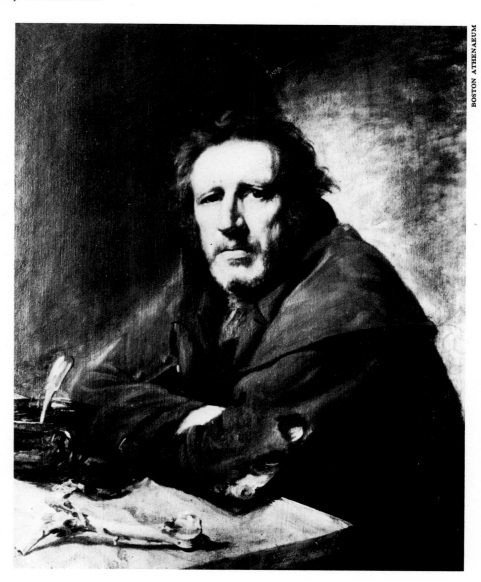

Opposite: Neagle's portrait of Pat Lyon, blacksmith, painted in 1829

Right: The Independent Beggar *by Samuel Lovett Waldo, painted 1819*

THE WORLD ABOUT

As the nineteenth century advanced, Americans began to recognize the wilderness as one of the nation's most priceless assets. Its vastness and variety were causes for wonder. Even some years before the start of the century William Bartram, the Quaker botanist and painter of flora and fauna, had followed his father to more or less unexplored places, from the Catskills to Florida and the banks of the Mississippi. His *Travels,* published in 1791, opened doors to an exotic world for such romancers and poets as Chateaubriand, Coleridge, Southey, and Wordsworth—all of whom borrowed impressions from its pages in their writings. The young Scottish immigrant Alexander Wilson also tramped through the wilderness, and he turned to Bartram for instruction in drawing and painting as he prepared his pioneering illustrated books on the birds of America. When the first of these nine volumes appeared in 1808, it excited interest throughout the nation. Hardly one small bird reached the Canadian border, he wrote, without a correspondent in that area notifying him. Wilson's drawings are clear and precise; he had made himself an admirable artist-naturalist; and his enterprise was prodigious. But as an artist he was overshadowed by the output of his successor, John James Audubon. Audubon had arrived in America from France in 1803 with a passion for dancing and a compulsion to observe and draw birds. His artistic talent was rudimentary, but by constant, diligent practice and towering determination he developed it to a rare degree of refinement in his bird portraits. No artist before him, and possibly none since, has so perceptively and spiritedly caught the natural likenesses of birds. When, in the late 1820's, his work was shown abroad it created a sensation, "Who would have expected such things from the woods of America?" exclaimed the fashionable Parisian artist François Gérard. These were more than ornithological studies executed on a brave new scale; they gave old Europe a fresh poetic vision of America that fired the imagination.

Top: The Little Owl, *drawing by Alexander Wilson*

Left: Imperial Moth of Florida, *by William Bartram*

Opposite: Audubon's drawing of passenger pigeons

Passenger Pigeon Male 1. Female 2
Columba migratoria

Thomas Cole's wash drawing of a large white pine with seedling

While naturalists like Bartram, Wilson, and Audubon were exploring the wilderness to record its wonders, more typical Americans seemed to share "an unconquerable aversion" to the forests that hemmed them in at every turn. In America, Nature was not a picturesque retreat for the romantic imagination, as it was for Wordsworth and Coleridge; it was for a while yet a stubborn, wild fact that had to be contended with on a continental scale. So they cut away all before them without mercy to let in the sun and to clear the way for their compulsive westward progress; and they killed the wild denizens they encountered in astronomical numbers to remove their menacing presence, for food, or simply for the sport of it. In the face of such attitudes realistic landscape painting, reflecting an interest in nature for its own sake, was slow to develop in America. Until the third or fourth decade of the nineteenth century most landscapes were ideal scenes of no place in particular, wall decorations and the like, or backgrounds for figure paintings. Upon his return from Europe in the early 1830's, Thomas Cole, America's first important landscape artist, undertook an epic series of five imaginary scenes in which he traced the rise and fall of empire, from its savage stage through its development and consummation to its decay and destruction. Laden as these allegories are with extravagant histrionics and weighty moral instruction, Cole's "cosmoramic" performance was applauded by the most sensitive critics of his generation.

Aside from its substantial aesthetic merits, the most discerning and best informed Americans of the time were apparently deeply moved by the theme of Cole's extravaganza when it was first shown. In an age of nuclear fission we have become all too familiar with the uneasy thought that human societies, like human beings, are perishable. But to the romantics of Cole's time the implication that this might ever happen to America, "the hope of the human race," as it had happened to great empires of the past, was novel and horrible. In another mood, Cole was a careful observer of nature who roamed on foot, from the White Mountains to Niagara, making pencil sketches for subsequent paintings which were popular, lyrical impressions of the actual American scene as he saw it and loved it.

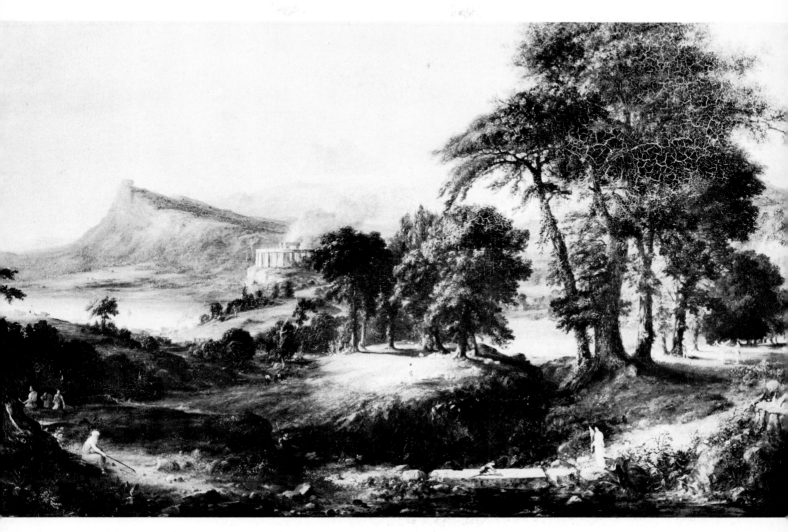

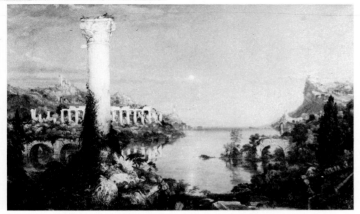

Above: the second in Cole's five-painting series The Course of Empire; *in this scene of arcadian innocence the empire emerges from savagery to a pastoral state.*

Left: The Ruins of Empire, *the final scene of the series; the wilderness closes in on Man's over-proud monuments.*

Overleaf: the third scene of Cole's The Course of Empire, *depicting civilization's triumph over the natural world*

65

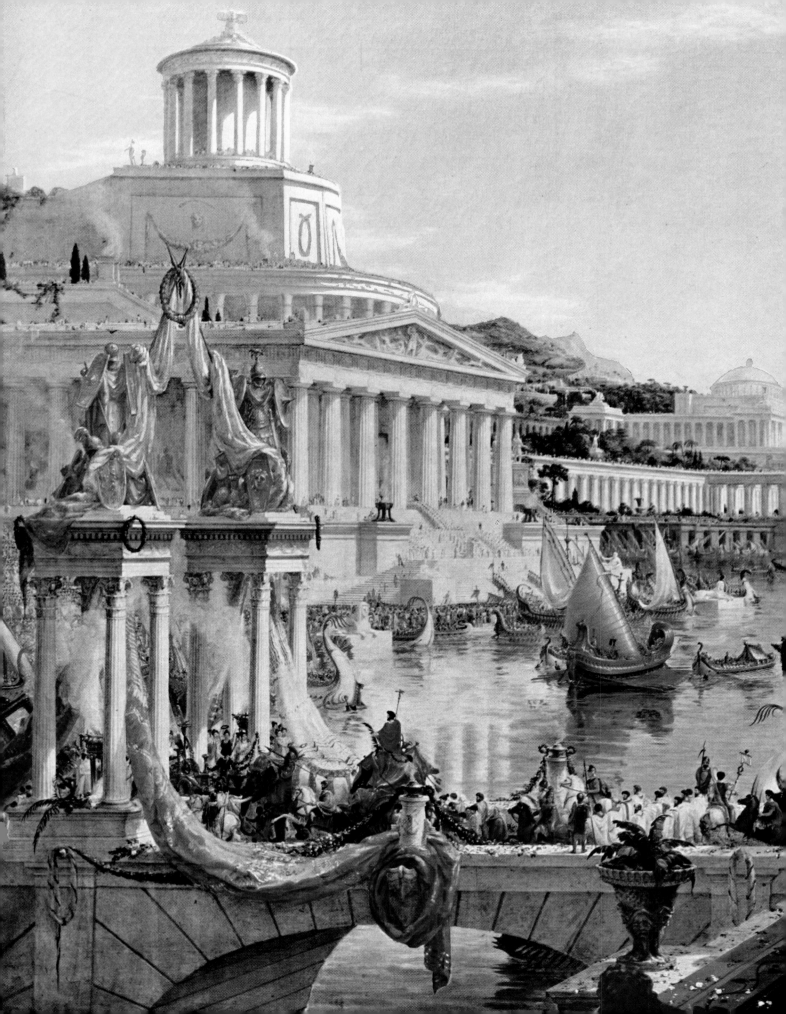

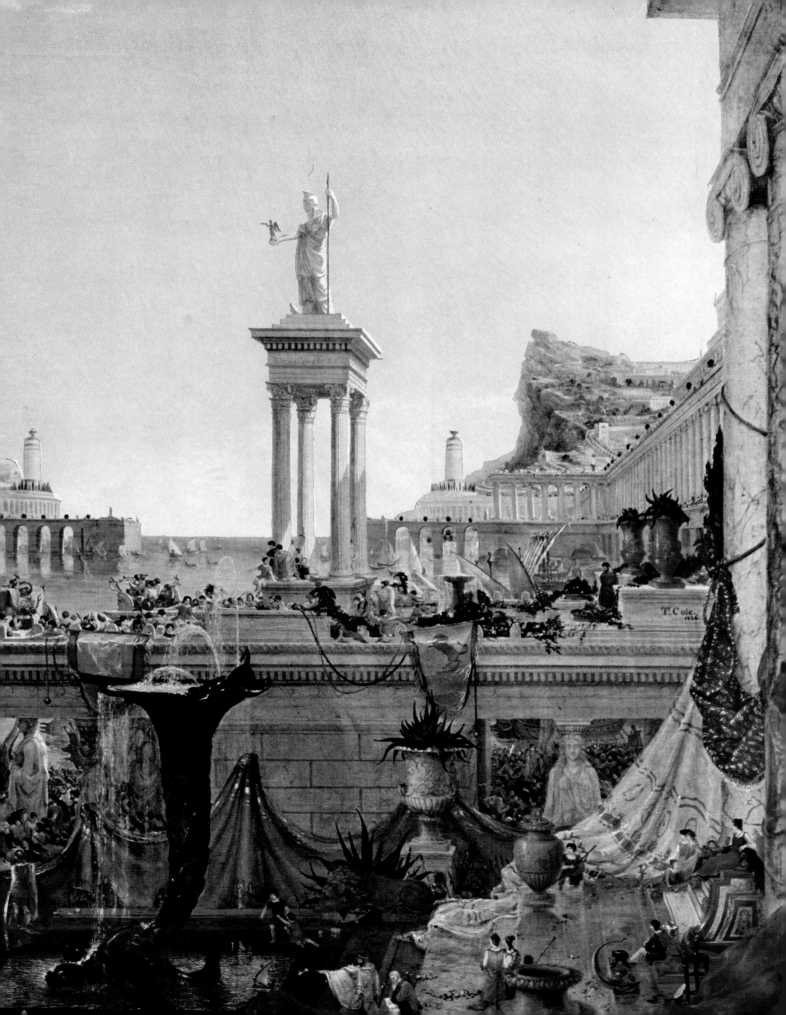

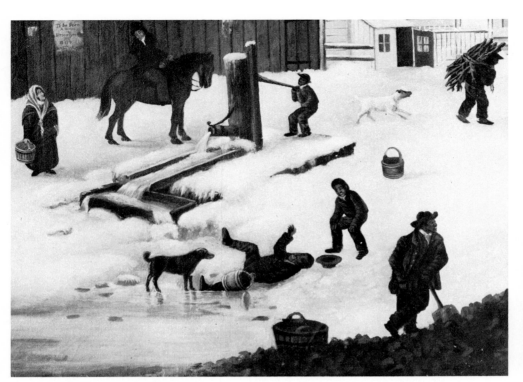

Above: detail of Francis Guy's Winter Scene *in Brooklyn (top, right), painted 1817–20 from the window of his house at 11 Front Street, between James and Fulton*

URBAN SCENE

In the decades following the end of the Revolutionary War, the little cities that had sprouted out of the wilderness during the colonial period flowered into substantial urban communities that had a growing influence on the nature of life in America. With the peace they became ports of entry for a new flow of European artists, from France, Denmark, Sweden, Germany, Switzerland, Russia, and Italy, as well as from the British Isles. Some of those newcomers, for the most part men of modest talent, left interesting views of street scenes and other aspects of activity in the American cities where they settled or visited. Francis Guy, an eccentric English cloth dyer and tailor, boldly undertook to become an artist after he arrived in the New World and, among other subjects, painted two memorable views of New York and Brooklyn. To ensure accuracy, Guy traced the outlines of his subjects in chalk on a piece of black gauze stretched across a window, then transposed that image on canvas for completion of his picture. His view of New York shows the famous Tontine Coffee House, where every ship's arrival was registered and where, from eleven to two o'clock each day, merchants, brokers, and others met to do business "in a large way" and to discuss the booming progress of the city. His animated, homely winter scene of Brooklyn, with its dark little figures outlined against a snowy background, inevitably recalls Pieter Bruegel's paintings of peasant life more than two centuries earlier. One historian recalled that when painting that scene Guy would at times lean out of his window and ask the passers-by to pause while he caught them in their poses on his gauze. A friendly critic of the time called it "one of the most natural, lively and fascinating Pictures ever produced by the Pencil."

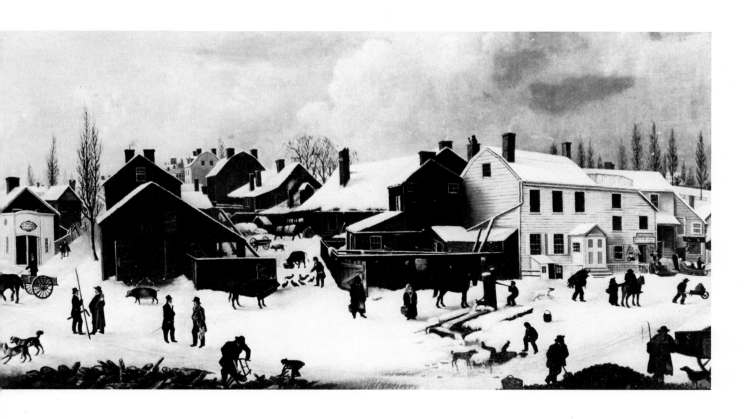

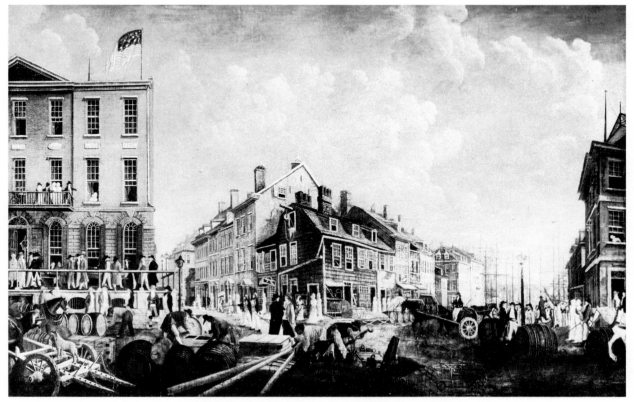

The Tontine Coffee House, *corner of Wall and Water streets, painted by Francis Guy about 1797*

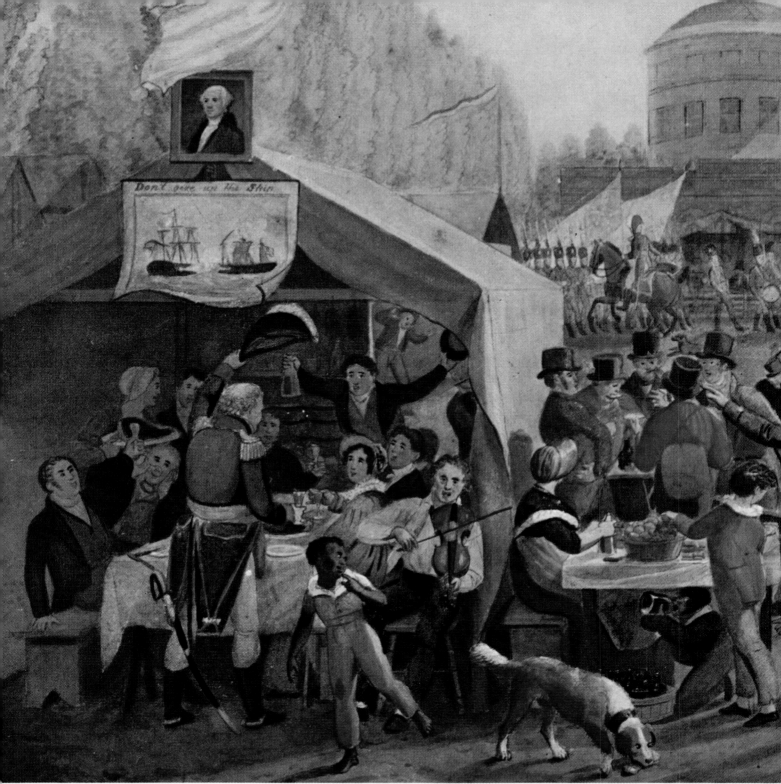

Above: John L. Krimmel's painting of Philadelphians joyously celebrating the Fourth of July at Center Square in 1819

Below: The Schuylkill Freed, *carving by William Rush, 1828*

70

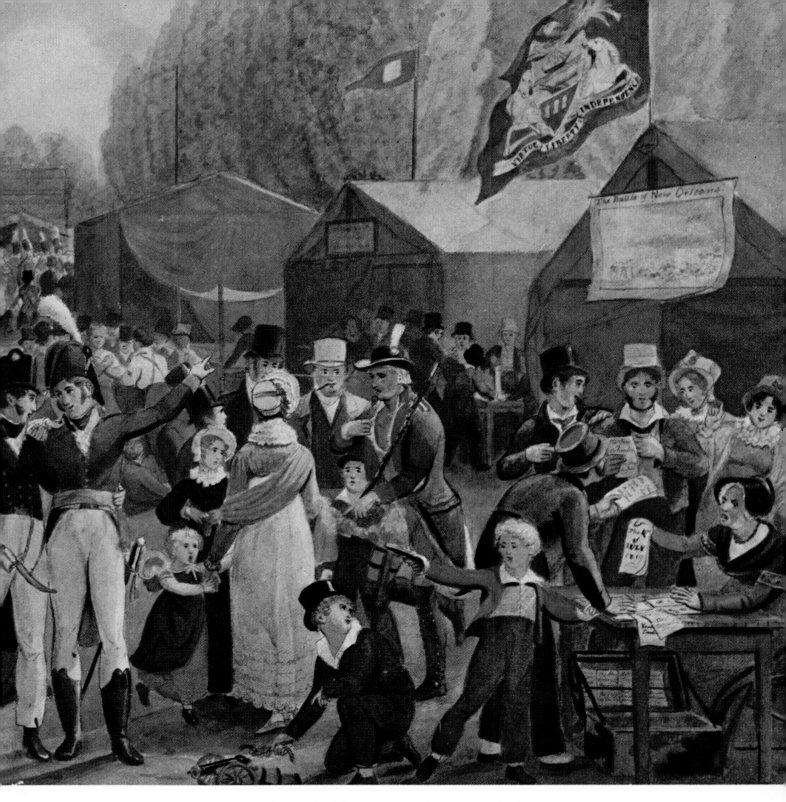

In his later years Gilbert Stuart enjoyed badgering his fellow Bostonians by recalling the days
he had spent in "The Athens of America," as he referred to Philadelphia; and the proud
Spartans of the northern city had to suffer his barbs. During the early years of the nineteenth
century Philadelphia did, in fact, remain the nation's cultural capital and the creative focus
of American art. In 1810 John Lewis Krimmel came there from Württemberg, Germany, at the age of
twenty-one. Native-born American artists considered scenes of local life too mean for their brush,
but Krimmel—like Guy and some other immigrants—found such genre subjects compellingly attractive.
However, he had time to do relatively few good pictures, such as *A Fourth of July Celebration in
Center Square, Philadelphia,* completed in 1819, before he died by drowning at the age of
thirty-two. He enjoyed no material success with his art, although shortly after his death he was
extravagantly said to have rivaled Hogarth "in truth, nature, and humour."

71

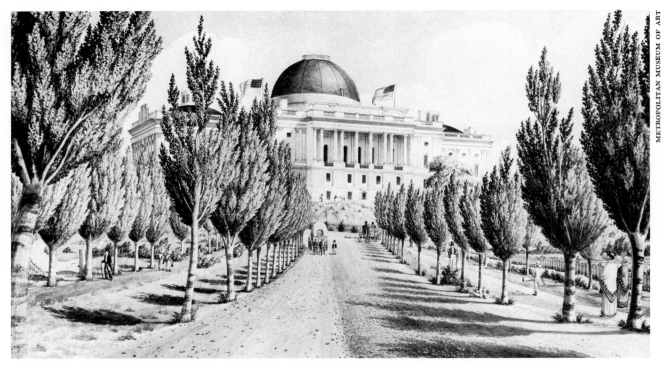

Above: Charles Burton's view of the Capitol, Washington, D. C.

Below: E Street, Washington, a water color painted in 1817 by the Baroness Hyde de Neuville

Opposite: The Tea Party; *detail of a painting by Henry Sargent*

In 1824 Charles Burton, an immigrant English draftsman and painter, made a unique water-color rendering of the national Capitol that shows the building as it had been reconstructed after its burning by the British in 1814 (without the high dome and far-spreading wings that were added decades later). When the hypercritical Frances Trollope, author of *Domestic Manners of the Americans* who had little good to say about America or its people, saw the building in 1827, she was "struck with admiration and surprise" to find such a structure rising out of the landscape of the raw, young city that Washington then was—and long remained. In the decades following the Revolution, Boston grew at a slower pace than other major cities. As always, however, it seemed a city where new, unexpected visions freely mingled with old traditional practices. It was ever the capital of New England, a region that, claimed one of the Cabots in 1804, included among its people "more wisdom and virtues than . . . any other part of the world." In the 1820's Henry Sargent, a native of Gloucester, Massachusetts, who had studied with West, painted two highly unusual conversation groups showing Bostonians of an earlier generation entertaining at home, the company dramatically revealed in the light, and the shadows cast by candles and Argand lamps—an unprecedented tour de force in Yankee painting.

MARITIME AMERICA

Most of the flourishing American merchant marine was beached or captured during the Revolution. But with peace and the lifting of the British blockade the new nation returned to the sea by a strong reflex action. During the next twenty years the growth of American shipping in all forms was extraordinary and a matter of national pride. For more than a generation after the peace, the small town of Salem, Massachusetts, was one of the celebrated ports of the world. In some remote parts where Salem's gaily painted little ships were everywhere to be seen, it was believed that the town *was* the United States—an immensely rich and important country. And the townsmen of Salem commissioned the most competent artists of the day to picture their vessels and the men who sailed them. "In every house we see the ships of our harbor," wrote the diarist William Bentley in 1804, "delineated for those who have navigated them. Painting before unknown in its first efforts, is now common among our children." A fair number of those ship portraits were painted by Antoine Roux, Sr., a celebrated marine artist, and his three sons in faraway Marseilles; they were commissioned by American sea captains who sailed that area and who brought home those treasured likenesses of their vessels. Michele Felice Corné, who had been displaced from his native Elba by the Napoleonic wars, was brought to Salem to practice his art by the great merchant and ship owner Elias Hasket Derby in 1799. Corné, in turn, taught young George Ropes, deaf and dumb son of a Salem sea captain, to record the local maritime scene at a time when the little seaport was at the peak of its prosperity. In 1805 George Crowninshield, Sr., commissioned Ropes to paint a view of Crowninshield's Wharf, lined with ships that ranged the globe, and its warehouses, filled with the treasure of the Indies.

Below: Crowninshield's Wharf, *painted by George Ropes; at the outer end of the wharf lies the* America, *famous pepper trader and later a privateer in the War of 1812.*

Opposite: Salem sea captain John Carnes, painted by an unidentified artist about 1790

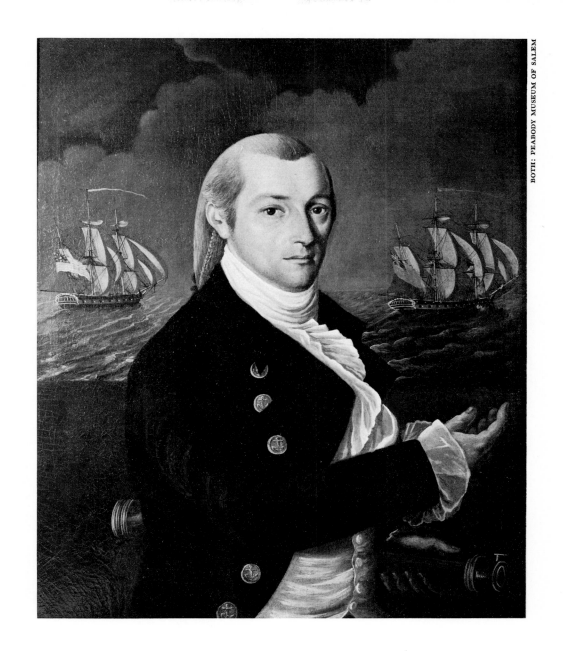

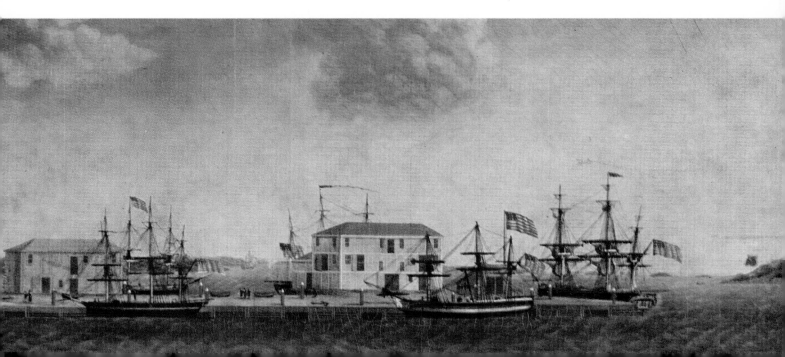

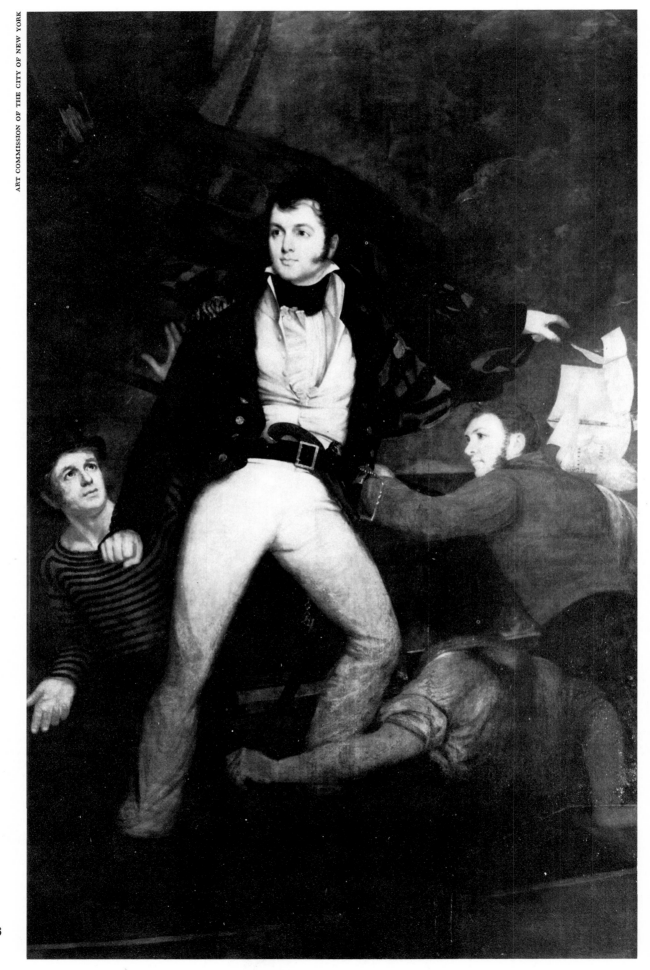

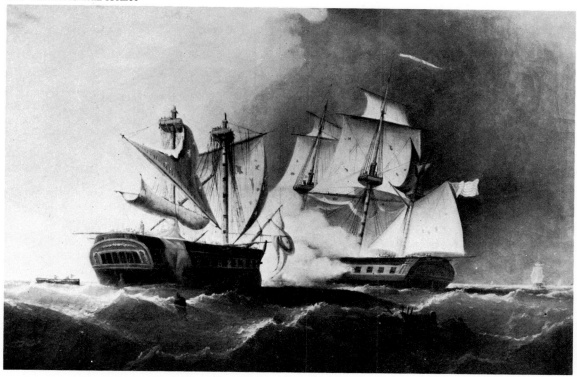

Above: Thomas Birch's painting of the naval engagement between the United States *and the* Macedonian

Opposite: Commodore Oliver Hazard Perry, *painted by Jarvis in 1816*

The War of 1812 once again brought a temporary halt to the epic seafaring of the American merchant marine, and once again a British blockade beached most American ships. In the long run the relatively small United States Navy was no match for England's huge fleet on the high seas. (The war proved little else.) But for a while, with lightning speed and notable results, American privateers preyed on British commerce, and combined with the early successes of the Navy itself, stunned England into disbelief. After the *United States* brought the *Macedonian* into New London and the *Constitution* knocked out the *Guerrière* and then the *Java*, all in 1812, a London journal reported: "Any man who foretold such disasters this day last year would have been treated as a madman or a traitor" Artists were called upon to commemorate those heroic exploits. In Philadelphia young Thomas Birch, son of an immigrant English engraver and painter, did a lively business during and after the war supplying pictures of such American triumphs. Among other scenes of the sort, he depicted the engagement between the *United States* and the *Macedonian* at least six times for a ready market, probably basing his studies on conversations with the victorious commanders, as well as on his own specialized interest in marine views. In these matters, wrote a critic of the times, "he stands unrivalled in our country." While the war was still being fought, the City of New York commissioned John Wesley Jarvis to paint six full-length portraits of the heroes of those early conflicts, including the picture of Commodore Oliver Hazard Perry at the dramatic point in his sensational victory over an English fleet on Lake Erie in 1813. ("We have met the enemy and they are ours," he reported.) Like Birch, Jarvis had been brought from England to Philadelphia as a child. After he moved to New York he was considered the best portraitist working in that city. He died in poverty, of a paralytic stroke, leaving behind him a lasting reputation as a hard-drinking bohemian and "the greatest storyteller that ever lived."

When Robert Salmon arrived in America from England in 1828, somewhat beyond midlife and already a thoroughly skilled artist, and he immediately won a popular audience with his marine paintings. In 1830, referring to one of his works on public exhibition at the time, the Boston press reported that "all persons of taste and curiosity will take an early opportunity to witness what is everyway worthy of attention." Over the following years his work earned increasing appreciation and distinguished patronage. No artist before him had so poetically and luminously rendered the activity and atmosphere of New England's seaboard whose wharves and ships were then still symbols of the local spirit as important to Yankees of the time as state houses and public monuments. In 1831 he sold some of his paintings to buy a boat in which he could sail about Boston's harbor to study the light, the weather, the glinting water, and the shapes of men and ships that were to be transcribed onto his canvases. His neat drawing and the studied lighting of his scenes on the one hand recall the eighteenth-century paintings of Canaletto, which Salmon could have seen in London; on the other hand, they anticipate the works of American artists of the next generation, who in turn would have known Salmon's pictures.

Above: Boston Harbor from Constitution Wharf, *one of Robert Salmon's typical marine scenes, about 1829*

Left: a ship's figurehead probably carved by Samuel McIntire, master craftsman of Salem, early 19th century

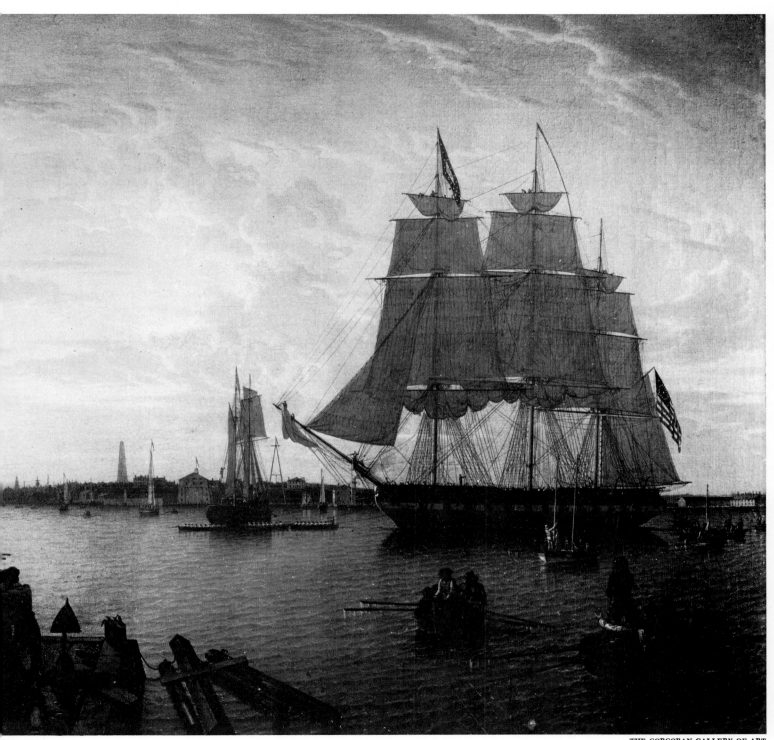

79

Vanderlyn's Panoramas

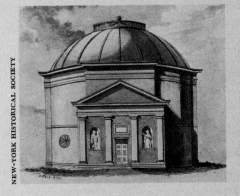

Above: John Vanderlyn, a self-portrait

Below: the Rotunda, built by the artist in 1818 as the first art museum

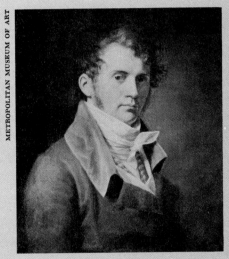

To find a modern version of what now seems the obvious and melodramatic imagery of Cole's *The Course of Empire* (see pages 64–67) we must turn to Hollywood's epic spectaculars. The analogy comes quickly to mind, for the artist was unquestionably influenced by those vast "wide-angle" panoramic canvases that enjoyed a great vogue in the nineteenth ceutury, and that at times, when they wound off one cylinder and onto another before delighted paying audiences, were in fact aptly called "moving pictures." The fourth of Cole's pictures, in which with horrendous details he depicts the destruction of empire, is indeed very closely related to one of the more popular panoramas of the day, Robert Burford's *Pandemonium from Milton's Paradise Lost*. Cole's paintings had been commissioned by Luman Reed, one of New York's most distinguished and liberal patrons of art in the nineteenth century. Some years earlier, between 1816 and 1819, John Vanderlyn completed a more ambitious, if less histrionic, canvas, *The Palace and Gardens of Versailles*, based on sketches he had made on the spot in 1814.

Born in 1775, he was the grandson of the Dutch-born primitive limner and house painter Peter Vanderlyn. In 1796, impressed by the promise of young Vanderlyn's early works, Aaron Burr sent him to Paris to study; he was apparently the first American artist to get training there. Burr's distinguished patronage gave Vanderlyn a special advantage over other contemporary American artists. However, when Burr mortally wounded Alexander Hamilton in a duel at Weehawken, New Jersey, in 1804, he not only wrecked his own career (he had earlier come very close to winning the presidency of the United States) but also seriously impaired Vanderlyn's hopes for the future. The shadow of Burr's infamy fell on the artist; his hope of governmental patronage was vastly diminished. Nevertheless, Vanderlyn persevered. In 1808, when he was again in Paris, one of his paintings that was shown in an exhibition at the Louvre was arbitrarily and imperiously awarded a gold medal by Napoleon as the best original work on display. Napoleon tried to buy the picture for the Louvre's collections, but Vanderlyn demurred.

It was upon his return to America in 1815 that Vanderlyn undertook his vast panorama of the palace and gardens of Versailles, confidently hoping that the public display of that dramatic performance would bring him ample financial rewards. Such works provided popular entertainment in the major cities of Europe. In Paris the artist-inventor Robert Fulton had supported himself by exhibiting a panorama as he worked on his steamboats and submarines. Vanderlyn's huge painting, covering almost two thousand square feet of canvas, does suggest theatrical scene painting. The painting was originally planned for exhibition in the New York Rotunda,

a building erected by the artist with the financial help of his friends at the northeast corner of City Hall Park, a plot of land rented to Vanderlyn by city officials for one peppercorn a year. The perspective of the painting was ingeniously adjusted to the circular shape in which the canvas was shown so that the spectator at dead center finds convincing vistas leading off in all directions. Onto this deceptively realistic stage Vanderlyn introduced a gay assortment of tourists, colorfully clad for a holiday amid the splendors of the world's most famous palace. It is the earliest American panorama that has survived in its entirety. Vanderlyn never thought of it as being in the same class with his other work, but it is a delightful tour de force contrived by an accomplished draftsman.

Vanderlyn had high hopes for the Rotunda. The tablet over the door read: Dedicated to the Fine Arts. By attracting his unsophisticated compatriots with the sensationalism of his panorama, he thought he might then lead them to appreciate the "higher branches" of art represented by his other paintings and those of some of his fellow artists. (Cole's *The Course of Empire* was shown there for a while.) The Rotunda might be the beginning of a great national gallery of art and, as founder and essential contributor, Vanderlyn would become its leading spirit. Entrance fees would provide him with money, enough to enable him to devote his time and tal-

ents to painting great historical scenes that would further enrich his reputation.

However, matters developed quite differently than he had planned. Vanderlyn's "show" was not a financial success; he fell into debt; and in 1829, only a few months after the panorama was put on display, he was evicted from the Rotunda—his dreams of glory shattered. (The building was demolished in 1870.) Nine years later, when he was sixty-three, he was commissioned by Congress to paint a panel depicting the landing of Christopher Columbus in America for the Rotunda of the Capitol—an assignment he had wanted for twenty years past. He went to France and spent almost eight years completing the subject. Old, tired, bitter, and frustrated, he finally produced a painting that belied all his early promise and won him devastating criticism when it was installed at Washington. A few years later he died, alone and reduced to virtual beggary, in a rented tavern room in his native town of Kingston, New York.

Details from Vanderlyn's panorama of Versailles, of which two major sections are shown above: opposite, top, the basin facing the palace; top, the palace

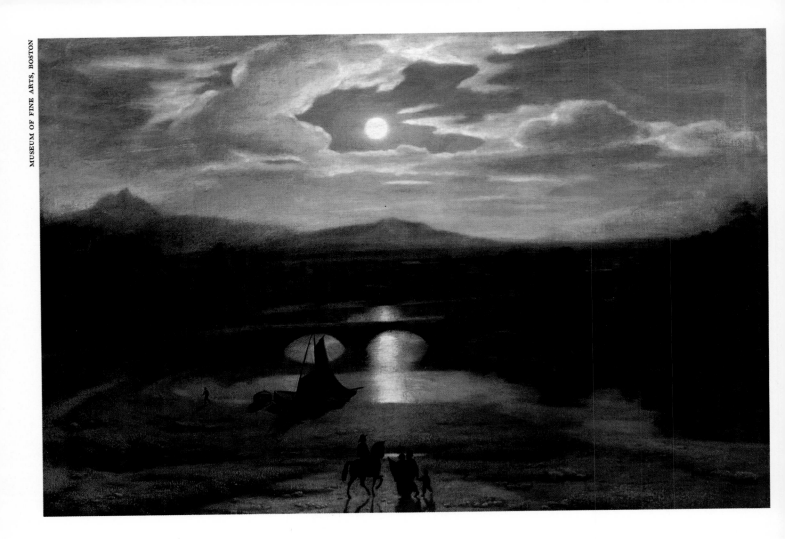

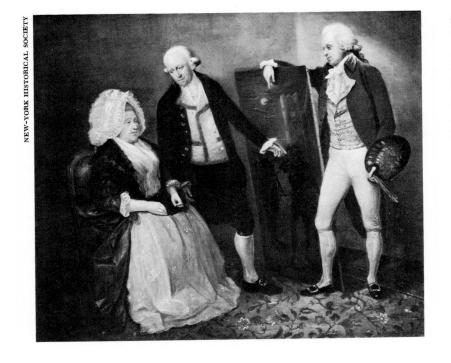

Above: Moonlit Landscape, *painted by Washington Allston in 1819*

Left: The Artist Showing a Picture from "Hamlet" to his Parents; *painted by William Dunlap, 1788*

Opposite: John Vanderlyn's Ariadne Asleep on the Island of Naxos, *painted in Paris, probably in 1812*

RETURN
OF THE
NATIVES

When Vanderlyn returned to New York he brought with him the paintings that had won him acclaim in Paris and, when the Rotunda was built, hung them there while he was also showing his Versailles panorama. New Yorkers were somewhat less impressed than Parisians had been. Some saw in the unabashed nudity of his *Ariadne Asleep on the Island of Naxos* a shocking witness to the depraving influence of European taste; nevertheless the delicately drawn body was in fact a demonstration of draughtsmanship beyond the skill of any other young American painter of the time. In any event, there were no purchasers for *Ariadne* and, short of cash, Vanderlyn later let it go for only $600 to Asher Durand, who made engraved copies that popularized the subject and were the culmination of Durand's own high reputation as an engraver.
Washington Allston returned from Europe a few years after Vanderlyn, also with a high reputation he had won in cultural circles abroad. His was a special talent: he was the first American artist to use color expressively for its own sake, as a musician uses notes to create "a thousand things the eye cannot see"; to go beyond natural appearances and aim his message to the imagination. His *Moonlit Landscape* is a tranquil, moody revery, bathed in luminous atmosphere, that suggests more than it states—a meditation whose ultimate meaning we must imagine for ourselves. The American public was not then willing or able to meet the artist on such terms. Allston could not accommodate himself to the mainstream of American life; he found little or nothing in the American scene worthy of his brush. He died, unproductive in his later years, but still resting on his old laurels; and he had opened a rich vein of painting for future American artists to exploit.

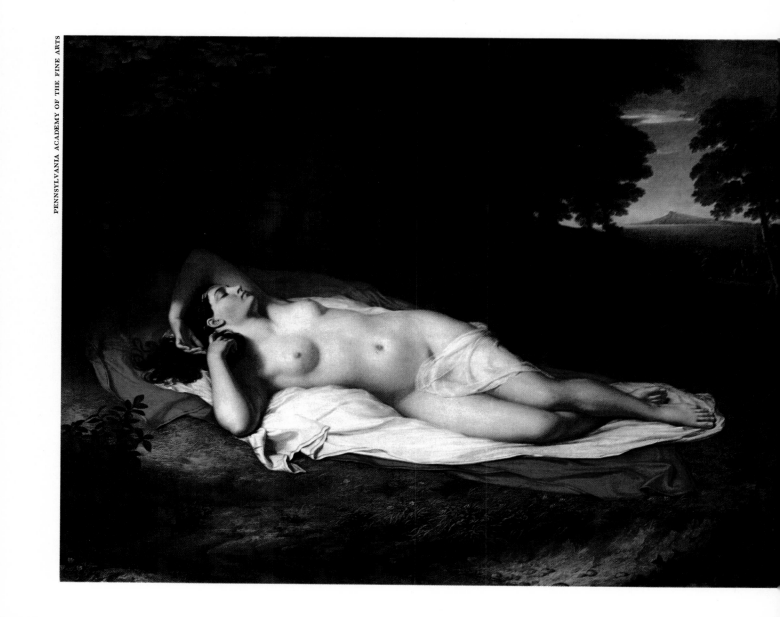

"If he meets with encouragement," Allston wrote from London of his protégé Samuel F. B. Morse, "he will be a great painter." Young Morse was fired with determination to be just that; "to rival the genius of a Raphael, a Michelangelo, or a Titian," as he wrote his parents. As a token of his high intentions he had already won a gold medal, oddly enough for his first and only sculpture, a figure of the dying Hercules. Then his painting of the same subject, made from the model, received extravagant praise when it was hung in the Royal Academy exhibition. He aspired to paint great historical canvases, but when he returned to America, as he feared, he was driven by practical considerations into being "a mere portrait painter." His compatriots were reluctant to pay for anything from his brush but their likenesses. Morse was in fact a first-rate portraitist, but like West before him he considered portraits hack work. In the end, however, he never really attempted to create the great masterpieces he talked about. He completed only two large canvases, and neither was the great imaginative vision he had dreamed of creating. His *Congress Hall* or *The Old House of Representatives* (see pages 42, 43), with its eighty-odd miniature portraits, its solemn, dramatic lighting, and its skillful handling of perspective, was a major accomplishment. But it remained a tour de force, a fine example of proficient reporting, and it aroused little public interest. On his second sojourn abroad he painted another huge scene showing the famous Salon Carré of the Louvre hung with a purely fanciful arrangement of that museum's masterpieces. In May, 1832, he wrote his brother that his anxiety to finish this work was driving him mad. James Fenimore Cooper, who was often by his side as he worked, wrote home from Paris the unwittingly damning report that Morse "copies admirably." Somewhere along the line his early ambition had lost its bearings. He was now copying the great masters, not rivaling them; and when he showed the picture in America, once again his countrymen remained apathetic. Shortly thereafter Morse turned all his attentions to developing the electric telegraph and photography. In later years he explained that he did not abandon art; art had abandoned him. He had spent a full half of his life before he put down his brushes. But in his canvases, excellent as so many of them were, he had never realized the mood of magic that now filled his dreams of telegraphy.

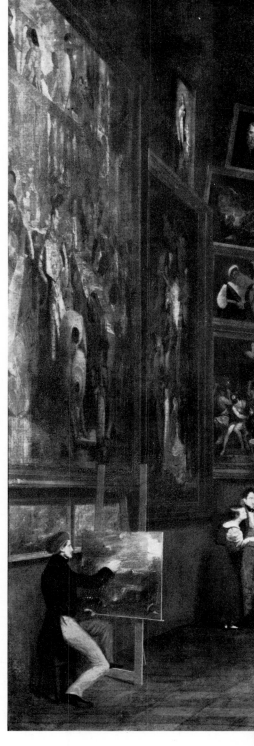

Above: Morse's painting of the Salon Carré in the Louvre; works by Leonardo, Titian, Raphael, and others are shown.

Left: a cast of Morse's sculpture of the dying Hercules, 1812

84

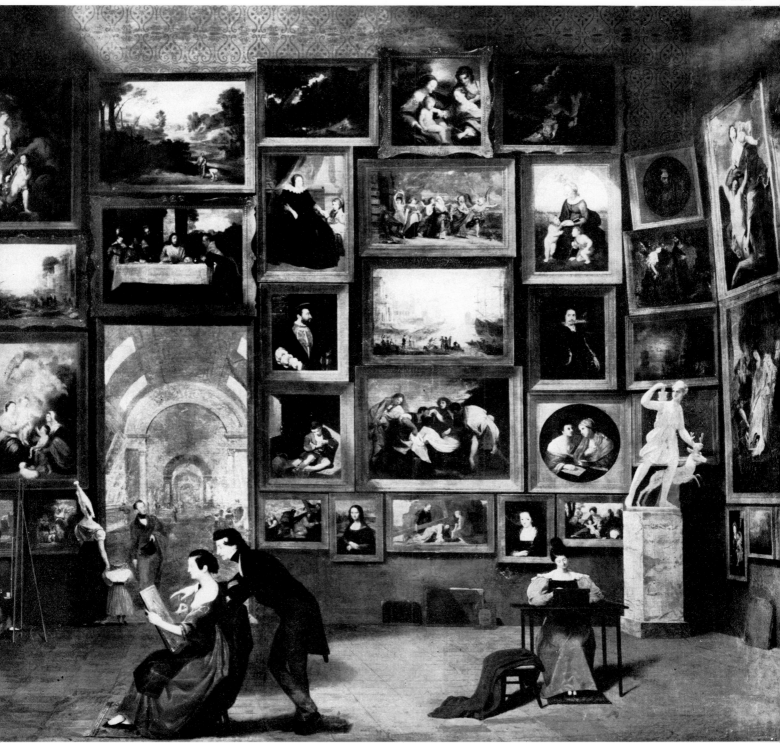

PEALES APLENTY

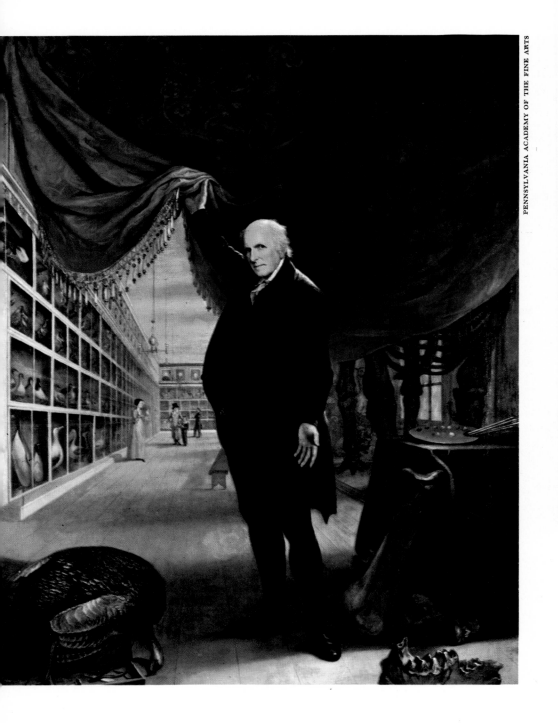

Above: ten members of the Peale family in a detail of a group portrait started by C. W. Peale in 1773 but only completed in 1809; the artist, upper left, bends over his brother.

Left: The Artist in his Museum, *a painting commissioned in 1823, when the artist was eighty-two years old, by the trustees of Peale's newly incorporated museum in Philadelphia*

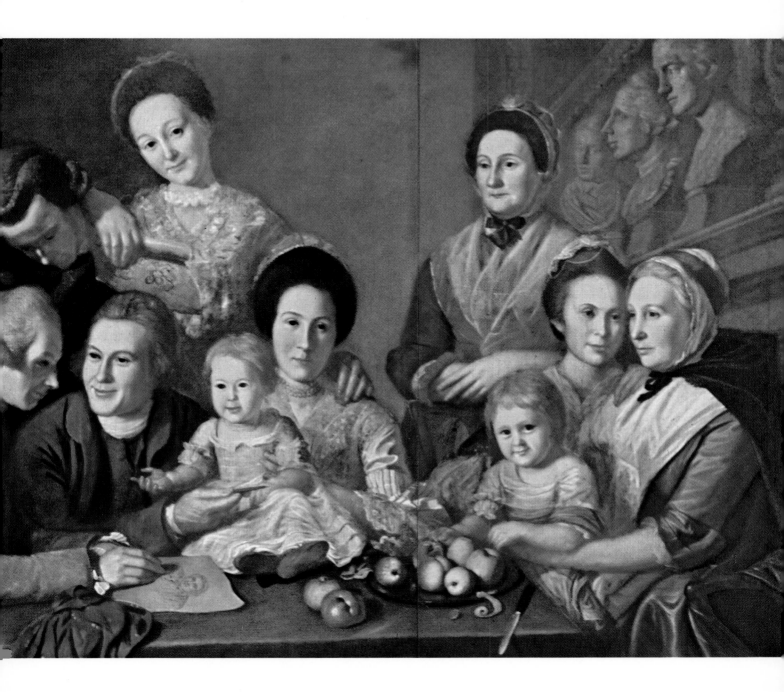

At one point or other in his long life Charles Willson Peale was an artist, a saddler, a soldier, an author, a naturalist, an inventor, a silversmith, an engraver, a museum director, and an upholsterer—among still other things. He was one of the first Americans to study with West in London, and he returned in plenty of time to join the Revolutionary forces in the field of battle, taking with him his painting kit along with his military gear. (He painted the most admired portraits of Washington as a general.) Peale married three times and sired seventeen children, some of whom he named after great painters of the past—Rembrandt, Rubens, Raphaelle, Titian. In spite of his innumerable other interests and activities, he continued to paint until the end of his life. On a visit to Peale's painting room in 1776, John Adams admired the artist's group portrait of his family. "There was a pleasant, a happy cheerfulness in their countenances," wrote Adams, "and a familiarity in their air towards each other." Actually, Peale did not put the finishing touches on the painting until 1809, thirty-six years after he had started it. He was eighty-two years old when he painted the full-length portrait of himself in his celebrated museum of art, science, and natural history in Philadelphia.

Peale's museum was an extraordinary institution for its time. Within it he hoped to create what he termed "a world in miniature." Although he exhibited portraits of a long list of American patriots, its greatest attraction was a collection of "birds and beasts, fishes and insects—of all that fly, leap, creep, or swim, and all things else," mounted in habitat groups; and of plants, minerals, fossils, and other natural curiosities, scientifically labeled. Eventually, his gallery was moved to Independence Hall, where it filled the entire second floor. It was one of the first museums in the world to present such orderly exhibitions. One of its principal attractions was the skeleton of a mastodon, which Peale himself helped to excavate from a bog in Ulster County, New York, in 1801—an event which he memorialized in one of his most delightful paintings, *Exhuming the Mastodon.* In that task Peale was aided by equipment supplied by the Army and Navy by order of President Jefferson, who complimented the artist on "obtaining a complete skeleton of the great incognitum." In his painting, finished in 1808, Peale included about seventy-five figures, among them portraits of members of his family and of friends and fellow scientists who were not present on the occasion, and some of whom were dead. No other American artist of the time was capable of such an engaging and informal combination of historical fact, personal experience, and spirited improvisation.

Above: Peale's painting, Exhuming the Mastodon, *begun in 1806; a detail from the work appears at left, showing the artist holding a scale drawing of the mastodon's leg as he approaches the diggings.*

The Lamplight Portrait of James Peale, painted in 1822 by Charles Willson Peale

In 1822, the same year he completed his museum self-portrait, Peale painted his brother James examining a miniature by the light of an Argand lamp. This sensitive and delicate study in light and shade, over which he worked long and hard, further testifies to the abiding skill of this wonderfully versatile old man. Almost thirty years earlier he had painted a remarkable life-size double portrait of his sons Raphaelle and Titian, the celebrated *Staircase Group*. When that painting was exhibited, set in the architectural frame of a doorway with an actual step built out into the room, it was so deceptive that—the story goes—Washington bowed politely to the painted figures as he passed, thinking them living persons. This fidelity to the reality before his eyes characterized all Peale's paintings. Probably because of his own experience, he believed anyone could learn to paint, and he tried to turn a number of his family and relations into artists. He taught James to paint miniatures, and several of his sons won reputations of their own. In 1801 Rembrandt, his second son, painted a portrait of his younger brother, Rubens Peale, holding what is believed to be the first geranium brought to America.

Above: Rubens Peale with a Geranium, *by Rembrandt Peale, 1801*

Opposite: The Staircase Group, *painted by C. W. Peale in 1795*

For almost one hundred years one or another member of the Peale family was painting pictures. As a group they left practically no kind of painting untried. James Peale and his nephew Raphaelle were in good measure responsible for the early development of still-life painting in America. James, in particular, found a ready audience for his opulent arrangements of fruit and vegetables with their unusual shapes and assorted rich textures. Raphaelle, Charles Willson Peale's eldest son, turned to still lifes about 1812 when he was all but crippled by a severe gout (that was not assuaged by his heavy drinking). His concerned father felt the young man had "considerable talent for such paintings," if not for portraits. By 1823 Raphaelle had become a confirmed alcoholic. Nevertheless, in that year he created one of his most accomplished canvases. In *After the Bath,* with sharp wit and completely controlled brush, he painted a deceptively realistic picture of a woman hiding her nakedness behind a crisply laundered linen sheet. According to entirely credible tradition, he designed this *trompe l'oeil* to fool and shock his hot-tempered, nagging wife. When she saw it, that lady obligingly snatched at the cloth in a rage. As a practical joke the picture was a complete success; as a painting it was a minor masterpiece. Raphaelle died two years later, a henpecked sot, while his father, in his mid-eighties, was courting a fourth wife.

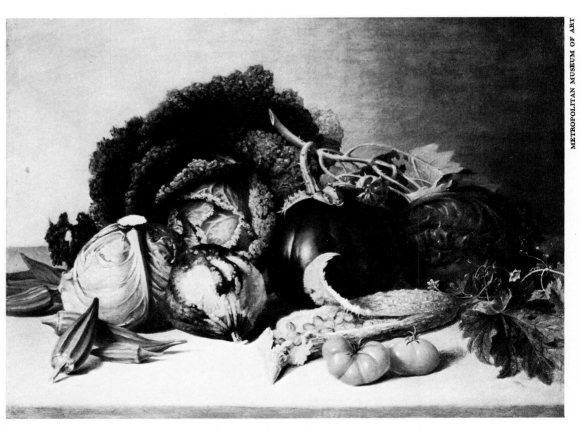

Above: Balsam Apple and Vegetables, *probably painted about 1822 by James Peale, Charles' brother*

Opposite: After the Bath, *signed in the lower right-hand corner of the sheet Raphaelle Peale 1823/ Pinxt*

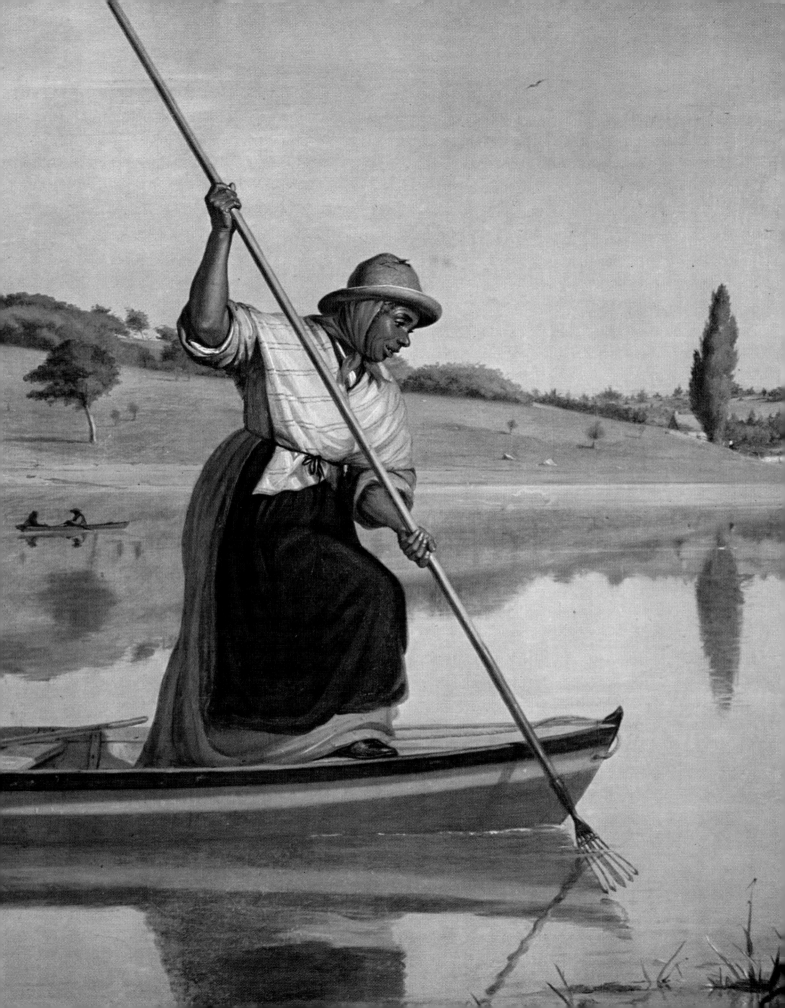

Paint pictures that will take with the public—

never paint for the few, but the many.

—WILLIAM SIDNEY MOUNT

DEMOCRACY'S MOLD

Opposite, detail of William S. Mount's Eel Spearing at Setauket *(above), painted in 1845*

John Quincy Adams was the last of the American presidents who represented the regime that had undertaken the Revolution and brought it to a successful conclusion; the last one whose inheritance from colonial experience and culture was direct, personal, and distinguished. As a child, by his mother's side, he had witnessed the battle of Bunker Hill. At the age of eleven and while the war continued, he accompanied his father, John Adams, on that elder statesman and future president's diplomatic missions to France and the Netherlands. During those youthful years he also briefly served his nascent country in St. Petersburg as secretary and interpreter to Francis Dana, the appointed American minister to Russia. In 1784 he was again in Paris as his father, Benjamin Franklin, and Thomas Jefferson gathered there to negotiate treaties with European powers. (At that time he saw so much of Jefferson that his father felt the lad was almost as much Jefferson's son as his own.) Thus, he was present both at the bloody beginnings and at the formal ending of his countrymen's struggle for independence, and as an impressionable youngster he had intimately associated with some of the principal founders of the new republic.

Both the elder Adams and Jefferson were still alive when John Quincy was elected as the sixth president of the United States in 1824. Then, seventeen months later, both the old men died at almost the same hour of the same day. By a further very singular coincidence that day was the Fourth of July, 1826— the fiftieth anniversary of the adoption by the Continental Congress of the Declaration of Independence; the document for which Jefferson had been so largely responsible and which, more than any other individual, John Adams had persuaded a hesitating Congress to approve.

During that half century the experiment in self-government, undertaken with such uncertain and such dire possibilities, had demonstrated new and unexpected truths. America had cast away the customary props of state—royalty, aristocracy, and an established national church—and framed its federal structure in the name of all the people. Few among the leaders of the new republic held that confidence in popular sovereignty which the Declaration of Independence implied. Democracy, indeed, was a tainted word at the time. Jefferson was, to be sure, a "Man of the People," as Abigail Adams referred to him in one of her letters, with utter

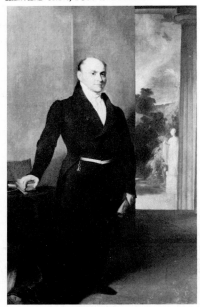

Portrait of John Quincy Adams, begun in 1825 by Gilbert Stuart, and later completed by Thomas Sully

John Lewis Krimmel's election scene at the State House, Philadelphia (Independence Hall), about 1818

distaste for his views. But the Constitution was drafted by men who for the most part firmly believed that affairs of government could not be safely referred to popular opinion. "The proposition that the people are the best keepers of their own liberties," John Adams had warned, "is not true." And to that point of view George Washington, John Jay, James Madison, John Marshall, and most other contemporary political leaders solemnly, if sometimes reluctantly, subscribed. Nevertheless, as one acute observer of the time remarked, the genius of the people was for democracy, and over the first three decades of the nineteenth century they exercised their genius for purposes that carried far beyond any plan of the Founding Fathers.

The intention of the men who framed the Constitution to safeguard the new nation against the "excesses" of democracy was already being undermined as John Quincy Adams assumed office for his single, unpopular term. Before he left that office the "horrible ravages of universal suffrage" were apparent all over the nation. Adams suffered the consequences from the very beginning. In the much-traveled days of his youth he had acquired tastes that remained with him through the years and that colored his judgments. "In the capitals of the great European nations," he recalled at one point, "the monuments of Architecture and Sculpture continually meet the eye and cannot escape the attention of the most careless observer. Painting, Musick, the Decorations of the Drama, and the Elegant Arts which are combined in its Representations, have a charm to the senses and imagination of youth. . . ." His taste in such matters, he concluded, contributed much to the enjoyment of his life. He obviously suffered none of his father's reservations about the present importance of the arts.

However, when in his State of the Union address to Congress in 1825 he proposed that the federal government should officially encourage the "Elegant Arts," among other cultural and practical endeavors—citing with approval the work along such lines being accomplished by "the nations of Europe . . . and their

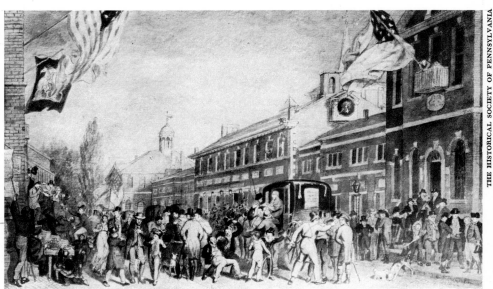

rulers"—he seemed to some in his audience to be echoing those monarchical patrons he referred to. The president, it was widely agreed, had been too long exposed to the conceits and pretensions of European courts. A completely false but widespread rumor had it that he lived at the White House in "regal magnificence," contrary to all republican, not to say democratic, principles. All in all, it was enough to revive old fears that the Adamses were royalists at heart; and at that point in their history Americans had developed an almost pathological antipathy to royalty in all its implications.

In any event, with the election of 1828, the rule of the ancien régime in American politics ended; Adams was succeeded by the populist Andrew Jackson, and democracy was triumphant. That frontiersman's supporters made a "people's day" of his inauguration, invading the White House in uncontrollable mobs, which celebrated their victory by guzzling all the refreshments in sight and forcing the new president, for safety's sake, to escape the crush through a window. The triumph of the masses over the classes, the elevation to such high office of a man without benefit of family, learning, or wealth, sent shudders up the spine of conservative society. Young gentlemen at Harvard burned the newly elected president in effigy, and their elders lamented and protested the reign of "King Mob" in the White House.

The gloomy predictions of the chaos that would follow Jackson's election, like similar ones made when Jefferson became president in the glorious "revolution" of 1800, did not, for all the antics of henchmen and followers, quite materialize. In less than forty years after the Constitution had been adopted, the ideal of popular sovereignty had been worked into a hard, practical political fact. Contrary to every intention of most of those who signed that document, and with hardly a change in its written form, America was developing into a more thorough democracy than the world had yet seen. "In America," wrote Alexis de Tocqueville during Jackson's administration, "the principle of sovereignty of the people is . . . recognized by the customs and proclaimed by the laws; it spreads freely, and arrives without impediment at its most remote consequences. If there is a country in the world where the doctrine of the sovereignty of the people can be fairly appreciated, where it can be studied in its application to the affairs of society, and where its dangers and advantages may be judged, that country is assuredly America." That the doctrine was not without serious perils, Tocqueville readily admitted—a sentiment repeated years later by G. K. Chesterton when he remarked that the world would never be made safe for democracy since "democracy is a dangerous trade."

The United States had emerged from the War of 1812, the second war for independence as it has been called, with a self-consciousness and self-confidence that mounted over the years that followed. For the first time in their history Americans felt free and able to develop and consolidate the resources of their land and pursue a separate destiny without further interference from abroad—to take command of their own fortunes, as Washington years earlier had hoped they might one day do. In the decade after Jackson's election, the nation teemed with unrestrained optimism and pride. "You are in a country," James Fenimore Cooper wrote to the sculptor Horatio Greenough, "in which every man swaggers and

Among the gifts President Jackson received was a 1,400-pound cheese, which he shared with the public.
NEW YORK PUBLIC LIBRARY

talks, knowledge or no knowledge, brains or no brains, taste or no taste. They are all *ex nato* connoisseurs, politicians, religionists, and every man's equal and all men's betters." To the critical foreign observer the American's insistent and assertive boast of his Americanism seemed a singularly unattractive aspect of the national character, a bumptiousness that could hardly be condoned or understood. "It is impossible to conceive a more troublesome or more garrulous patriotism, it wearies even those who are disposed to respect it," wrote Tocqueville, among the most discerning of visitors.

However, faith in the country's independent and unbounded future burned with evangelical fervor at every level. "Our day of dependence, our long apprenticeship to the learning of other lands, draws to a close," Emerson counseled his countrymen. "The millions that around us are rushing into life, cannot always be fed on the sere remains of foreign harvests. Events, actions arise, that must be sung, that will sing themselves." In his turn, Herman Melville called Americans the advance guard of mankind, "sent on through the wilderness of untried things, to break a path in the New World that is ours." And the history of the next several decades would be largely written across the breadth of the continent in terms of that spirit.

In their unbridled enthusiasm, and heeding Emerson's words, Americans were clamoring for an art of their own, forms that would suggest the limitless abundance and wonder they discovered in their native land, and the down-to-earth success of American democracy in action. They got what they asked for in an unprecedented profusion of paintings. In 1837–38 an Irish visitor, Mrs. Anna Jameson, was "struck by the manner in which the imaginative talent of the people had thrown itself forth into painting; the country seemed to swarm with painters." They were literally everywhere, she reported, intent on discovering and recording the character of the land and of the people about them. A few years earlier Mrs. Trollope had with amused condescension noted that with the exception of a few rare, discerning individuals the American public was delighted with what it was getting. The newspapers, she reported, "almost pant with ecstasy in speaking of their native *chef-d'oeuvres*. I should be hardly believed were I to relate the instances which fell in my way, of the utter ignorance respecting pictures to be found among persons of the *first standing* in society." Her amusement turned to indignation when an American acquaintance suggested that the self-taught backwoodsman Chester Harding was a better painter than Sir Thomas Lawrence. She may not have known it, but Harding, on a visit to England some years earlier, had won many commissions in London from royal dukes and others among the nobility, even while Lawrence was in his prime.

It seems almost symbolic that Gilbert Stuart, the last American exponent of the eighteenth-century tradition in art, died the same year that Adams was voted out of office. At least, it underlines the fact that with that year the period of transition had ended and a new phase of American life had begun. The succeeding generation of artists was to open vistas that had been only dimly perceived by Stuart and his contemporaries. This was quite literally true in that these years saw the beginnings of a significant American tradition in landscape painting. Thomas Cole, generally considered this country's first important landscapist, was a virtually self-taught English immigrant who had a strong influence on a group of

Detail of a lithograph portraying a local artist at work in his studio

artists known as the Hudson River school. In their meticulous yet lyrical portraits of the hills and lakes, the valleys and rivers of their still semiwild continent, this unorganized fraternity of able painters luminously displayed the newly perceived beauty and grandeur of America as Washington Irving, James Fenimore Cooper, and William Cullen Bryant were celebrating it in their writings.

While these Hudson River men—Asher B. Durand, John F. Kensett, John W. Casilear, Frederick E. Church, among others—were exploring and recording the wide horizons of the land (often far beyond the banks of the Hudson), other contemporary painters were taking a close look at the common man in his rural and village habitats, on the western rivers and plains, and in a spirit of flattering candor reporting him at work and play. William Sidney Mount's quiet pictures of his Long Island neighbors, George Caleb Bingham's depictions of the western rivermen, of fur traders, and of the hurly-burly of local elections, and the paintings of the farther, wilder west by George Catlin, Seth Eastman, Alfred Miller, and others reflect the range of this relatively benign chauvinism of Jacksonian democracy and its aftermath.

At mid-century contemporary American art was probably more widely popular than it has been at any other time in our history. In a number of years what was in effect a national lottery run by the American Art-Union distributed thousands of paintings by Cole, Bingham, and hundreds of other artists, and scores of thousands of engraved copies of their works to an eager public in all parts of the land. The nation was steeped in its own image, a sentimental exercise that was to be intensified and quaintly vulgarized in the ubiquitous lithographs of Currier and Ives and the anecdotal sculptured groups of John Rogers, and that was to be harmonized in the sweeping, peaceful landscapes of George Inness and melodramatized in the grandiose vision of Western scenery by Albert Bierstadt and by Thomas Moran. With these last large, impressive canvases one might say that the rediscovery of America by its artists was complete.

That development was not fully realized until after the Civil War. However, the men who were most active during the generation before the war had established a broad base of popular art forms; forms far more diversified than those attempted by their precursors of the Federal period. It would hardly be accurate to claim that these artists were on the whole better than the earlier men, but they spoke more directly to a much wider public; and when they did this they could and did prosper in their profession.

As in earlier days, more than just a few of these successful practitioners did not discover their vocation until they were in their twenties. Thus, Thomas Cole did not seriously undertake painting until, at about the age of twenty, his talent was sparked by a chance meeting in Steubenville, Ohio, with an itinerant portraitist. (Consider that in France his contemporary Delacroix was already thoroughly trained and famous at that age.) But Cole's success was quick. Within a very few years his work had caught the respectful attention of the aging and eminent John Trumbull, and his pictures were selling. Although Cole was English-born, he thoroughly and intimately identified himself with the American scene. When he left on a visit to Europe in 1829 (he was still in his twenties), William Cullen Bryant, his friend and kindred spirit, advised him in a sonnet to keep bright that

A member of Congress as illustrated in Frances Trollope's Domestic Manners of the Americans, *1832*

Hiram Powers' Greek Slave, in marble, was completed in 1843.

"earlier, wilder image" of their own beloved land while he contemplated the different and antique splendors of the Old World. To impress that image more brightly on his mind's eye, Cole made one last excursion into the wilderness just before he sailed away from home; and he returned to produce some of the most satisfying landscapes that were painted in America in his time. In May, 1833, the memorable diarist and ex-mayor of New York Philip Hone went to the spring exhibition of the National Academy and found it a good one. "Cole maintains his ground," he reported. "His pictures are admirable representatives of that description of scenery which he has studied so well in his native forest. . . . I think every American is bound to prove his love of country by admiring Cole." It is a token both of his reputation and of the popular enthusiasm for pictures such as he produced that his untimely death in 1848 was considered a public calamity.

During this same period, roughly the second third of the nineteenth century, an American school of marble sculpture came into sudden and unexpected bloom. Those who worked in stone had difficulties unknown to the painters. The stone available in America was so refractory that it discouraged the sculptor as well as the stonecutter who might be commissioned to do his bidding. Consequently, for the most part, those who aspired to work in the round flocked to Italy, where marble was abundant and wages of expert stonecutters were low. Here the aspiring sculptor could pass on a cast of a figure he had modeled in clay and depend on local craftsmen to chisel a faithful replica of it in enduring marble—or any number of replicas and copies in various sizes if the piece caught the public fancy, to be sold at a tidy profit. Here, too, works by the great masters might be seen and studied. On his arrival in Rome in 1837 Hiram Powers, one of the earliest of those "Yankee stonecutters," felt as if he were "riding in an expresstrain through a canebreak" of art treasures.

In Italy, too, the artists could model nudes without suffering the social criticism that greeted such exposures in America. Even as late as the 1860's one visiting French critic observed that in this country the depiction of woman's natural form was "not permitted . . . beyond the head and the extremities." When the acidulous Mrs. Trollope visited Cincinnati in 1828–30, she was amused by the curious wax effigies (adequately clothed, presumably) that Powers had installed in a museum there. Nevertheless, by the 1840's that sculptor was unquestionably the most celebrated living American artist. In 1843, at Florence, he had completed his *Greek Slave,* a marble statue of a nude young girl bound in chains, standing on view in a Turkish slave market. It was an immediate and smashing popular success. To prudes of the day it might have seemed like a decidedly lascivious statement; but, as one clergyman maintained, as an expression of a pure and modest maiden's frightful plight, the figure was "clothed all over with sentiment, sheltered, protected by it, from every profane eye." That such a "sublime" vision could have been realized by a virtually unheralded artist from the cultural wasteland of America caught European audiences by surprise. Powers became an international celebrity almost overnight, and his fame reflected the growing prestige of the American school. In Florence he was a close and valued friend of Robert and Elizabeth Barrett Browning—"a most charming, simple, straightforward

American," wrote Mrs. Browning, with eyes "like a wild Indian's, so black and full of light." She wrote a sonnet in praise of the *Slave*. Powers sold a number of replicas of the statue at an average price of about $4,000, a very handsome sum at the time. Beyond that, Henry James later recalled, for years American parlors displayed miniature copies of the figure, "so undressed, yet so refined, even so pensive, in sugarwhite alabaster, exposed under little domed glass covers in such . . . homes as could bring themselves to think things right."

If anything further were needed to confirm the popularity of the visual image at mid-century it could easily be found in the substantial proliferation of prints, both as separate items and as book illustrations, that characterized the period. Following the conclusion of the War of 1812 a number of talented English engravers migrated to America and produced a series of excellent aquatints, resembling water-color drawings in their transparently realistic, hand-colored depictions of the American scene. Such publications as John Hill's *Picturesque Views of American Scenery* (1820), W. G. Wall's *The Hudson River Portfolio* (1828), and William J. Bennett's outstanding topographical views of American cities (issued 1831–38) no doubt encouraged a taste for landscape that Cole and other artists would profit by. In 1839 when he had finished the monumental task of reproducing Audubon's four hundred thirty-two original water-color drawings for *The Birds of America*, the superb English aquatinter, Robert Havell, Jr., followed Audubon back to America, and settled in the Hudson River valley, where he devoted the remainder of his career to delineating in oils and aquatints the countryside made legendary by Washington Irving.

Sailors Aloft, *a bank note engraving showing seamen coping with sails*

In the years tnat followed those enterprises many prominent American artists supplied illustrations for mushrooming magazines and for steadily multiplying numbers of books of all sorts. As early as 1835 the publisher of the New York *Mirror*, a flourishing periodical, complained that competent engravers were all so busy he had been unable to find anyone to prepare plates for him "for the last six weeks." Such a publisher sometimes paid more for a single plate (some cost at least as much as $1,000 apiece) than for all the literary contents he had commissioned.

Still other artists, Asher B. Durand and John Kensett among them, were responsible for the often exquisite little vignettes that embellished bank notes of the period. In these unpretentious and ubiquitous scenes the whole range of contemporary life was depicted with meticulous precision, as will be seen. The rise of lithography loosed still a fresh torrent of pictures that, as will also be seen, subsequently reached a climax of sorts in the vast output of prints by Currier and Ives that flooded the country in the decades following the Civil War.

Lithography had hardly come of age as a mechanical means of reproducing images of the painter's vision of the actual world when it was in turn challenged by developments in photography. Nothing the pencil or brush could do matched the camera as a recorder of factual detail. So long as the artist sought for consummate realism in his work, he would now be outdistanced by the camera's lens. As the English artist Charles Landseer warned a colleague, science had at last produced "a *foe-to-graphic* art." Whether it was in truth a foe or rather a powerful new influence on the direction of arts was not immediately apparent.

IMAGES
OF THE LAND

"This youth," remarked the aging John Trumbull when he spotted some of Thomas Cole's canvases in a New York store window, "has done what all my life I have attempted in vain." He bought a picture for $24, and persuaded his friends to buy others. Within months Cole was receiving commissions for landscapes from many of the important figures in the cultural life of New York. He went on to produce some of the most satisfying landscapes that were painted in America in his time. Late in his life William Cullen Bryant vividly recalled that the interest young Cole's paintings aroused was like that "awakened by some great discovery." That interest in the American landscape was freshened and fortified when, in his first published work, Ralph Waldo Emerson reminded his audience that in Nature man would find his true emancipation—a pronouncement with which leading romanticists of the day were in complete sympathy. Cole spent weeks and months of every year walking and sketching his way through the Catskills, the White Mountains, and other areas where he was lured by the wild mountain scenery. He was ever advising young painters of the necessity of such outdoor, on the spot drawing of nature. When he completed those trips he would return to his studio and work up the paintings, which, most often, he had been commissioned to do by one or another patron. His earliest successful landscapes date from about 1825, and he was already prospering when he painted *The Clove, Catskills*, in 1827. Nine years later his friends Asher B. Durand and Luman Reed persuaded him to paint something expressly for exhibition and for public sale. In response to their suggestions, on March 2, 1836, Cole wrote Reed, "I have already commenced a view from Mount Holyoke." The resulting landscape, showing the oxbow of the Connecticut River after a thunderstorm, is one of his finest works.

A marble bust of Thomas Cole by the sculptor Henry Kirke Brown, about 1840

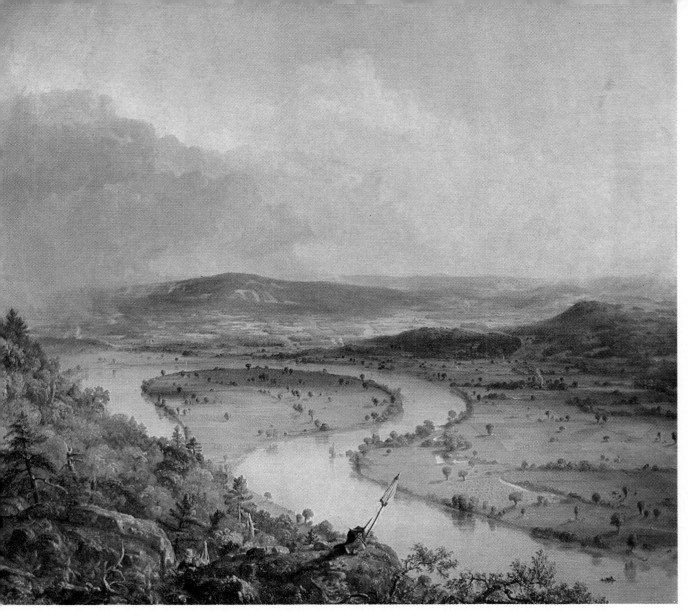

Above: The Oxbow (The Connecticut River near Northampton), *painted by Cole, 1836*

Below: The Clove, Catskills (Kaaterskill Clove), *painted by Cole in 1827*

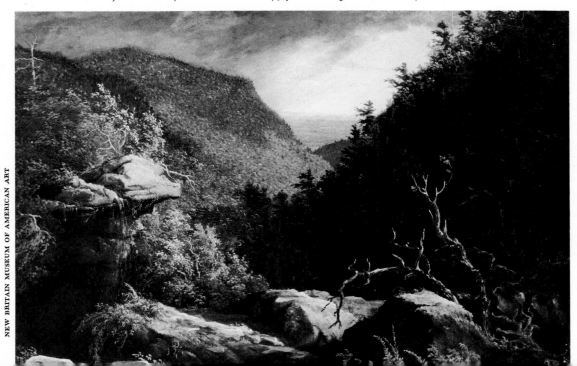

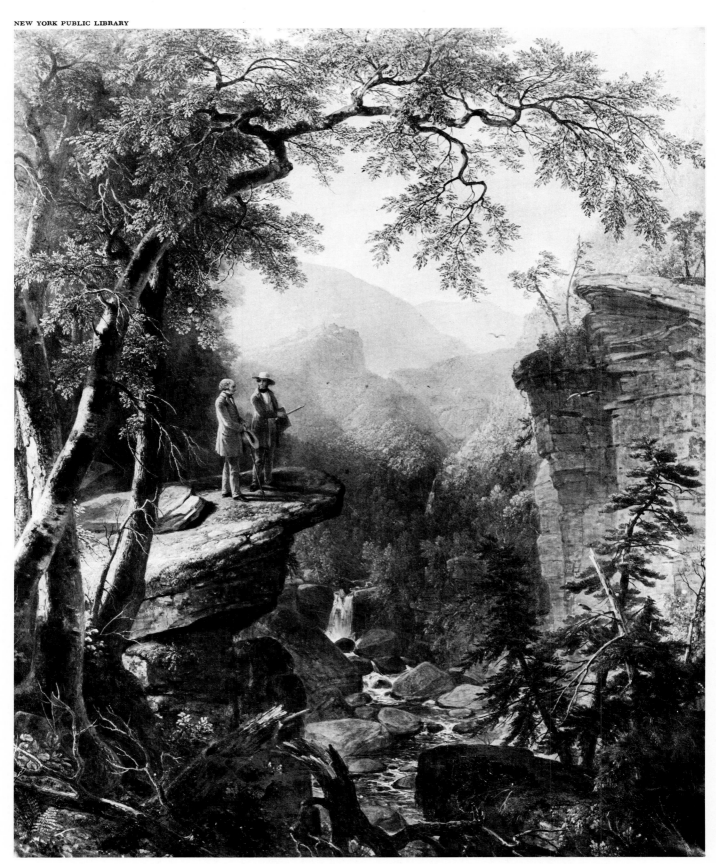

Above: Kindred Spirits, *Asher B. Durand's painting, executed in 1849*

Opposite: Fishing by a Waterfall, *painted by Doughty in the late 1830's*

When Cole died in 1848, William Cullen Bryant delivered a funeral oration, showering lavish praise on the old friend with whom he had shared "many delightful rambles in the Catskills." In appreciation of his remarks, Jonathan Sturges, who had been one of Cole's faithful patrons, commissioned Asher B. Durand to paint a picture recalling the friendship between the artist and the poet, those "kindred spirits" as he referred to them, for presentation to Bryant. Durand had also long known and admired Cole and had explored the Catskills with him. In his dual portrait he placed the two figures—Bryant with his hat in his hand, Cole with a book under his arm—on a rocky ledge overlooking the clove, a site Cole had lovingly painted twenty-one years earlier. Bryant wrote Durand that the painting was "in your best manner, which is the highest praise." Thomas Doughty was another early member of the so-called Hudson River school; by some, indeed, he was considered a founder of it along with Cole. In 1839 a visiting English artist, noting the accomplishment of these men and their fellow artists, wrote: "The American School of Landscape Painting is decidedly and peculiarly original, fresh, bold, brilliant and grand . . . we may mention Doughty of Boston as eminently combining these qualities. . . . He must undoubtedly be considered the master and founder of a new school." During his own lifetime Doughty was hardly aware of being a member of any regional school and actually did not frequent the Hudson River area until his later years. But he shared with Cole and the others a love of nature, and like them painted all aspects of American scenery, usually in realistic detail. The view reproduced below may represent a scene near Newburgh, New York, more softly and dreamily rendered than the landscapes shown in his earlier works. Doughty was an ardent hunter and fisherman, and his paintings express the joys of solitude and sober contemplation that can be found in the pursuit of such sports.

In the decades following Cole's death, a growing number of younger artists carried the development of landscape painting in new directions. A sizable group of them shared a preoccupation with the effects of light and atmosphere, which earned them the name of luminists. Fitz Hugh Lane, a partially crippled Yankee from Gloucester, Massachusetts, was the first really good native American seascapist. He knew intimately the air of the New England coast, the nature of its waters, and the structure of the ships that plied there. His tranquil, spacious, light-filled marine scenes were so popular that he founded a lithography firm to reproduce them in quantity. (Lane had been trained as a lithographer.) The work of John Frederick Kensett was probably even more popular. Kensett's *Lake George*, a subtle counterpoint of land, water, and shimmering atmosphere, painted in 1869, and one of his masterpieces, was sold for $3,000—a very high price for the time. (The abiding popularity of his work is suggested by the fact that following his death in 1872 the canvases remaining in his studio realized more than $150,000 at public auction.) In Martin Johnson Heade's *Thunderstorm, Narragansett Bay* (see pages 108–109), with its ominous clouds, lightning flash, and threat of wind gusts, the normal serenity of the scene takes on an almost surrealistic character. In such landscape work the broad, enveloping effect of light is often combined with minute precision of detail, a reminder that in their younger days a good number of these landscapists had been trained as engravers.

Opposite: Lake George, *by Kensett, 1869*

Below: Owl's Head, *Penobscot Bay, Me.,
painted by Fitz Hugh Lane in 1862; a
detail from the work appears at right.*

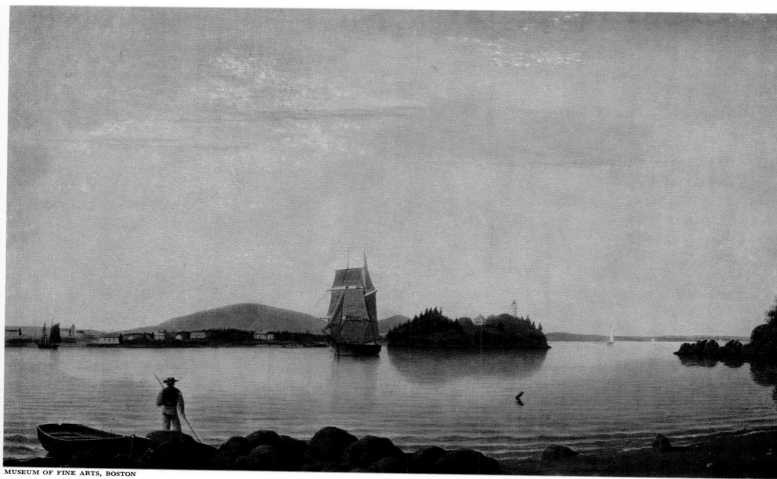

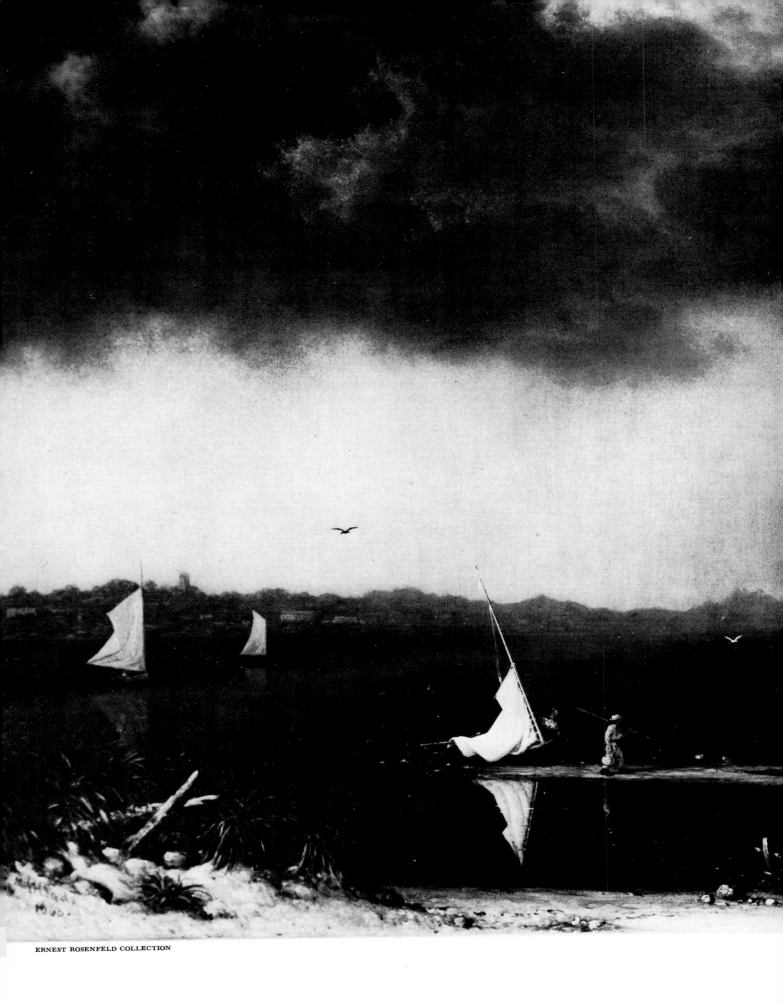

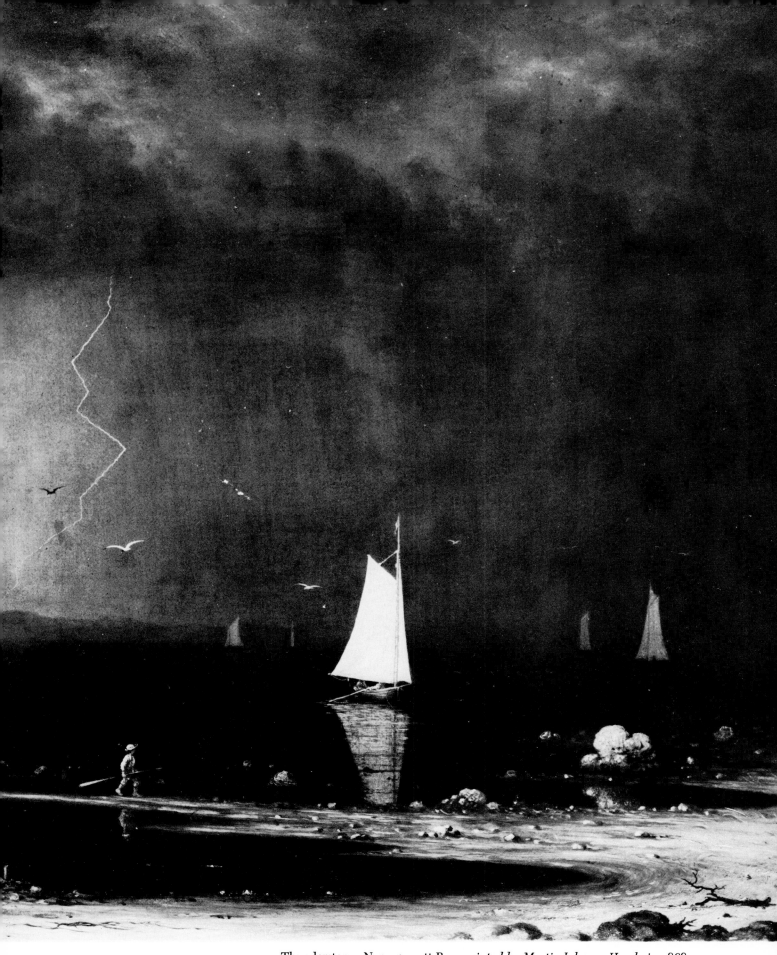

Thunderstorm, Narragansett Bay, *painted by Martin Johnson Heade in 1868*

A mere listing of the swarm of competent artists who painted the American landscape during the middle years of the last century would require columns of type. Sanford Robinson Gifford was one of the outstanding members of the so-called luminist group, along with Kensett, Lane, and Heade. Like most of the others, he traveled widely abroad—as far as Athens and the Nile (he later went to Turkey and Spain and to the Rockies and Alaska)—and returned to paint his native scene with freshened interest. He would go off on his woodland expeditions to the Catskills or wherever, knapsack on his back, leaving his studio door unlocked. In 1862, after his second European trip, he painted the Kauterskill Falls, a favorite subject of Hudson River school artists, veiled in a translucent, radiant mist of atmospheric color. A few years later, after he in his turn had come back from travel in Europe, Samuel Colman, a sometime student of Durand's, painted his view of Storm King mountain on the Hudson River just north of West Point—a fabled gathering place of storms and a weather signal to neighboring residents. A melancholy note underlaid poetic lyricism in such renderings. While artists were celebrating the glories of America's natural wonders, their industrious countrymen were raping the wilderness with lusty abandon. Before he died, Cole wrote Luman Reed, "They are cutting down all the trees in the beautiful valley on which I have looked so often with a loving eye . . . maledictions on all our dollar-goaded utilitarians." It behooved the artist, wrote one critic in 1847, to salvage what he could of the wilderness heritage before it was "forever too late."

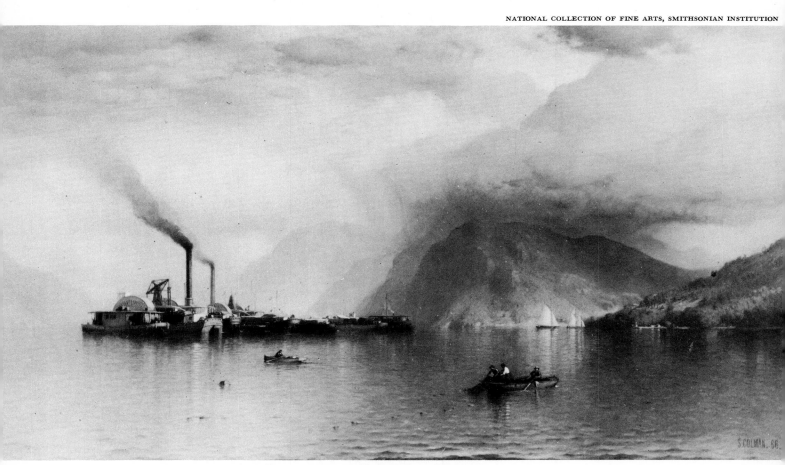

Storm King on the Hudson, *painted by Samuel Colman in 1866*

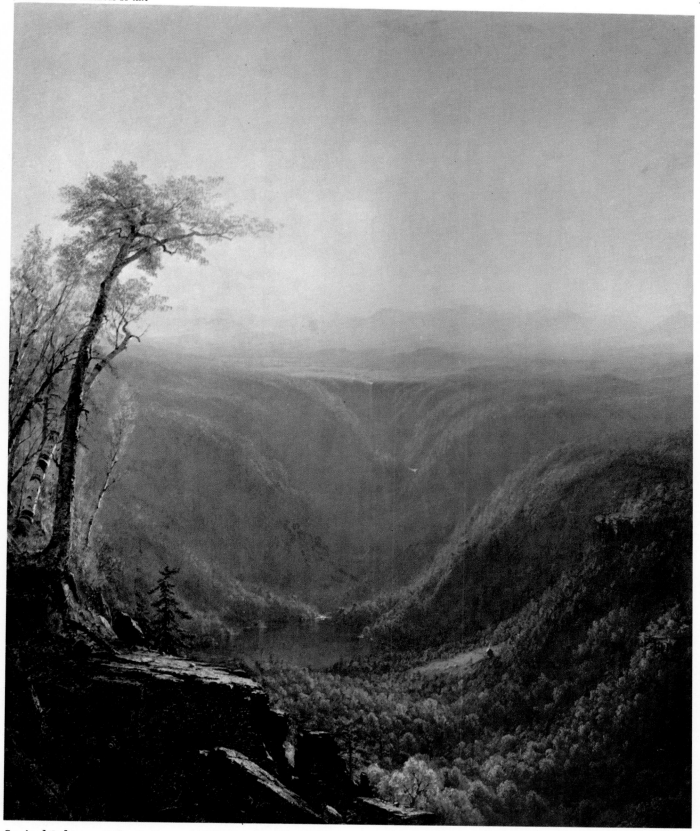

Sanford Robinson Gifford's Kauterskill Falls, *painted in 1862*

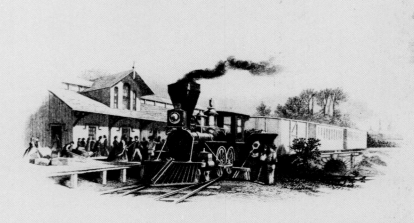

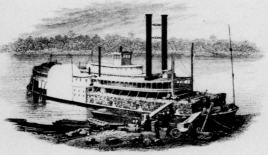

VIGNETTES
OF VALUE

In 1845 Asher B. Durand succeeded Samuel F. B. Morse as president of the National Academy of Design in New York; for a landscape artist to reach such a prestigious office was clear proof of how important that brand of painting, once so little esteemed, had become in professional and public regard. Also, with his copies of Trumbull's *Declaration of Independence* and Vanderlyn's *Ariadne,* among other subjects, Durand had won considerable distinction as an engraver, but had put aside his burin to devote himself exclusively to painting. In May, 1836, the New York *Mirror* reported: "Mr. Durand has almost relinquished the graver. Perhaps he thinks he cannot go beyond his Ariadne. No one else can." Like a good number of contemporary artists, Kensett among them, Durand had also worked as a bank-note engraver, supplying the meticulously drawn vignettes, such as the two shown at the top of this column, that embellished the paper currency issued by local and state banks. In turn these were transferred to steel cylinders for printing early in the nineteenth century by a process conceived by the American Jacob Perkins. His innovations were this country's principal technical contribution to printmaking. The superior workmanship of American bank-note engraving, samples of which surround this text, and of bond certificates was widely acknowledged abroad. The tiny scenes that were drawn for such reproduction illustrate almost every aspect of contemporary American life, they provide a virtual album of American experience of the time. Like other bank-note engravers turned painters, Durand never lost the delicate precision in drawing that he gained from that early practice—a detailed accuracy that characterizes so much of the Hudson River school of painting.

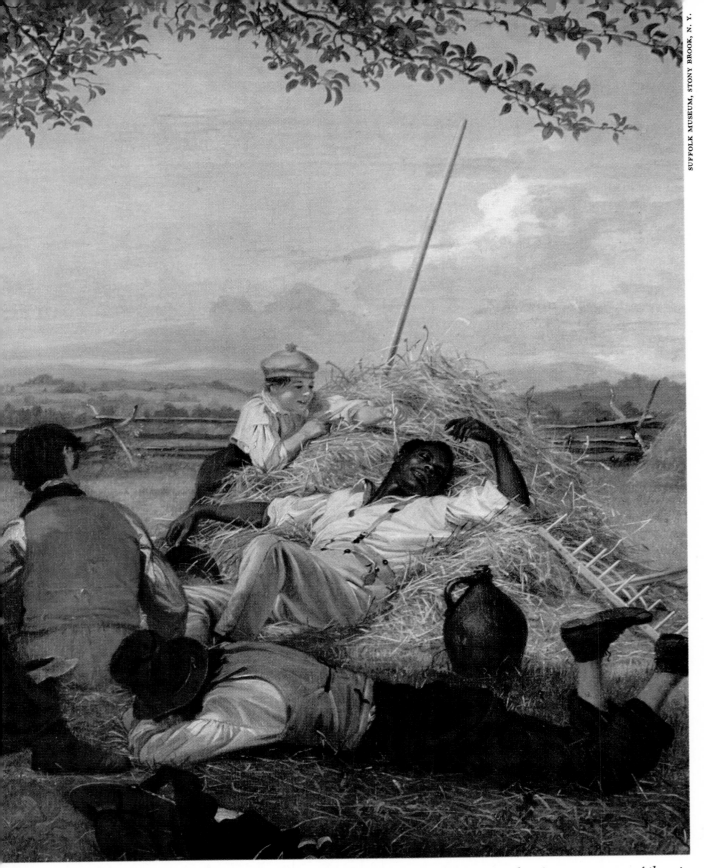

Detail of Farmers Nooning, *painted by William Sidney Mount in 1836 for Jonathan Sturges, a patron of the arts*

ART FOR THE MANY

While the landscapists and seascapists were so actively and so pleasantly charting the mountains, woodlands, lakes, and coasts of the land on their canvases, other painters were sharply recording their fellow Americans at work, at rest, and at play. Hardly an aspect of daily life escaped their brush—and daily life in America around mid-century was more richly varied than it had ever been. There is an intimacy, and at times humor, about such paintings, reflecting a bond between the artists and a broad public. American painting had become, for a time at least, a popular art. In 1846, when William Sidney Mount's *Eel Spearing at Setauket* (see pages 94, 95) was on exhibition at the National Academy of Design, the conventional, old-fashioned New York diarist George Templeton Strong immediately disliked such an anecdotal depiction of the commonplace. Strong was a gentleman of an older school who preferred more formal and grandiloquent painting. However, Washington Allston observed that if Mount were to study the works of such Dutch masters as Adriaen van Ostade and Jan Steen, he could become "a great artist in the line he has chosen." Mount never did bother to go to Europe to see such works at first hand (although he may have seen examples in New York collections), yet his familiar scenes of rural life on Long Island have indeed been compared by later critics with Dutch genre painting of the seventeenth century. His formula for success in his art was simple enough: "Paint pictures that will take with the public—never paint for the few, but the many." When he was in his teens Mount had served an apprenticeship with a sign-painting older brother. He later studied at the National Academy while Morse was president. And he had been encouraged to pursue his special bent by such older artists as Durand, Trumbull, and Morse. So apparent was his promise that Luman Reed, Jonathan Sturges, and the prominent art firm of Goupil, Vibert & Co. all offered to send him abroad to study. But Mount demurred. "Originality is not confined to one place or country," he wrote in a letter, "which is very consoling to us Yankees." His faith in following his own way was justified. As early as 1835 the New York *Mirror* reported: "His pictures will . . . reward him better if confined to domestick, comick, or rural scenes, than if his time and talents were thrown away on muffin-faces, or even in portraying gentlemen and ladies."

Mount's The Painter's Triumph, *painted in 1838*

The Power of Music, *another of Mount's rural scenes, painted in 1847*

In his address before the Phi Beta Kappa Society at Harvard on August 31, 1837, Ralph Waldo Emerson proclaimed: "I embrace the common, I explore and sit at the feet of the familiar, the low. Give me insight into to-day, and you may have the antique and future worlds." His statement was a sublimated expression of what the genre painters, like Mount and his more or less gifted contemporaries, were attempting to do—to picture ordinary people behaving as they customarily did in their world. The popularity of such representations, many of them soon to be endlessly reproduced in lithographic copies by Currier and Ives and other publishers, attracted artists of strangely assorted backgrounds and degrees of talents. Albertus D. O. Browere was a sculptor's son and a sometime California gold miner who spent most of his life in Catskill, New York, and who painted the passing scene as he saw it in his meanderings. According to an obituary, Richard Caton Woodville was of "aristocratic lineage, courtly manners and very handsome . . . essentially the artist. . . . His sense of humor was refined and he expressed dramatic situations with rare power of composition." His phenomenal eyesight, it was said, enabled him to record the most minute details in his paintings. John Carlin was a deaf-mute who, despite his severe handicaps, became a popular artist. He was patronized by a number of old New York families and leading political figures of his day.

Mrs. McCormick's General Store, painted by Albertus D. O. Browere in 1844

After a Long Cruise, *painted by John Carlin probably about mid-century*

The Sailor's Wedding, *painted in 1852 by Richard Caton Woodville*

Above: extra-curricular activity under the Apostle's Oak, Waban, Mass., a painting by George Harvey dated 1841

Below: The Haymakers *in Vermont, painted by Thompson*

It is the other schoolboys, not the schoolmaster, Emerson once noted, who educate a boy—on the way to school and at play and sport, rather than in the classroom. In 1841 George Harvey pictured such extra-curricular education taking place under the Apostle's Oak in Waban, Massachusetts (where John Eliot, "Apostle of the Indians," had preached to them). Harvey was an English-born artist who was intrigued by "the ever-varying atmospheric effects of the American climate"—effects which he found remarkably different from those in England, and which with skilled technique he revealed in his paintings of the American scene. In *The Haymakers* Jerome B. Thompson also painted a New England landscape with rare luminosity. Thompson was a farm boy turned artist, whose best works, Henry Tuckerman said at the time, were "half landscape and half rural labors or sport." Many of his sentimental genre scenes were reproduced in lithographic copies, as were those of his contemporary George Henry Durrie. As his career progressed, after a decade of portrait painting, Durrie turned to rustic scenes, with which he established a considerable reputation. He has been aptly called "the Whittier of American painting." His romanticized rural scenes, faithfully copied in large prints by Currier and Ives, were very popular—and are today coveted by collectors.

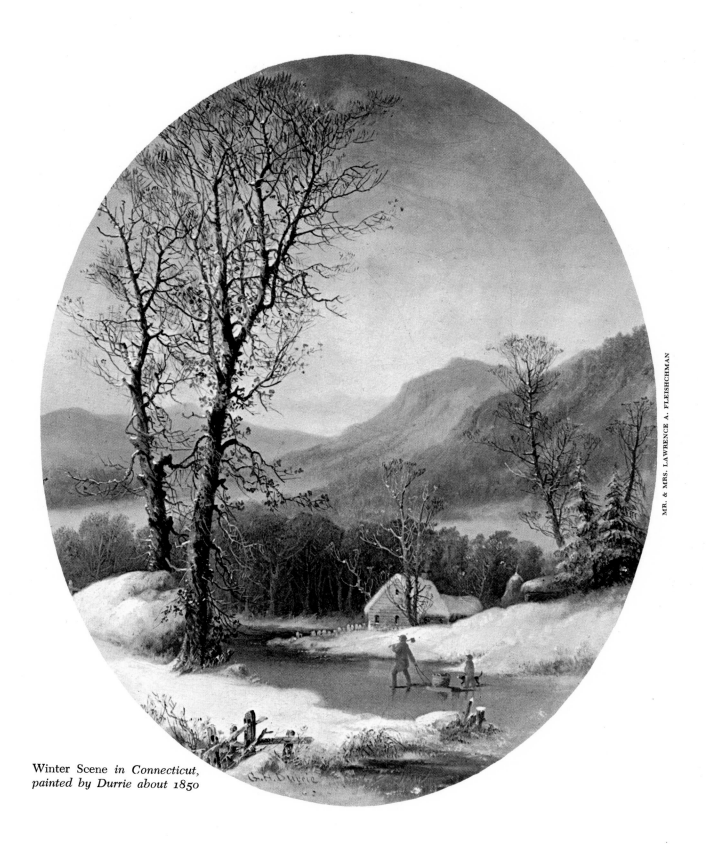

Winter Scene *in Connecticut,*
painted by Durrie about 1850

George Caleb Bingham was born in 1811 in Virginia but grew up in Missouri, at the far edge of settlement in that territory. He rolled cigars, studied law and theology, and practiced cabinetwork before he turned to painting professionally. He was a true son of the West, with an amazingly keen sense of what was important and interesting among the events and circumstances of that time and place. He made numerous trips back East and lived for a few years (1856–58) in Düsseldorf, Germany, perfecting his technique. In Missouri he painted the rough men and the toilers of the frontier and the Mississippi River. A New Orleans newspaper reported that Bingham was "to the Western what Mount is to the Eastern States." He was personally involved in the politics of the day, and in 1846 was elected to the state legislature. In 1855 he finished *The Verdict of the People,* of which he wrote, "all . . . who have seen it, pronounce it the best of my works." That painting was, one reporter observed, "at once suggestive and illustrative of a scene all have witnessed, with a truthfulness that cannot fail to excite our admiration . . . the genius of the artist has transferred to canvas a *principle* in our government—the exercise of the elective franchise—and submission by the people to the will of the majority. . . ."

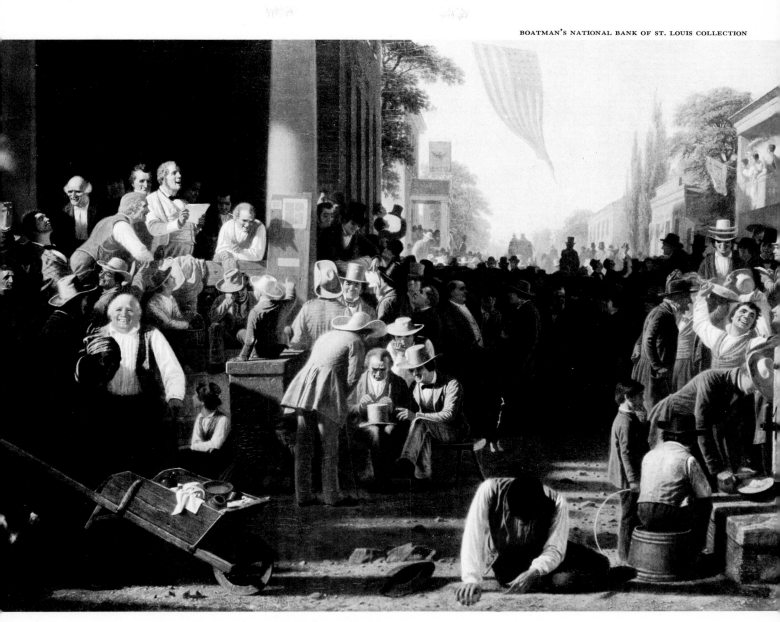

Above: The Verdict of the People, *painted by George Caleb Bingham in 1855;*
a detail from the work, showing an election-day celebrant, appears opposite, bottom.

Opposite, top: a candidate for office addressing an audience, drawn by Bingham

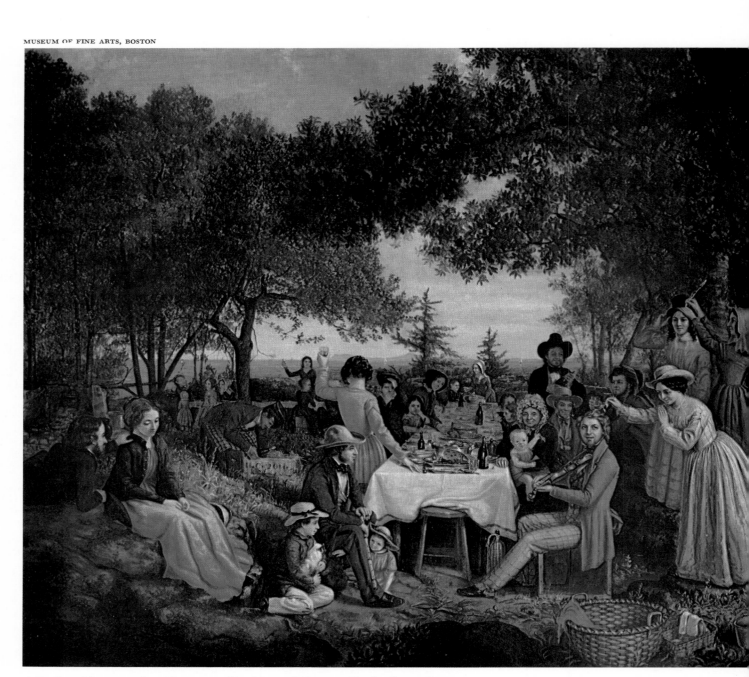

A "pick nick" in Camden, Me., painted by Jeremiah Pearson Hardy about 1855

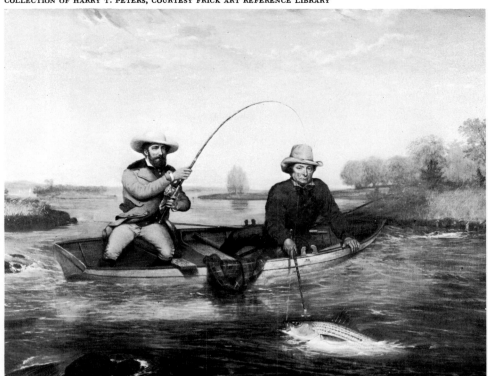

Striped-Bass Fishing, *by Arthur Fitzwilliam Tait*

As more and **more** Americans led their workaday lives cooped up in cities, wise **men**
advised them to refresh their spirits by returning occasionally to the out-of-
doors. Jeremiah Pearson Hardy's painting of a "pic nick," as he called it, reflects
the enthusiasm that greeted such counsel. "The eagerness with which we enter
upon picnics," *Appleton's Journal* observed shortly after Hardy completed his
painting, "the keenness with which we relish them, are proof of the supremacy
of the out of doors." Hardy was born in New Hampshire and had little enough
instruction before he turned professional artist. But he had a sensitive eye
for detail and the competence to record it with effect. His studio was reportedly
"the meeting place of the witty, the brilliant, even the fashionable of the
city" of Bangor, Maine, where he finally settled down to live. He seems never
to have lacked commissions. Arthur Fitzwilliam Tait, an English immigrant, brought
with him the British formula for painting sporting pictures, which he
applied to numerous paintings of wild-western scenes as well (although he never
did go to the West). "Every summer, for several years," the *Cosmopolitan Art
Journal* reported in 1858, "he has spent in the depths of the vast primeval forests
of northern New-York, trapping and gunning after the true back-woodsman fashion."
His paintings of men with gun or reel were widely distributed in chromolithograph
copies by Currier and Ives, but Tait was often dissatisfied with the quality
of those prints and complained that they hindered the sale of his paintings.

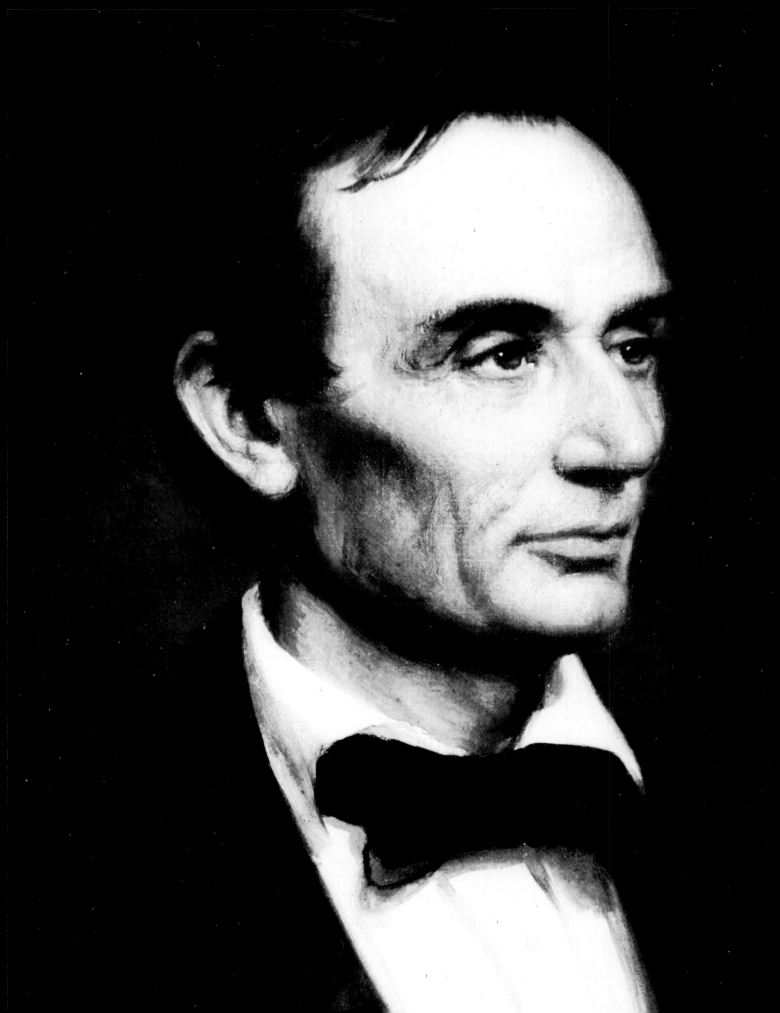

PORTRAITS OF THE AGE

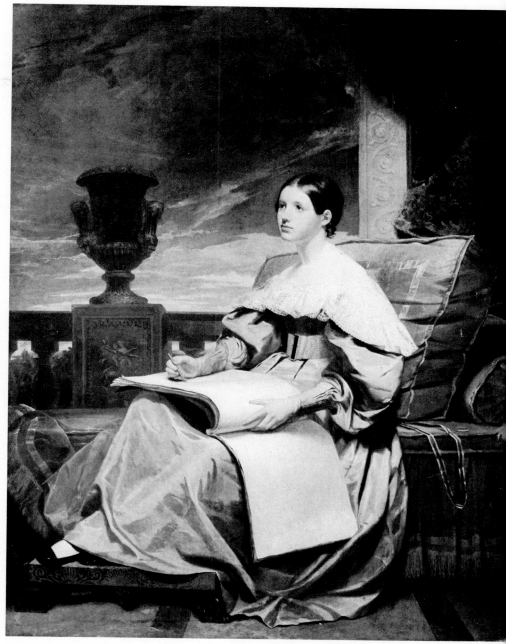

The Muse—Susan Walker Morse, *painted by S. F. B. Morse about 1835–37*

Henry Inman's remark that the rage for portraits in America would give way "to a higher and purer taste" was true to a degree. The popularity of landscape and genre painting did divert many artists from portraiture. However, the taking of likenesses continued to preoccupy many major figures. Before he put away his brushes forever Samuel Morse painted many superb portraits, despite his stated aversion to that branch of art. The painting of his daughter Susan Walker Morse is a glowing example. George Peter Alexander Healy had extraordinary success as a portraitist. In Paris Louis Philippe sat for him and commissioned him to paint likenesses of outstanding American statesmen for the royal collection. He painted Lincoln first as a beardless president-elect and, later, several times as president. Charles Cromwell Ingham's *The Flower Girl* and Charles Loring Elliott's painting of Mrs. Thomas Goulding (see pages 126, 127) are two highly contrasting examples of mid-century portraiture at its best.

Opposite: George Peter Alexander Healy's portrait of Abraham Lincoln in 1860

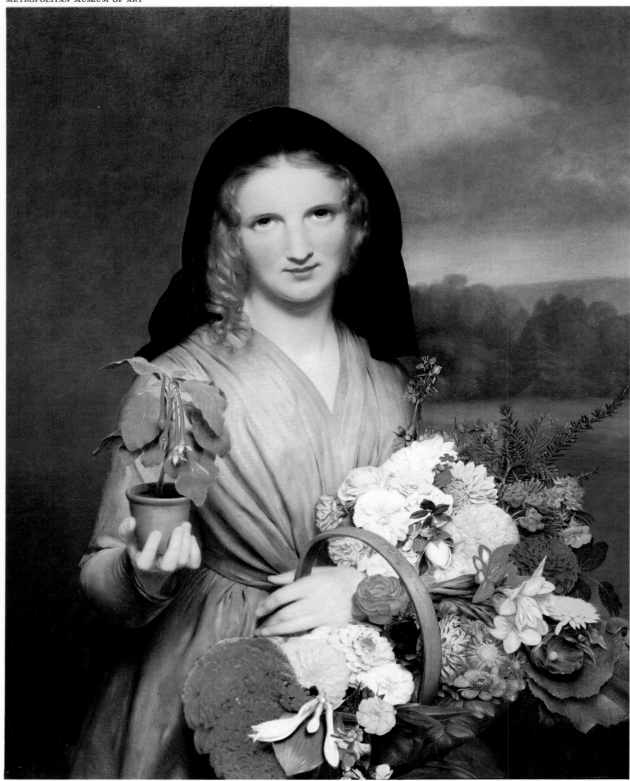

The Flower Girl, *a sentimental study painted in 1846 by Charles Cromwell Ing-*
ham, an Irish-born artist. Ingham's highly polished, miniaturelike technique
appealed to fashionable New Yorkers in the decades before the Civil War.

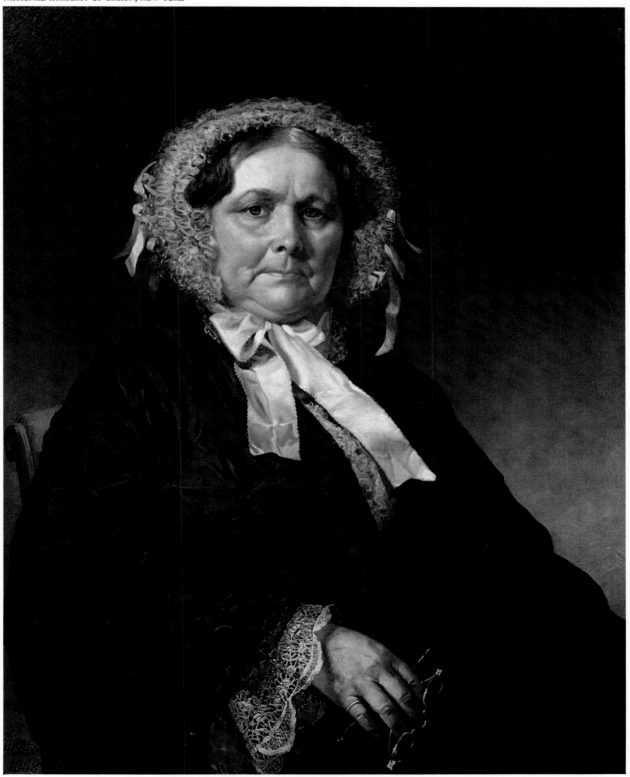

Mrs. Thomas Goulding, painted by Charles Loring Elliott in 1858. The artist once remarked: "There is nothing in all nature like a fine human face." He, too, was favored by the patronage of members of the Knickerbocker society.

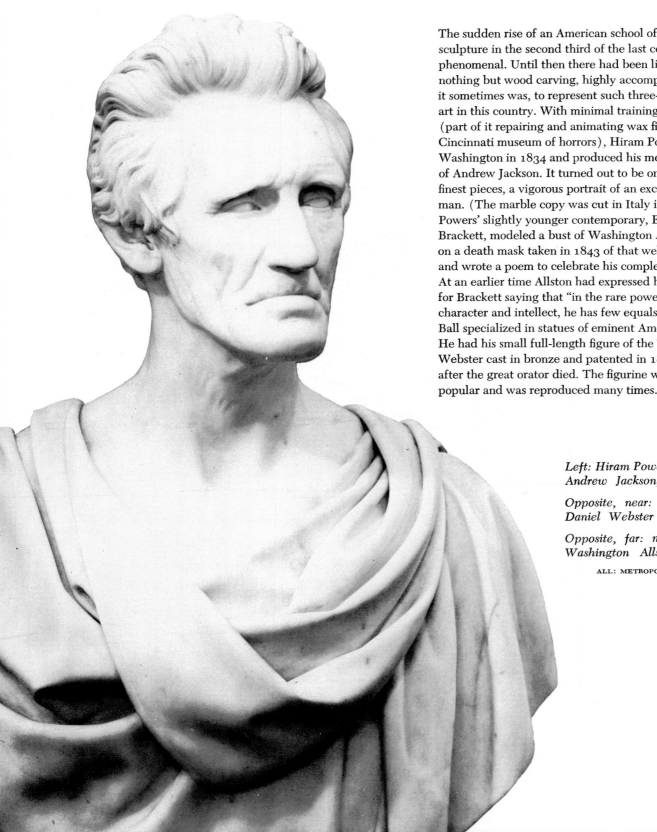

The sudden rise of an American school of marble sculpture in the second third of the last century was phenomenal. Until then there had been little or nothing but wood carving, highly accomplished though it sometimes was, to represent such three-dimensional art in this country. With minimal training in sculpture (part of it repairing and animating wax figures for a Cincinnati museum of horrors), Hiram Powers went to Washington in 1834 and produced his memorable bust of Andrew Jackson. It turned out to be one of his finest pieces, a vigorous portrait of an exceptional man. (The marble copy was cut in Italy in 1837.) Powers' slightly younger contemporary, Edward Augustus Brackett, modeled a bust of Washington Allston based on a death mask taken in 1843 of that well-known painter, and wrote a poem to celebrate his completion of it. At an earlier time Allston had expressed his admiration for Brackett saying that "in the rare power of expressing character and intellect, he has few equals." Thomas Ball specialized in statues of eminent Americans. He had his small full-length figure of the "godlike" Daniel Webster cast in bronze and patented in 1853, a year after the great orator died. The figurine was very popular and was reproduced many times.

Left: Hiram Powers' marble bust of Andrew Jackson, carved in 1835

Opposite, near: bronze figure of Daniel Webster by Thomas Ball

Opposite, far: marble portrait of Washington Allston by Brackett

ALL: METROPOLITAN MUSEUM OF ART

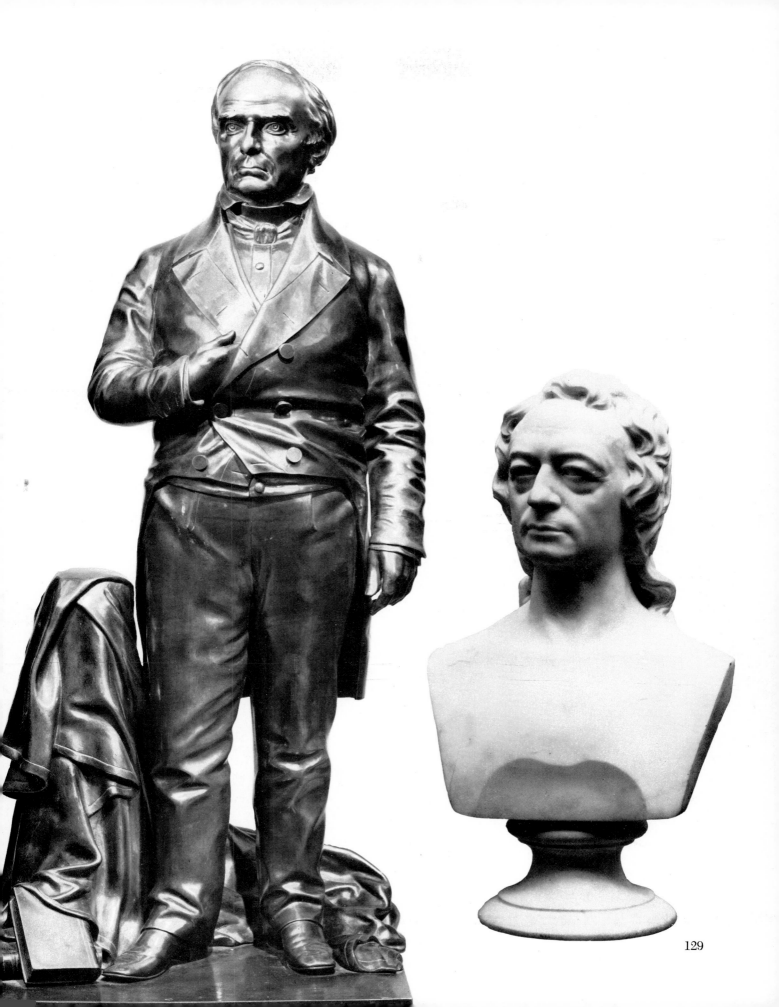

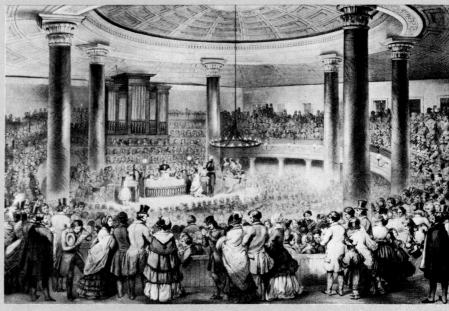

Lithograph after a drawing by T. H. Matteson depicting the distribution of American Art-Union prizes at the Broadway Tabernacle in December, 1847

The American Art-Union

Around the middle of the nineteenth century an organization known as the American Art-Union precipitated the first big art boom the country had ever seen. Recognizing the need for democratizing art and culture, the Art-Union, during its brief existence, afforded native artists patronage on a generous scale, made art available to all of the people for the first time, and finally dispelled the widely held belief that art was an indulgence for the "rich and effeminate."

The enterprise was conceived by a young portraitist named James Herring, who in 1838 opened the Apollo Gallery at 410 Broadway, in New York, as a "suitable depot for the temporary exhibition of [artists'] works . . . and for the lovers of Art as a place of resort, where they may expect to find a rich variety of subjects for study or for sale." Upon payment of a 25 cent admission fee, the public was given the rare and edifying opportunity of browsing among genuine old masters, copies of old masters, por-

traits, and an occasional painting by a contemporary American artist. When the gallery failed in 1839, largely as a result of the hard times that followed the Panic of 1837, Herring launched a second scheme, adapted from a Scottish prototype, that saw a potential art market among people of "cultivated taste" who could not afford to buy original works of art. The new Apollo Association required joiners to pay a $5 annual subscription fee, which would then be used to "purchase paintings and sculpture, statuettes in bronze, and medals, by native or resident artists." In return, members could attend free exhibitions and would receive "a large and costly Original Engraving from an American painting" as well as a numbered ticket which had a long-shot chance of winning a "hand-painted" picture at a raffle held at Christmastime. Aesthetic considerations notwithstanding, the lottery proved, over the years, to be the organization's feature attraction, for it appealed to the love of specula-

tion so deeply etched on the American character. Initially held in the New York Society Library, the lottery was such a popular success that it was later moved to the more commodious accommodations of the Broadway Tabernacle. Here, subscribers clutched their ticket stubs breathlessly as two pantalooned little girls drew the winning numbers out of urns. When it was learned that certain individuals were joining the association in December just to attend the gala event, the management was forced to set a deadline for the receipt of subscriptions.

In 1844 the Apollo Association was renamed the American Art-Union, and William Cullen Bryant was installed as its president. Honorary secretaries were appointed in nearly four hundred communities outside of New York to handle local business, collect dues, and distribute engravings and prizes. It was not without difficulty, as a Union official pointed out, that the secretaries extracted the then considerable sum of $500 from new members: "Among our subscribers, but a very small part have been volunteers . . . the remainder have been procured by the faithful services of our agent. . . . Our soil does not yield these rich fruits without thorough culture." A Committee of Management, composed of businessmen-connoisseurs, administered the affairs of the Art-Union from 1842 to 1852. They carefully decided upon purchases, guided by the principle that "all artists of the country should be equally regarded without distinction of birth-place or residence," and sought to "encourage genius and talent wherever they may be found." Indeed, by 1848, the Committee had patronized two hundred and thirty-one artists in fifteen states. Mindful at once of the exigencies of a new democracy and the prevailing Victorian moral code, these upright citizens urged aspiring artists to depict "subjects illustrating national character, history, or scenery" in a comprehensi-

ble, contemporary technique, and to eschew "impure ideas," "voluptuousness of figure," or an "enchanted sensual atmosphere" in their oeuvre. Contributors to the Art-Union included such landscapists as Thomas Doughty and Asher B. Durand, and the genre painter William Sidney Mount. George Caleb Bingham's *Fur Traders Descending the Missouri* (see page 138) and *Jolly Flatboatmen* were both Art-Union selections—the latter being engraved and distributed, in 1847, to nearly ten thousand subscribers. Immensely popular, also, was Thomas Cole's *Youth* from a nostalgic series of four paintings entitled *The Voyage of Life*, which in 1849 drew upward of half a million visitors to the Art-Union's gallery.

As the fame of the Art-Union spread into the hinterland, the middle classes clambered aboard the bandwagon. By 1846, four hundred and fifty paintings, costing over $40,000, were parceled out to some eight thousand members. The Union's success seemed so phenomenal that one president waxed euphoric: "The acorn which almost by stealth we planted . . . has become an oak. Under its spreading branches, Art reposes itself in grateful security, sheltered from many of the storms which often frown upon genius and talent. What a change has been wrought in the space of a few short years, in the prospects and hopes of American artists!"

Even at the zenith of its popularity, however, the Art-Union had detractors. There were dissatisfied artists whose works were rejected by the Union, as well as several eminent painters who felt that the work of younger unknowns was given priority over their own. Other malcontents decried the Union's crass mercenary motives, and the fact that many of its purchases smacked of mediocrity. Acting as its own apologist, the Committee of Management retorted that its selections, mediocre though they might be, reflected "the majority of quality"

in the nation at that time, and added, "This fear of mediocrity in Art comes with ill grace from a community like ours . . . no one affects to fear mediocrity in religion or learning, why should we fear it in art? . . . Someone may rise by and by, and for *his* sake we are content to encourage a host of lesser lights." On the whole, the Union believed it was implanting seeds of good taste in the populace so that great art could, at last, flourish.

The Art-Union's enemies could not be placated, and finally succeeded in silencing it once and for all. In collaboration with the muckraking New York *Herald,* they instigated a suit against the Art-Union in 1851 on the charge that it was operating a lottery which was illegal in the state of New York. Although the Union's defenders insisted that this was the only equitable method of dividing its art among the subscribers, it lost its case and the lottery had to be abandoned. For a time the Art-Union remained open as a regular picture gallery, but this aroused little interest among the new "art lovers" denied the lagniappe of the little numbered tickets. Thus, the Art-Union was forced to auction off its works in 1853, liquidate its debts, and close its doors. Similar organizations sprang up in various parts of the country, but none could fulfill the Art-Union's important function. As John Durand observed in the biography of his father, Asher, the number of artists in America had been insignificant in 1836, but "in 1851 when the Art-Union fell under the ban of law, American artists formed a large band." During its short-lived career the Union had distributed some twenty-five hundred works of art, exclusive of its subscription engravings; and Durand commented, "The Institution, if not a creator for a taste for art in the community, disseminated a knowledge for it and largely stimulated its growth. Through it the people awoke to the fact that art was one of the forces of society."

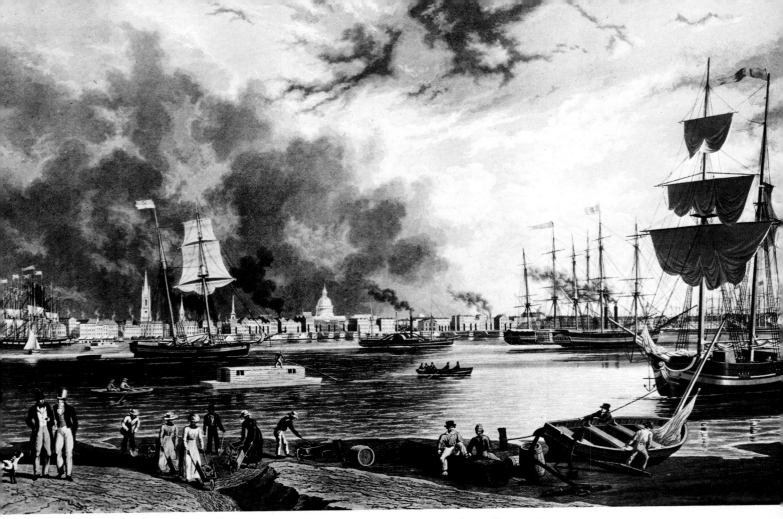

New Orleans, Taken from the opposite side . . . *(as of 1840)*, *aquatint by William J. Bennett*

Junction of the Erie and the Northern Canals *(about 1835)*, *aquatint by John W. Hill*

PRINTS AND PLACES

In 1816, very shortly after the conclusion of the War of 1812, John Hill and William J. Bennett migrated to America from England. Both men were professional artists and both were skilled aquatint engravers. Aquatint engraving is a process in which, typically, a printing plate is etched by the action of acid, carefully manipulated, biting its way through a granular covering layer of rosin. Better than any other early method of printmaking, it enabled the artist to capture the continuous tone of a water-color wash in the reproduction of many copies of the original. When the basic black-and-white designs were pulled off the plate and hand colored, they could be pleasantly deceptive replicas of the original painting, issued in quantities at a relatively low unit cost. Among his other works, Bennett produced a remarkable series of nineteen colored aquatints of American city views taken from his own paintings; in 1837 these retailed for $4 and $5 apiece. (The building at the extreme left of Bennett's view of Broadway, shown below, was occupied by George Washington during the early days of the Revolution.) Hill's aquatint views of the American scene, engraved after paintings by himself and other artists, including Joshua Shaw and William Guy Wall, were published under such titles as *Picturesque Views of American Scenery* (1820) and *The Hudson River Portfolio* (1828). As already suggested, those efforts foreshadowed the work of Thomas Cole and helped to popularize a public taste for the romantic landscapists of the coming generation.

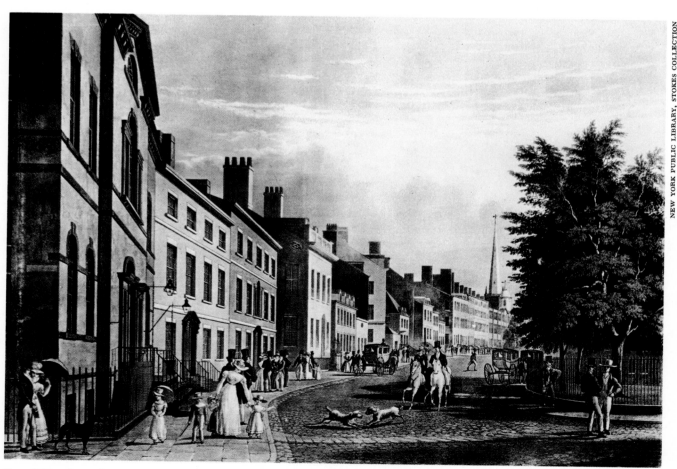

Broad Way from the Bowling Green *(about 1826), aquatint by Bennett after his own painting*

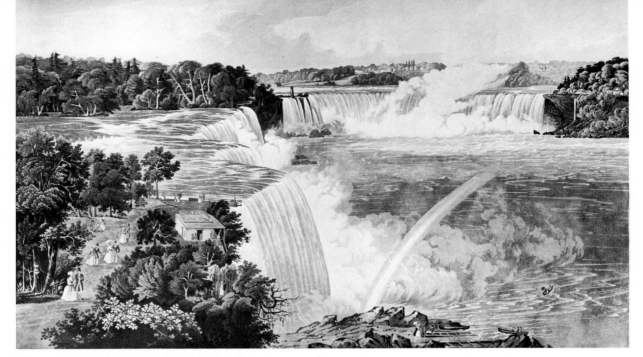

Above: Niagara Falls, Painted from the Chinese Pagoda, Point View Gardens, *aquatint by Robert Havell, 1844*

Below: View of the Natural Bridge, Virginia *(about 1835), aquatint by Bennett after a painting by Ward*

Bennett made aquatint copies of the work of other artists as well as of his own. His *View of the Natural Bridge* followed a painting of Jacob C. Ward of Bloomfield, New Jersey, a migrant who traveled to the Mississippi valley and to South America in search of subjects. George Harvey (whose work is mentioned on page 118), planned an elaborate album of engravings to be made by Bennett, but discontinued the series after the first four aquatints were issued. (Harvey settled on an estate in the Hudson River valley, close to Washington Irving's "Sunnyside," which he helped the author remodel.) Another extremely gifted English aquatint engraver, Robert Havell, came to America in 1839 after he had concluded his monumental task of reproducing the water-color drawings of John James Audubon for *The Birds of America.*

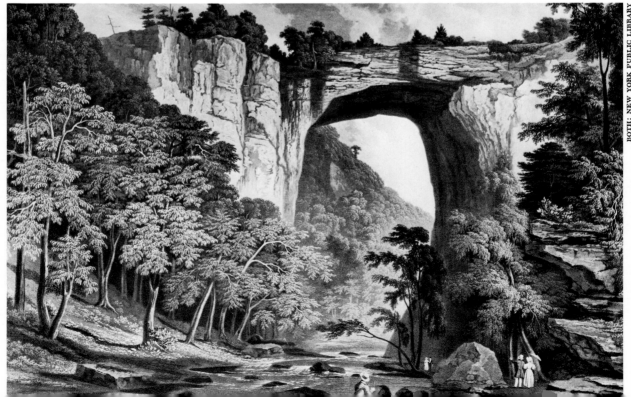

A Road Accident a glimpse thro' an opening of the Primitive Forest, *aquatint by Bennett, after George Harvey*

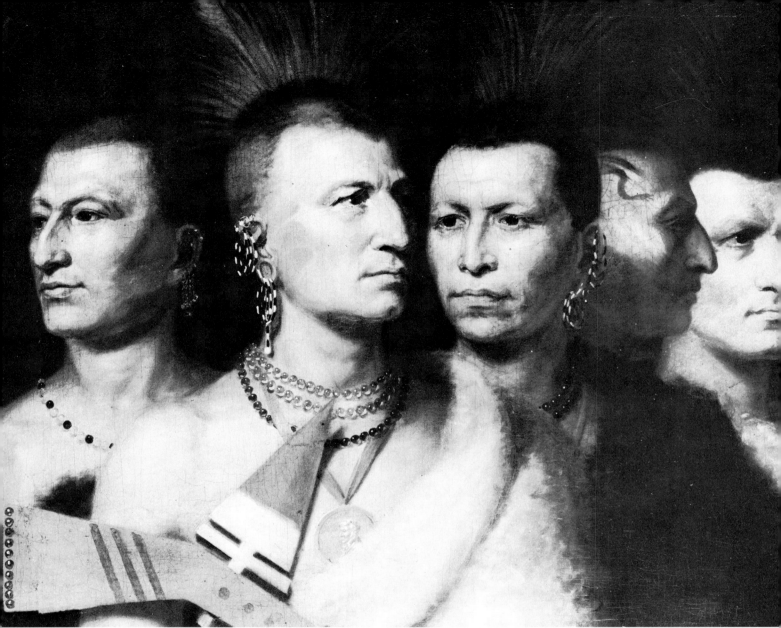

FAR WESTERN SCENES

In 1821, under the auspices of the War Department, an Indian Gallery was set up in Washington to preserve the likenesses of aborigines who came to the capital on tribal business—usually to be cozened out of their lands. Many of those portraits were painted by Charles Bird King, who had studied with Benjamin West before settling down in the capital. About that time George Catlin saw a delegation of Indians on its way through Philadelphia and was so impressed by the "silent and stoic dignity" of the "lords of the forest" that he determined to become their historian. After about eight years of painting in the West, in 1839 Catlin took his invaluable gallery of hundreds of pictures to London, where as the first Wild West show it was an enormous success and where the artist was lionized by society and by the intelligentsia. He returned to America only in 1870. Seth Eastman, a West Pointer, also made valuable pictorial records of the Indians while on duty in the West. "All his leisure time has been devoted to the study of Indian character," wrote one visitor to Eastman's post at Fort Snelling in 1847. Many of his sketches were used to illustrate books on Indians and frontier life.

136

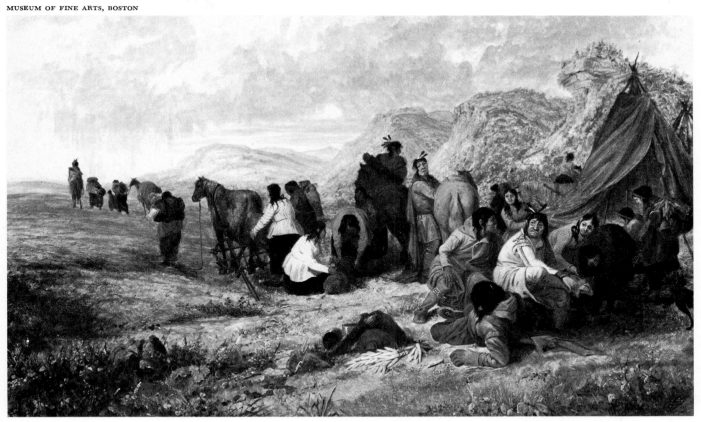

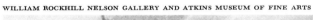

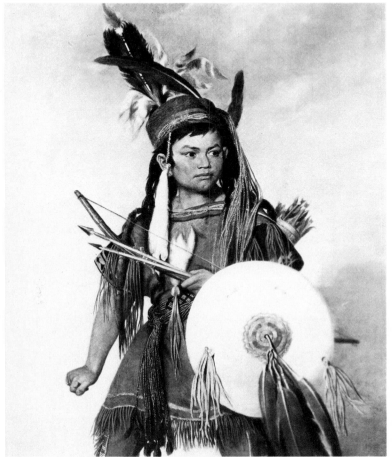

Above: Sioux Indians Breaking Up Camp, *painted in the 1840's by Seth Eastman*

Left: Indian Boy, *painted by George Catlin*

Opposite: Young Omahaw, War Eagle, Little Missouri and Pawnees, *B. King, 1821*

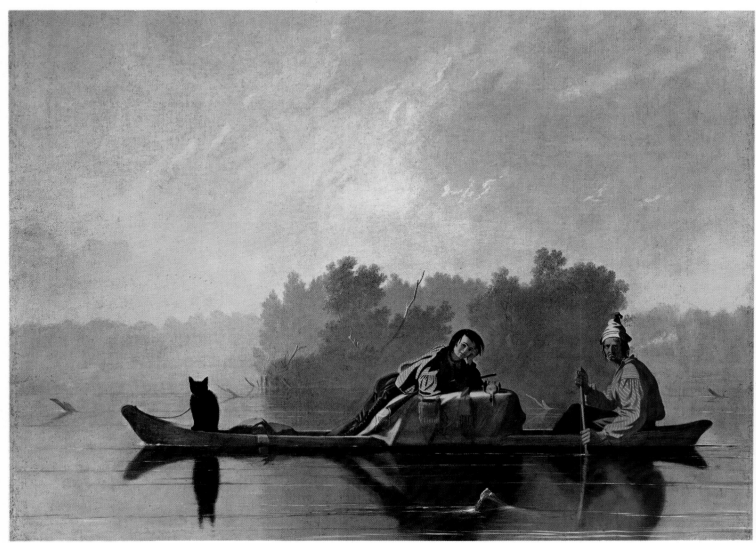

As a Westerner Bingham knew some aspects of frontier life more intimately than the Easterners who traveled to and beyond the wide Missouri River to witness picturesque features. He was familiar with the international proletariat that trapped the back country for pelts of beaver and other game, with the French-Canadian and half-breed *voyageurs* whose gaudy dress and gay song, whose endless stamina and expert zeal, were a never-ceasing wonder. *Fur Traders Descending the Missouri* pictures two of these colorful individuals and their pet racoon floating lazily downstream in a pirogue. It is a hauntingly poetic painting—Bingham's best and one of the most appealing of the time. In 1837 Alfred Jacob Miller, a young Baltimore artist, went West with the Rocky Mountain expedition of Captain William Drummond Stewart, an eccentric Scot of titled lineage who had fought under Wellington at Waterloo. In the course of a brief few months, with swift water-color sketches, Miller made what have remained unique records of frontier experience. Audubon was a toothless, grizzled veteran when, in 1843, he made his own last sortie into the wilderness—a journey to Fort Union at the mouth of the Yellowstone River to gather material for a book on mammals. He died before his sons and friends, to whom in his senility he had to relinquish the task, completed the project for him.

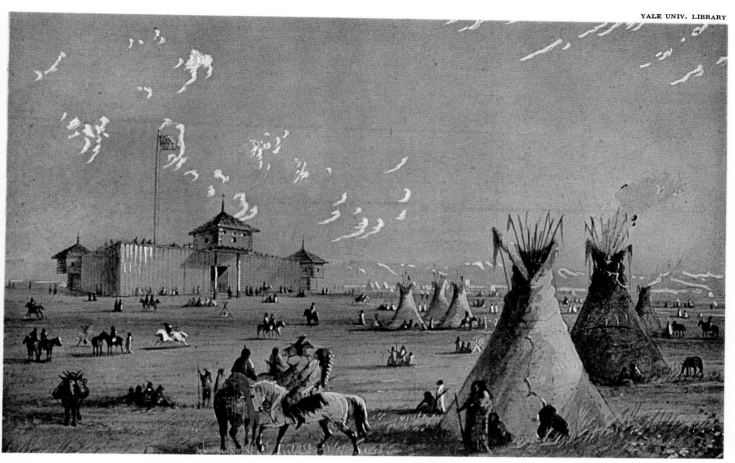

Above: Fort Laramie, a major Western trading post, painted by Alfred J. Miller

Opposite: Fur Traders Descending the Missouri, painted by Bingham about 1845

Below: water color of a wolverine, painted by John Woodhouse Audubon, 1843

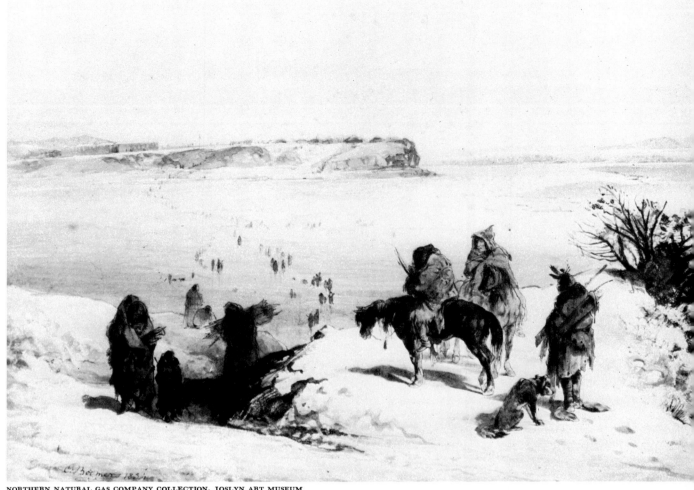

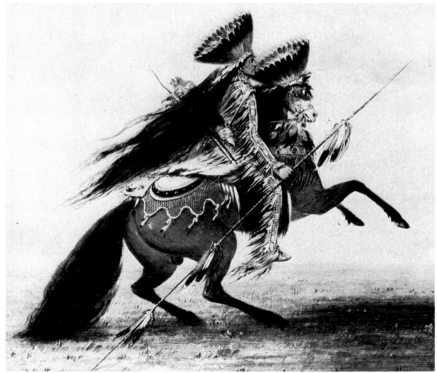

Above: Bodmer's painting of Indians approaching Fort McKenzie in dead of winter. That western outpost was Maximilian's party's farthest penetration into the North American continent.

Left: "A Crow Chief making a display of his magnificent dress and horsemanship with scalps attached to his bridle reins. . . ." Sketch by George Catlin

Opposite: Western Landscape, painted by John Mix Stanley, probably in 1853

In 1832 Alexander Philip Maximilian, of Wied-Neuwied, a Rhineland princeling
of venerable ancestry, an honored veteran of the Napoleonic wars, and
a dedicated student of the natural sciences, came to the United States—
among other reasons to chart the farther West and faithfully describe its
native tribes. He brought with him as artist-reporter Karl Bodmer, a
young Swiss then at the start of his long career. Almost everything Bodmer
produced on that American journey was intended for reproduction, to provide
specific graphic reports of the prince's observations; but as his admirer
Théophile Gautier remarked in later years, the youth had "the soul and
eye of a painter." The purely artistic quality of his work was never
lost in the reportorial realism required of him. He produced illustrations
that, in their fidelity and charm alike, present an unsurpassed image
of a vanishing America. Probably no artist who covered the early
West knew the territory and its aborigines better than John Mix Stanley,
a native New Yorker who moved westward with the general flow of population and
spent many years of his mature life exploring the world beyond the Mississippi
on his own and as a recording "draftsman" on various government expeditions
during the 1840's and 1850's. Seth Eastman thought Stanley's artistic merits
"far superior to Mr. Catlin's." His gallery of some two hundred Indian portraits
were in the Smithsonian Institution when a fire in that structure in 1865
destroyed all but five of them, a tragic loss for the artist and for the nation.

Above: The Captive Charger, *painted by Charles F. Wimar in 1854; the Indians are shown leading the captured mount of a presumably dead U.S. Army officer to their camp.*

Left: The Dying Chief Contemplating the Progress of Civilization, *designed by Thomas Crawford in the 1850's for a pediment on the Senate wing of the United States Capitol*

Opposite, top: Indian Hunter, *a small bronze model completed by John Quincy Adams Ward in 1864; a life-size replica was later cast and placed in Central Park, New York*

Opposite, bottom: aquatint after Bodmer's eyewitness painting of an intertribal mêlée between Assinboin and Cree Indians and Blackfeet at Fort McKenzie, Aug. 28, 1833

142

To many Europeans and to eastbound Americans, once he had been pushed back out of sight the American Indian remained something of a prodigy; a creature of innumerable contrasting legends, curiously resembling the uncanny, savage hunter of James Fenimore Cooper's early tales, the incredibly chaste and virtuous Atala of Chateaubriand, or the bloodthirsty scalp hunter reported by Western frontiersmen in their lurid tales. The artists who painted and modeled images of the aborigines showed them with varying degrees of versimilitude. Although the German-born Charles F. Wimar spent almost half his short life in America, where he studied the Indian in his native habitat, he painted *The Captive Charger* in Düsseldorf, Germany, and in its insistence on detail it clearly reflects the influence of that center of academic art. Crawford's heroic and melancholy marble statue is a highly romanticized study in the form of an allegory. Although John Quincy Adams Ward made a trip to study the Indians, his bronze of a stalking native with his hunting dog is a dramatic idealization of the sort that pleased and impressed contemporary critics and the public alike. At times in his travels Bodmer was confronted with what must have seemed to him nightmarish landscape and grotesque savagery, but he depicted these alien sights without reading into them what he had been taught and what he remembered the world about him *should* look like.

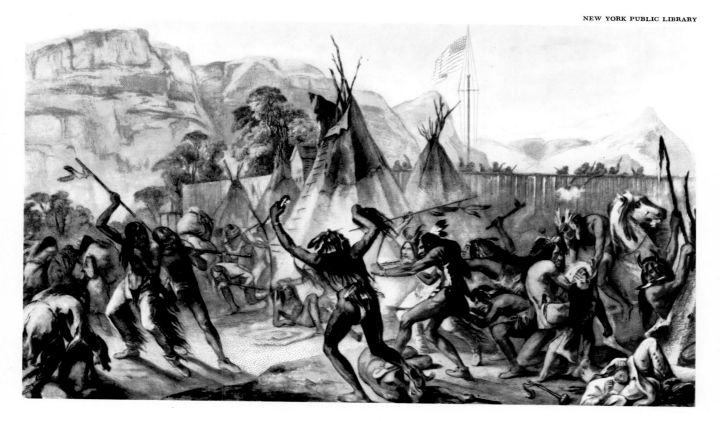

FUN, FICTION & FANTASY

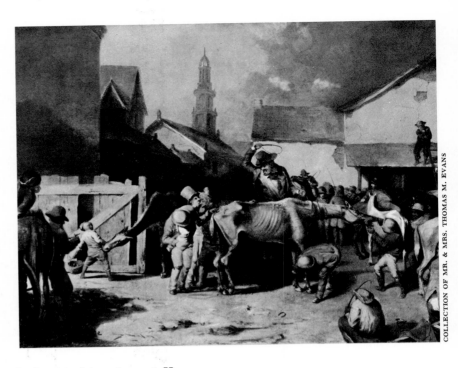

David Gilmore Blythe was a rare satirist in the history of American art. He saw the world about him with an unflinching view of the foibles and fancies of life. He had been apprenticed to a wood carver; he turned to house painting, and then served as a ship's carpenter in the United States Navy before settling permanently in western Pennsylvania. As an artist he was apparently entirely self-taught. Yet his humorous anecdotal paintings cut to the quick of matters and interested his contemporaries as they still interest us today. When a group of his canvases was shown in a local dealer's window, it was said, they were "the talk of the town, and attracted such crowds that one could hardly get along the street." From his studio, which he referred to as the rat's nest, Blythe issued to mix liquor, art, and jokes—and to observe the local world in and about Pittsburgh, reporting his observations with a critical eye that recalled the caricatures of Honoré Daumier and, further back in time, those of William Hogarth.

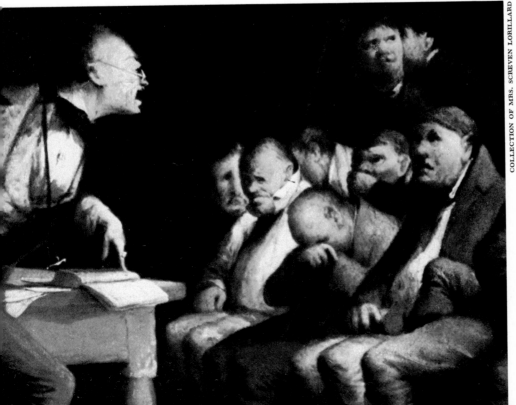

Above: Pittsburgh Horse Market, *painted by David Gilmore Blythe at his best*

Left: detail of Courtroom Scene, *painted by Blythe. The verdict was "Guilty."*

Opposite: Blythe's Post Office, Pittsburgh, *a scene of utter confusion and depravity*

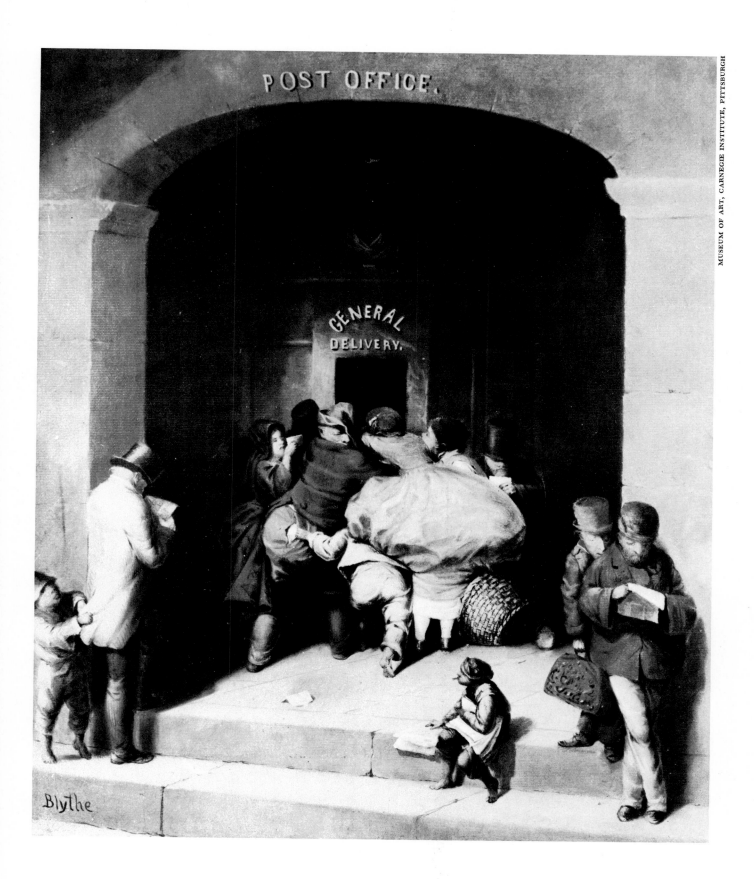

John Quidor was among the earliest American genre painters. In 1828 one
critic hailed him as "an original genius," but he never enjoyed any substantial
success. His work was too highly individualistic and his temperament too
decidedly eccentric to attract either professional followers or a wide public.
Like Blythe after him, he shunned the realism that was the prevailing convention
in the art of his time; and like Blythe he distorted and exaggerated the
appearance of things to accent the special nature of his message (as twentieth-
century expressionists have done and as other original artists have done from
time out of mind). Unlike Blythe, however, his typical and most memorable
works were not observations of the world about him, but rather illustrations
of episodes from contemporary fiction, especially the legendary tales
of Washington Irving. Even so, the results were not so much pictorial interpretations
of Irving's texts as colorful adventures into the world of Quidor's imagination,
in a weird mixture of horror and humor. For bread and butter—and alcohol—
Quidor painted signs, banners, and panels of fire engines. One of these
panels, it is said, showing a half-naked Indian maiden saying farewell to
her lover, brought topers out of bars to cheer the engine as it was
pulled through the streets.

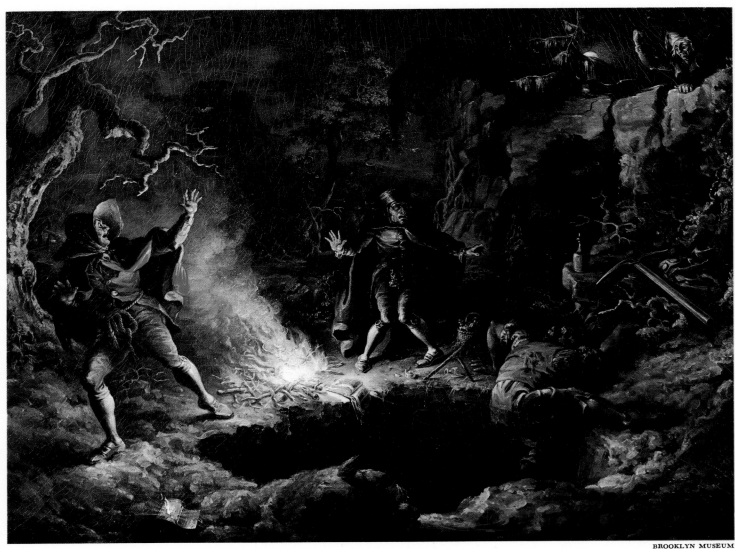

Right: The Return of Rip Van Winkle, *by* Quidor; *a detail from that painting is above.*

Opposite: The Money Diggers, *illustration of an episode from Washington Irving's* Tales of a Traveller, *also painted by Quidor, 1832*

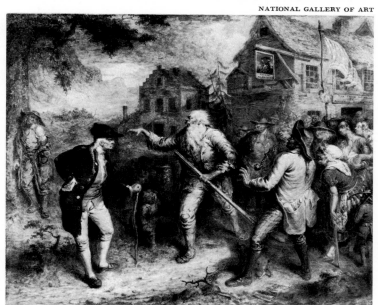

The Questioner of the Sphinx, *painted by Elihu Vedder in 1863*

Above: Flight and Pursuit, *painted by William Rimmer in 1872. Below:* Despair, *one of Rimmer's figure sculptures*

Two other artists active in the middle third of the last century also remained outside the mainstream of American painting, and also made singular contributions to the history of art in this country. William Rimmer has been called "the strangest historical painter of the American mid-century, and possibly the one possessed of the greatest inborn genius." Like Audubon before him, Rimmer's father thought himself to be the Lost Dauphin of France, a delusion that was visited on the son. Fascinated by the human figure, young Rimmer taught himself anatomy and medicine, and then taught others what he had learned, without benefit of academic license or professional degree. His haunted imagination led him to paint fantasies like his *Flight and Pursuit,* a vision of some indecipherable nightmare that is unique in the history of American art. His sculptures, on the other hand, were so anatomically correct they were thought to be casts from life. Although Elihu Vedder lived much of his life abroad, mainly in Italy, he painted his strange allegory of the sphinx in New York, his native city, during the Civil War. His ideal figures, set in a mystical Oriental scene, reflected a European trend that found its way into American painting.

EXOTIC VISTAS

At the same time that many of the nation's artists were recording aspects of the domestic landscape, other painters sought their subject matter in remote, exotic regions. A multivolume opus, entitled *Kosmos,* by the German naturalist Alexander von Humboldt, whetted the wanderlust of Frederick Edwin Church, a former pupil of Thomas Cole, by suggesting that in "the torrid zone . . . on the declivities of the snow-crowned Andes . . . an inexhaustible treasure remains still unopened by the landscape painter." From his two expeditions to South America in 1853 and 1857, Church produced heroic canvases that reveal both the beauty of the areas visited and his careful observation of scientific fact. In Ecuador the awesome volcano Cotopaxi incited Church to paint the phenomenon three times "in continuous but not violent eruption." The peripatetic painter also explored the Arctic, whence his pictures of icebergs, aptly described by the *New York Times* as "frozen white and mute with horror at the dread secrets of the ages."

Above: Cotopaxi, *painted by
Frederick E. Church in 1862*

Right: The Iceberg, *inspired
by Church's trip to Labrador*

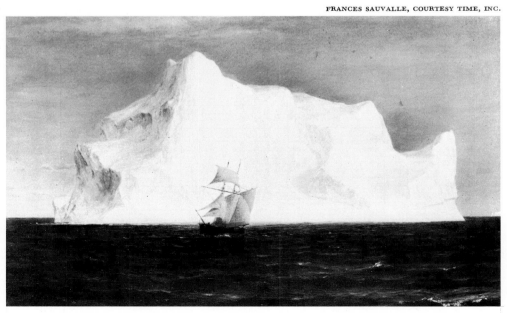

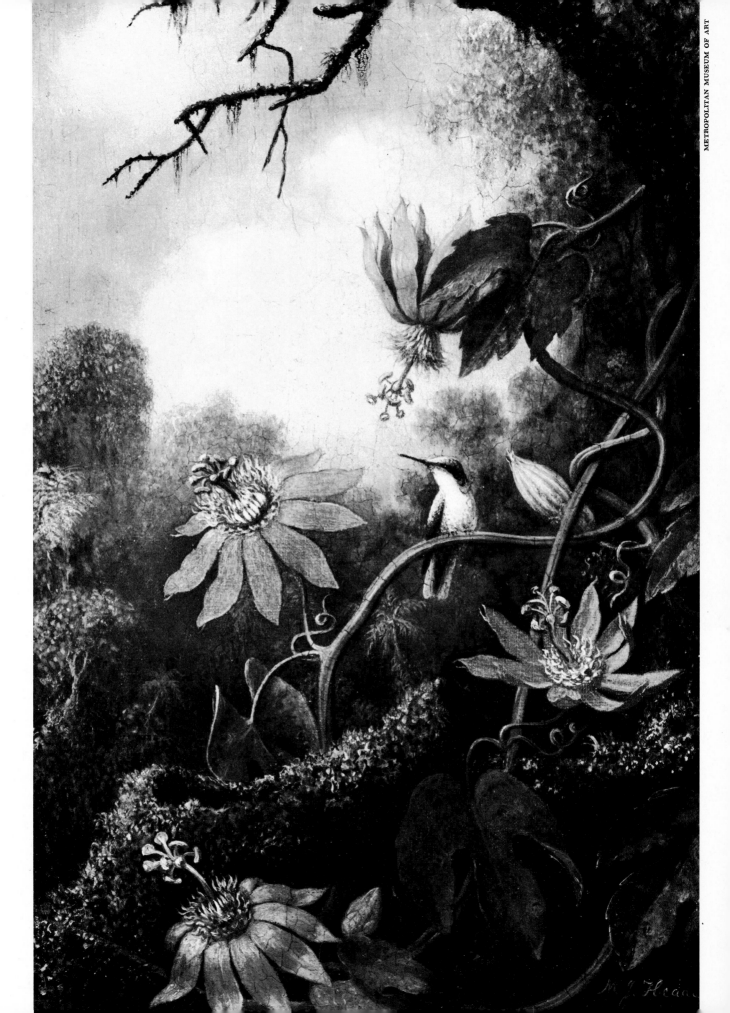

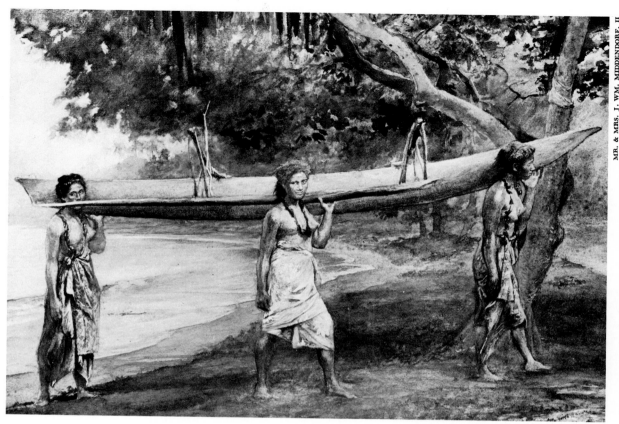

Above: three Samoan women carrying a canoe, portrayed by John La Farge in a water color, 1891

Opposite: Hummingbird and Passionflowers, *painted by Martin J. Heade on a visit to South America*

Below: another water color by La Farge, depicting Samoan girls making kava, a peppery beverage

In the 1860's and 1870's Martin Johnson Heade, like Frederick Church, traveled to South America, where the lush tropical scenery inspired his finest paintings. Lacking his compatriot's cosmic vision, however, Heade depicted the fauna and flora of Brazil's rain forests in such small, intimate studies as *Hummingbird and Passionflowers,* exquisite in their detail and subtle atmospheric effects. Heade typically portrayed the tiny birds, not in flight, as did Audubon, but perched quietly. The New York-born John La Farge voyaged even farther than either Church or Heade. After painting landscapes in the 1860's in a manner recalling the luminists, La Farge pursued a varied career that included still-life and mural painting, stained glass designing, writing, and lecturing. In 1890, a year before Gauguin made his celebrated pilgrimage to Tahiti, La Farge, accompanied by his friend Henry Adams, visited the South Sea Islands. Here in a series of vivid water colors La Farge conveyed a sense of the "rustic and Boetian antiquity" of the noble, bronze-skinned Polynesians, whom he often placed against backdrops of sea as blue as the Aegean.

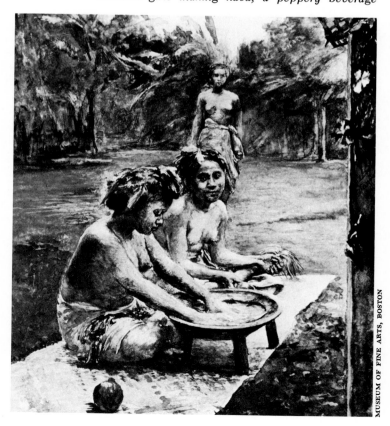

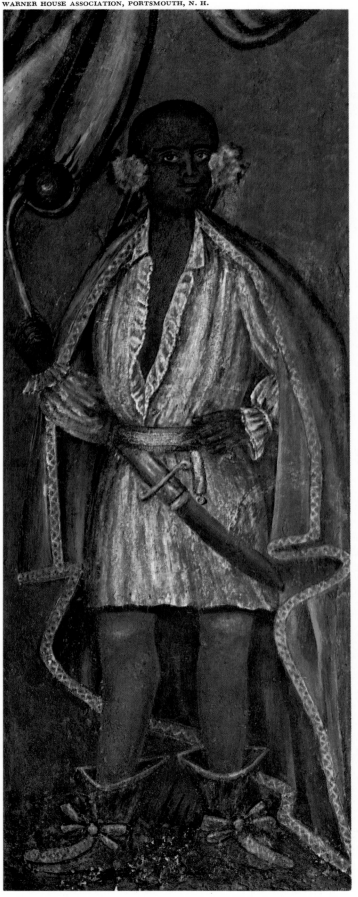

NAIVE ART

From the time of the earliest settlements in America, there has existed a current of art and craftsmanship that, compared to the high professional standards of the day, has been relatively unsophisticated in technique and expression. Diverse in form and uneven in quality, this art has been variously termed primitive, folk, and—more recently—naive art. Its practitioners have included professionals and amateurs, schoolgirls and decorators alike, who had rarely received any academic instruction in the arts and who were swayed little by the vagaries of fashion. Their creations were commonly such useful objects as ships' figureheads, weather vanes, and tavern signs. Sometimes their products merely pleased the eye. House painters, for example, enlivened the interiors of even humble dwellings with simulations of exotic woods and stenciled patterns on plain wall surfaces. They also painted murals, like the life-size representation of two Indian sachems on the stairway of a Portsmouth home, or the overmantel panel from a Massachusetts residence portraying its owner against a scenic backdrop. During the seventeenth and eighteenth centuries most of the art in this country was unsophisticated by European standards, and the distinction between folk and formal art was blurred at best. Accomplished painters limned likenesses that were little more than provincial versions of overseas portraiture. Although Shem Drowne, who executed the Indian weather vane for Boston's Province House, was a celebrated weather vane-maker of the mid 1700's, to our lights his work appears to be totally naive. Moreover, in the relatively mobile society of the era, such artists as Benjamin West began as self-taught primitives, but developed high degrees of competency and won lasting reputations. Still others, like Abraham Delanoy, Jr., who had studied in London with West, practiced on several levels at once, as his 1785 advertisement indicates: "Likenesses painted on canvas, carriages painted, ornamented, gilt and varnished. Plain house and ship painting carried on. . . . Paints mixt at short notice." In the young Republic, when cities became centers for well-trained professionals, folk artists largely took to the countryside, seeking business in isolated communities and adapting their talents to their customers' needs and pocketbooks.

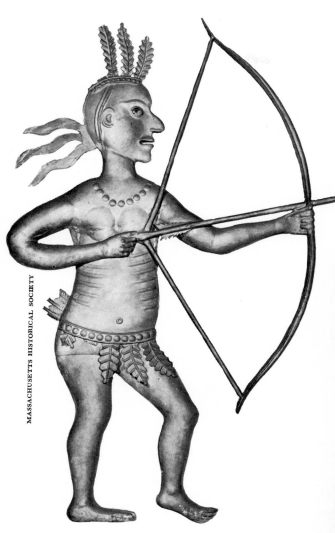

Above: Shem Drowne's Indian warrior weather vane that crowned the Province House in Boston

Opposite: mural of an Indian sachem, one of two paintings created around 1720 for the Macpheadris-Warner house in Portsmouth, N. H.

Right: pre-Revolutionary overmantel panel from the home of Moses Marcy, Southbridge, Mass.

Above: a compote of fruit, painted in water colors by Emma Cady about 1820

Below: a deer, imaginatively drawn in ink as a penmanship exercise about 1820

There were more painters per capita during the first half of the nineteenth century than at any other time in the nation's history, and much of their prodigious output consisted of folk art. Among the fertile sources of this naive work were young schoolgirls, for whom painting and other forms of handiwork were considered to be polite accomplishments. One itinerant painter who had sought commissions in Cincinnati discovered to his distress that there was "a lady artist in every family." At seminaries and finishing schools, drawing was featured in the curricula. Trained to produce still lifes on paper and fabrics, young ladies, like the talented Emma Cady, frequently depended on a stencil or "theorem" to compose the neat outlines of their apples, pears, or cherries. To demonstrate the newly fashionable Spencerean script, schoolmasters provided virtuoso displays of the proper strokes and flourishes in such calligraphic exercises as the deer shown opposite. Whether the amateur efforts of adolescent females or the work of untutored artisan-artists, a certain stylistic unity underlies the various forms of folk art. Common characteristics include the arbitrary use of color, simplified drawing, and an emphasis on expressive pattern—features which we have begun to appreciate only in recent years with our acceptance of the abstractions of modern art. The folk artist's only casual interest in imitating reality is typified by the painting on glass below. Either from intent or incompetence, its author ignored the formal rules of perspective and proportion in rendering the seated mother, and presented the baby as a miniature adult in swaddling clothes.

A mother and infant, painted in oil on glass by a New England artist about 1810

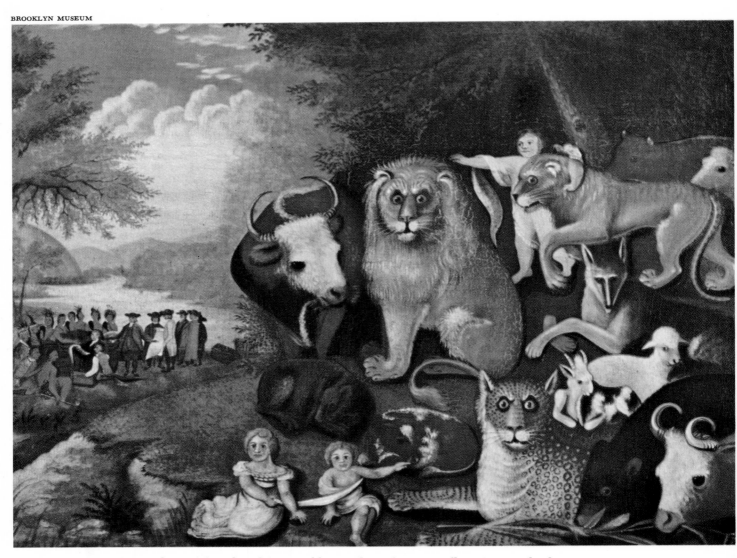

Above: Edward Hicks' Peaceable Kingdom, *showing William Penn in the distance*

The provincial folk artist of the early 1800's, who catered to a limited local public, often found it practical and profitable to engage in several types of painting. George Washington Mark of Connecticut, for instance, wielded his versatile brush painting vehicles, signs, and houses, stenciling furniture, and rendering landscapes and likenesses. In the child's portrait on the opposite page, Mark's exquisitely detailed woodwork indicates a continuity from one aspect of his profession to another. Similarly, Edward Hicks, a pious Quaker self-described as a "poor, illiterate mechanic," spent much of his adult life in Newtown, Pennsylvania, making and painting coaches, designing signs and mileposts, and depicting scenes from the Bible. Obsessed by the passage from Isaiah prophesying a time when "the wolf . . . shall dwell with the lamb, and the leopard shall lie down with the kid," this gentle spirit made the Peaceable Kingdom his perennial theme, painting the allegory more than one hundred times in the course of his career. Almost as if to underscore his own peaceful persuasions, Hicks included in many of his versions a background vignette of William Penn signing a treaty with the Indians, which was inspired by Benjamin West's famous historical treatment of the same subject.

Opposite: a child portrayed in a doorway by G. W. Mark of Greenfield, Conn.

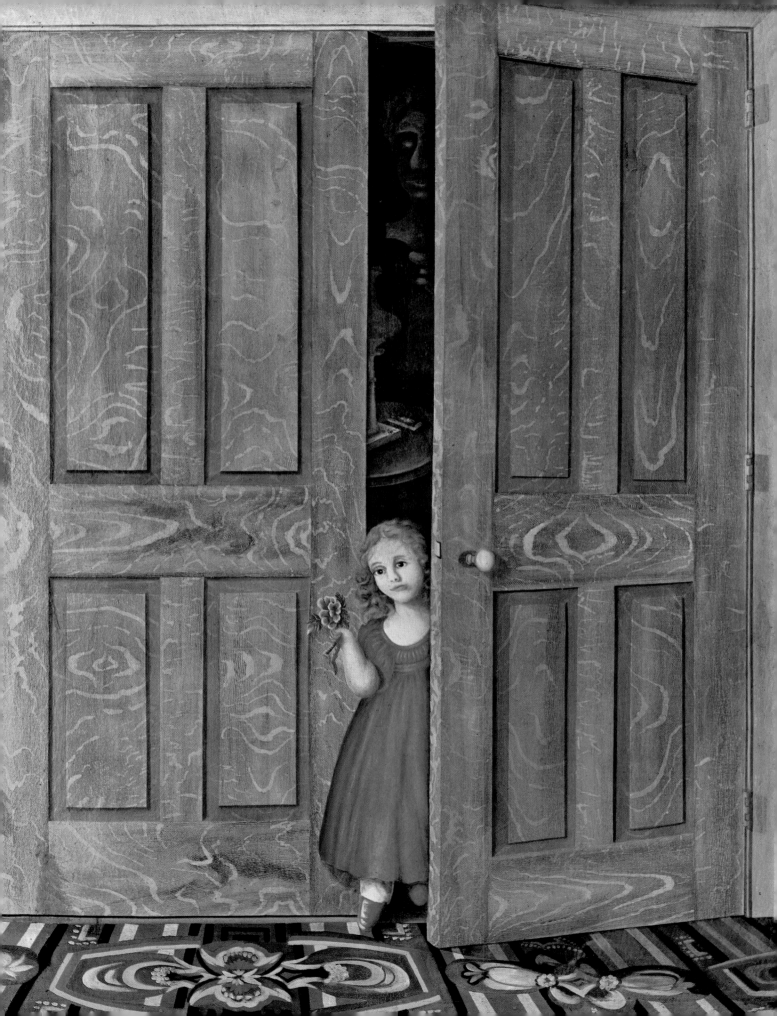

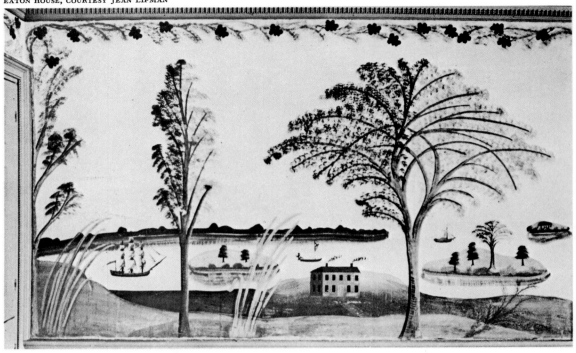

Above: a mural from Joshua Eaton house, Bradford, N. H., painted about 1824 and attributed to Rufus Porter

Left: an unidentified artist's portrait of Agnes Frazee and her child, painted in 1834

Opposite: Meditation by the Sea, *created in the 1850's by an anonymous painter*

160

During the second quarter of the nineteenth century, country painters generally took highly personal approaches to both subject matter and means of expression. The prolific itinerant Rufus Porter pursued a colorful career that included establishing a mobile one-man factory for original portraiture, writing a book entitled *Curious Arts* that contained a section on how "to change the colour of a Horse from white to black," and painting panoramic murals in houses throughout New England. Characteristic of his work is his wall painting of a harbor view, executed for Joshua Eaton's home at Bradford, New Hampshire. With typical Yankee ingenuity, Porter expedited his progress by employing stencils for his house and sailboats, and cork stoppers to print the foliage of the "feather-duster" trees. Totally different in mood from Porter's stylized renditions of the American landscape is the romantic *Meditation by the Sea,* whose anonymous artist evidently derived his inspiration from the inner world of reverie, rather than external appearances. Portraitists also represented their patrons with varying degrees of verisimilitude. Whether the individual who depicted Agnes Frazee and her child painted his subjects in their own frilly bonnets, or whether he simply used studio props to offset the angularity of their faces and create a pleasing pattern, remains unknown.

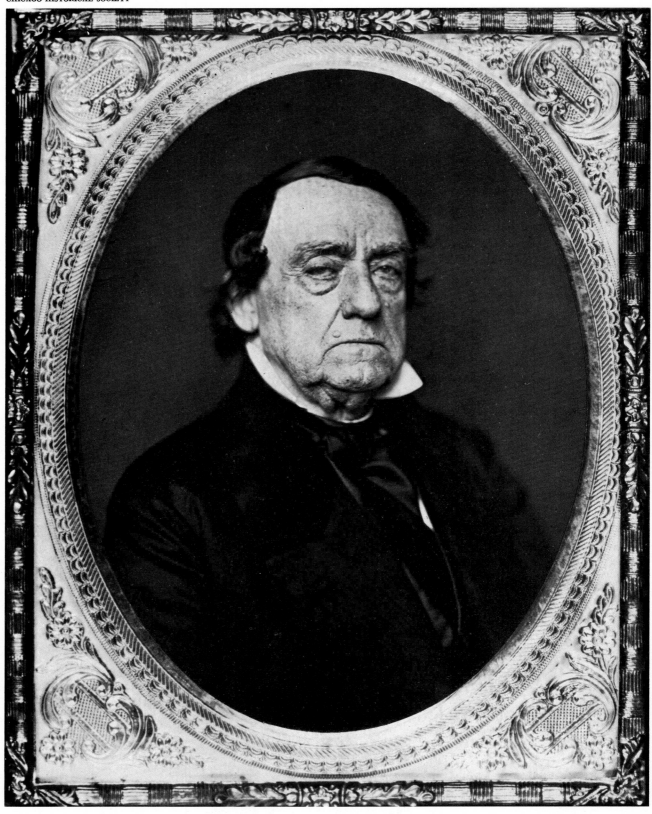

*A daguerreotype of the politician Lewis
Cass, by Edward Anthony about 1851*

ART AND THE CAMERA

When Louis Daguerre introduced his "sun picture" to the world in 1839, the Frenchman had little idea that photography would revolutionize the arts, much less the entire history of human communication. Artists, for generations, had sought a means of preserving a literal record of their visual surroundings that would eliminate the tedious task of making sketches and that would enable them to see elements of a situation beyond the range of the naked eye. Daguerre's combination of a lens, shutter, and a light-sensitive silvered copper plate, which was exposed to a still life and developed by mercury vapor, provided just that solution.

To be sure, the "new method . . . for fixing the images of nature without having recourse to an artist" had a long history dating back thousands of years. The camera obscura, consisting of a dark, enclosed space into which light was projected through a small aperture, was known to the ancient Greeks. In Renaissance Europe the apparatus was fitted with a lens, and portable models were devised. By the seventeenth century the camera obscura was a standard piece of equipment for such eminent painters as Vermeer, who employed the instrument as an aid in rendering his landscapes and portraits with optical exactitude.

Nevertheless, the first publicized accounts of the daguerreotype generated a storm of controversy that raged furiously on both sides of the Atlantic. At a time when artists aspired toward verisimilitude in their work, many regarded the camera as a competitor. And the fear was not unfounded. In America the common man was so enchanted with the realism of the photograph that the primitive portraitist lost much of his business. One critic contended that photography was not art, since it "attached no more importance to expression than a politician does to truth." Rembrandt Peale focused his attack on such technical shortcomings as the camera's inferiority to the brush in capturing nuances of shadow, and the stiff poses in camera-made portraits, caused by the use of iron head clamps to immobilize sitters during the long period of exposure. Despite such reactions, other people welcomed the advent of photography. No one was more impressed, perhaps, than Samuel F. B. Morse, who had visited Daguerre's studio in Paris. He pronounced the pictures of street scenes in which every detail, down to the smallest chimney pot, was unerringly reproduced, "Rembrandt perfected."

Morse was largely responsible for explaining the intricacies of the new medium to Americans. By mid-century photography had left its imprint on artists of every shade of temperament. Portraitists increasingly painted from photographs rather than life. The sharpness of detail in many a landscape painted in the 1850's and 1860's was due to the camera, which along with paintbox and easel had been strapped to an artist's back on his excursions into the back country. The roster of painters who relied, in one way or another, on the camera grew to include such diverse personalities as George P. A. Healy, Frederick Church, Frederic Remington, and Thomas Eakins. Perhaps the impressionist Theodore Robinson offered the best explanation for the popularity of photography: "Painting from nature is difficult as things do not remain the same, the camera helps to retain the picture in your mind."

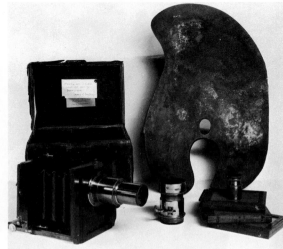

The camera and palette that served Thomas Eakins in his paintings

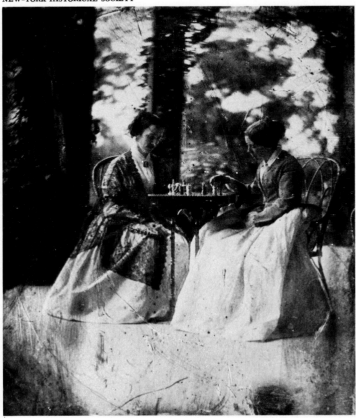

Shortly after Daguerre announced his discovery, the academician Paul Delaroche acknowledged that the new process for making pictorial records "completely satisfies all the demands of art," and predicted that photography would "become a subject of observation and study even to the most accomplished painter." His prophecy was soon fulfilled. One of the first artists of note to use the camera was Samuel F. B. Morse, who took daguerreotypes "to accumulate for my studio models for my canvas." His wife and daughter were among Morse's favorite subjects; he photographed them repeatedly over the years. In 1839 the two women had posed patiently "from ten to twenty minutes, out of doors, on the roof of a building, in the full sunlight, [and] with the eyes closed" for the world's first portrait photograph. In the 1880's Thomas Eakins not only used the camera as an aid to his painting, but recognized photography as an art in its own right, and adapted elements of his personal technique to the medium. Eakins' snapshot of his two nephews beside a brook on their Avondale, Pennsylvania, farm, for example, reflects the artist's concern for carefully balanced compositions —the water line and tree bisect the picture—as well as his painterly style in his use of the soft focus technique to evoke a mood of rustic tranquility. Many professional photographers, including John Moran, brother of the landscapist Thomas Moran, likewise realized the close interaction of art and photography. Moran's arrangement, entitled the *Delaware Water Gap*, with its feathery trees and luministic effects, clearly demonstrates that photography, at its best, was more than a mere collection of facts, and could quite correctly be termed "photographic art."

Left, top: daguerreotype of Samuel Morse's wife (left) and daughter, taken after 1848

Left, bottom: Delaware Water Gap, *recorded by John Moran of Philadelphia in 1863*

Opposite: Thomas Eakins' photograph of his nephews on their farm at Avondale, Pa.

Above: The Arch of Titus, *painted in 1871 by Healy, Church, and McEntee. The photograph of Henry and Edith Longfellow (opposite, top left) served as a model; the grid was added by the artists, to be used as a scaling mechanism.*

Opposite, bottom left: Henry Robinson's Fading Away, *1858, shown reversed*

Opposite, bottom right: A Portrait of the Artist's Mother by James Whistler

After the Civil War, photographs aided artists in a variety of ways. While painting the *Arch of Titus* in conjunction with Frederick Church and Jervis McEntee, George Healy used snapshots of Henry W. Longfellow and his daughter to help recall their earlier meeting in Rome. Similarly, Henry Robinson's sentimental *Fading Away* served as a prototype for James Whistler's portrait of his mother. And, in 1878, painters who had traditionally rendered the galloping horse with its legs outstretched, learned that they had been in error. A series of pictures taken by Eadweard Muybridge proved that at one phase of the gait, all four legs were lifted and tucked under the animal's belly. Thereupon, such artists of the horse as Frederic Remington revised their methods.

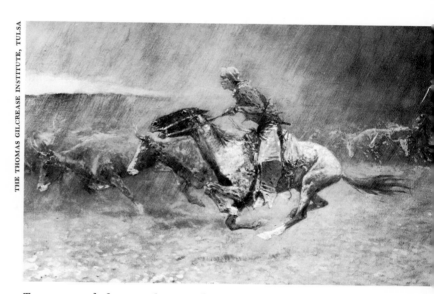

Top: reversed photograph of Muybridge's galloping horses

Above: Stampeded by Lightning *by Frederic Remington*

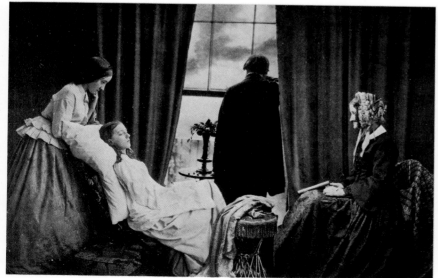

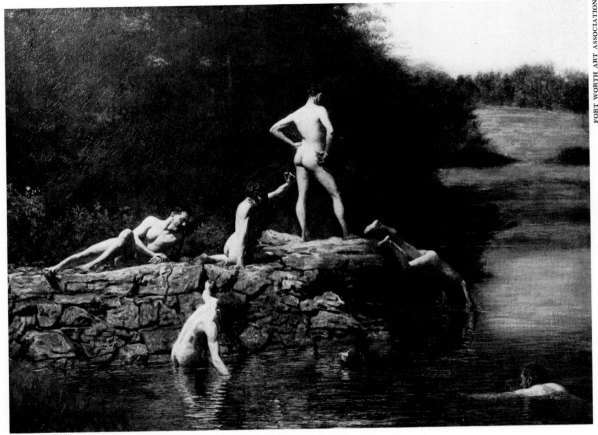

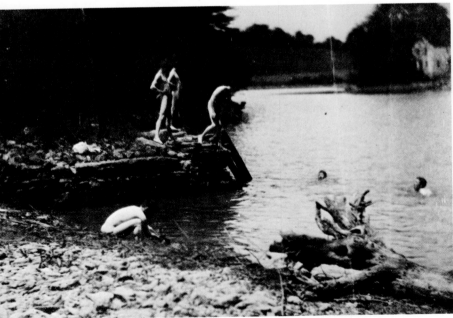

Top: The Swimming Hole, *painted in oil by Thomas Eakins in 1883*

Bottom, left: Eakins' photograph of his students at the swimming site

Bottom, right: snapshot of nude Thomas Eakins playing the pipes

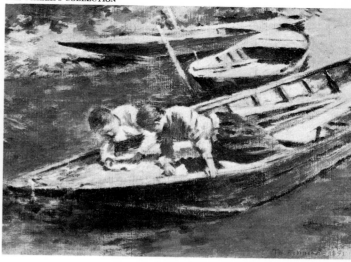

Above: Two in a Boat, *painted by Theodore Robinson, and its photographic source (above, left)*

Below: photograph taken by Charles Sheeler in 1939, and the source for Rolling Power *(bottom)*

Inspired by Muybridge's photographic analyses of animal locomotion, Thomas Eakins made several camera studies of the nude form in action, and, upon occasion, even doffed his clothing to model himself. The moving figures in the *Swimming Hole,* for instance, owe their anatomical correctness to a snapshot taken by Eakins probably in 1883. Unlike Eakins, the impressionist Theodore Robinson was somewhat apologetic about using photographs for such outdoor scenes as *Two in a Boat,* painted in 1891. He confessed, "I don't know just why I do this . . . partly I fear because I am in New York where other men are doing this; it is in the air." The camera's close relationship to art has continued well into the twentieth century. In glorifying industrial technology in pictures like *Rolling Power,* Charles Sheeler approximated the smooth surfaces and precise detail of his own expertly composed photographs.

Art should be independent of all claptrap—should stand alone, and appeal to the artistic sense of eye or ear, without confounding this with emotions entirely foreign to it.

—JAMES MCNEILL WHISTLER

YEARS OF PEACE & PLENTY

Opposite, detail of Thomas Eakins' The Gross Clinic (above), painted in 1875

The events and circumstances attending the Civil War loosed titanic forces that radically transformed the American scene in a remarkably brief span of years. Looking back at what had been achieved before the war, and contrasting it to developments that grew out of that conflict, seemed to one chronicler of the times like reviewing ancient history. When young Henry Adams returned to his native land in 1868 after serving in London as his distinguished father's secretary, he encountered a world almost unrecognizably different from the one he had left just ten years earlier. In effect, he observed, a revolution had taken place during his absence. The postwar generation, in which he must now find his place, was geared to other values than those he had been taught to cherish—values that would impose a new order on American society and culture, as on politics, industry, and commerce.

The changes that the war brought to a crescendo had been developing at a progressive rate for decades past. They could be traced in the accelerating growth of railroads, the gradual consolidation of the factory system, the spreading influence of wealth, the widening way to the West, and the swelling tide of immigration. By 1860 the railroads alone were absorbing about half the output of the country's burgeoning iron mills and furnaces. Then, military demands for iron and steel products of higher and more uniform quality, handled in larger masses and worked to more exacting specifications, tremendously encouraged improvements in metalwork practices.

Shortly after Appomattox, American manufacturers undertook to make steel by the Bessemer process, an operation that delighted onlookers with its brilliant showers of hissing sparks as air was blown through the incandescent pig iron in the converters. More to the point, steel production soared upward and steel prices tumbled downward. Twenty years after the close of the war America was the greatest steel-manufacturing nation in the world; and by then steel production had become a basic index to the industrial prowess of nations. A large part of that production went into more tracks for railroads. (Between 1865 and 1872 railroad mileage in the country doubled.)

Over these years machine farming on an unprecedented scale found its perfect proving ground in the American West. During the 1860's more than eight million

Engraving depicting the threshing of grain by steam in Dakota, 1879

The production of steel by the Bessemer process, a woodcut of 1886

acres of new land were brought under cultivation in Illinois alone. As Lincoln claimed during the war, the fertile basin west of the Mississippi was America's Egypt, an incalculably rich granary that had barely been tapped before the war. During those same postwar years, with explosive suddenness, the "cow country" burst out of its Texas corner and spread over an enormous domain stretching from the Rio Grande to Canada and from central Kansas to the Rocky Mountains. Exports of meat and meat products rose from about thirty-seven million dollars in 1865 to over one hundred sixteen million dollars fifteen years later. The United States was becoming the world's greatest single source of food. The immense flow of American produce upset the habits of Europe as completely as the importation of American gold and silver had done during the days of the *conquistadores.* Those great harvests of wheat and beef (and the volume of Western manufacturers as well) could never have been carried to market on the relatively soft iron rails that had earlier served of necessity.

Meanwhile, the increasing scale of industrial operations of various kinds made it desirable to integrate the processes of manufacture in ever larger units. Industrial organization entered a new phase in which the problems of mounting production could be efficiently centralized, if need be, thanks to steam power fired by plentiful coal supplies and to the proliferation of the railroads far from the sources of raw materials, from scattered sites of water power, and from the ultimate markets for finished goods.

To provide the raw materials that fed the factories the nation mounted a gigantic treasure hunt. In the process forests were obliterated, hills and mountains were plundered, and the soil of the land exploited for all it was worth. For the moment the appalling waste could not be counted in the mad scramble for instant profits. The war had uprooted the native population, which never had been very stable, and wandering people sought everywhere for better prospects, for rewards to be drawn from the seemingly inexhaustible resources of the continent. In the wake of the native migrants followed a horde of immigrants who put their brawn, energy, and persistence to work in field and factory.

By 1870 petroleum, hardly known before the war—except as an occasional remedy for various types of aches and pains—was being pumped from newly discovered oil fields at the rate of five million barrels a year and being used for an increasing number of industrial and domestic purposes. The formation of The Standard Oil Company (of Ohio) in 1870, with a capital of one million dollars and a position of massive strength in the mushrooming industry, was but a token of the greater build-up of large operating units, concentrated resources, and centralized control that was to follow in other industries.

The traditional domestic economy was definitely a thing of the past, replaced by what has been colorfully referred to as a "buccaneering orgy." That unbridled speculation and booming prosperity was attended by corruption that was also practiced on an unwonted large scale in both public office and private industry, and by extravagant displays of new wealth. This was "the gilded age," a term Mark Twain and Charles Dudley Warner used as the title of a novel, published in 1873, in which they deprecatingly characterized that immediate postwar period. As Emerson observed, more than a little of the old idealism vanished in those

years of change; the youthful and generous dreams of the early republic and the exalted hopes of the patriot fathers faded into limbo. And, as Van Wyck Brooks has suggested, it left the mind of the people morally flabby in contrast.

The merits of the art of the prewar decades were limited but still considerable; in any case, they reflected a harmony with the daily American experience of those years. By and large, the representative artist of the period shared a common vision with the society about him. Unlike his European counterpart, he worked not from some established artistic dogma, but rather from an intuitive and natural relationship with an appreciative public audience. But in the succeeding shuffle of aims and values that was redirecting life in America, that cultural unity was lost. It was just one indication of shifting orientations that wealthy American patrons were swarming overseas to loot Europe of its art treasures with which to fill their European-style mansions at home. "As wealth and European travel have increased," it was reported in 1876, "a taste for the skilled handiwork of foreign craftsmen has been rapidly developed among our [American] people, and the desire to become the possessors of elegant objects to make homes attractive has amounted almost to a passion." Henry James in his novel *The American* dramatized the sorry plight of the wealthy American who fled to Europe to acquire the culture he felt could not be found in the raw, commercial atmosphere of his own country. James himself was not immune to such sentiments, and he chose to quit his native land to live abroad as an expatriate.

Harper's Magazine had earlier commented on this developing preoccupation with European cultural values on the part of wealthy Americans (and some not so wealthy) and their looting expeditions overseas. "What is fine in the buildings of the old countries we can borrow," wrote the magazine's editor prophetically; "their statues and their pictures we will be able in good time to buy." However, to the delight of many other Americans, in *The Innocents Abroad* Mark Twain pointed out that much of European culture was pretense and fraud and alien to solid American virtues that might better be cultivated and appreciated. But that did little or nothing to halt the incoming tide of foreign treasures. In 1870 the Metropolitan Museum of Art in New York and the Museum of Fine Arts in Boston were incorporated, fulfilling old intentions, and booty from around the world found its way into their galleries, as *Harper's* had predicted would happen. After a visit to the Metropolitan in 1873, the diarist George Templeton Strong remarked: "Art treasures (so-called) are evidently accumulating in New York, being picked up in Europe by our millionaires and brought home. This collection promises very well, indeed. Twenty years hence it will probably have grown into a really instructive museum."

It was during those years that Richard Morris Hunt, after intensive study at the Ecole des Beaux-Arts in Paris and extensive travel in Egypt, Turkey, Italy, and —most significantly—the Loire Valley, won his towering reputation as architect for the very rich. The sumptuous and ostentatious "French chateaux" he built in Newport, Rhode Island, in Asheville, North Carolina, in New York, and elsewhere for the Vanderbilts and other millionaires showed off fashionable society in its most exaggerated state. One French visitor remarked that they might have been removed from the Loire Valley without disturbing the traditional, mellowed

Woodcut showing the arrival of grain in New York by rail, 1877

Excitement in the Oil Fields, lithograph of 1865 showing the frenzied dash for wealth by speculators

Frank Waller's interior view of the Metropolitan Museum of Art when it was located on West 14th St.

aspects of that part of the world. The architect's older brother, the painter William Morris Hunt, after his own studies abroad in Barbizon, Düsseldorf, and Paris, had also returned to America, and as a dedicated and competent disciple of the artist Jean François Millet sparked a fresh interest in French painting in this country. (When the Boston Museum opened its first building in the winter of 1875–76, for example, its collections included no less than seven pictures by Millet.)

About this same time European painting, notably in France, was reaching a new high point in its development, and a host of other American artists crossed the ocean to search for inspiration and to learn from European example and teaching. Earlier generations of painters had gone abroad, to be sure, but for the most part they had done so as mature men whose basic approach to art had already been formed. This later group, now speeded and eased on its way by railroads and steamships, went as students looking for direction which, when they found what they needed in Munich, Paris, or wherever, made a solid impression on their style and technique.

Although most of these touring students in good season returned to America to exercise their new-found skills, some stayed on to live out their professional lives as expatriates. As early as 1855, after being dismissed from West Point, James Abbott McNeill Whistler left his job of a few months with the Coast and Geodetic Survey in Washington and went to Paris, at the age of twenty-one, to study art under Charles Gabriel Gleyre. (As a lad Whistler had studied drawing at the Academy of Fine Arts in St. Petersburg in Russia, where his father had gone at the bidding of Czar Nicholas I to build a railroad.) In 1863 he showed *The White Girl* at the Salon des Refusés, along with Edouard Manet's *Déjeuner sur l'herbe*, which was considered one of the most scandalous attractions of that notorious exhibition. Following that experience, he moved to England and there continued a controversial but successful career.

Whistler was the first American artist to express outright scorn for the importance of subject matter in painting; and, as well, to decry any pretense to national expression in art. "There is no such thing as English Art," he once observed. "You might as well talk of English Mathematics. Art is Art, and Mathematics is Mathematics." This elegant wit, insisting on art for art's sake, developed his own highly personal style based on the intrinsic interest of formal, decorative harmonies which he disassociated from their ostensible subject by labeling them Nocturnes, Symphonies, and Arrangements. One of his so-called Nocturnes enraged the aging English critic John Ruskin, who wrote: "I have seen, and heard, much of Cockney impudence before now; but never expected to hear a coxcomb ask two hundred guineas for flinging a pot of paint in the public's face." Whistler sued the old man for libel, as much for the sport of it as for any better reason. The trial, at which the artist displayed his acid wit before an amused audience, ended with an award for damages of one farthing (see pages 184–85). In any case, Whistler created a greater sensation in European art circles than any American painter had done since Benjamin West. Few Americans were prepared to follow his lead (he had no pupils), but his influence on the aesthetic theories of his day were considerable.

His younger American contemporary John Singer Sargent also studied and

worked in Paris, and at an early age also caused a stir in artistic circles. (Henry James wondered at "the slightly uncanny spectacle of a talent which on the very threshold of its career has nothing more to learn.") In 1883 one of his paintings shown at the Paris Salon of that year was purchased by a Boston collector for a sizable sum and sent back to Beacon Hill. For an American patron to buy a painting by an American artist in Paris was almost unheard of, and the transaction created a sensation of sorts. Two years later Sargent's "daring" portrait of *Madame X* (his designation for Mme. Pierre Gautreau, a celebrated beauty of the day), a painting which he later believed to be the best he had ever done, caused such a shock that, like Whistler before him, he removed to London, which from then on became the center of his eminently successful career (with "branch offices" in Boston and New York). Utterly cosmopolitan, Sargent produced masterful and flattering characterizations and with consummate virtuosity. To be "done" by his fashionable brush for $5,000 and up was a distinction and a privilege.

Still another expatriate was Mary Cassatt, an extraordinary young Philadelphian who overrode her wealthy parents' objections and went to Paris to study art. There she worked with Degas and became an established member of the impressionist group. She remained a spinster who found a vicarious motherhood in her glowing depiction of women and their small children. Beyond those considerable achievements, Miss Cassatt introduced her wealthy American friends to the new art and urged them to collect it. By such persuasiveness she had an important influence on the development of American taste—at least the taste of some outstanding American collectors.

There were many others who returned from overseas and who contributed substantially to the changing pattern of American art when they regained their native land. They swarmed in numbers far too many to list here; they studied under masters of various styles and techniques, not only in Paris but in Düsseldorf, Munich, Barbizon, The Hague, and elsewhere; and they brought home the intention to paint in the manner of their different instructors (as Hunt had earlier done). Almost inevitably those intentions were modified to a degree by the separate circumstances that characterized the American scene. However, quite enough of foreign influences remained to introduce new and variant strains into the development of painting in this country, as will be shown in later pages of this book.

In the meantime, at home in America, other artists were exploring the scene about them and finding a flattering reception for their canvases in some quarters. Although the landscapist George Inness made a number of trips to Europe, he was in the beginning largely self-taught, and his earlier and possibly his best paintings show the influence of the native Hudson River school as much as that of European practices. Another landscapist, Albert Bierstadt, who had returned to his parents' native city of Düsseldorf for training, brought a new talent to the vast panoramas of the American West, which he painted, typically, on a heroic scale. So celebrated was his work that when his huge *The Rocky Mountains* was first shown in New York, banners were strung across Broadway to announce the event. One further indication of Bierstadt's reputation in his own day (he was "the most talked of artist in New York," according to one observer) was that he could

John Singer Sargent in his Paris studio, and behind him, the celebrated portrait of Madame X

175

command up to $35,000 for a canvas, a higher figure than had ever before been paid to an American painter.

In the decades that followed the Civil War, two other entirely different artists, both strongly independent and utterly candid in their vision of the world about them—Winslow Homer and Thomas Eakins—were painting canvases that today are rated among the finest the New World has produced. To Homer's indigenous spirit and native temperament art for art's sake was unthinkable. For him art was the answer to a compulsive instinct that, like mending the fence and gathering the hay, had its right moment. He painted what he wanted, when he wanted, as he wanted. More than once he wrote his impatient agents that he was too busy with homely chores to think of painting. When, at one point, he was asked to be a candidate for the Carnegie Institute jury he reluctantly accepted under pressure. "I do not regret to say and I will say," he wrote the director of the institute, "that I have been more interested in other matters than Art for the past year."

Homer was utterly free of the pose and cant that made such a mystery of art in some circles. Once, irritated by the attentions of a would-be authority on his work, he retorted: "I care nothing for art." The truth underlying that display of cussedness is that he would not be forced into attitudes toward art, his own or anyone else's. He worked almost without reference to the prevailing modes, and only once, later in life, did he admit that he might have profitably mixed more with his fellow artists. He had no teachers, really, and no pupils, and he was the sole great independent artist of his day to win recognition during his own lifetime. The often rude strength of his work, the plain honesty of his vision, his understanding of the elemental forces of nature, and the rugged independence of his accomplishment led one French critic to describe him as *le yankee des yankees.*

Thomas Eakins dealt largely with a more urban milieu. But here again, uncompromising integrity, a high degree of technical competence, and uninhibited candor produced images that caused some of his fellow citizens of Philadelphia to flinch from the realities he so expressively revealed; and they virtually ostracized him when he attempted to teach his female students to paint from "the absolute nude." "People who like Eakins best," wrote Walt Whitman, "are people who have no art prejudices to interpose"; and of those Whitman had none. (The poet also admired a large painting of Custer's Last Stand, which qualifies our judgment of him as an art critic.) Like Homer, Eakins had visited France, and he had studied there at a time when Manet's art was the scandal of Paris.

But Parisian vogues held no fascination for Eakins either, who was primarily intent on perfecting his technique in order the better to express his own intensely personal vision. To this end he worked himself into a state of illness. However, he accomplished his purpose, and after a refreshing and instructive visit to Spain he returned to Philadelphia to paint the familiar life of his family and friends and the passing scene about him. His professed objective was "to peer deeper into the heart of American life," and this he did to a degree and in a way that is unmatched in the history of American art. He may well be, as has been claimed, America's greatest painter. However, his uncompromising realism, the probing criticism of his brush, and, often, his choice of subject (his nudes, scenes of the boxing ring, the blood-stained hands of a surgeon at work, and so on) rather tended to shock

Detail of a photograph portrait of Winslow Homer, still dapper at seventy-two

and displease a public accustomed to prettier pictures and to subjects less searchingly revealed. Even his friends sometimes found their portraits by Eakins disturbingly profound and refused to take them home as gifts. Until he was dismissed from several posts because he insisted that his students learn to understand the problems of painting a living nude figure (the human body, he insisted, is "the most beautiful thing there is"), Eakins was an immensely effective teacher. But his whole approach to art was too unconventional and unfashionable to attract a wide audience. He did not live to see his reputation reach the secure pinnacle on which it rests today. When he died in 1916 he was relatively unknown.

There were other artists, many of them, of varying degrees of competence who returned from their European sojourns to find their countrymen indifferent to their work. Wealthy patrons who had developed a taste for traveling abroad had, like the artists themselves, learned to admire the fashionable painters whose works they saw in Paris and elsewhere on the Continent. By and large, they preferred to pay sizable sums for such originals, even by men who are today considered second- and third-rate talents, rather than speculate on the output of American imitators, whatever their merits. Around mid-nineteenth century painting was a fairly lucrative profession in America. When Jasper Cropsey auctioned off his studies and sketches in 1856, the editor of *The Crayon* wrote: "We believe that in no other country will the same class of pictures bring so high prices as here, especially if they are painted by American artists." A few decades later that was hardly true, notably the last phrase. While paintings by the most representative Paris- and Munich-trained Americans went begging on the market, William H. Vanderbilt and A. T. Stewart, for example, were paying $50,000 and $60,000 for laboriously storytelling, detailed illustrations—for they are essentially that—by the popular, long-since devaluated French artist Jean Louis Ernest Meissonier. (On the other hand, as early as 1889 the Metropolitan Museum of Art received as a gift two important paintings by the outstanding impressionist Edouard Manet, whose reputation was only to rise in the years to come.)

To consolidate their position and publicize their work, in 1877 the younger painters—and some of the more progressive academicians—founded the Society of American Artists, a group independent of the older, conservative men who dominated the National Academy. It was the beginning of a rift between the adventurous seekers after new truths and the steadfast guardians of established tradition that widened with time. For the moment at least, the American public in general was slow to accept the innovators (the same thing was true in France), who found more publicity than buyers for their works. When the younger men who had formed the new society went abroad to study, painting was still a fairly lucrative profession in America; when they returned, however, as indicated above, they found it was not possible to make even a decent living by their brush, whatever their talents or wherever they had studied. After almost thirty years the members of the Society returned in a body to the fold of the National Academy. But even while the younger organization proudly functioned, some of its members broke away to form a separate group of still more liberal spirits. With the passing years that sort of fission within the art world would accelerate.

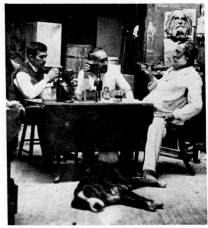

Thomas Eakins (center) with sculptor friends; photographed by Eakins

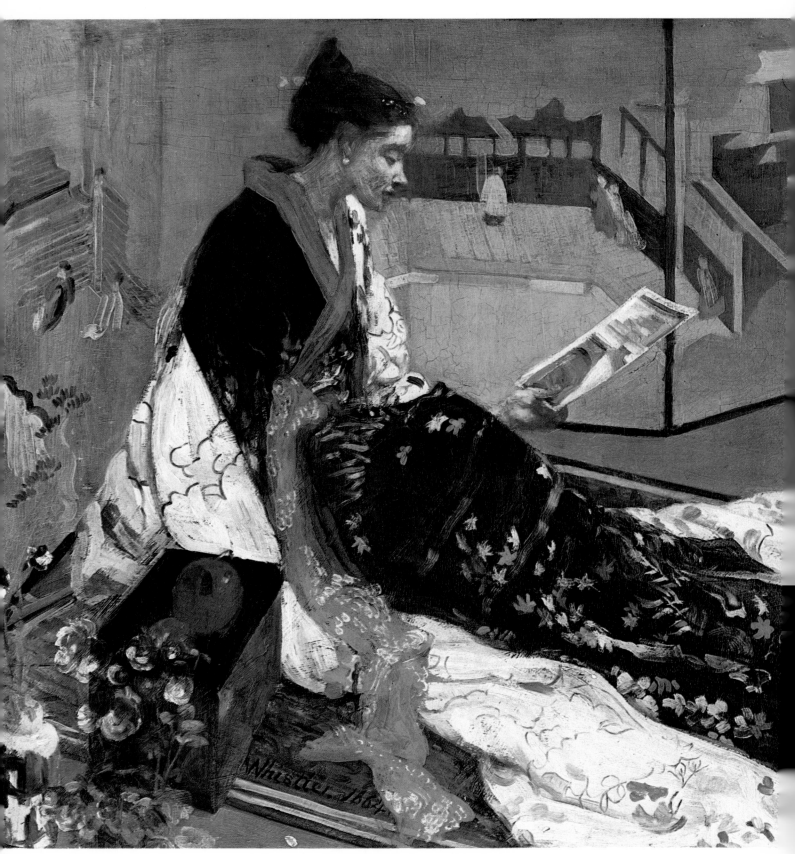

Whistler's Caprice in Purple and Gold, No. 2: The Golden Screen, *painted in 1864; one of a series of paintings using Japanese motifs*

ART OF
THE EXPATRIATES

James McNeill Whistler was born at Lowell, Massachusetts, in 1834, but he preferred it to be otherwise. Years later when he was reminded of that fact of his life he rejoined, "I shall be born when and where I want, and I do not choose to be born at Lowell." The remark was characteristic of the obstreperous independence with which he conducted his life. In 1855 he went to Paris. There he received his first serious training in art, and there he made his first European contacts since the childhood days he had spent with his father in Russia and, for a while, in England. He had learned to speak fluent French in Russia (where he also had had drawing lessons), making it easier for him to join the bohemian life of his fellow French students in Paris. After five years he removed to London, where he spent the greater part of his mature years. Whistler never did return to his native land, but he remained proudly American in his attitudes throughout his life. Although he was celebrated as a wit with a mercilessly sharp tongue and pen and as a somewhat notorious dandy, in the privacy of his own studio he was an earnest, hard-working, and self-disciplined artist. In Paris, along with his friends Baudelaire, the de Goncourts, Manet, and Fantin-Latour, he had visited La Porte Chinoise, a shop opened by a Madame de Soye in 1862 at 220 rue de Rivoli, and had formed a deep admiration for the arts of the Orient. He started avidly collecting Chinese porcelains, Japanese prints and fans, and other such *objets* from the Far East, which he discovered there and which he took to England to introduce a taste for such exotic fare in that country. He may have been the first important artist in the Western world to adapt elements of Japanese art to his own personal style. In *Caprice in Purple and Gold, No. 2: The Golden Screen,* painted in 1864 as one of a series of essays in this vein, a contemplative young woman clad in a kimono and with her hair done up in pseudo-Oriental style (probably his current mistress as well as his model) languidly gazes at Japanese prints, surrounded by studio trappings—a Japanese screen, a lacquer box, an Oriental-style folding chair—all no doubt from the artist's own collection. In a very general way this silhouetted figure seated before a *yamatoe* screen, shown almost as a flat diagram, anticipates Whistler's portrait of his mother (see page 182), which he undertook a few years later.

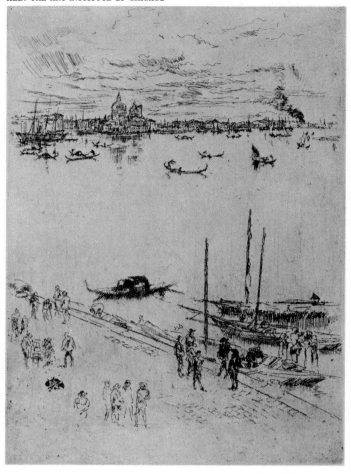

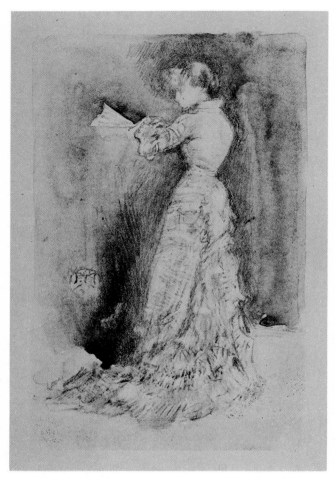

Whistler's Upright Venice, *etching published in 1886* The Toilet, *lithograph published in 1878*

During the brief interval between his dismissal from West Point because of his excessive number of demerits and his departure for France, Whistler worked for $1.50 per day with the United States Coast and Geodetic Survey making maps and charting shorelines. Although he took his job quite casually, he did receive excellent training in etching and the principles of printmaking. At that time he also made some amateurish lithographs. His first recognition as an artist in Paris actually came not with paintings but with a series of Twelve Etchings from Nature known as the French Set. In 1871 he published a Thames Set, which he first called Moonlights, then Nocturnes. The costs of his famous libel suit against Ruskin ruined Whistler financially. However, almost immediately afterward he was commissioned by the Fine Arts Society to do twelve etchings of Venice, and the success of these plates not only brought him an income but confirmed his status as a rare artist. These delicately conceived subjects marked a complete change in his style, and the fourteen months he spent in Venice had a lasting influence on his subsequent work. Toward the end of his life Whistler created a large number of brilliant lithographs, which added further luster to his reputation as an artist. With these prints he helped to reclaim the art from the hands of commercial lithographers.

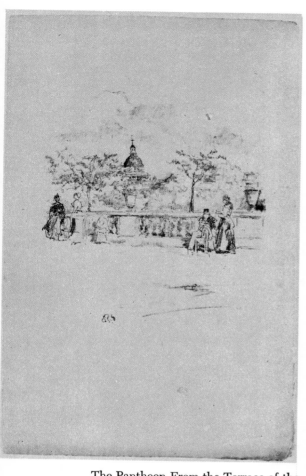

The Pantheon From the Terrace of the
Luxembourg Gardens, *lithograph, 1893*

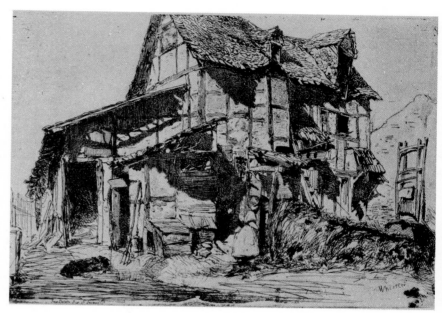

The Unsafe Tenement, *etching from the French Set, 1858*

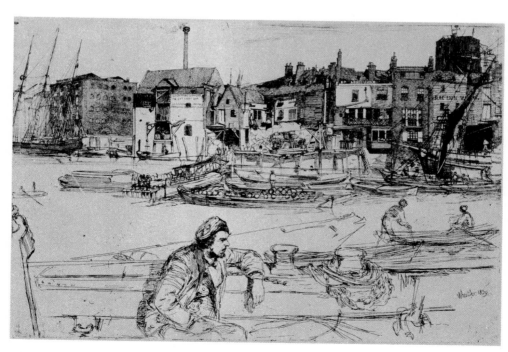

Black Lion Wharf, *etching published in 1871*

Today Whistler's portrait of his mother, in which he tried to express the reverent devotion he felt for that fragile old lady, remains his most popular work. He entitled the picture *Arrangement in Gray and Black* because, he said, "that is what it is. To me it is an interesting picture of my mother; but what . . . ought the public to care about the identity of the portrait?" However, the Royal Academy showed the painting in 1872 with the utmost reluctance, and critics raged at the artist's sentimentality. However, with time opinions changed. Some years after the picture was hung at the Paris Salon of 1883 it was bought for a nominal $800 by the French government at the instigation of Georges Clemenceau. Thomas Carlyle greatly admired the painting, and in 1872 Whistler had done his portrait in the same style and setting. In 1891 the painting was purchased by the Glasgow Corporation for 1,000 guineas. Both portraits had been used by Whistler as collateral for loans when he was short of funds. When his *The Falling Rocket* was shown at the Grosvenor Gallery in 1877, it triggered Ruskin's violent criticism which resulted in Whistler's suit for libel.

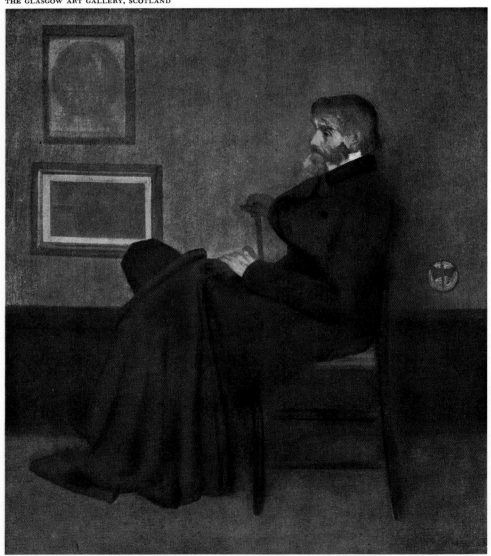

Left: portrait of Thomas Carlyle, Arrangement in Gray and Black, No. 2

Opposite: The Falling Rocket: Nocturne in Black and Gold, *about 1874*

Below: Whistler's mother, Arrangement in Gray and Black, No. 1

Whistler's Art

James McNeill Whistler giving evidence in a London courtroom; a caricature of the painter by Max Beerbohm

On a gloomy November 26, 1878, the case of Whistler vs. Ruskin was brought before the dimly lit Court of the Exchequer, Westminster Hall, London. Crowded into the chamber, for what was to be a spectacular art trial, were the judge, a predominantly middle-class jury, lawyers, newspapermen, and assorted onlookers. Of the principals involved, only the plaintiff James McNeill Whistler, dapper as always in his starched white linen and double-breasted blue serge suit, was present. The defendant, John Ruskin, England's moral critic par excellence, was in the throes of mental illness and unable to attend.

At the time of the trial Whistler had earned the distinction of being one of London's most unpopular artists. The British public as well as his fellow painters regarded the expatriate American as an improvident eccentric whose wit and other histrionic gifts far surpassed his talents at the easel. From his earliest days in London, Whistler had engaged in bitter exchanges with various art critics. One unfavorable review, for instance, in which the critic P. G. Hamerton had noted that Whistler's *Symphony in White, No. III* was "not precisely a symphony in white . . . for there is a yellowish dress . . . brown hair, etc.," elicited this venomous reply. "*Bon Dieu!* did this wise person expect white hair and chalked faces? And does he then . . . believe that a symphony in F contains no other note, but shall be a continued repetition of F, F, F? . . . Fool!" Whistler's flare for publicity was likewise evident. In 1876 Whistler offered to redesign the dining room of the parvenu art patron Frederick Leyland, to create a suitable setting for the painting *La Princesse du Pays de la Porcelaine*, which Leyland had purchased. He imposed on the room a fantastic decorative scheme of blue and gold that was culminated by a wall cartoon of a rich and poor peacock at war. Although the work was vulgar, amateurish, and unprofessional from the start, Whistler refused to admit defeat, but rather turned the production into a virtuoso performance. The public was cordially invited to view the spectacle in progress. Every day Whistler would hold court from his ladder, which he would descend at tea time to dance with the ladies present. Unfortunately, Leyland viewed the finished Peacock Room with something less than enthusiasm, and instead of paying Whistler's fee of 200 guineas, gave the painter a mere £200 for his services—the ultimate insult.

Soon after the Peacock Room fiasco, in 1877, another wealthy art patron, Sir Coutts Lindsay, opened the palatial Grosvenor Gallery and invited several of the more unorthodox artists of the day, including Edward Burne-Jones and Whistler, to contribute to the first exhibition. Among the celebrities attending the gala event of the London season was Oxford's famous Slade Professor John Ruskin, who, restored to health, came as a reporter for his magazine *Fors Clavigera*. An admirer of the pre-Raphaelites, whose highly finished canvases seemed to reflect painstaking human effort and, therefore, aesthetic and moral virtue, the don praised the paintings of Burne-Jones. However, the sight of Whistler's work—particularly the *Nocturne in Black and Gold* representing a night-time display of fireworks at Cremorne Gardens—incited Ruskin's wrath. How could, he emoted, this splash of color on a canvas be considered art? The picture reflected no *work* and was worth nowhere near Whistler's price of £200. In the next issue of his periodical Ruskin felt duty bound to inform the masses that

"For Mr. Whistler's own sake, no less than for the protection of the purchaser, Sir Coutts Lindsay ought not to have admitted works into the gallery in which the ill-educated conceit of the artist so nearly approached the aspect of wilful imposture. . . ." He then accused Whistler of "cockney impudence" and of being a "coxcomb" for "flinging a pot of paint in the public's face." Upon seeing the article Whistler exclaimed, "It is the most debased style of criticism I have had thrown at me yet," and he subsequently sued Ruskin for libel and one thousand pounds in damages.

Thus began the legal battle whose issues involved more than the validity of Whistler's art, but dealt with the larger question of art for art's sake. A record of the proceedings, with its often brilliant repartee, was kept and later published in a collection of Whistler's writings entitled *The Gentle Art of Making Enemies*. Whistler took the stand as his own witness and the attorney-general's long cross-examination began. When asked where he was born, Whistler did not mention Lowell, Massachusetts, but instead named St. Petersburg, where his interest in art was first kindled. The painting of the falling rocket that had inspired Ruskin's attack was soon brought into the poorly illuminated courtroom and presented upside down. Addressing Whistler, the attorney-general inquired if the *Nocturne in Black and Gold* was a "view of Cremorne." Whistler replied, "If it were called a view of Cremorne, it would certainly bring about nothing but disappointment on the part of the beholders." The audience laughed and the plaintiff continued, "It is an artistic arrangement. It was marked two hundred guineas." The attorney-general then demanded, "Is not that what we, who are not artists, would call a

stiffish price?" Whistler assented, and added, "I do not know Mr. Ruskin, or that he holds the view that a picture should only be exhibited when it is finished, when nothing can be done to improve it, but that is the correct view; the arrangement in black and gold was a finished picture, I did not intend to do anything more to it." After Whistler announced that he had worked on the picture about two days, the attorney-general launched his attack: "The labor of two days, then is that for which you ask two hundred guineas?" Realizing that his inquisitor had made a tactical error by shifting the discussion from art to the subject of time, human effort, and money—work that prepared a man for excellence in any field—Whistler answered slowly and deliberately, "No;—I ask it for the knowledge of a lifetime." At this climactic moment the jurors, at last grasping the import of what was being said, applauded with approval. Whistler knew that his battle was won.

For the remainder of the trial the atmosphere in the courtroom fluctuated dramatically between that of high comedy and melodrama. When questioned about the role of the art critic, Whistler stated, "I should not disapprove in any way of technical criticism by a man whose whole life is passed in the practice of the science which he criticizes; but for the opinion of a man whose life is not so passed I would have as little regard as you would, if he expressed an opinion on law." Following a brief adjournment to allow jurors to examine Whistler's paintings at close range, the cross-examination continued. Again referring to the *Nocturne*, the attorney-general queried, "Do you think now that you could make *me* see the beauty of that picture, *The Falling Rocket?*" With a dramatic flourish

worthy of a seasoned actor, Whistler paused, gazed at the attorney-general's face, looked at the picture, and then uttered a resounding "No! Do you know I fear it would be as hopeless as for a musician to pour his notes into the ear of a deaf man." Everyone now was being thoroughly entertained, and gales of laughter rippled through the courtroom.

On the following day three witnesses, including Edward Burne-Jones, testified on behalf of the defendant. By this time, however, the jury was weary of talk of art, and when a Titian portrait was shown as an example of a finished painting the jurors refused to look, saying that they were tired of viewing Mr. Whistler's pictures. The mistake of a Titian for a Whistler was a fitting denouement for the proceedings. The judge summed up the case, concluding that Ruskin's words amounted to libel. Knowing only that Ruskin's epithets about Whistler were unjust, and that the artist's paintings did contain the knowledge of a lifetime, the enervated jury pronounced Ruskin guilty, and awarded Whistler a minimum token of victory of one farthing. The costs of the trial were to be shared equally by Ruskin and Whistler. Ruskin's friends assumed his half of the burden, but Whistler was forced into bankruptcy. Nevertheless, Whistler considered the verdict a moral triumph, and for the rest of his life wore the famous farthing from his watch chain.

Most of the resulting newspaper publicity was also to Whistler's advantage. Only a young American reporter, the aspiring novelist Henry James, took a more cynical attitude: "If it had taken place in some Western American town, it would have been called provincial and barbarous; it would have been cited as an incident of low civilization."

John Singer Sargent has been called "the most consummate virtuoso America produced." He did have an extraordinary facility with the brush, a precocious talent that seemed to Henry James almost frightening in its early and easy accomplishments. Sir William Rothenstein, an English artist who knew him well, wrote reminiscently of Sargent's "uncritical hunger for mere painting which distinguished him from the French and English painters whom he rivalled, and often surpassed, in facility. . . . He never relied on his facility, but gave all his energies to each task." Sargent was born in Florence of wandering American parents, and he studied drawing there before going to Paris in 1874 as a teen-ager to learn from Carolus-Duran, one of the leading and most fashionable portrait painters of the day among the international set. There Sargent quickly learned to paint directly on a canvas in broad brush strokes, without benefit of preliminary drawing, in a manner that created an impression of absolute spontaneity. In good time Sargent himself became one of the leading and most fashionable portraitists of his time, even eclipsing his master. He was "the first portrait painter since Reynolds and Gainsborough," one contemporary critic observed. Like those earlier English artists, Sargent had a genius for catching a likeness of his sitters and at the same time flattering them. He transformed almost every subject who sat for his brush into a recognizable aristocrat, reason enough to explain why he shuttled back and forth across the Atlantic to complete the innumerable and remunerative commissions that in good time came his way from Boston and New York as well as from London, Paris, and elsewhere. As just one example, the three Wyndham sisters, so casually but artfully posed in all their lush late Victorian elegance, are beyond any shadow of doubt all but regal beauties— ladies of fastidious appearance and faultless demeanor. Real and would-be celebrities flocked to Sargent's studio to be immortalized by his brush. Occasionally, some naturally appealing subject would provide him with an opportunity to vary his standard, successful formula and reveal his extraordinary talent in fresh guise, as when he painted an Egyptian girl in the nude on a trip to North Africa in 1891.

Left: John Sargent's Egyptian Girl; *this painting was shown at the World's Columbian Exposition.*

Opposite: the Wyndham sisters; Lady Elcho, Lady Glenconner, and Mrs. Adeane, painted in 1899

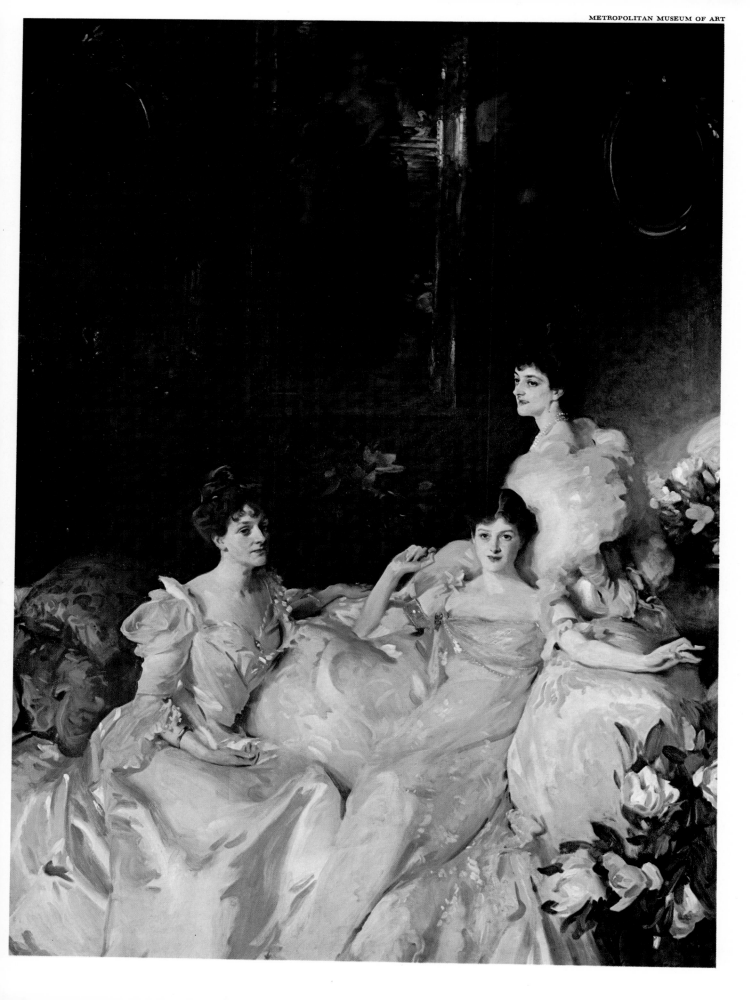

John S. Sargent's Madame X, *1884*

In 1879, some years before the demand for his portraits virtually monopolized his time and effort, Sargent journeyed to Spain to study the works of Velasquez. He drew on that experience to paint *El Jaleo,* in which he caught with flashing style a passing moment in the rhythm and gestures of an Andalusian dancer performing before her musical accompanists and her boisterous Spanish audience. Probably none of Sargent's contemporaries could have demonstrated such nimble and assured brushwork—and he was only twenty-six years old at the time. As James remarked, at that age Sargent's work continued to be as astonishing as it had been considered at even earlier stages of his career. The picture was shown in the Paris Salon of 1882, and the artist was acclaimed as the painter of the year. A year later he expressed a "great desire" to paint a portrait of Mme. Pierre Gautreau, who he thought had "the most beautiful lines" and who he believed was "waiting for someone to propose this homage to her beauty." This she apparently was, although at one point Sargent confessed her beauty "unpaintable" and her laziness "hopeless." The finished portrait, which recalled his debt to Velasquez, was hung in the Salon of 1884 with the title *Portrait de Mme. . . .,* and it caused a scandal. Critics complained of the artist's impropriety in showing the lady in the extreme decolletage and the shocking lavender make-up and scarlet hair she actually did affect in her not-so-private life. The lady was herself embarrassed by this public exposure. Such was the uproar from polite society, on whose good will he depended for his commissions, that Sargent removed the painting from the exhibition and carried it off with his own hands. He shortly thereafter quit Paris for London, and rarely again attempted such candor in his portraits. In England Robert Louis Stevenson sat for Sargent, resulting in a brilliant and spontaneous suggestion of that author's vital personality. Now Sargent's career as a successful portraitist was well begun. He soon had to hire two maids to help his valet while he busied himself painting what became a steady flow of clients. Stevenson recalled him as "a person with a kind of exhibition manner and English accent, who proves, on examination, simple, bashful, honest, enthusiastic, and rude. . . ."

Right: portrait of Robert Louis Stevenson, one of two likenesses of the Scottish author by Sargent; painted 1884–87

Below: El Jaleo represents John Singer Sargent's ability to capture an instant in the lively movement of a Spanish dancer.

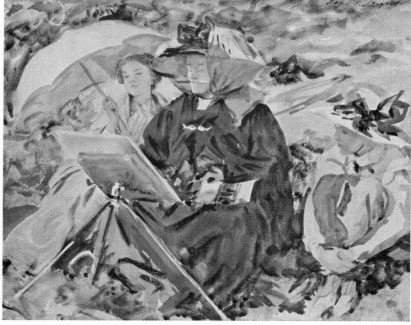

A group of water colors by John S. Sargent:

Upper left: Gourds, *an early travel note*

Above: Bedouins, *painted in Egypt in 1891*

Left: Simplon Pass: The Lesson; *Sargent's sister and her two nieces, painted in 1911*

Opposite: Santa Maria della Salute, *in Venice, painted during a visit to Italy in 1904*

Sargent's success with portraiture was almost too easy, and the routine of fashionable performances led him to cynical opinions of his own profession. He once defined a portrait as "a painting with a little something wrong about the mouth"; another time he remarked in self-disgust that portraiture was "a pimp's profession." Yet his success was almost magical. One diplomat of the time is reported to have said that whenever he was at a loss for dinner table conversation at distinguished gatherings he had only to turn to the person beside him and ask, "How do you like your Sargent drawing?"—a subject that inevitably brought an interested and pleasant response that relieved all social strain. Whistler and Degas spoke disparagingly of his work; Rodin and James, of course, admired it; his clients loved it. Sargent found an escape from his own perfunctory success in that field by creating water colors of rare brilliance. Here his virtuosity, unhampered by any need to satisfy a client, found fresh outlets in recording informal subjects as suited his mood. He was painting for himself for a change, and in a medium natural to his quick and fluid style of recording impressions; where, in fact, his debt to impressionism may be most clearly recognized, and where his manner is so personal and immediate that it is impossible to remain indifferent to them. They often recall the many afternoons Sargent, a confirmed bachelor, spent with his sisters and mother, while she lived, setting down his impressions of the much-traveled world he moved through. Like Whistler, although Sargent spent most of his life abroad, he always considered himself an American in fact and at heart. He refused a knighthood in Great Britain rather than lose his United States citizenship, which he prized to the end of his days.

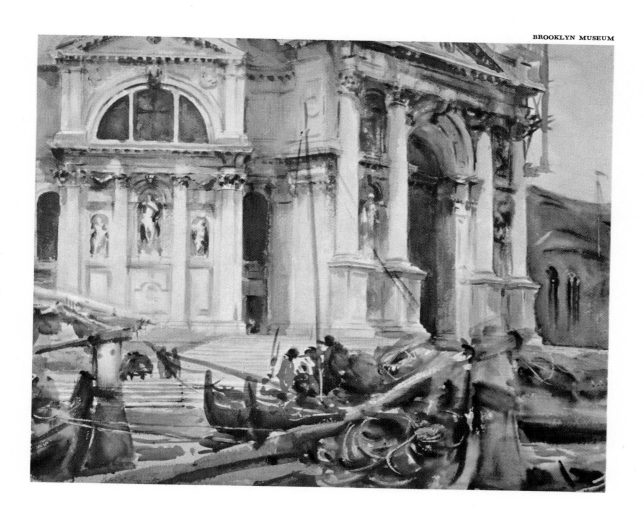

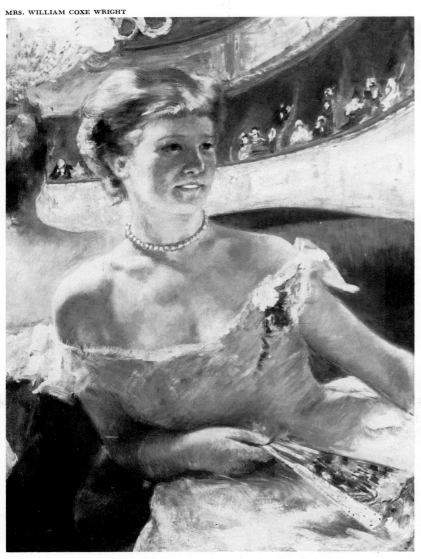

La Loge, *by Mary Cassatt; one of two paintings by the artist shown in the Fourth Impressionist Exhibition at Paris in 1879*

Mary Cassatt, a third distinguished American expatriate artist, was both as a person and a painter a far cry from Whistler or Sargent. She was a privileged gentlewoman, born of very wealthy Pennsylvania parents, and her personal life was ever that of a sensible, cultivated lady with no trace of bohemianism either in her attitudes or her habits. She was the first important American woman artist, and perhaps she still remains the best. When Degas, whose work served her as an early model, saw one of Miss Cassatt's pictures for the first time he exclaimed, "I would not have admitted that a woman could draw as well as that." In spite of her substantial means and her social position, which could have provided her with many distractions, she worked at her chosen profession with strong self-discipline and unflagging application. She was the only American artist to be associated with the central French group of impressionists, although her social life was apart from theirs. Even Degas, whom she so strongly admired as an artist, this proper spinster once referred to as "that common little man." Nor was she interested in important personages for her subject matter. She treated her sitters so impersonally that except for members of her own family, few of them are even identified. Although she profited from her exposure to the works of Degas and of the impressionists as a group, in the end she imitated none of them. And although virtually her entire professional career was pursued abroad, she remained "exclusively of her people," as one French critic observed. "Hers," he added, "is a direct and significant expression of the American character." Her reputation was slow in reaching America. When she visited Philadelphia in 1899 a newspaper reported, "Mary Cassatt, sister of Mr. Cassatt, president of the Pennsylvania Railroad, returned from Europe yesterday. She has been studying painting in France, and owns the smallest Pekingese dog in the world."

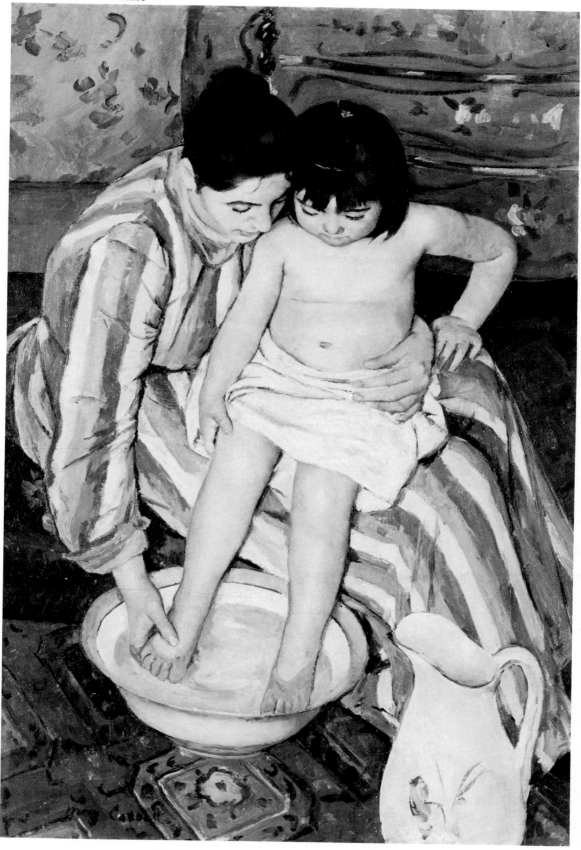

The Bath, *painted by Miss Cassatt about 1892; one of her many portraits of mothers with their children*

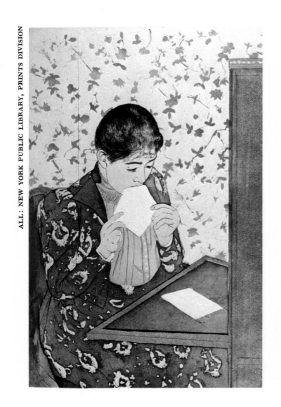

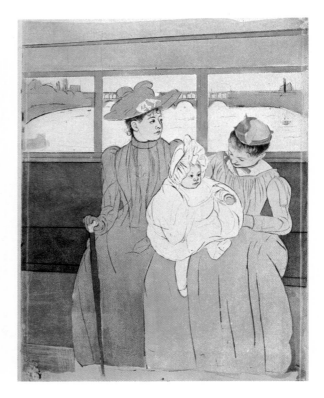

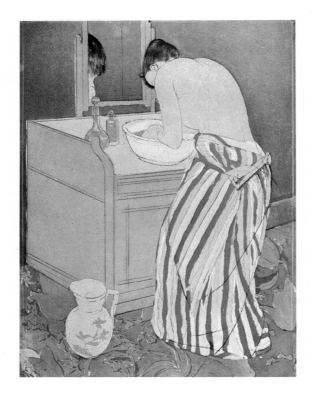

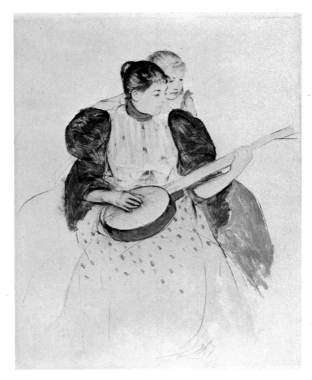

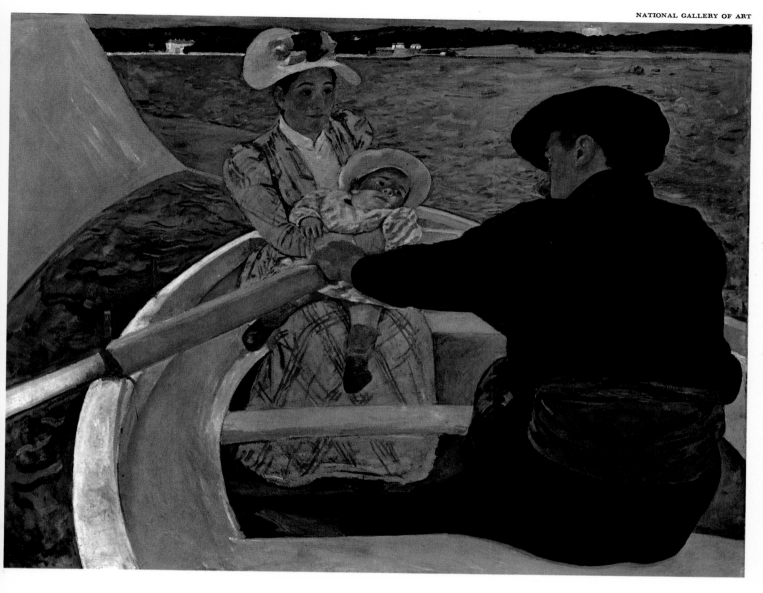

Above: The Boating Party, *painted by Mary Cassatt in 1893–94, shows the artist's debt to Edouard Manet and to Japanese wood blocks.*

Opposite: four aquatints executed by Cassatt, clockwise, The Letter, In the Omnibus, The Banjo Lesson, Woman Bathing; *these, too, exhibit the Japanese influence on her work.*

For all her gentility Mary Cassatt was not suppressed by her respect for conventions. She was a sharp, argumentative, and voluble conversationalist with decided opinions. She enjoyed people. Her paintings held their own surprisingly well in the distinguished company they kept at Paris exhibitions. "She may make no smile," wrote one French critic, "but the last word belongs to her fundamental good sense and, above all, her exquisite drawing." Gauguin observed, "Mary Cassatt has charm, but she also has force." But, had she never painted a stroke she would be remembered for the superb prints she produced. Like so many contemporary artists, she was influenced by the Japanese art that could be seen in Paris in the last decades of the nineteenth century, and this is even more apparent in her engravings than in her paintings. Her taste was all but impeccable, and she guided a number of wealthy Americans in the formation of truly great collections of European art, notably the H. O. Havemeyers, most of whose treasures are now in the Metropolitan Museum of Art.

195

THE NATIVE STRAIN

Homer's sketch of a Yankee soldier boy

In his own lifetime Winslow Homer was called "the greatest American artist," "the most American painter," "the most intensely American painter of his time." Today, more than sixty years after his death, it is still possible to agree with those appraisals. He had no teachers, really, and no pupils. Boston and Cambridge, where he lived as a youth, had no academy, no museum, no school of art, in any real sense. While he was still in his teens an innate compulsion to draw led him to an apprenticeship in a lithographer's shop. From there he went into the service of the illustrated periodicals of the day. In 1859 he moved to New York to improve his chances, and here he studied a bit at drawing schools and briefly with a third-rate French painter named Frédéric Rondel. He was then twenty-three. In 1861 *Harper's Weekly* commissioned him to cover Lincoln's inauguration as the magazine's artist-reporter. With the outbreak of the Civil War he made several trips to the front, returning to New York with sketches enough to provide him with material for some time to come. After the war he converted several of these into his earliest paintings in oil, at least one of which won instant acclaim. A wider world took notice when two of these war paintings were shown at the great Universal Exposition, held at Paris in 1867. The *London Art Journal* reported, "Certainly most capital for touch, character and vigour, are a couple of little pictures . . . by Mr. Winslow Homer of New York. These works are real: the artist paints what he has seen and known." Homer was himself in Paris at the time (his first visit) and had the pleasure of seeing his works also well reviewed by French critics. By this time he had already begun to find himself as a painter of children and young people at play or work in rural settings. Whittier's barefoot boys and Howells' summertime idlers move through these scenes. From the beginning he looked at the world about him and painted it with an innocent eye, as he saw it at the moment of his creation—without sentiment, without preconceptions in his mind's eye as to what it should look like, and without deference to ways other painters had filled their canvases. ("If a man wants to be an artist," he once said, "he should never look at pictures"; and his painter friend John La Farge remarked that "Homer was too great a man to be tied by the knowledges of art.") The quickly captured realism of Homer's freckle-faced Yankee urchins and his pie-nurtured maidens in calico seemed rude and almost unfinished to some of his critics. Henry James found them "damnably ugly"; but James found much distasteful about the American scene and was just about to quit it for a life in England. "He [Homer] has chosen the least pictorial features of the least pictorial range of scenery and civilization," wrote James; "he has resolutely treated them as if they *were* pictorial. . . . He sees not in lines, but in masses, in gross, broad masses. Things come already modelled to his eye." However, even this severe critic paid respect to Homer's doggedness in seeing things his own way. Somewhat grudgingly James concluded that Homer was in truth "a genuine painter" with a stamp of his own.

Above: Snap the Whip, *painted by Homer in 1872; Below:* The Country School, *1871*

Although James could not tolerate Homer's choice of subject matter, he confessed that there was something he liked about his paintings. The artist had at least one great merit, James reflected, in that "he naturally sees everything at one with its envelope of light and air." Homer's important early pictures, such as *Gloucester Farm* and *Long Branch,* have somewhat the same concern with natural outdoor light as appears in the early works of such impressionists as Monet and Boudin, and represented with much the same sparkle and economy. However, it seems improbable that Homer was at the time familiar with the paintings of either of those two French painters. In any case, he remained ruggedly independent throughout his life, and became increasingly a loner. To this Yankee son of a Yankee hardware merchant, art was something of a commodity, a "notion," if you will, of solid and measurable worth. It irked him when his paintings did not sell, less for mercenary reasons than because of the implication that the true value of his handiwork was not recognized in a fair offer of trade. He tended to lose interest in painting when there seemed to be no market for his wares. He often threatened to paint no more, but his compulsive instinct never deserted him, and he did find buyers. Among his most important patrons was Thomas B. Clarke, who very perceptively bought Homer's work, if at relatively modest prices. When Clarke sold his first large collection of American paintings in 1899 (he subsequently formed another), Homer's paintings brought by far the highest prices among the works of living artists. The sale was a sensation of sorts, grossing nearly a quarter of a million dollars, an unprecedented sum, and as one consequence Homer's stock rose sharply in the art market—a point of which the artist was keenly aware. He wrote Clarke a frank note of gratitude for having boosted his reputation. Some years later the Metropolitan Museum bought one of his oils (*The Gulf Stream*) for $4,500, the highest price Homer had yet received for a work. At the time of his death all but one of his canvases had been sold.

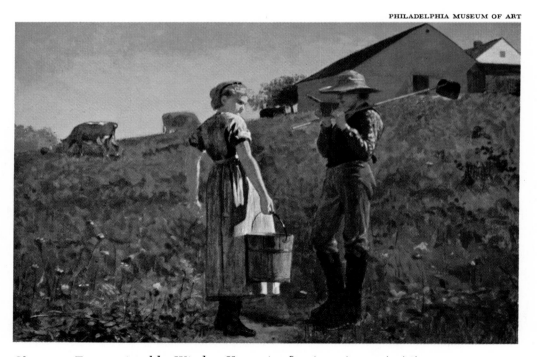

Gloucester Farm, *painted by Winslow Homer in 1874 in an impressionistic manner*

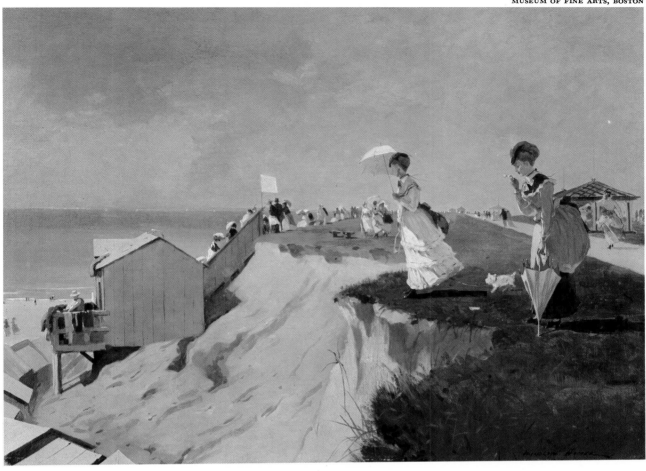

Above: Long Branch, New Jersey, *an early oil by Homer, painted in 1869*

Left: *drawing of a young girl on a swing, executed by Homer in 1879*

Below: Croquet Scene, *1866; croquet was an epidemic fashion at the time.*

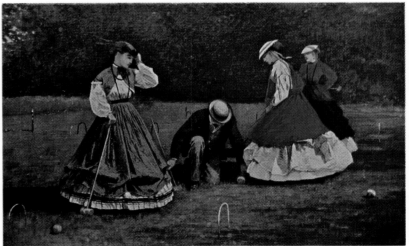

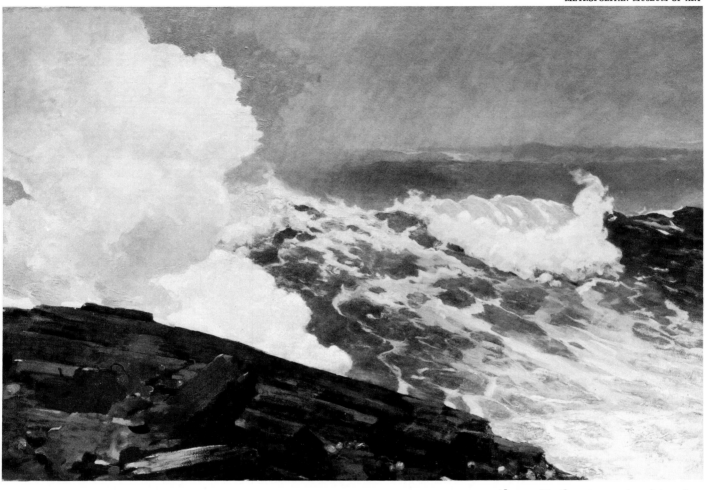

Above: Northeaster, *painted in 1895*

Opposite: The Lookout—"All's Well,"
painted at Prouts Neck, Me., in 1896

In his middle age Homer abandoned his gentle bucolic scenes and turned
to dramatic representations of men and women confronting the elemental
forces of nature, particularly the raging seas and those who struggled
against them. "Solitude, the safeguard of mediocrity," wrote Emerson, "is
to genius the stern friend, the cold obscure shelter, where moult
the wings which will bear it farther than sun or stars." And so Homer
found it. Homer spent solitary years, all but a recluse, at Prouts Neck
ten miles below Portland on the bleak coast of Maine, producing
magnificent impressions of the lonely sea at his door. Impressions
is still the right word. He contrived a portable shelter so that he could
witness the primordial force of the ocean in its stormiest temper and
catch its instant image on his canvas. Late in his life he wrote someone
that he was working very hard every afternoon from 4:30 to 4:40
(on a picture called *Early Evening*), "that being the limit of the light
that I represent." As Emerson advised, he steadfastly tried to see things
in "a true light and in large relations." He had developed his talent
for naturalism close to its limit.

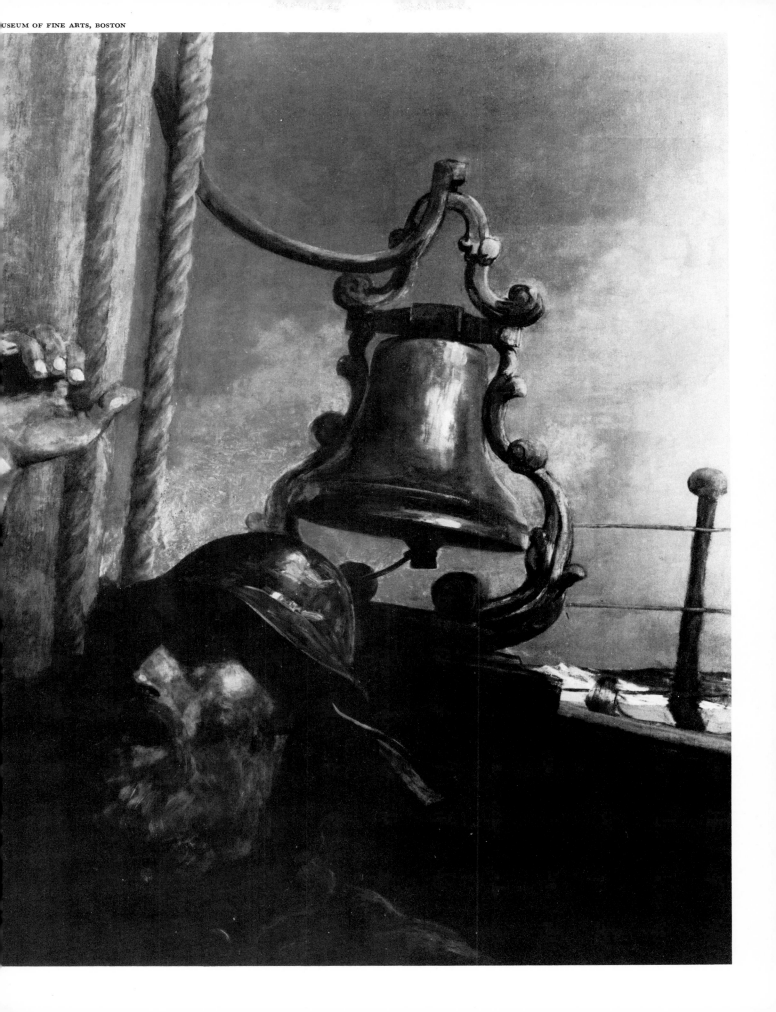

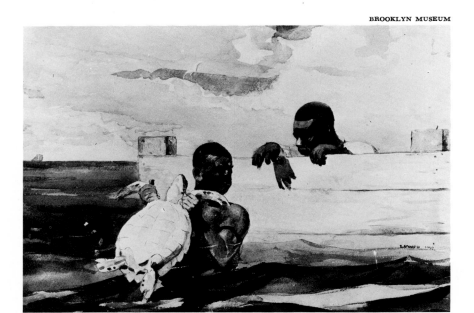

Left: The Turtle Pond, *water color painted by Winslow Homer in 1898*

Below, left: Palm Tree, Nassau, *another water color painted in 1898*

Opposite: Old Friends, *a scene in the Adirondacks painted in 1894*

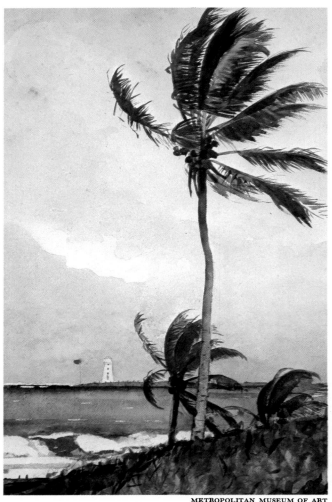

METROPOLITAN MUSEUM OF ART

In his late work Homer discovered the essence of his genius in water color. Here his swift grasp of reality found its perfect medium. With bold, rapid strokes of transparent color applied to white paper he caught the fresh impact of a scene with a purity and luminosity he never quite achieved in oil. He had learned, possibly from Japanese prints he had seen, the importance of blank spaces in his compositions; and this understanding he brought with special emphasis to his water colors. "You will see," he once told his dealer, "in the future I will live by my water colors." That was not quite true, but Homer was in fact the first modern water colorist in America—one of the first anywhere, for that matter. In the winter of 1884 he saw the tropics for the first time, and during succeeding periods in Florida, Nassau, Cuba, and Bermuda he painted some of the boldest and freshest of his works. He also hiked through the northern woods and pictured men, who are never identified, facing the wilderness with the self-reliant confidence born of the pioneer spirit. With his quick brush he caught the pure brilliance of sunlight in the south, the filtered light of the northern forests at a precise moment in time. Shortly after Homer's death the English dramatist and novelist Arnold Bennett came to America, giving as one of his reasons for the visit a wish to see Homer's work. "There is one American painter," he explained, "who has achieved a reputation . . . in Europe without (it is said) having been influenced by Europe. . . ." When he chanced on an exhibition of Homer's water colors, he found them "clearly the productions of a master. . . . They were beautiful; they thrilled; they were genuine America; there is nothing else like them."

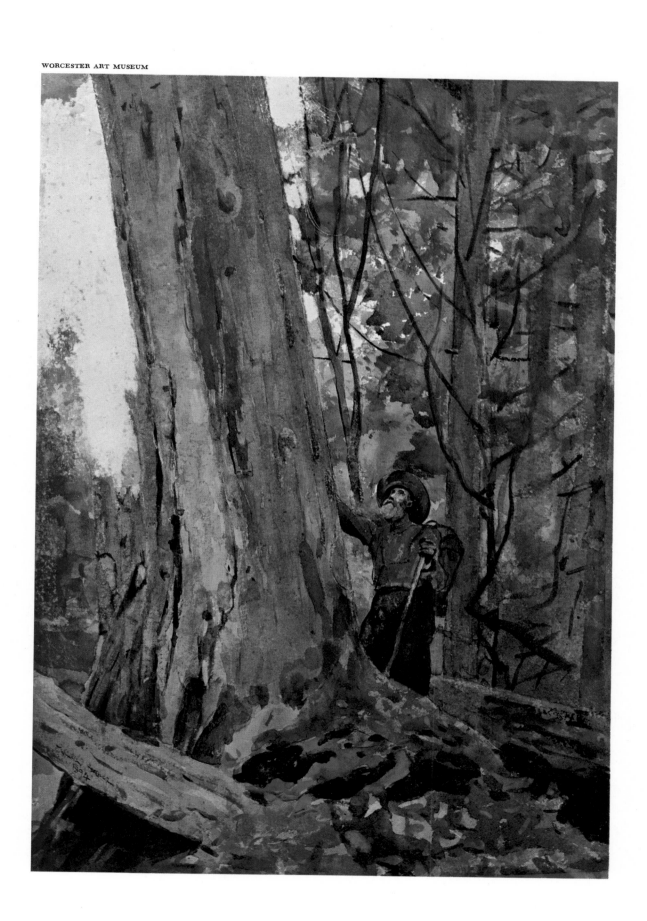

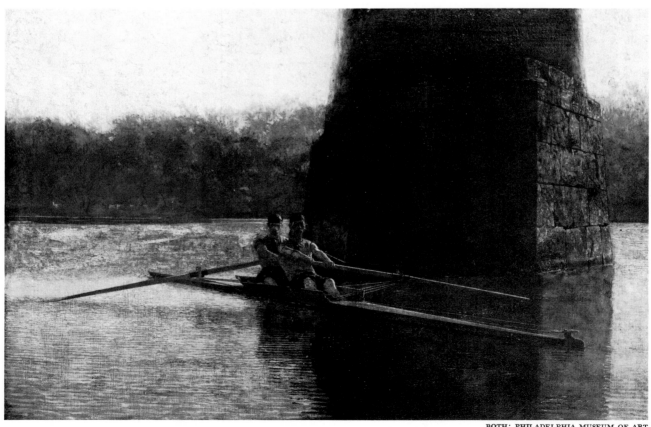

If Homer has any rival as the greatest artist in the annals of American art it is certainly Thomas Eakins. The talents of these two men were so disparate, although of correspondingly high order, that such comparisons are invidious. Eakins' fame came only after his death with the slow recognition of his extraordinary accomplishments. During his lifetime he was thought of more as a scientist and teacher than as an artist. His passion to understand human anatomy so that he might most truly and expressively represent his living figures led him to dissect cadavers at Jefferson Medical College in Philadelphia. His interest in the total reality of the world about him led him to serious experiments in photography, as has been told. "All the sciences," he observed, "are done in a simple way; in mathematics the complicated things are reduced to simple things. So it is in painting." Thus, by geometrical perspective he precisely plotted and meticulously drew the sketch shown opposite, and in 1872 transferred it to an oil on canvas as *The Pair-Oared Shell*. (Eakins had little interest in drawing except as a means to an end.) In all his paintings he was a "scientific realist," a term that is accurate enough except that it does not suggest the warmth of spirit that invests his art. In 1866, when he was twenty-two, he went to Paris to study. The early impressionistic works of Manet were just then creating a roaring scandal. But he was apparently indifferent to this. Like Homer, Eakins went his own, different way. Although he often painted the urban bourgeoisie at their amusements and occupations, as did the French impressionists, no one could possibly confuse any of his canvases for a French painting, or the Schuylkill River at Philadelphia for the Seine. In *Mending the Net* Eakins demonstrated his peculiar talent for combining the most precisely calculated composition with an effect of complete naturalness and spontaneity, as every detail attests.

Opposite: a perspective sketch and the canvas, The Pair-Oared Shell, *derived from it, painted by Thomas Eakins in 1872*

Right: Mending the Net, *painted by Thomas Eakins, 1881; a detail from the work appears above it.*

Overleaf, right: portrait of Miss Amelia C. Van Buren, painted by Eakins about 1891; left: The Pathetic Song, *painted in 1881*

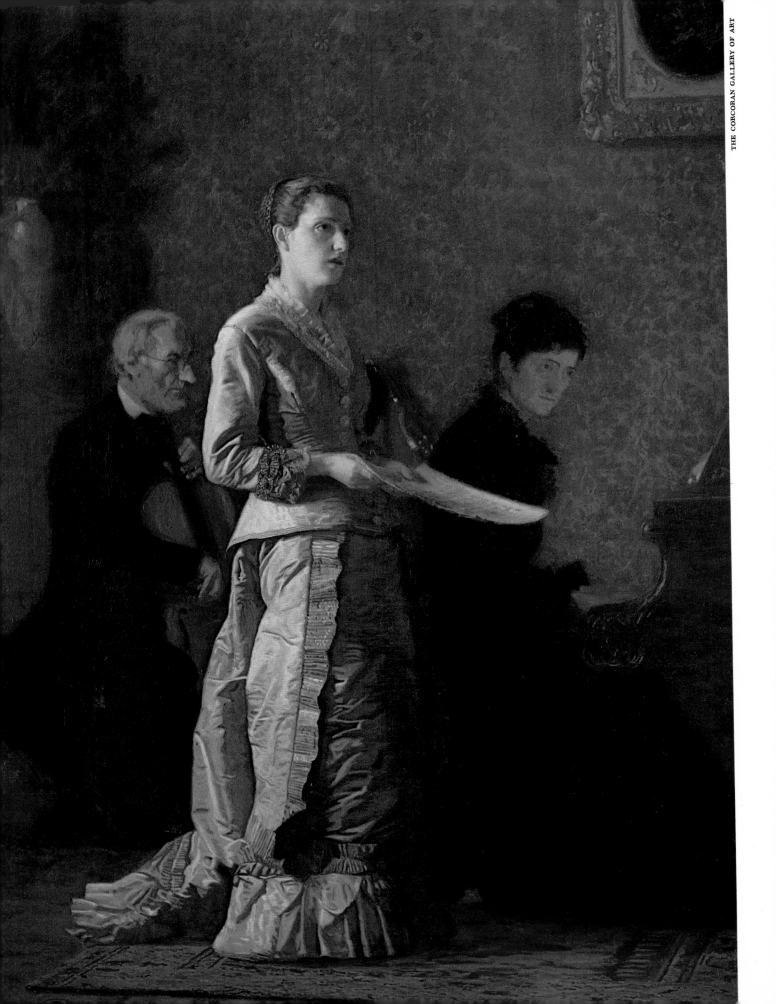

Sargent made all his women subjects appear beautiful, gracious, and aristocratic; but no woman ever gained any beauty from Eakins' brush. The marked contrast between the former's exaggerated flourishes and the latter's forthright and penetrating characterizations may explain why Sargent, in self-disgust, referred to portraiture as a "pimp's profession." Sargent knew and admired Eakins' work; on a visit to Philadelphia, where he was lionized as befitted the most fashionable portraitist of the time, Sargent was asked by his hostess if he chose to meet anyone in particular. His answer was "Eakins"; the lady did not even recognize the name. It is difficult to understand how Eakins' work should have been so little known in his own time and place, except, of course, to his grateful and respectful students. When, in 1886, he was obliged to resign his teaching post at the Pennsylvania Academy because he insisted that his pupils, women and men alike, draw male nudes without the customary and disfiguring loincloth, Eakins' considerable influence on younger painters was all but halted and the artist himself fell increasingly into obscurity. It was not his first or only defeat. Eleven years earlier he had painted his now celebrated picture *The Gross Clinic* (see pages 170, 171) for exhibition at the Philadelphia Centennial Exhibition. This and his painting of Dr. Agnew's clinic are the only important paintings of their kind since Rembrandt (whose influence they surely reflect). *The Gross Clinic* is a highly dramatic but completely literal view of a moment during a surgical operation. The eminent surgeon, scalpel in his bloody hand, turns from the body before him and from his concentrating assistants to make some comment to the spectators in the darkly lit tiers of the background. His figure dominates the composition; the intellectual character of his head is emphasized by superb highlighting. This painting has recently been termed by one eminent critic "the most powerful and important painting by a nineteenth-century American artist, and certainly the most extraordinary history painting by any American artist." However, at the time the gory details were considered shocking, and the picture was rejected by the exhibition's art committee. Eakins received few commissions for portraits. Actually, he did not consider himself a portraitist. For the most part he painted his friends, members of his family, or his students, and largely for his own benefit and pleasure. His relentless, realistic objectivity, his utter honesty, and his emphatic and accurate drawing of essential details could reveal too much of his sitters to please them. Yet, if he did not flatter his women neither did he avoid painting beautiful ones. Essentially, he looked for interesting and characterful subjects of either sex, some of whom were also handsome or beautiful. At his death Eakins' studio was filled with remarkable likenesses, some of the best in the history of American art. One of the finest was his portrait of Amelia C. Van Buren, who had been in Eakins' classes at the Pennsylvania Academy, painted in 1891 during the dark days after he left that institution. Music played a good part in the artist's life—as a communion between friends. In *The Pathetic Song* the pianist is another pupil, Susan Hannah Macdowell, whom Eakins married in 1884. Even his most abundantly clothed subjects still reveal his profound understanding of the human body beneath the overlaying garments, an understanding that found clear and immediate expression in his several scenes showing prize fighters in or on their way to the boxing ring. In *Between Rounds* the spectators as well as the principal are portraits. The young fighter resting on his stool is Billy Smith, who figured in other prize-fighting scenes. Long before, in Paris, Eakins had discovered that he learned much more by watching his stripped companions wrestle than he did from drawing posed models in his studio.

Left: portrait of Mrs. William D. Frismuth, and details of her hands, painted by Thomas Eakins in 1900

Opposite: Between Rounds, *painted by Eakins in 1899*

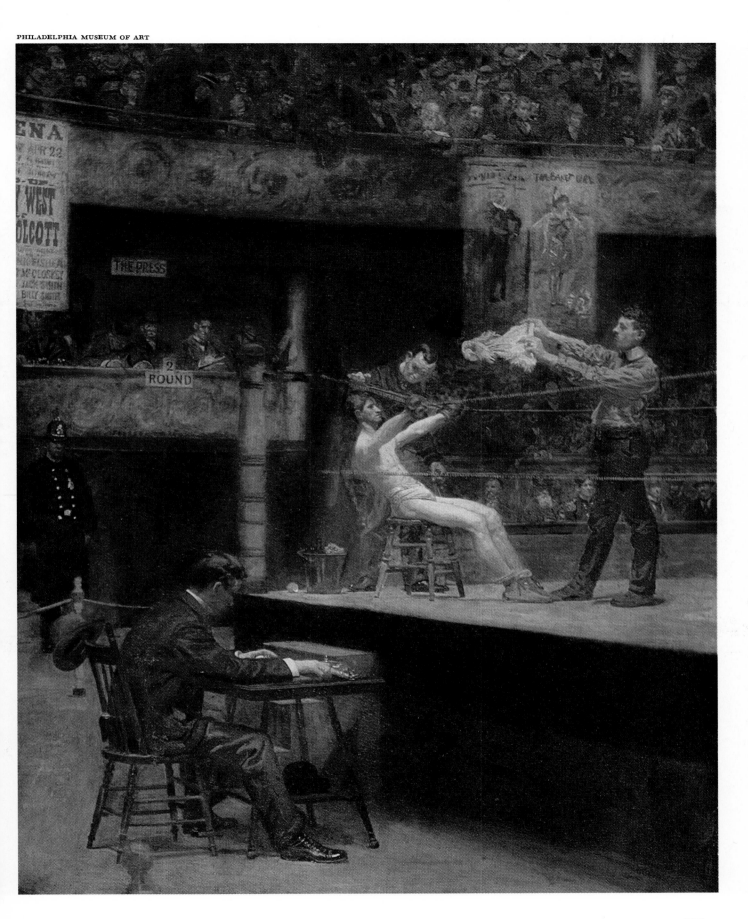

MYSTIC MOODS

Opposite: The Race Track, *painted by A. P. Ryder*

Below: Moonlight, *by A. Blakelock, about 1887–88*

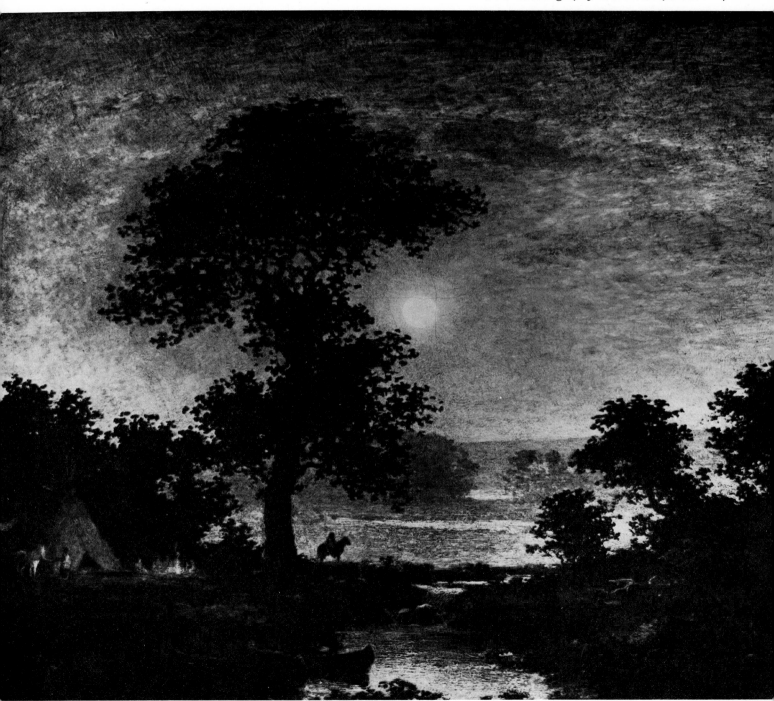

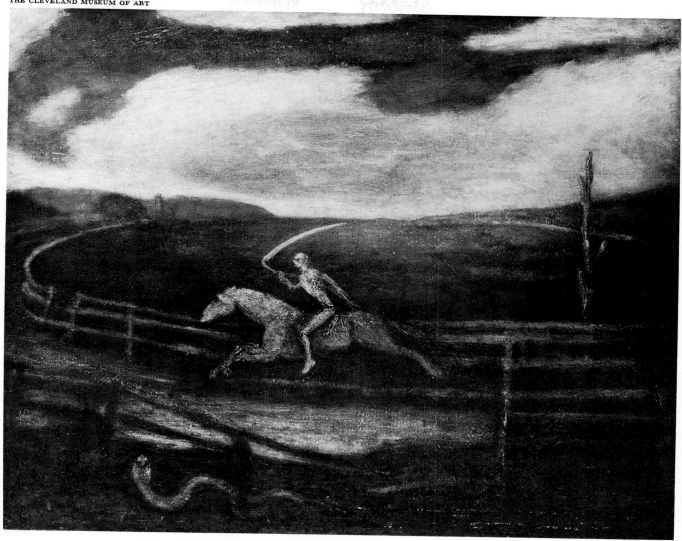

Albert Blakelock and Albert Pinkham Ryder were almost exact contemporaries of Homer and Eakins, but it would be difficult to imagine two pairs of artists who differed more remarkably in the images they created. Where Homer and Eakins were objective and realistic in their separate ways, Blakelock and Ryder were subjective and imaginative in *their* separate ways; where the former pair painted subjects in broad daylight, the latter two habitually painted crepuscular or moonlit scenes. Blakelock was haunted by the mystery of the forest, the forest that lingered within his unstable mind. Over and over again he painted generally similar visions of woodlands, with trees silhouetted against twilit or moonlit skies, often with an Indian encampment in the middle- or foreground—a dark but beautiful world. Ryder had his own, quite different visions—visions of unearthly quality and intensely personal character. *The Race Track*, sometimes called *Death on a Pale Horse*, was inspired by the suicide of an acquaintance, a waiter in Ryder's brother's hotel who had lost his life's savings betting on a horse race. The incident "formed a cloud over my mind," Ryder wrote, "that I could not throw off." When the owner of the picture asked the artist whether the scene represented night or day, Ryder replied, "I hadn't thought about it." Scythe in hand, the specter races in "a light that was never on sea or land." Both Blakelock and Ryder were careless technicians who applied, and re-applied, paint and varnish to their canvases, piling up unstable layers of pigment with no regard, or perhaps knowledge, of the ultimate consequences. Few of their paintings have survived in a condition that represents the effects intended by the two artists when they finally released them.

211

Blakelock's life was tragic. The difficulties of selling his work drove him mad and into an insane asylum. Ironically, almost immediately thereafter his paintings began to bring high prices, with no benefit to the impoverished artist or his needy family. After twenty years of incarceration his sanity returned—and he lived for just one more month. His paintings were then selling for as much as $20,000. As Blakelock was haunted by the forest, Ryder was haunted by the sea—the sea as it had never been pictured before in its awesome and sombre loneliness. "The artist," he once explained, "should fear to become the slave of detail. He should strive to express his thought and not the surface of it. What avails a storm cloud accurate in form and color if the storm is not therein?" Ryder obviously never became "the slave of detail," and in his striving to express his purest thoughts he reworked many of his canvases over periods of years. He rarely painted from nature, and his mind's eye constantly suggested changes in what he had already done. To one buyer who asked for a painting that had been long in the process of final completion Ryder wrote, "Have you ever seen an inch worm crawl up a leaf or twig, and then clinging to the very end, revolve in the air, feeling for something to reach something? That's like me. I am trying to find something out there beyond the place on which I have a footing." Under the circumstances it is usually impossible to give a precise date to his works. He declined one dealer's offer to pay liberally for ten pictures to be completed in three brief years, although he sorely needed the money. Sometime between 1890 and 1900 he finished his poignant depiction of a dead bird, an exceptional variation of his more typical moonlight marines, but reiterating in its different way the theme of death and destiny that he so often employed. Ryder ended his days as an eccentric recluse. His last domicile, a back room in an old house, was almost unbelievably cluttered with disorderly piles of reworked canvases, heaps of rubbish of old magazines and newspapers, and a great miscellany of untidy odds and ends, all spotted with paint and varnish—such a clutter as Ryder himself could scarcely find his way through to open the door. Both Blakelock and Ryder won enough fame to trigger the cupidity of innumerable forgers during their own lifetime and after.

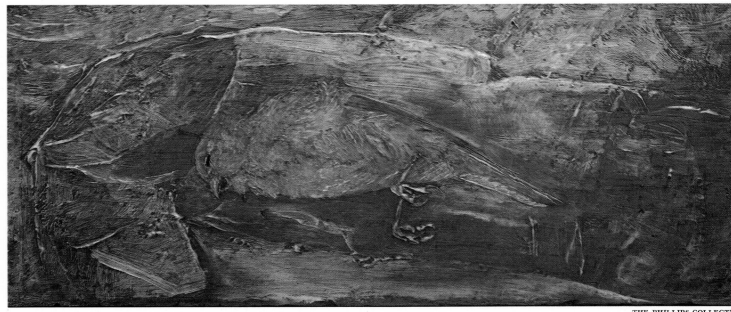

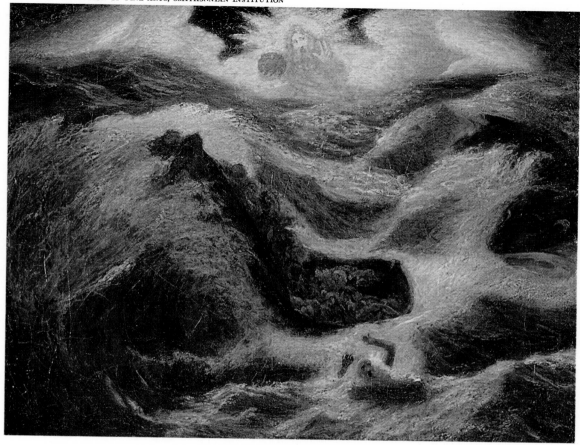

Above: Jonah, *a painting much changed from the state in which it had been first exhibited and illustrated in 1890*

Opposite: The Dead Bird, *by A. P. Ryder*

Right: Moonlight Marine. *Ryder was born in the old whaling port of New Bedford, Mass., and his lifelong fascination with the sea greatly influenced his work.*

213

POPULAR INTERLUDES

Generations of American school children, and adults as well, have formed visual
impressions of their country's history by the sentimentalized reconstructions
of the colonial past produced during the second half of the last century.
Among the earliest and most influential of these recreations was *Washington
Crossing the Delaware* by Emanuel Leutze, a prolific German-born artist who had
been brought to America as a child and who had returned to Germany to study
at Düsseldorf, where a school of romantic painting flourished around the middle of
the nineteenth century. It was at Düsseldorf, before returning to America,
that he painted his most famous picture which, although it is false in
almost every historical detail, has become a widely accepted symbol of
Washington's heroic coup during the Revolution on Christmas Night, 1776.
(Among other misrepresentations the flag Leutze shows was not adopted until some
months later, the iron boats actually used for the crossing were much larger,
and so on.) Leutze's friend, the American artist Worthington Whittredge,
then visiting Düsseldorf, posed for both Washington and the steersman, and
gratefully accepted a full draught of champagne after the ordeal was over. The
English-born artist George H. Boughton's *Pilgrims Going to Church* strikes the
same vein of sentimental and reverent retrospection that idealized history, with
only casual regard for factual circumstance and detail. Such expressions were
less a matter of art than a form of ancestor worship, especially appealing to
those hordes of immigrant newcomers whose ancestors lived in distant lands
and who wished to identify themselves with American traditions. Longfellow's poetic
version of the midnight ride of Paul Revere revived interest in this Revolutionary
hero and patriot—and silversmith; an interest that led to a Boston competition
for a figure of Paul Revere as a memorial. James E. Kelly, who executed the
Monmouth Battle Monument in New Jersey and Count Rochambeau in Southington,
Connecticut, entered a statuette showing Revere about to take off on his historic ride.

Opposite: Washington Crossing the Delaware *(dated 1851), painted by Emanuel Leutze at Düsseldorf*

Right: sketch, reproduced from Harper's Weekly, *of a Paul Revere statuette by James E. Kelly, 1882*

Below: Pilgrims Going to Church, *painted by G. H. Boughton, an illustrator of Hawthorne's* Scarlet Letter

CULVER

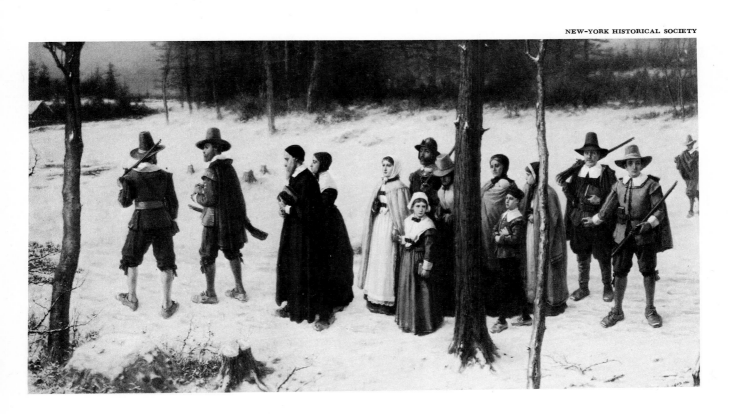

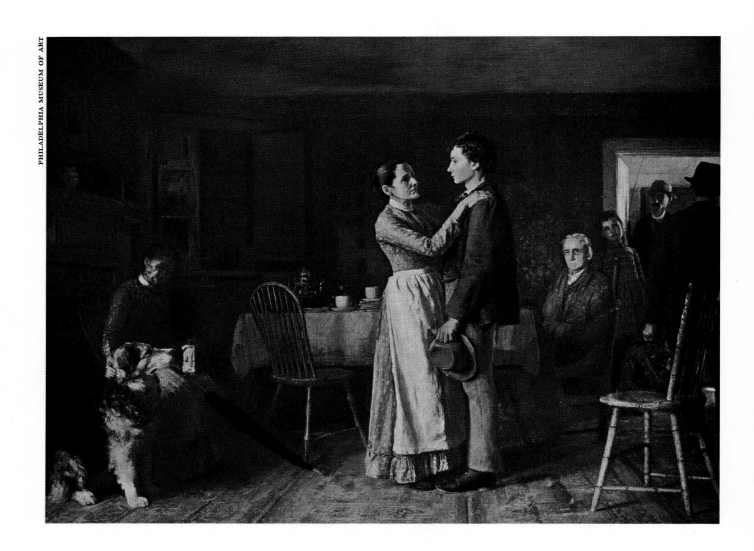

None of Ryder's uniquely imaginative paintings was shown at the World's Columbian Exposition at Chicago in 1893. The popular favorite among the American art exhibited at that fair was Thomas Hovenden's *Breaking Home Ties*, a strictly storytelling picture that left nothing whatsoever to the imagination. Hovenden's painting is so obviously sentimental and anecdotal that it is easily dismissed by sophisticated modern critics of art. However, it is not only highly representative of public taste at the time it was painted; like so much of the salon art of the day, it is executed with great competence. The depiction of an awkwardly overgrown country lad leaving his mother and sisters to seek his fortune elsewhere is restrained, not maudlin. Hovenden, who had emigrated to America from Ireland, was a masterful teacher at the Pennsylvania Academy, much respected by his students (who included the Ash Can realist Robert Henri—see pages 262–63), before he gave his life in 1895, at the age of forty-five, to save a child from being killed by a railroad train—and before he had fully developed his unquestionable talent. Another foreign-born, skillful, and eminently successful genre painter of the later-nineteenth century was the immigrant Englishman John George Brown, whose pictures of cheerful, well-scrubbed, Horatio Algerish New York street urchins—bootblacks and newsboys—were so popular that he rarely had opportunity to paint anything else. His *Music Lesson*, distributed in engraved copies as *A Game Two Can Play At*, was a departure from his standard formula. All in all, Brown was so well in tune with popular taste he became an exceptionally rich artist.

Opposite: Thomas Hovenden's Breaking Home Ties

Below: The Music Lesson, *painted in 1870 by John G. Brown; a scene of disguised courtship*

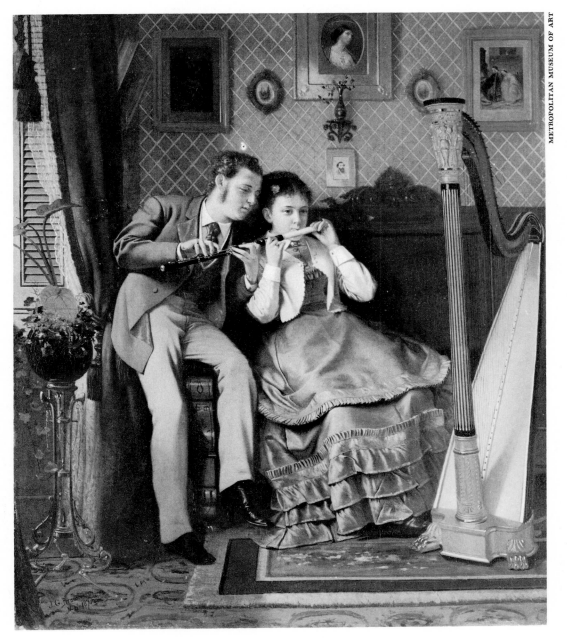

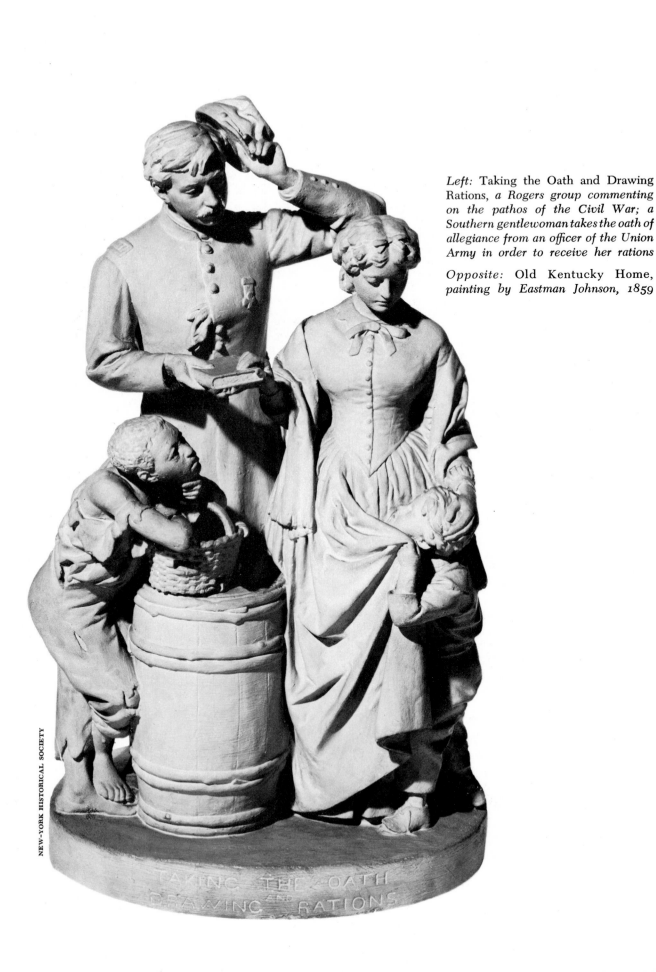

Left: Taking the Oath and Drawing Rations, *a Rogers group commenting on the pathos of the Civil War; a Southern gentlewoman takes the oath of allegiance from an officer of the Union Army in order to receive her rations*

Opposite: Old Kentucky Home, *painting by Eastman Johnson, 1859*

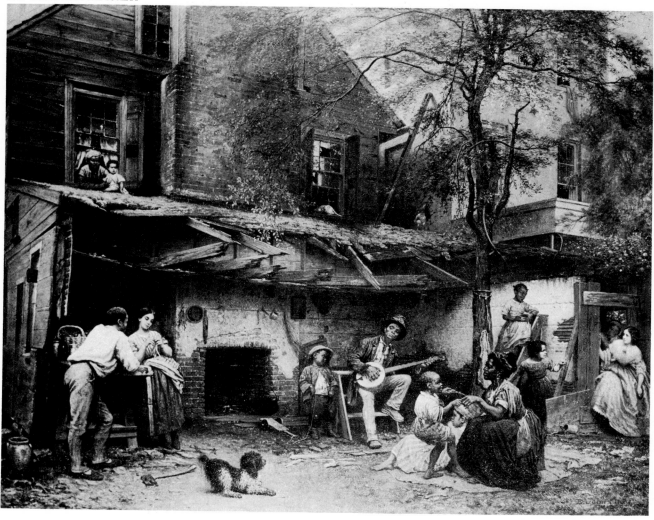

Eastman Johnson was another skilled artist who could turn his brush to sentimental genre painting, as he did in presenting the beneficent aspects of the Negro's lot in American life with *Old Kentucky Home*. Johnson had shared a studio with Leutze in Düsseldorf and had later settled for nearly four years in The Hague, where he was known as the "American Rembrandt" and was offered the position of court painter, if he would remain. Popular as his storytelling pictures were in their day, and still are to a degree, his reputation now rests largely on his strong, realistic portraits and his later, somewhat impressionistic landscapes. As to the genre paintings, one critic has written that Johnson pictured a scene as one imagines it might have been, whereas Homer painted what it was actually like, as it could not otherwise have been. Ranking in popularity with the ubiquitous prints of Currier and Ives, and Prang, over the last four decades of the nineteenth century were the homespun statuettes of John Rogers. For Rogers, sculpture was a narrative art. "His art is for the people," one contemporary reported in 1869. "All can understand it; all can appreciate its meaning; all can perceive its truth, and respond to its feeling." "Large sales and small profits" was his professed motto. He ran a factory in his New York studio where he employed up to sixty assistants. Between 1860 and 1893 an enthusiastic public bought almost eighty thousand copies of his little plaster groups at an average price of $14 each. *Taking the Oath and Drawing Rations*, one of his popular subjects, continued to sell over a period of thirty years.

THE LITHOGRAPHER'S ART

Above: Power of Music, *lithograph after a painting by William Sidney Mount, which appears on page* 115

Opposite, top: Going to Church, *after a painting by George Durrie*

Opposite, bottom: Preparing for Market, *after Louis Maurer, a well-known artist commissioned by the lithographic firm of Currier and Ives*

In the second half of the nineteenth century, for those large numbers of Americans who craved art for their homes but could not afford to buy original works, lithographs provided an acceptable choice of reproductions. Cheaper and quicker to produce than aquatints, they replaced such earlier prints in popularity. In the best-selling book, *The American Woman's Home*, published in 1869, Catherine E. Beecher and her sister, Harriet Beecher Stowe, advised their readers that lithographs after the work of the best American artists could be bought with the $20 or $30 budgeted for pictures in the furnishing of a parlor. When the huge landscapes of Albert Bierstadt were selling for staggering prices, for example, a lithograph copy of his *Sunset in the Yosemite Valley* could be purchased for $12. Between 1835 and 1907 the New York firm of Nathaniel Currier, later Currier and Ives, lithographed 4,300 subjects for distribution about the Atlantic world that sold from 20 cents to $3 each. Popular paintings by well-known artists, like William Sidney Mount, George Durrie, and others who have been mentioned earlier in these pages, were reproduced by copyists whose black-and-white prints were in turn hand-colored by teams of women working at home. Subsequently, the colors were also printed from a series of lithographic stones, one for each of the basic colors, in a manner that mechanized the whole procedure and that was called chromolithography.

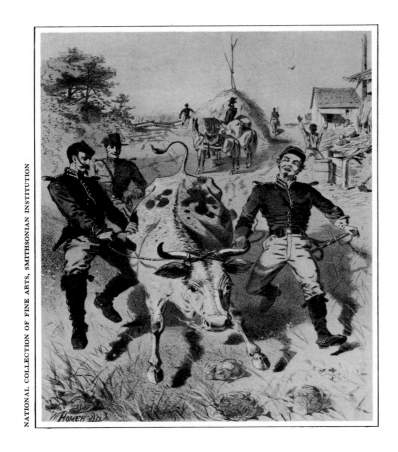

Left: Foraging, *a print by A. Prang and Co., after a campaign sketch by Homer*

Below: Catching a Trout, *by Arthur Tait, was the painting from which Currier and Ives engraved this lithographic print.*

Opposite, top: West Point, *one of numerous fine prints whose origin is unknown*

Opposite, bottom: Marguerite, *George Ward Nichols' lithographic print, after the portrait by Eastman Johnson*

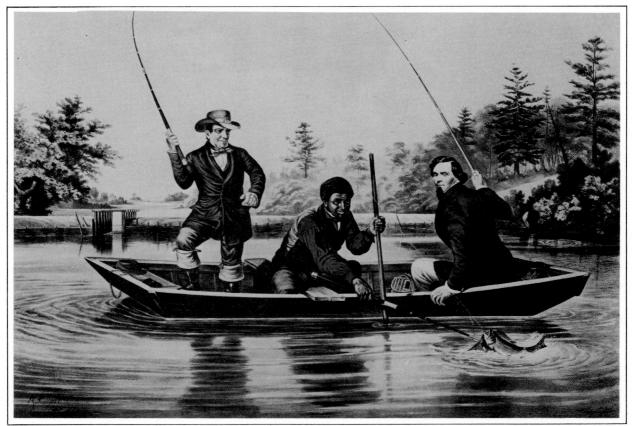

222

E. L. Godkin, long-time editor of *The Nation,*
described American culture of the post-Civil War
years as a "chromo civilization," a derogatory
reference to the cheap, mechanically produced
chromolithographs of the period—art by
machinery, as it were. There were others,
however, who held more generous views of those
prints. James Parton, the distinguished biographer of
Benjamin Franklin, Thomas Jefferson, and others,
asserted that when some of these "chromos"
were hung side by side with the originals "not
even the artist who painted the picture could
always tell them apart," and he was not alone
in that extravagant appreciation. "It is not too
much to say," wrote another contemporary of the
output of the Boston chromolithographer Louis
Prang, "that he has done more to create a popular
knowledge and appreciation of what may be called
every day art than any other man in America."
In black and white or in color the lithograph did
indeed bring fair approximations of original
drawings and paintings to a much wider audience
than had ever before been aware that such
pictures existed in the first place.

HARRY T. PETERS, *America on Stone*

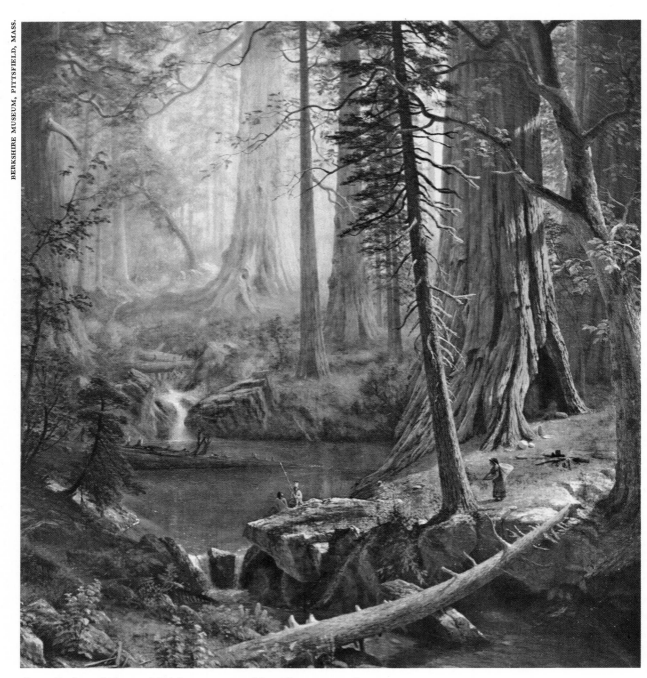

Giant Redwood Trees of California, *painted by Albert Bierstadt*

WESTERN PANORAMAS

By 1890 the ragged line of the Western frontier that had been drawn and redrawn so frequently on successive maps of America, from Jamestown on, had finally disintegrated into a jumble of small, vanishing circles. And still the country's center of population moved westward. The West continued to serve as a theatre for ancient dreams, a land of wonders and heroic achievements that were multiplied and magnified when seen from the window of sedate eastern parlors. "Every sunset which I witness," Thoreau wrote in the name of a multitude of wondering Easterners, "inspires me with the desire to go to a West as distant and as fair as that into which the sun goes down. He appears to migrate westward daily, and tempt us to follow him. He is the Great Western Pioneer whom the nations follow. We dream all night of those mountain-ridges in the horizon, though they may be of vapor only, which were last gilded by his rays. The island of Atlantis, and the islands and gardens of the Hesperides, a sort of terrestrial paradise, appear to have been the Great West of the ancients, enveloped in mystery and poetry. Who has not seen in imagination, when looking into the sunset sky, the gardens of the Hesperides, and the foundation of all those fables?" In his panoramic canvases of the far western scene Albert Bierstadt portrayed the melodrama implicit in Thoreau's sentiments more successfully than any other artist, and made a fair fortune in the process. As one critic wrote, the grandeur of such vast landscapes "did not daunt him," especially as he worked up his huge pictures from on-the-spot sketches when he returned to his eastern studio on the banks of the Hudson River. In the Rocky Mountains he recognized similarities to the Swiss Alps and to Italian mountains, remembered from his years of travel and study in Europe, and in the end he brought those resemblances into his studio productions of the American West. He was not without critics in his own day for his elaborations. "With singular inconsistency of mind," wrote James Jackson Jarves, one of the keenest observers of the contemporary art scene, in methodical German manner Bierstadt idealized his compositions and "materialized" their execution until, "though the details of the scenery are substantially correct, the scene as a whole often is false." However, Bierstadt received far more for one or another of his extravagant canvases than Homer, Eakins, or Ryder ever dreamed of. Congress purchased two of his paintings; his fame spread abroad; and then the tides of taste changed, and his fashion passed.

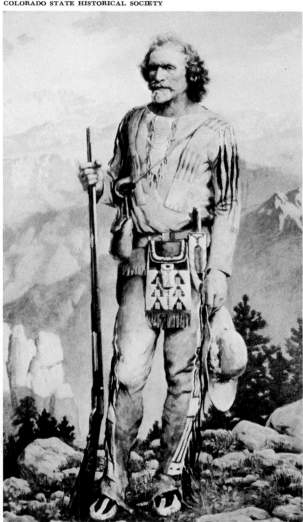

Portrait by Waldo Love of Jim Baker, celebrated mountainman, dressed in a costume made by a Sioux squaw; Baker's "hand to hand" fight with two grizzlie bears, both of which he killed, was a well-known Western tale.

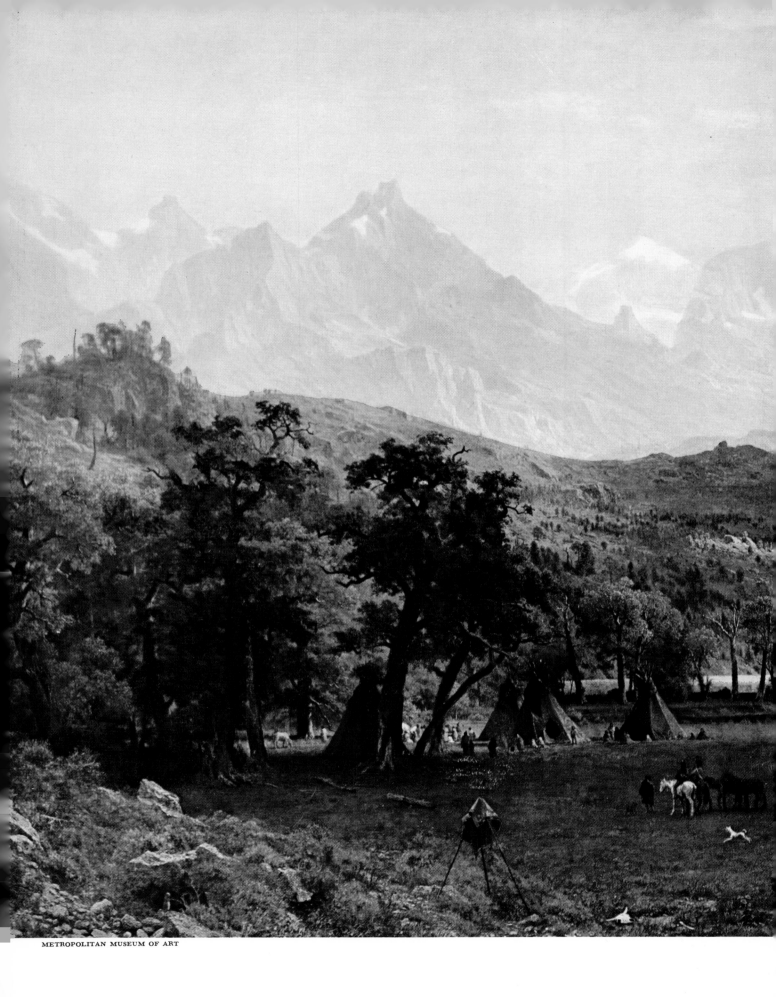

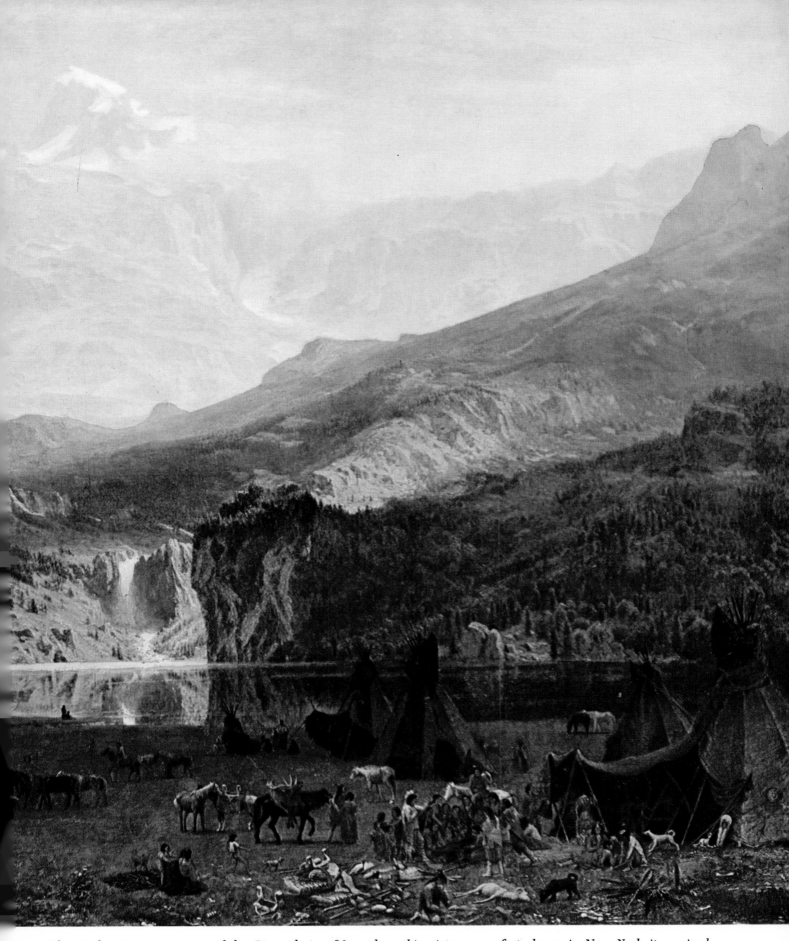

The Rocky Mountains, *painted by Bierstadt in 1863; when this picture was first shown in New York it received a spectacular welcome. Bierstadt not only became something of a national hero, he was decorated by foreign governments.*

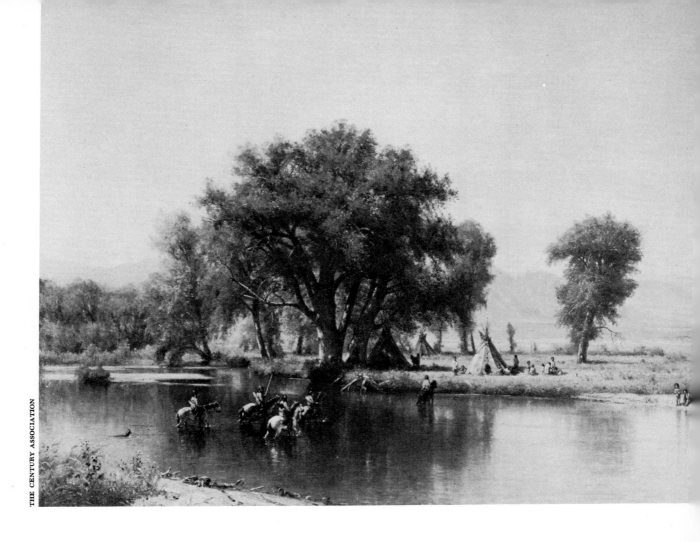

The golden legend of the West acted like a magnet on a number of artists who looked to
the vanishing wilderness for subjects whose novelty and grandeur would challenge their
wildest and most adventurous visions before that vast territory became a familiar and
domesticated part of the American scene. In 1865–66 Worthington Whittredge joined a military
expedition through Colorado and along the Eastern Rocky Mountains into New Mexico, accompanied
by his fellow artists Sanford Gifford and John Kensett. Whittredge was born on a pioneer
farm in Ohio and started his career as a sign and house painter, then briefly as a photographer
and portraitist in Indiana. With the backing of a wealthy acquaintance who had confidence
in his talent, he sailed for Europe in 1842 to further his studies. He spent ten years in
Düsseldorf, Paris, and Rome, and returned an accomplished landscapist. His *Crossing the Ford*
was reconstructed from field sketches he had made on his western journey. In it, he pictured
in the background Long's Peak, north of Denver, and as in so many of Blakelock's and his friend
Bierstadt's western subjects, he included an Indian encampment to emphasize the still-wild
aspect of the scene. "Whosoever crossed the plains at that period," he wrote in his autobiography,
". . . could hardly fail to be impressed with [the] vastness and silence and the appearance everywhere
of an innocent, primitive existence." In 1871 the English-born artist Thomas Moran also joined
a government expedition to the West, and from his sketches developed large, brilliant, and
accurate paintings of the Grand Canyon of the Yellowstone and comparable natural wonders.
"I cast all my claims to being an artist into this one picture of the Great Canyon and am
willing to abide by the judgment on it." That same year Congress established Yellowstone
as a national park—and bought Moran's painting.

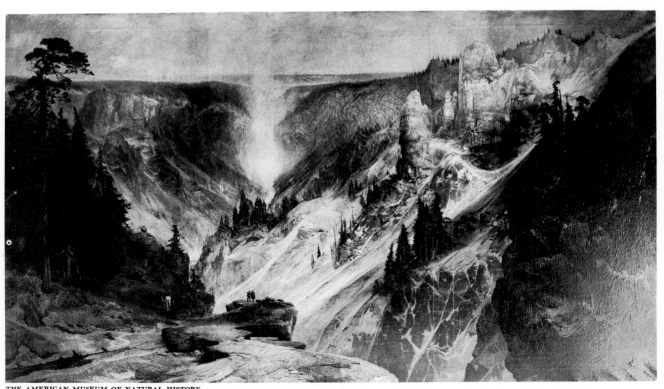

Left: Crossing the Ford, Platte River, Colorado, *painted by Worthington Whittredge in 1870*

Below: Thomas Moran's The Grand Canyon of the Yellowstone, *painted in 1871 and shown in 1872*

229

As a young man William Morris Hunt left Harvard and went to Rome with the intention of becoming a sculptor. In 1855 he returned to America a painter, strongly influenced by the work of the Barbizon school and particularly by the paintings of Jean François Millet. To a large degree it was Hunt's own influence on students and collectors that led to the growing interest in French art in America. His teachings were carefully recorded by one of those students. At one point Hunt remarked, "When you paint what you see, you paint an object. When you paint what you feel, you paint a poem." In 1878 he was commissioned to paint two large murals for the New York State Capitol at Albany. Years before, Hunt had read a translation of a Persian poem about Anahita, goddess of night, which fascinated him so that he had made numerous attempts to translate the theme into pictorial terms, including the plaster relief here illustrated, with the "fearful plunge" of its "well-trained coursers." It was to this model that he turned to furnish one of the murals, which he then entitled *The Flight of Night*. The strain of completing those paintings led to Hunt's nervous collapse, and his death soon afterward. Daniel Chester French had received some instruction from Hunt and had also attended William Rimmer's anatomy class in Boston before he undertook his portrait of Ralph Waldo Emerson in 1879, which he modeled from life. "The more it resembles me," Emerson is said to have quipped, "the worse it looks." But he remarked of the finished likeness, "Yes, that is the face I shave." More than forty years later French completed what is probably his best known work, the statue of Abraham Lincoln in the Lincoln Memorial in Washington.

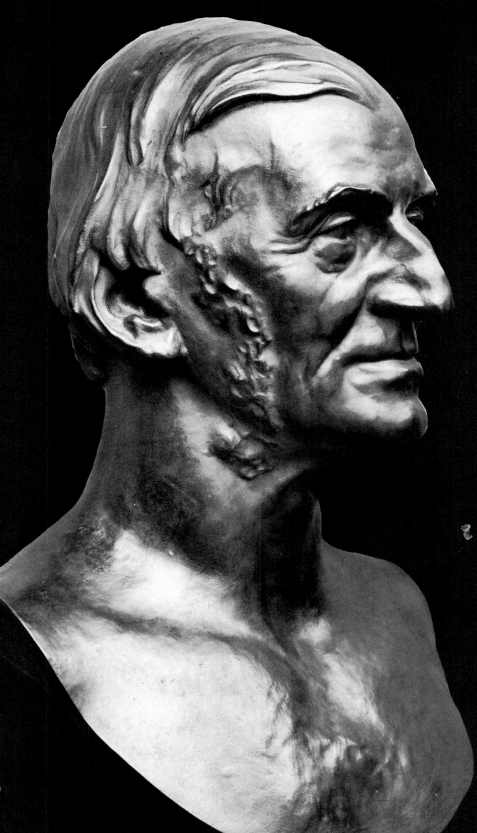

FORMS OF SCULPTURE

Opposite: The Horses of Anahita, or Flight of Night, *painted plaster relief by William Morris Hunt*

Right: bronze head of Emerson by Daniel Chester French, 1879

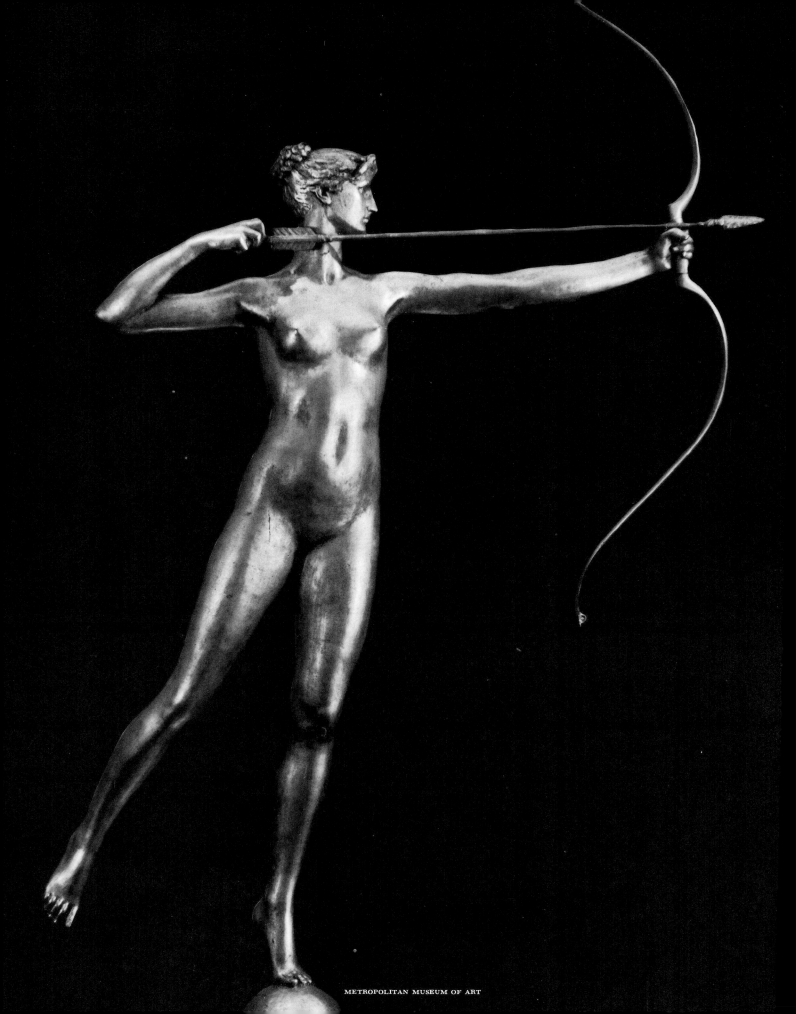

MetropolitanManzaMuseum of Art

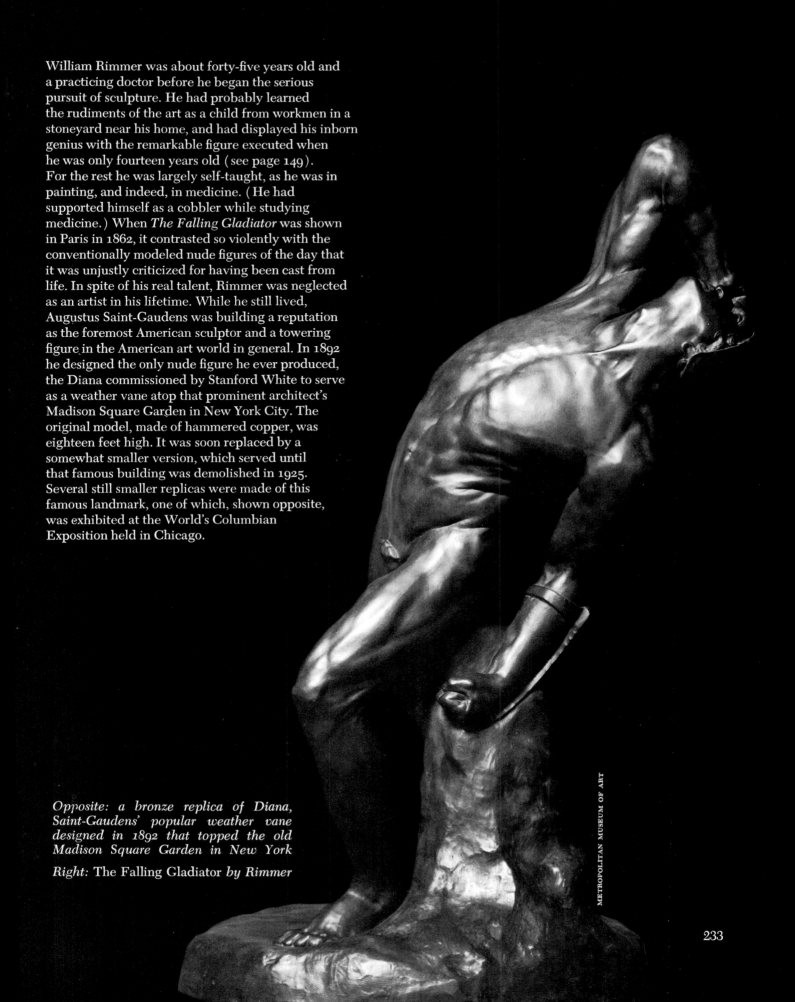

William Rimmer was about forty-five years old and a practicing doctor before he began the serious pursuit of sculpture. He had probably learned the rudiments of the art as a child from workmen in a stoneyard near his home, and had displayed his inborn genius with the remarkable figure executed when he was only fourteen years old (see page 149). For the rest he was largely self-taught, as he was in painting, and indeed, in medicine. (He had supported himself as a cobbler while studying medicine.) When *The Falling Gladiator* was shown in Paris in 1862, it contrasted so violently with the conventionally modeled nude figures of the day that it was unjustly criticized for having been cast from life. In spite of his real talent, Rimmer was neglected as an artist in his lifetime. While he still lived, Augustus Saint-Gaudens was building a reputation as the foremost American sculptor and a towering figure in the American art world in general. In 1892 he designed the only nude figure he ever produced, the Diana commissioned by Stanford White to serve as a weather vane atop that prominent architect's Madison Square Garden in New York City. The original model, made of hammered copper, was eighteen feet high. It was soon replaced by a somewhat smaller version, which served until that famous building was demolished in 1925. Several still smaller replicas were made of this famous landmark, one of which, shown opposite, was exhibited at the World's Columbian Exposition held in Chicago.

Opposite: a bronze replica of Diana, Saint-Gaudens' popular weather vane designed in 1892 that topped the old Madison Square Garden in New York

Right: The Falling Gladiator *by Rimmer*

One of Saint-Gaudens' most important rivals as America's foremost sculptor of the late nineteenth and early twentieth centuries was Daniel Chester French. In 1874, some years before he had portrayed Emerson, that "Sage of Concord" had been instrumental in getting French the commission to execute the figure for the Minute Man monument in Concord. The artist was then only twenty-four, and this achievement won him almost instant fame when the job was completed in 1874. American sculpture was coming of age in those years. In 1891 George Grey Barnard, then a poor and lonely young student in Paris, finished his model for the *Struggle of the Two Natures in Man,* which was highly praised by French critics when a marble version was exhibited a few years later. His conservative American contemporaries for years to come considered Barnard a somewhat radical modernist, but the great French sculptor Rodin was among the many who admired his work and who were impressed by its expressive powers. While still in his twenties he composed this group. He had seen and been inspired by the works of Michelangelo, and he proceeded to cut the marble version himself, without help from professional stonecutters, as the great renaissance master habitually did. It was a feat few of his fellow sculptors could have accomplished. (The group was first exhibited as *Je sens deux hommes en moi*—"I feel two beings within me"—the title of one of Victor Hugo's poems.) Just before Barnard chiseled that statuary, his exact contemporary Frederick William MacMonnies completed his *Bacchante and Infant Faun,* a graceful and decorative statue slightly larger than life size; it had been commissioned for the Boston Public Library by the eminent architect Charles F. McKim as a center piece for a fountain. (As MacMonnies was finishing the figure the French government ordered a replica for the Luxembourg.) "With its vitality and gaiety, and its suggestion of the joy of life," wrote one contemporary, "it promises to gain by contrast with the austere dignity of its surroundings. In giving it, Mr. McKim and Mr. MacMonnies will give Boston one of the few admirable examples of imaginative sculpture in public places in America." Both Saint-Gaudens and French also expressed their approval. However, there were other prominent persons, including that eminent critic of the fine arts, Charles Eliot Norton, who viewed such a "monument to inebriety" with some dismay. "The statue would undoubtedly shock a great many people," the president of M.I.T. believed, ". . . although admirably executed from a technical point of view, [it] was that of a drunken woman." Others were concerned by the careless and precarious way the giddy bacchante held the child in the crook of her arm. All in all, a Boston clergyman preached to a large audience, if they accepted the gift, the library trustees would be guilty of "no petty treason, but high treason—treason to purity and sobriety and virtue, and Almighty God." Under pressure McKim finally withdrew the gift, and *Bacchante* settled happily in the Metropolitan Museum of Art.

CONCORD, MASS.

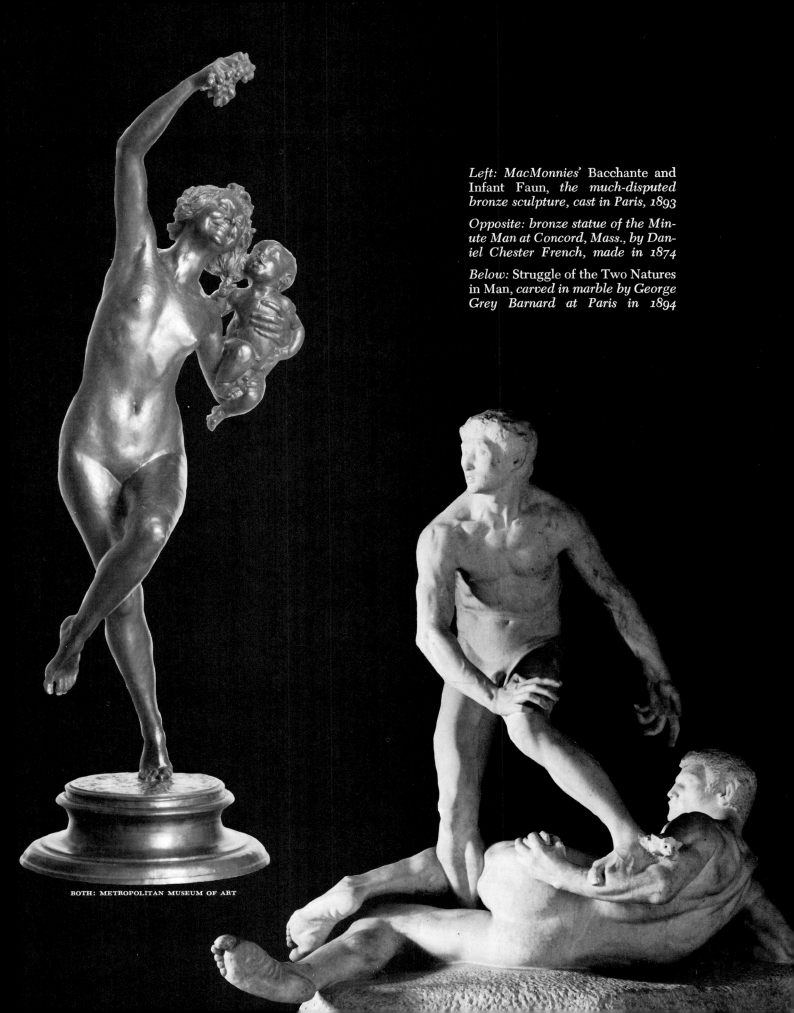

Left: MacMonnies' Bacchante and Infant Faun, *the much-disputed bronze sculpture, cast in Paris, 1893*

Opposite: bronze statue of the Minute Man at Concord, Mass., by Daniel Chester French, made in 1874

Below: Struggle of the Two Natures in Man, *carved in marble by George Grey Barnard at Paris in 1894*

BITS
AND PIECES
OF ART

Opposite: The Poor Man's Store, *by John Frederick Peto; painted in 1885*

Below: John Haberle's A Bachelor's Drawer, *painted between 1890–94*

To create an illusion of three-dimensional reality on a flat painted surface was the traditional goal of artists in the Western world until fairly recent times. In the last several decades of the nineteenth century a number of American painters carried the imitation of nature to the extreme point where their works—*trompe l'oeil,* as they are called—did literally fool the eye. The degree of their success is evident today whenever the best of such paintings are placed on exhibit, as the public inevitably strains to determine by very close scrutiny whether the objects depicted are in fact real or merely painted images. William Michael Harnett is considered the father of this school of virtuosos. While he studied art he supported himself by engraving silver, until 1875 when he turned professional painter. His career was well marked when his most celebrated work, *After the Hunt* (see page 239), was shown at the Paris Salon of 1885 and won high praise from the press. (The painting was later acquired by a popular New York saloon where convivial customers from all over America were diverted, and sometimes bewildered, by its singular and ingenious artistry.) To accomplish his special purpose he selected objects for his compositions that were usually old and used, with appealing, contrasting textures and with patinas. Harnett's contemporary, friend, and disciple, John F. Peto, made his generally similar compositions poetic commentaries on the "fantasticality of the commonplace and the pathos of the discarded," as one authority has observed. Peto dropped out of the art world in his later years, and his works remained unrecognized until he was rediscovered as an identifiable and original artist about twenty-five year ago. By that time many of his paintings bore the forged signature of Harnett.

Above: The Artist's Card Rack, *painted by William Michael Harnett in 1879, a motif that had European precedents and that had been used earlier in the century in at least one painting by Raphaelle Peale.*

Opposite: Harnett's After the Hunt, *his best-known work in one of several versions; it was critically acclaimed at the Paris Salon of 1885.*

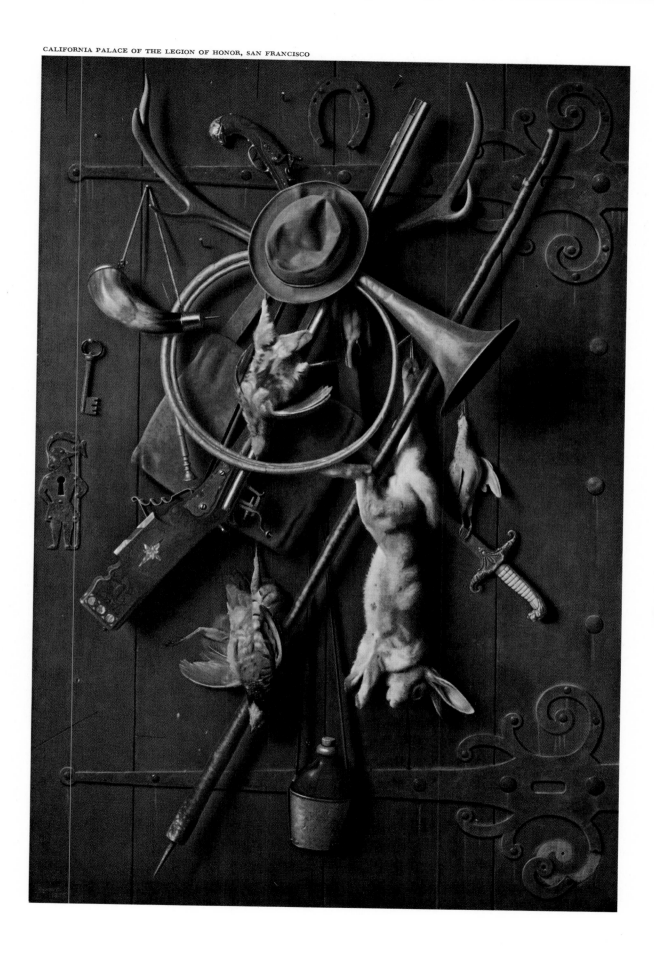

Opposite: Josephine and Mercie, *painted in 1908 by Tarbell and depicting proper Bostonians in a well-appointed interior*

Below: Mother and Child, *painted by Brush*

THE AMERICAN MADONNA

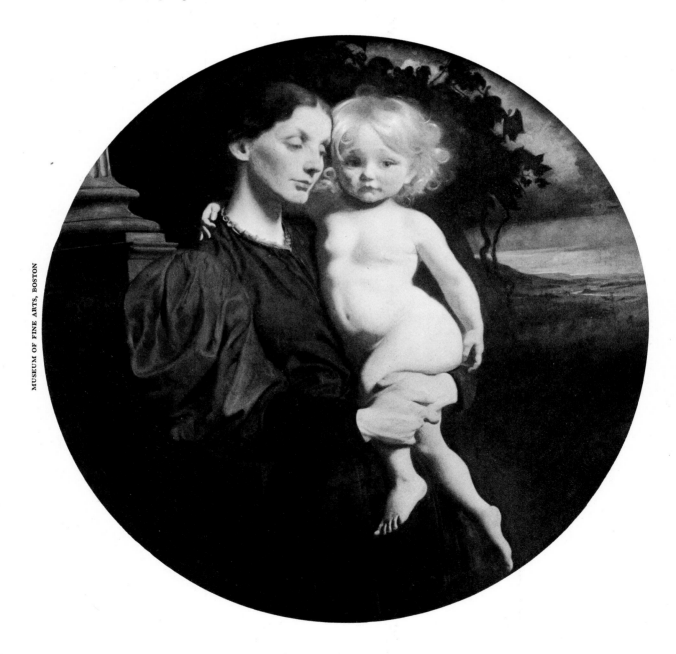

MUSEUM OF FINE ARTS, BOSTON

With some exceptions, Henry Adams once observed, American artists "used sex for sentiment, never for force." In those years of which he wrote, around the turn of the century, the idealization of womankind seemed to foreign observers to be a peculiarly American phenomenon—womankind, elevated or reduced according to the point of view, to a somewhat bloodless, sexless, and purified version of the species. George de Forest Brush, who had lived with the Indians for a time after returning from his studies in Paris and painted their likenesses, believed the modern artist must not "run after new things," but "find out what the [old] masters knew." His circular painting of a mother and her baby (here illustrated) recalls an Italian Renaissance tondo of the Madonna and Child in its solemnity and in its tenderness, as well as in its play of sharply defined light and dark areas, its chiaroscuro. By the painted evidence of the times, ladies of irreproachable propriety nurtured daughters who developed into healthy, obedient, outdoor girls, in homes with a proper balance of early American furnishings with Japanese accents, much as Edmund C. Tarbell pictured that passing scene in 1908 in his *Josephine and Mercie*, showing the living room of a Boston home. The young lady here pictured, it has been suggested would have attended Miss Winser's school, gone to the correct series of subscription dances and to the meetings of the sewing circle.

"My mother and father had the utmost contempt for painters who painted things out of their heads . . . ," recalled the writer Nancy Hale, both of whose parents were artists influenced by much the same training and circumstances that had shaped the art of Tarbell and Brush. "They wanted to 'render the object'—," she wrote, "an immensely subtle process involving the interplay of the painter's subjective view with the way the light actually fell upon the object. The conflict—rather, the marriage—of objectivity and subjectivity was what made art such a wildly exciting and magical thing. . . ." It is difficult to think of Julian Alden Weir's *Idle Hours* as "a wildly exciting thing," but this is generally the sort of painting referred to in that quotation. (The subjects were the painter's wife and child). However, the painting does demonstrate Weir's sensitive understanding of the play of light and the subtle use of color that qualified him in his later work as an American impressionist. In *The Virgin* Abbott H. Thayer came close to the limit in glorifying and purifying the American girl. "With little wings," wrote James Thomas Flexner, this figment "was a fairy; with big wings, an angel; nude she was The Spirit of the Water Lily; dressed, Virginity." Thayer's study of protective coloration of animals provided a basis for the art of camouflage as it was practiced in World War I.

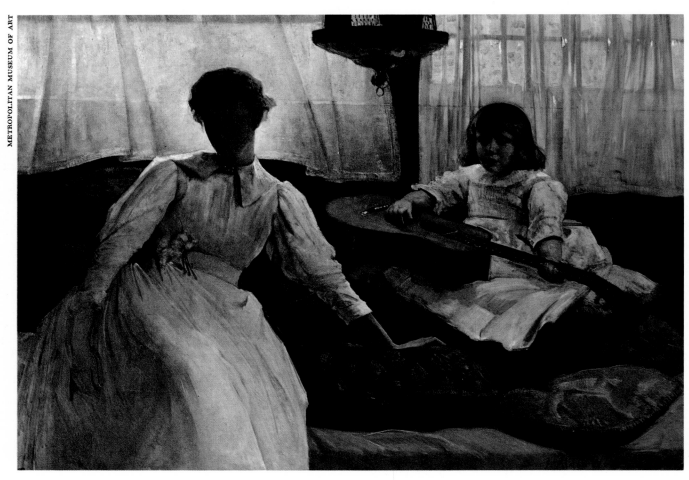

Above: Idle Hours, *painted by Julian Alden Weir in 1888*

Opposite: The Virgin, *an apotheosis of pure American womanhood, painted by Abbott H. Thayer in 1893*

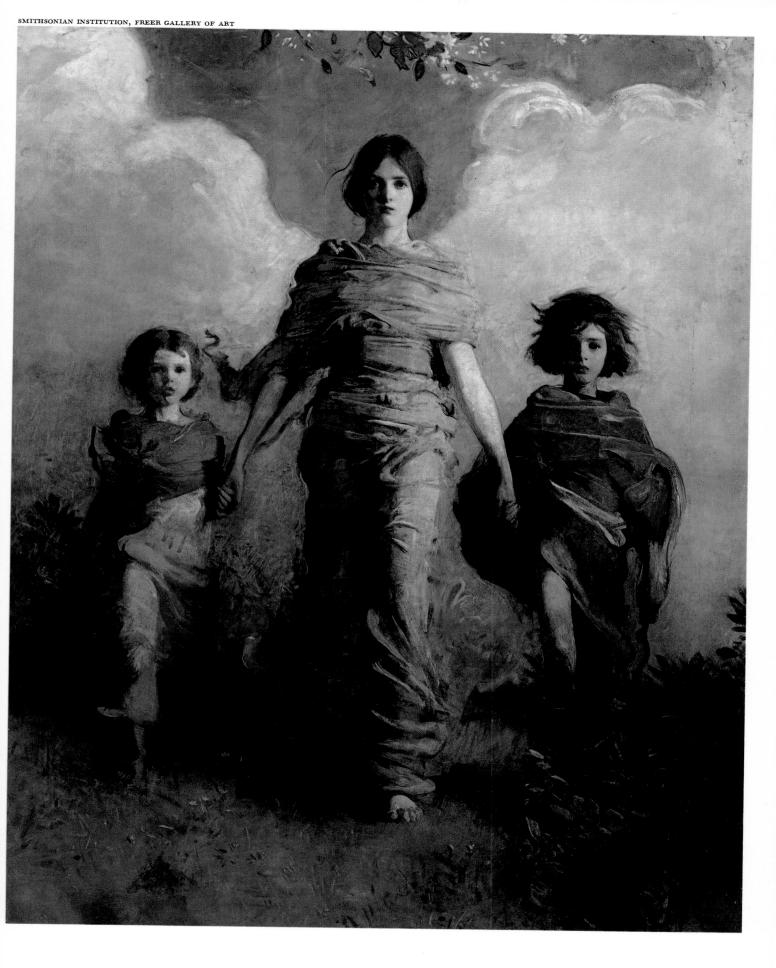

John White Alexander's Isabella *or* The Pot of Basil, *1897; a theme taken from Boccaccio's* Decameron

Writing early in this century, Samuel Isham, an American artist and esteemed art critic, enlarging on James' comments, observed that, partly because of their Puritan tradition, Americans "have no goddesses or saints, they have forgotten their legends, they do not read the poets, but something of what goddess, saint, or heroine represented to other races they find in the idealization of their womankind. They will have such idealization decorous; there is no room for the note of unrestrained passion, still less for sensuality. It is the grace of children, the tenderness of motherhood, the beauty and purity of young girls which they demand, but especially the last. The American girl is placed upon a pedestal and each offers worship according to his abilities, the artist among the rest. All of the papers from the yellowest of the daily press to the most dignified of the magazines are filled with representations of her. [Charles Dana] Gibson has created the best-known type, to which his name has been given ["the Gibson girl"], a creature rather overwhelming in her perfections, with no occupation in life save to be adored by young athletes in tennis clothes or by disreputable foreign noblemen." Gibson's girl did indeed become the popular and ubiquitous symbol of such improbable creatures, whom more staid and formal artists portrayed in different moods and with different styles. Thomas W. Dewing typically presented his ladies more as wraiths than as solid bodies, delicately drawn figures that all but blend into the background of a dimly lit interior or a vaguely defined meadow, lost in some poetic revery as they play or listen to music. The enveloping atmosphere is soft, shimmering, and evanescent; the ladies themselves refined and detached from their surroundings In his *Isabella,* on the other hand, John White Alexander's heroine assumes an almost posterlike quality with the artist's suppression of unnecessary detail, a notable characteristic of the Japanese prints so popular at the time. Alexander never studied in Paris, although he lived and practiced there for a number of years and was familiar with the art-nouveau style that was such a fashionable aspect in the poster and decorative arts at the turn of the century. The theme of *Isabella* (derived from Boccaccio's *Decameron*) was used by Keats in a poem of that name. Isabella's brothers, the story went, eager to marry their sister to a nobleman, murdered the girl's humbly born lover and buried him in a wood near Florence. In her grief she unearthed the corpse, severed the head, and concealed it in a jar planted with sweet basil, an Italian symbol of love.

Above: The Spinet, *painted by Thomas Wilmer Dewing about 1802*

Below: *"The Gibson Girl," after Charles Dana Gibson's drawing*

Now Art should never try to be popular

The public should try to make itself artistic.

—OSCAR WILDE

A TIME OF TRANSITION

Opposite, detail of Childe Hassam's painting Washington Arch in Spring, *1890 (above)*

On New Year's Day, 1641, John Winthrop, Jr., one of America's pioneer scientists and industrialists, resolved to give up his habit of inventing things. In that moment of reflection the earnest Puritan doubted whether any technological improvements he could devise would ever help him, or anyone else, to salvation. They might provide practical advantages unknown to past generations, but the spiritual gains were dubious.

As the nineteenth century waned, there were some who thought that the dilemma faced by Winthrop was still a matter of very real and present concern, that the questions it raised were, in fact, more acute than ever. Life in America had never been so complex. Industry, whose activity had been so sharply accelerated by the Civil War, seemed to be reaching some great, even awesome, climax. Nowhere on earth was human society being so profoundly modified—so richly benefited or so pitilessly tested—by the advances of technology. Writing in the *Atlantic Monthly* late in the century, Professor Woodrow Wilson commented that the "haste, anxiety, preoccupation, the need to specialize and make machines of ourselves," had quite transformed and excessively complicated the world about him. To some others it seemed that mechanization was progressively taking command of human destiny, that civilization on such terms was itself a "preposterous fraud."

For centuries past, an abundance of free land to the West had provided an outlet for the discontented and restless elements of the population; it had afforded opportunities for those who hoped to change and better their lot in life. The land seemed illimitable—bounded only by the Day of Judgment, as one early Kentuckian said. Even Benjamin Franklin, our major prophet and apostle of expansion, miscalculated, thinking it would take ages to fill the western regions of the continent. But in 1890, only a few generations after his observation, the Superintendent of the Census reported that to all intents the old frontier had vanished from the map. A relatively few buffalo continued to straggle across the plains, and several territories still awaited statehood; but most of the good free land had been staked out. One scholar pointed out at the time that with the passing of the frontier the first large period of American history had closed.

Meanwhile, the cities of the land were growing at a prodigious rate, in complexity as well as in size. With their diverse mechanical operations (including the

telegraph and telephone) and their new mobility (supplied by such rapid conveyances as electric trolley cars, elevated trains, and elevators, then automobiles and subways), they represented, in effect, a new type of community, one without precedent in history. "What shall we do with our great cities?" "What will our great cities do with us?" were questions urgently addressed to thoughtful Americans in the 1890's. New techniques of living and a new social philosophy had to be learned and practiced. To mold the vast congeries of life that massed in and around the larger cities into a systematic organism that would provide welfare and amenity for their swollen populations involved novel and difficult problems that somehow would have to be solved if the dreams of democracy were to be realized. Many of those problems remain with us today.

For better or for worse, urban ways and habits were becoming the prevailing standard across the countryside. Rural folk in all corners of the nation turned to their "wishing books" (the mail-order catalogues of Montgomery, Ward and Company and of Sears, Roebuck and Company) to linger over illustrations and descriptions of commodities considered fashionable by city dwellers—or, rather, inexpensive approximations of such commodities. The big city was a magnet that, in spite of moralists who preached about its corruptions and miseries—or perhaps because of their lurid descriptions of the sinful indulgences practiced there— attracted men and women, boys and girls, from their rural retreats at all points of the compass. "We cannot all live in cities," Horace Greely had exclaimed earlier in the century, "yet nearly all seemed determined to do so." By the century's end the urban movement had become a great migration. To add to the crush of people in the larger centers, in the two decades just before and after the turn of the century almost twelve and a half million immigrants swarmed into America from countries about the globe; and a large proportion of them was shunted into the tenement districts, the slums, of industrial cities to live there as they might.

In 1888 Edward Bellamy published his romance, *Looking Backward, 2000–1887*, in which the hero awakens in Boston in the year 2000 from a century-long sleep to discover that the machine has been mastered and harnessed for the happiness of mankind; competitive capitalism with all the inequities and injustices it visited on the poor and oppressed has been abandoned for cooperative enterprise in which all share equally in the opulence they helped to create. Air pollution has been eliminated; air conditioning is commonplace; housework is mechanized and human drudgery abolished; broadcasting systems provide musical programs that can be selectively reviewed and controlled in volume. Shaded streets and open squares filled with trees, splashing fountains, and glistening statues give the city a "delicious freshness" for everyone to enjoy. And all this had been accomplished by the peaceful evolution of democratic principles and practices, by social planners, engineers, architects, and artists with a high, united common purpose. Beneath the surface of his utopian vision Bellamy was, of course, critically attacking the sordid and materialistic aspects of the world he lived in.

Just five years after that memorable book was issued, the nation suffered one of its periodic economic crises, and many of the evils against which Bellamy had directed his attack were made more poignantly manifest. The panic of 1893 slipped into a depression that lasted for several years. Unemployment was wide-

Title page of the book by James William Buel, published in 1883

spread; banks closed; strikes were launched, to be met with violence; "Coxey's Army" of workless men marched on Washington (one of a number of demonstrations that dramatized the real economic unrest of the period), and its straggling remnants were arrested for trampling on the grass of the Capitol grounds.

In spite of the sorry state of the times, on the first of May, 1893, Chicago opened the gates to the World's Columbian Exposition celebrating (a year late) the four hundredth anniversary of Columbus' discovery of America. It also celebrated (a few years early) the rounding out of a century of progress, and by extension of that record, with its impressive displays of technological achievements, it forecast a more promising tomorrow for Americans and for human beings everywhere. The great fair, it was announced, would "awaken forces which, in all time to come, [would] influence the welfare, the dignity and the freedom of mankind."

It was a monumental extravaganza. Paradoxically, the new wonders of electricity and other modern advances in technology that were shown there were housed in structures designed in the spirit of Beaux-Arts classicism, reaching back for inspiration to the crumbled civilizations of ancient Greece and Rome—an incongruity that was not lost on some critics of the time. Louis Sullivan, who represented a new and vital trend in American architecture, whose steel-frame skyscrapers were already giving Chicago architecture unique distinction, and whose Transportation Building at the Exposition was a brilliant exception to the "snowy palaces, vast and beautiful" that surrounded it on the fairgrounds, thought that those other structures were a retrograde and disastrous influence on the development of American building. He referred to such products of "the pallid academic mind, denying the real, exacting the fictitious and the false, incapable of adjusting itself to the flow of living things."

However, for people-at-large the White City, as the assemblage of buildings on the fairgrounds was called, presented a dazzling spectacle. Even such Eastern sophisticates as Henry Adams and Charles Eliot Norton were moved to wonder at the apparently endless vista of harmoniously correlated façades (made of plaster of Paris, though they were) arranged in an entirely artificial landscape on the shore of Lake Michigan, masterfully designed by Frederick Law Olmsted, creator of New York's Central Park. Part of the wonder was that barely twenty years earlier Chicago had virtually burned to ashes—even more quickly than it had sprouted from the wilderness such a short time before that. The Chicago fire of 1871 was one of the most horrible catastrophes of the century. But the city was reborn, and with amazing speed had developed into the great metropolis of the vigorous prairie world in the Northwest. That such an "inconceivable scenic display" as the fair could have been mounted there at the time and under the circumstances seemed to Adams "more surprising, as it was, than anything else on the continent, Niagara Falls, the Yellowstone Geysers, and the whole railway system thrown in. . . ."

A host of distinguished architects, sculptors, and painters had been summoned to stage that performance; men whose reputations were then for the most part established and unassailable. Richard Morris Hunt, famed for the magnificent chateaux he designed for the very wealthy in Newport and New York, came from the East to lend his talents, as did Stanford White of the prestigious firm of

The administration and electrical buildings at the Chicago Fair, 1893

The great Allis-Corliss engine at the World's Columbian Exposition

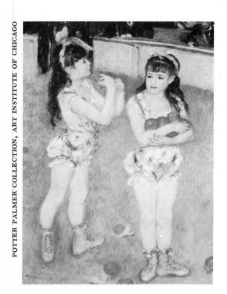

Pierre Auguste Renoir's Two Little Circus Girls, *painted in 1879, once owned by Mrs. Potter Palmer*

McKim, Mead, and White. Among the artists called upon to embellish the scene with their sculptures were Augustus Saint-Gaudens, Daniel Chester French, and Frederick William MacMonnies. Painters of equivalent stature were commissioned to decorate acres of wall space with murals. At one point in the discussions of the program Saint-Gaudens turned to Daniel Hudson Burnham, the Chicago architect charged with the all-over planning, and remarked, "Look here, old fellow, do you realize that this is the greatest meeting of artists since the fifteenth century?"

Some involved were not that great. Largely at the insistence of the wealthy and determined Mrs. Potter Palmer, supported by her militantly feminist associates, the Woman's Pavilion at the fair was designed by a Miss Sophia G. Hayden, a twenty-two-year-old lady from Boston whose other professional accomplishments would hardly be remembered by posterity. (In passing, Mrs. Palmer advocated a "baby-sitting" building at the fair.) The decoration of the Woman's Pavilion was entrusted to Mary Cassatt, Mrs. Palmer's friend and her adviser in the formation of a very impressive collection of paintings, which included a number of the first French impressionist canvases to be brought to this country. She thereby set a precedent for other elite members of Chicago society; to the degree that when, in recent years, a visitor to the Art Institute of Chicago patronizingly commented that its gallery of Renoirs must have cost that museum a lot of money, its president could remark, "Not at all: In Chicago we don't buy Renoirs. We inherit them from our grandmothers."

There were no Renoirs in the official representation from France in the fair's Art Palace; or anything by Courbet, Degas, Daumier, or even Corot. Like most of the other nations, France had sent largely standard examples of academic salon painting of the day. The exhibition of American art, on the other hand, was more representative of the best work being done in this country and by American painters abroad, including paintings by Inness, Whistler, Sargent, Homer, and Eakins, among others. Wilhelm von Bode, esteemed German art critic and museum director, went home from the fair with the most enthusiastic and generous admiration for the beauty and originality of the American school of painting, an appreciation he published in the *Zeitschrift für Bildende Kunst* for the benefit of his countrymen. The American section, he reported, was not only the largest but the best in the exhibition.

The last third of the nineteenth century had witnessed vital changes in the world of American art, changes that by the century's end could be seen in perspective. Among other developments the art museum had assumed an established role in civic life. From Brunswick, Maine, to San Francisco, California, galleries were now open to the public; some of them were holding national and international exhibitions. In the larger cities art schools of highly respectable caliber offered students a decent alternative to going abroad for their training, notably at the Pennsylvania Academy of Fine Arts and at New York's Art Students League, where the teachings of Thomas Eakins and William Merritt Chase had a profound influence on a rising generation of painters. Dealers in art had proliferated (some prominent artists were themselves dealers of sorts), and a very sizable group of well-advised, discerning collectors were adding magnificent treasures to America's share of the artistic heritage of Western civilization—such persons as John Pierpont Morgan, Isabella Stewart Gardner, Henry Walters,

John G. Johnson, and still many others, most of whose accumulations have long since been made available to the American public. Immensely wealthy, well advised, and highly acquisitive, these men and women bought European art of every description and of incalculable value. Morgan alone purchased in a flash of his pen huge collections that sometimes had taken long years for someone else to assemble.

Two other developments, both resulting from technological advances, affected the direction of painting and the appreciation of art in general. Shortly after the middle of the nineteenth century synthetic pigments of new, irresistible brilliance replaced the mineral and vegetable colors of old tradition on the artist's palette. The varieties of hues made possible by these chemically designed formulas resulted in a confusion of experimentation, most successfully resolved in the work of the French impressionists, who soon had followers throughout the Western world, including America.

Somewhat unexpectedly the American author from the Western prairies, Hamlin Garland, championed the impressionists. "Each age writes, paints, sings of its own time and for its time . . . ," he remarked. "The surest way to write for all time is to embody the present in the finest form with the highest sincerity and with the frankest truthfulness." In "the mighty pivotal present" he recognized the new spirit that was invigorating European culture. He detected a changing viewpoint toward the physical world that, he believed, was finding an apt expression in the work of the impressionists. Those advanced painters had given Garland fresh perceptions. He saw sunshine and shadows with new eyes, and he hoped contemporary American artists might share this vision and depict their own countryside with all the shimmering brightness that could be found there.

Hardly less important in the history of American art and of art in general, thanks in good measure to the inventiveness of George Eastman of Rochester, New York, was the progressive development of photography into a large-scale production of standardized images. Then, in turn, the development of photo-engraving techniques in the 1880's and 1890's made possible the all but endless reproduction of such reliable images in printed form. Those accomplishments were among the remarkable and far-reaching innovations of the century which, like the telephone and electric power, have become in our own day altogether commonplace. Thanks to such mechanically copied versions, it became possible to form reasonably accurate impressions of works scattered about the globe; paintings, objects, and buildings that to earlier generations would have been beyond the range of all but the most determined and fortunate traveler. As one consequence, artists, students, teachers, and public alike were becoming aware of more aspects of the world of art than were dreamed of by previous generations. As another consequence, the whole study and writing of the history of art had to be reconsidered in view of this abundance of newly available evidence. Artists themselves had vastly increased sources of guidance and inspiration.

The young painters who had swarmed to Europe for instruction in the years following the Civil War and who began returning to America with new techniques and new cosmopolitan attitudes in the 1870's and 1880's, had found the earlier generation of artists, the men who were still directing affairs at the National Academy of Design, hopelessly old-fashioned. Better to serve their own and differ-

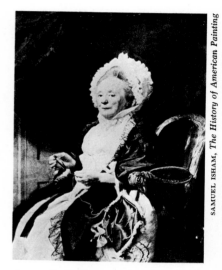

An early half-tone reproduction of John S. Copley's portrait of Mrs. Seymour Fort, published in 1905

251

ent interest, on their return the Europeanized younger men founded a separate organization, the Society of American Artists, and a school, the Art Students League. It was one of those periodic wars of generations that in art, as in other forms of social activity, apply fresh spurs to the progress of ideas and attitudes.

As an artist, a teacher, and a leader William Merritt Chase played an important role in all this. He had worked in his father's Indianapolis shoe store before turning to art. In 1872, sponsored by a group of businessmen, he went to Munich, where, with his American friend Frank Duveneck, he quickly and successfully learned to paint with the slashing, broad brush strokes characteristic of the manner taught in that city and recalling the techniques of such old masters as Velasquez and Frans Hals. He returned to America in 1878, bemedaled and otherwise honored, to teach at the newly formed Art Students League and for ten years to serve as president of the Society of American Artists.

Chase was an immensely influential teacher; in his long career he probably instructed more art students than any other American painter. Over the course of those years, in his own work he dropped the dark tonalities of his earlier Munich days and accepted the bright and shimmering palette of impressionism, a fashion made increasingly prevalent by growing numbers of young men returning from terms of training in Paris. In 1895, in another reorganization within the ranks of American painters, a group of them from Boston and New York banded together in a kind of academy of American impressionism under the name of the Ten American Painters. This group included four of the leading practitioners of impressionism: Thomas Dewing, John H. Twachtman, J. Alden Weir, and Childe Hassam. In 1902, upon the death of Twachtman, Chase joined the others and continued teaching with his unfailing and abounding energy.

It was on such a note that the century closed. Homer, Eakins, and Ryder, and Whistler and Sargent, were still painting; but they were growing old. The younger generation with its naturalized, somewhat tempered and quiet versions of European aestheticism was now in the ascendant. Once upon a time, before the Civil War, the typical American painter had much he wanted to say, but often lacked the technical refinement to record his message as well as he aspired to. Now, his later counterpart had a highly developed facility with his brush, but all too often not enough to say with it. Technique in the cause of more or less pure aestheticism was the fashion of the moment.

Over the near horizon, just beyond the turn of the century, new explosive forces were gathering that would shatter all such genteel and fashionable patterns into bits and pieces. For generations to come, it seems increasingly clear, they might never be put together again in a manner that had given such established uniformity to the successive historic styles of the past. From abroad fauvism and cubism that burst onto the scene in Paris, expressionism that forced its way out of the traditional dullness of German art, and futurism that became a singularly new adventure in Italian painting, all sent offshoots to America, where they were grafted on the native strain.

From within the country, also, new directions in art were dictated by the changing temper of the times. As already mentioned, the rapid industrialization and urbanization of the nation seemed to be converting the American dream of rugged individualism and homespun virtue into a nightmare of mechanized labor

William Merritt Chase's painting of his studio, executed about 1880

and mass-produced values. Although Frederic Remington could win success with his picturesque records of fast-vanishing ways of life among the cowboys and Indians of the recent Wild West, the sentimental anecdotes of rural life as it had earlier been recalled by Currier and Ives had lost their relevance among the commonplace realities of life in the new century.

There were artists who squarely faced those commonplace realities and found poetry worthy of their brush even among the ash cans of dirty, noisy cities. The best known of these "radicals" were men who had been journalist-artists and who with their quick pencils were accustomed to reporting the passing scene in illustrations for contemporary magazines and newspapers, and whose journalistic function was being replaced by the development of photoengraving.

The most prominent among these pathbreakers was the group made up of Robert Henri, George Luks, William Glackens, John Sloan, Everett Shinn, Arthur B. Davies, Maurice Prendergast, and Ernest Lawson—a group that will probably always be known as The Eight, although they were also anathematized as the "Ash Can school" and "The Revolutionary Black Gang" by less than appreciative critics of their aims and their work. These men were never formally organized, and all eight were staunchly individual in their styles and techniques. However, they did share an aversion to the approved academic art of their day. When, in 1908, they held an exhibition of their own work in New York, the event marked a clear departure from the directions being followed by most other American artists of the time. The significant developments in American art in the decade to come can be read in the series of such independent exhibitions, held outside the walls of the academies.

All eight were more or less familiar with advanced trends in European art (as well as with the old masters, for that matter), and in 1913, to amplify their voice of dissent, they helped to mount the memorable Armory Show—the most important art exhibition ever held in America. Here was a revelation not only of all manner of advanced contemporary American art, but an even more sensational exposure of avant-garde European art. For the first time Americans at large suffered the shock of recent developments in France through the works of Duchamp, Picasso, Cézanne, Matisse, Brancusi, and others among the leading innovators that had been imported for the occasion and that carried experimentation far beyond the limits of impressionism.

About a quarter of a million people paid to see the show in New York and, as it traveled on, in Chicago and Boston. Some were moved to laughter, others to wonder. In Chicago students of the Art Institute burned a Matisse in effigy; in Boston special guards were hired to protect the more controversial paintings from possible damage by an outraged public. Royal Cortissoz, a most eminent art critic of the times, considered this invasion of foreign-born talent as dangerous as the swarming immigrants who by their numbers and alien traditions were threatening the established nature of American society. However, three hundred of the exhibits were sold, among them a Cézanne, which entered the Metropolitan Museum as the first example by that artist to be acquired by a public institution (Cortissoz had termed Cézanne a "complacent ignoramus"). "Modern art" had become a phrase to conjure with, a battle cry that continues to excite strong feelings ranging from ecstasy to revulsion.

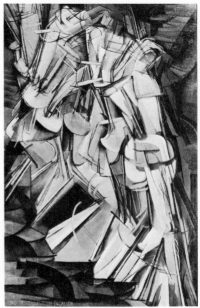

Marcel Duchamp's painting Nude Descending a Staircase, No. 2, *1912*

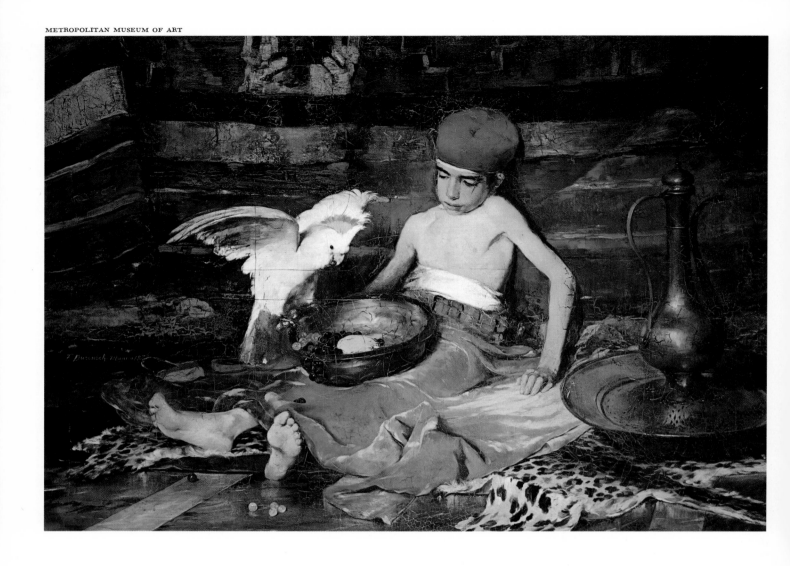

FASHIONS FROM ABROAD

The American artists who returned from their European studies in the decades following the Civil War brought with them a mixed bag of teachings and impressions gleaned from their experiences in Munich, Paris, and other Continental art centers. At Munich Frank Duveneck, born in Kentucky in 1848, and William Merritt Chase, born in Indiana a year later, both learned to paint in the broad, slashing style that looked back to the work of Frans Hals, Rubens, and Velasquez. Duveneck succeeded so well that he attracted a group of students ("Duveneck Boys") to his atelier in Munich and became a master in his own right there, and in Florence and Venice, where he traveled with his attendant group. In 1875, when his work was shown in Boston, it created something of a sensation. *The Turkish Page* was painted the following year in Chase's Munich studio, which was well equipped with exotic props, and when the canvas was exhibited in New York it was hailed by *The Art Journal* for its drawing and painting, for its "numerous perfect little pictures within the picture," although it was considered excessively realistic. After meeting Whistler in England and traveling about the Continent, Chase abandoned his earlier Munich style for a lighter palette, which suited his choice of outdoor subjects seen in bright light and led him toward an impressionistic manner. In his still lifes of fish, a theme he frequently painted, Chase rendered their limp weight and shimmering, silvery scales with unsurpassed subtlety and beauty.

Opposite: Frank Duveneck's The Turkish Page, *painted in the Munich studio of Chase, 1876*

Right: Fish and Still Life *by Chase, painted about 1908; one of a number of such studies*

Below: Chase's The Open Air Breakfast, *about 1888, shows the artist's wife and small child seated at the table near a Japanese screen.*

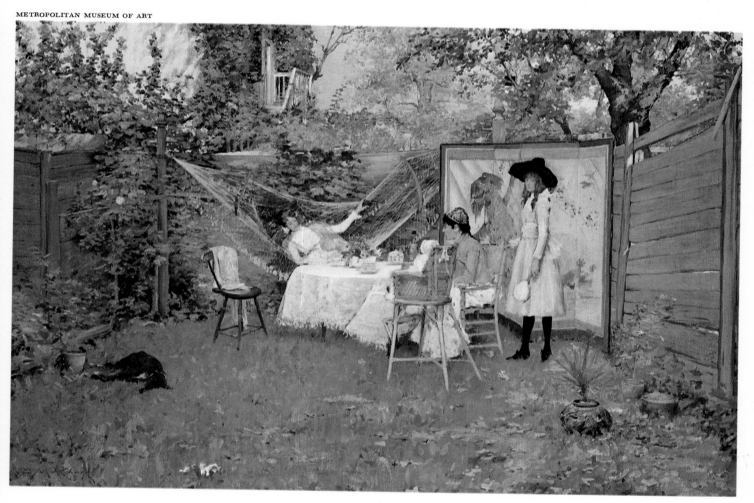

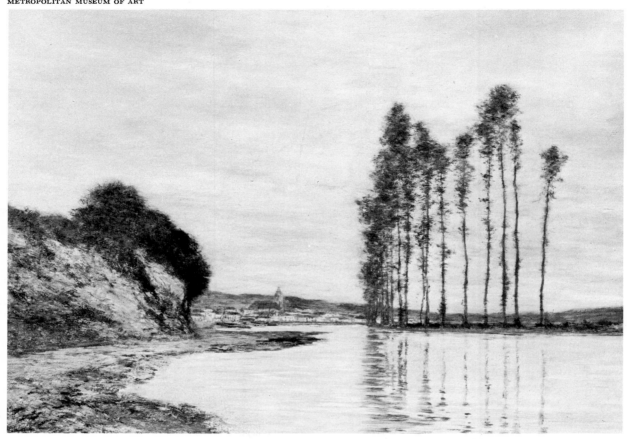

Above: Harp of the Winds: A View on the Seine, *painted by Homer Dodge Martin in 1895 when the artist was almost blind*

Opposite: The Wedding March, *painted in Giverny, France, by Theodore Robinson, a pupil of Claude Monet, in 1892*

Below: The Coming Storm, *1878, one of the later landscapes by George Inness when the artist had developed his mature style*

256

In his own day George Inness was hailed as the supreme American landscapist. He was an epileptic, and a man of varying moods and of unequal performances. As one contemporary said, his work was "unequal" and often "unequalled." Although he once remarked that the French impressionists had "sunk to the depths of imbecility," his own later works, light-saturated harmonies in delicate tones, approach a form of impressionism. His contemporary Homer Dodge Martin was more clearly influenced by the French impressionists during a long visit to France in the 1880's. He once wrote of his pleasure in "putting little bits of paint alongside each other to try to make them twinkle"—which he did in his personal fashion. His *Harp of the Winds* was one of his most successful canvases and was once one of the best known of American paintings, although by the time he painted it he had all but lost his eyesight. The influence of the impressionists, of Claude Monet particularly, who was his friend and teacher, also shaped the direction of Theodore Robinson's talent before ill health brought his career to an early end. *The Wedding March*, painted in Normandy, France, just before he returned to America, and four years before his untimely death at the age of forty-four, is one of his finest canvases.

COLLECTION OF MRS. JOHN BARRY RYAN

Above: The Red Bridge, *near Windham, Conn., painted by Julian Alden Weir in 1895*

Opposite: Allies Day, May, 1917, *by Childe Hassam; a scene on Fifth Ave., New York*

In his book *Crumbling Idols*, published in 1894, Hamlin Garland wrote that the French impressionists had taught him to see colors everywhere. Here, he explained, was a "momentary concept of the sense of sight; the stayed and reproduced effect of a single section of the world of color upon the eye"; and he urged his compatriots to look about at their own land with this novel and illuminating vision. However, the American artists who returned from France had to adjust their sights to the different realities of the American scene and atmosphere. The light in this country was different from that in France, and to those who had grown accustomed to the clustered stone villages of Normandy and Brittany and their picturesquely costumed natives, America in its progressive commotion seemed to offer only prosaic counterparts. It required adjustments. J. Alden Weir, who returned from France in 1883, was dismayed to find an old covered bridge spanning the Shetucket River being replaced by a cast-iron construction until suddenly he saw a luminous picture in that stark replacement with its preparatory red-lead coating in a setting of summer verdure. In 1889 Childe Hassam returned from his visit to France where, influenced by Monet, he had adopted the technique and the palette of the impressionists. Among his most memorable paintings are those of New York's flag-hung streets during the days of World War I. This was thirty years or so after he had first learned to lay his colors on canvas in separate, bright flakes for the eye of the observer to mix in its own way.

Left: November, *painted in 1890 by R. Vonnoh*

Opposite: The White Bridge, *by J. Twachtman*

Below: a group portrait of the artist's daughters, painted by Frank W. Benson, 1907

All three of the artists whose works are shown here, like so many of their fellow
Americans, studied for a time at the Académie Julien in Paris. In effect, Julien ran
a business at his academy, or atelier. Competent French artists routinely criticized the
efforts of students who crammed such classes for training in the French tradition.
Robert William Vonnoh returned to America after that training to teach such notable
artists as Robert Henri, John Sloan, and William Glackens, all of whom became
associated with the so-called Ash Can group. John Henry Twachtman spent summers in
France painting with Childe Hassam, Theodore Robinson, and others, and came home
to assume a prominent place among the American impressionists. Along with
Twachtman, Hassam, Dewing, Tarbell, and still others, Frank Weston Benson returned
to Boston to help form a group known as the Ten American Painters that exhibited
together and that contributed a sort of transplanted academy of impressionism.
Benson is said to have been the best-selling artist of the group, with an annual income of
six figures. This whole generation of European-trained artists came back to their
native land with a feeling that they were an advance guard of a new and important
phase of American painting.

261

A NEW REALISM

"If America is to produce great painters and if young art students wish to assume a place in the history of the art of their country," Thomas Eakins observed, "their first desire should be to remain in America to peer deeper into the heart of American life, rather than to spend their time abroad obtaining a superficial view of the art of the Old World." It was well enough to go abroad and study the works of the old masters, he opined, but American painters "must remain free from any foreign superficialities. . . . They must strike out for themselves, and only by doing this will we create a great and distinctively American art." That statement might almost stand as the creed of the so-called Ash Can school of painters. In contrast to the generation of artists who returned from their course of European training with their impressionist palletes and their choice of lyrical subjects, the Ash Can group dared to be American in their whole manner of painting and to find subjects, forthrightly represented, in the daily life of their urban milieu, however commonplace that might be. Robert Henri was to a large extent the leader and teacher as well as a colleague of these eight men and their followers. He urged his pupils to use their brushes with "the freshness of broad statement and direct handling," as Manet and Goya and Frans Hals had done—artists with whose work he had become familiar during his European travels and studies. But such brushwork was not an end in itself; it was the most direct way of communicating a personal message. Since they knew the city in its many moods, he urged his disciples to paint the city as they saw it and felt it, as he did in his wintery evening view of West 57th Street in New York City, painted in 1902.

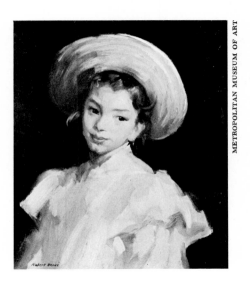

Above: West 57th Street, New York, *painted by Robert Henri*
Right: Henri's Dutch Girl in White, *painted in 1907 in Europe*

263

Opposite, top: John Sloan's painting of McSorley's bar
Opposite, bottom: The Spielers, *painted by Luks in 1905*
Below: The Old Duchess, *painted by George Luks, 1905*

METROPOLITAN MUSEUM OF ART

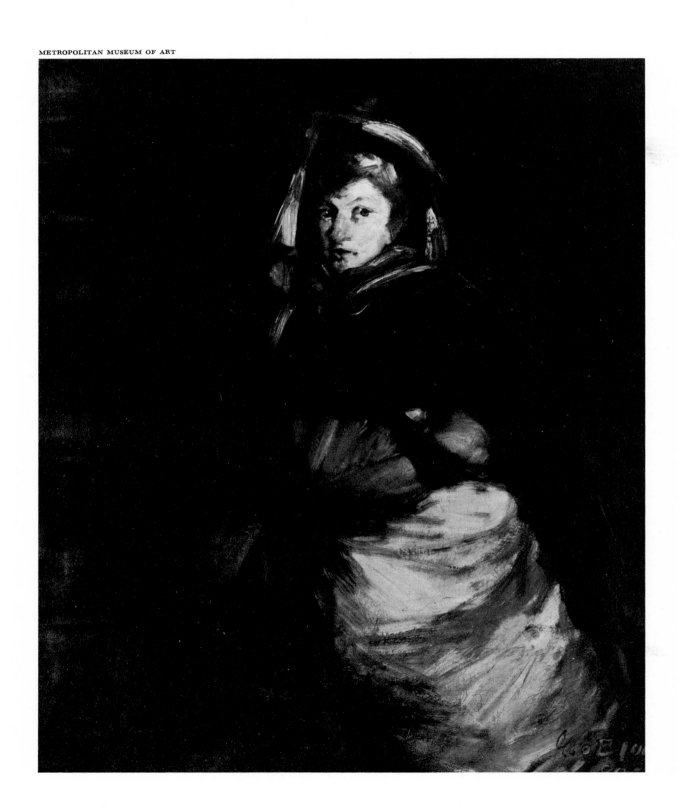

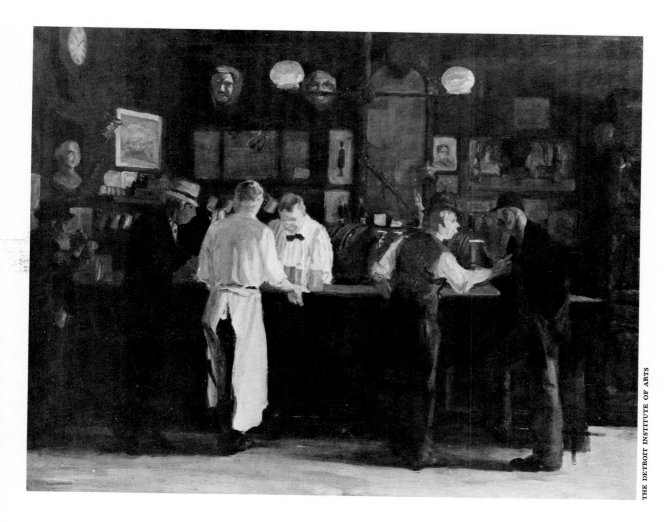

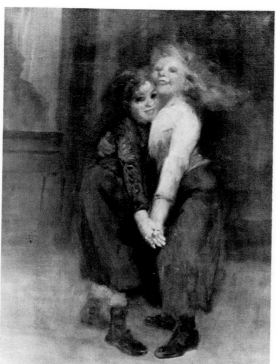

George Benjamin Luks and John Sloan were two of Henri's favorite pupils. Luks had studied in Düsseldorf, London, and Paris, as well as with Henri in Philadelphia. A man of extraordinary vitality (known as "Lusty" to his intimates), Luks had been an artist-reporter for *The Philadelphia Evening Bulletin* during the Spanish-American War, and had worked up comic strips for *The New York World* before that; on the advice of Arthur Brisbane he turned his full energies to painting. He looked to the sidewalks of New York for his subjects, and what he saw and painted there with such forthrightness dismayed the old guard of the National Academy. In *The Old Duchess*, a subject Luks painted several times, he portrayed with complete candor a picturesque and bibulous character once well known about Jefferson Market. In *The Spielers* he caught with tender understanding a happy, passing moment of childhood adventure on the city's streets. John Sloan was also a newspaper staff artist before, and after, he began painting seriously; and he also knew well the life of the city. One of his favorite subjects was McSorley's celebrated bar, an "out of the way retreat for appreciative ale drinkers." He recalled that he was forty-nine years old before he managed to sell one of his canvases. Even so, he worked unselfishly to further interest in the new art movements, supporting himself in the meantime by teaching and working as an illustrator.

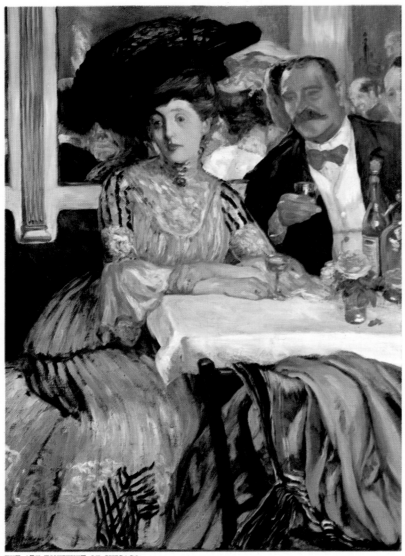

The eight central members of the Ash Can group, which is more properly called The Eight, were individualists in their styles and techniques; each solved the problems he faced in his own manner and independently chose such subjects as most appealed to him. What held them together as a group was their conviction that the standards of the National Academy of Design were hampering artistic creativity and originality. At the time, annual exhibitions of art were tightly controlled by juries chosen by the academicians. Unless the artists subscribed to standards imposed by those juries, they had little or no opportunity for showing their work publicly. "The jury system," wrote John Sloan, "automatically suppressed the new, the challenging, the unfashionable thing, and it automatically upheld the mediocre thing." As a gesture of defiance, in 1908 The Eight staged an exhibition of their own, their first and only showing as a group, with widespread consequences. At the exhibition, one critic reported: "Vulgarity smites one in the face . . . and I defy you to find anyone in a healthy frame of mind who, for instance, wants to hang Luks' posteriors of pigs, or Glackens' *At Mouquins,* or John Sloan's *Hairdresser's Window* in his living rooms or gallery, and not get disgusted two days later," and so on. Other reporters were more kind, and a number of the pictures were sold—four, notably, to Gertrude Vanderbilt Whitney, who was becoming the foremost patron of modern American art. Not only that, the National Academy was somewhat shaken out of its complacency. Almost in disbelief, William Glackens proclaimed shortly afterward: "The Academy has turned over a new leaf and has accepted everybody this year." Glackens, still another who gave up illustration for painting, was a fellow student of Sloan's, and took part in every advanced art movement. He chose rather pleasant subjects. His *Green Car* is a nostalgic reminder of the trolley cars that were. *Chez Mouquin* pictures a couple in a New York restaurant that was popular among writers, artists, men-about-town, and ladies of the demimonde; it was the favorite meeting place of The Eight.

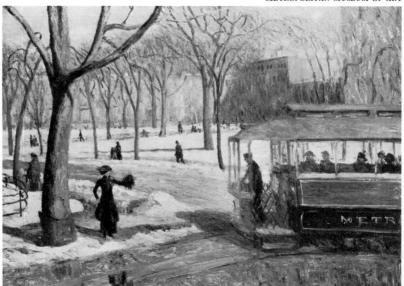

Opposite: Glackens' Chez Mouquin, *1905*

Right: The Green Car, *by Glackens, 1910*

Below: Backyards, Greenwich Village, *New York, painted by John Sloan in 1914*

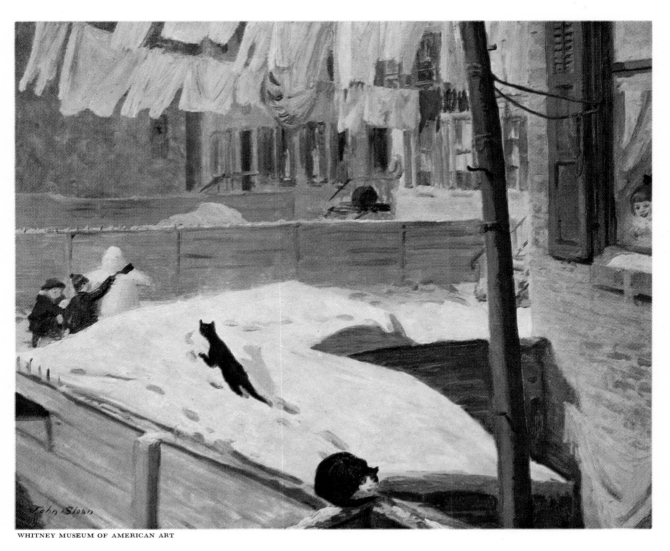

Everett Shinn was a Quaker who as a youth had no intention of becoming a painter. He worked as still another of the newspaper artists who was trained by that experience in an exacting school of realistic, pictorial reporting. "We were called upon," he recalled, "to cover everything that is caught by the modern camera in the twinkling of an eye . . . and we did good drawing too." He joined The Eight more out of his friendship for the other artists than in protest against the Academy or anything else. (Nicknamed "the Kid," he was the youngest of that group, and the last of them to die—in 1953.) Early in the winter of 1899, when he was anxious for commissions, Shinn was asked by the editor and publisher of *Harper's Weekly* if he had a large color drawing of Broadway in a snowstorm. Noting that it was then snowing, he replied that he thought he had, and went home to do one overnight— his *Winter's Night on Broadway,* which first publicly appeared as a two-page center-spread reproduction in the magazine on February 17 and for which he received a gratifying fee of $400. Shinn became a favored protégé of such influential persons as William Chase, Elsie de Wolfe, and Stanford White, and the same year that his work was reproduced in *Harper's* he sold twenty pictures. For the most part Shinn looked more to fashionable uptown New York for his subjects. Among other things, he decorated theatres, the walls of the houses of his wealthy clients, and other structures. One of his closest friends was the landscapist Ernest Lawson (another habitué of Mouquin's), who had studied with the American impressionists Twachtman and Weir and who also joined The Eight— although he was a member of the National Academy. His work was exclusively landscape, a painter of rare ability, but the least well remembered of the group. His personal version of impressionism was influenced by Cézanne's insistence on basic structure in painting. The personal formula that he arrived at has been often imitated.

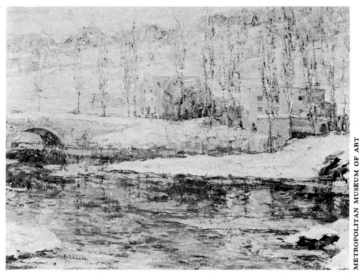

Above: Winter, *painted by the landscapist Ernest Lawson, 1914*

Right: Everett Shinn's pastel drawing, A Winter's Night on Broadway; *an illustration for* Harper's Weekly, *Feb. 17, 1900*

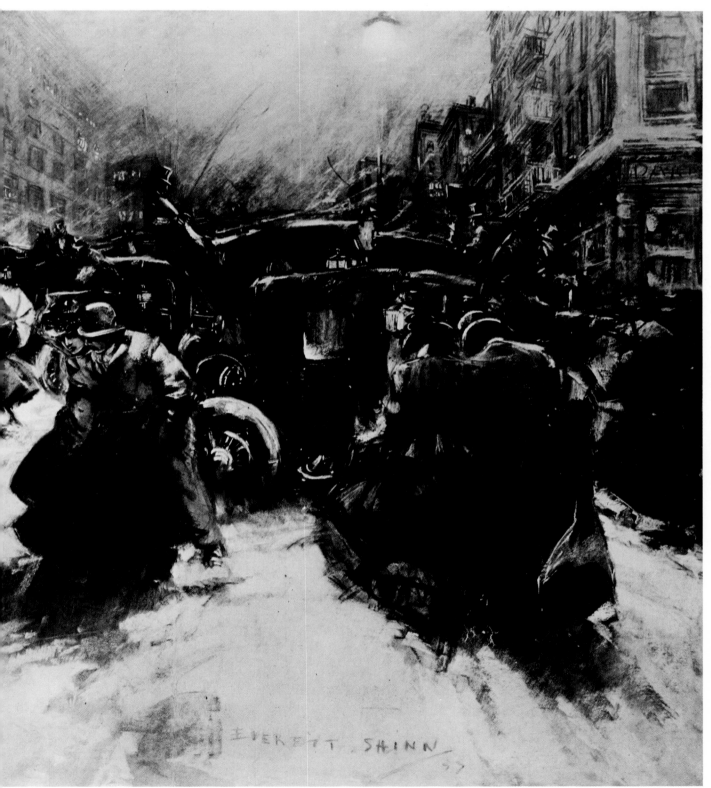

EVERETT SHINN

Harper's Weekly, Feb. 17, 1900

ARTHUR G. ALTSCHUL

Many of Shinn's best-known paintings and drawings depict the theatrical, music-hall, and circus worlds. With these "lively anecdotes in paint," he introduced a new kind of subject matter to American art; and in these his debt to Edgar Degas, greatest of all painters of the theatre, is obvious. A favorite of society and the theatre, Shinn was accused of being a social snob. "Not at all," he commented, "—it's just that the uptown life with all its glitter was more good-looking." Two other artists of distinctively different styles and talents, Arthur B. Davies and Maurice Brazil Prendergast, were also members of The Eight. Davies was a lyrical artist who turned his back on the realities of city life and painted scenes drawn from mythology and from his own imagination. The poetic symbolism of his *Unicorns,* one of his best-known works, is too dreamlike for explanation. Yet Davies had great talent for promoting the cause of modern art, and he played a major part in organizing the famous Armory Show. One critic of the 1908 exhibition complained that the "spotty canvases" of Prendergast were "artistic tommy rot." His individual style, with its small flecks of bright color, was based on the impressionistic practices of his student days in Paris. When he eventually won considerable success, and awards, he remarked, "I'm glad they've found out I'm not crazy, anyway."

Above: Unicorns, *a mythical scene by Arthur B. Davies, 1906*

Opposite: Footlight Flirtation, *painted by Everett Shinn, 1912*

Below: the mosaiclike application of color in Central Park, *1903, is exemplary of Prendergast's debt to the impressionists.*

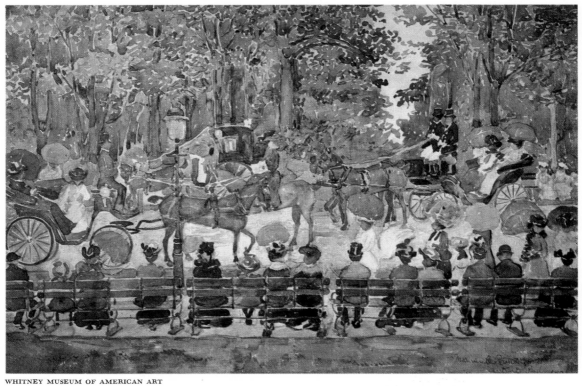

271

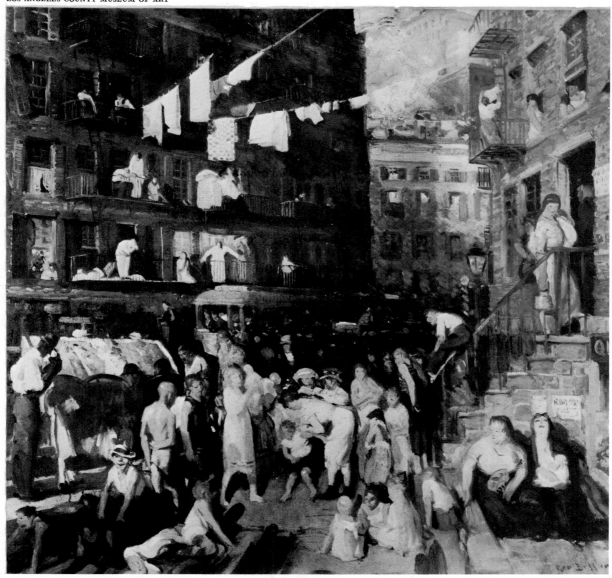

George Bellows studied under Robert Henri, who counseled him to paint fast and forthrightly, and his work was related to the independent mood of The Eight; but he was not a member of that group. He never went to Europe to study or observe, as most of his aspiring contemporaries did, but he became the youngest member of the National Academy. He was a lusty, athletic man with great vitality, yet he died relatively young, in 1925, at the age of forty-three. He had chosen to be a professional painter instead of a professional baseball player, and he was a popular artist from the start of his career. He painted the world about him and its people as realistically and straightforwardly as any member of the Ash Can school— but in his own way. He painted prize fighters in action, ladies at ease, tenement-district streets, and quiet landscapes. Until his early death he was an indefatigable experimentalist who was always trying new things. His sporting subjects, such as *Stag at Sharkey's*, his first great picture and one that established his reputation, remain especially popular.

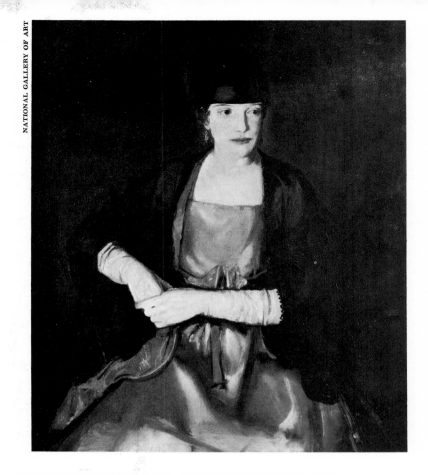

Opposite: Cliff Dwellers, *a scene in the New York slums, by George Bellows, 1913*

Right: *portrait of Mrs. Chester Dale, painted by Bellows in the year 1919*

Below: Stag at Sharkey's, *painted in 1907 by Bellows and subsequently copied by the artist in a popular lithograph*

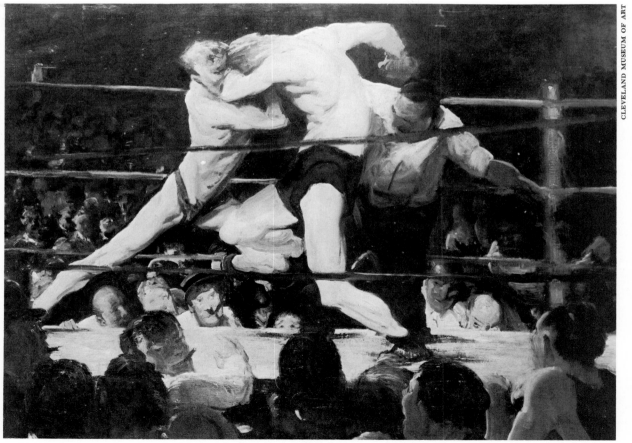

273

THE
WEST
REMEMBERED

Far from the swarming eastern cities, the West was completing an epic cycle, as in 1890 the frontier was officially declared closed. Over the preceding decades the frontier had set its own pace, invading lands "forever" set aside for the Indians, crossing lands that were "impassable," opening for settlement land that had been deemed "uninhabitable," and crossing mountains that stood "like a Chinese wall" against the westward movement of people. Conquering and taming those vast areas had been a herculean undertaking, an achievement the mythical giants of antiquity might well have envied, as Thomas Carlyle wrote in 1849 to Emerson. "How beautiful," Carlyle remarked with poetic license, "to think of lean tough Yankee settlers, tough as gutta-percha, with most *occult* unsubduable fire in their belly, steering over the Western Mountains to annihilate the jungle, and bring bacon and corn out of it for the Posterity of Adam.—There is no *Myth* of Athene or Herakles equal to this *fact*." So it was, and the experience left the nation with an imperishable legend of heroic deeds and golden dreams. With some good reason Frederic Sackrider Remington considered himself *the* illustrator of the rapidly vanishing life of the frontier. After a brief spell at Yale, where he boxed and played football with more enthusiasm than he studied art, he tried ranching and saloon-keeping in the West; he also worked as a cowboy, did some prospecting, and rode with the Army in its forays with the Indians. The pictures that he developed out of such experiences remain a vivid guide for most of us when we try to visualize the passing of the Wild West.

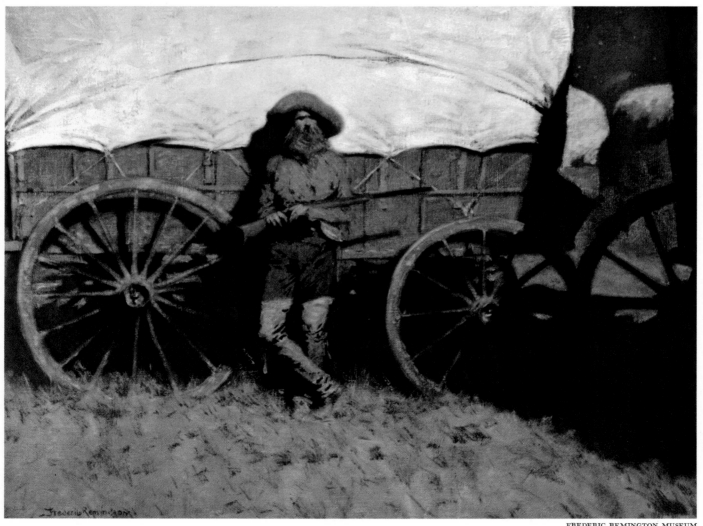

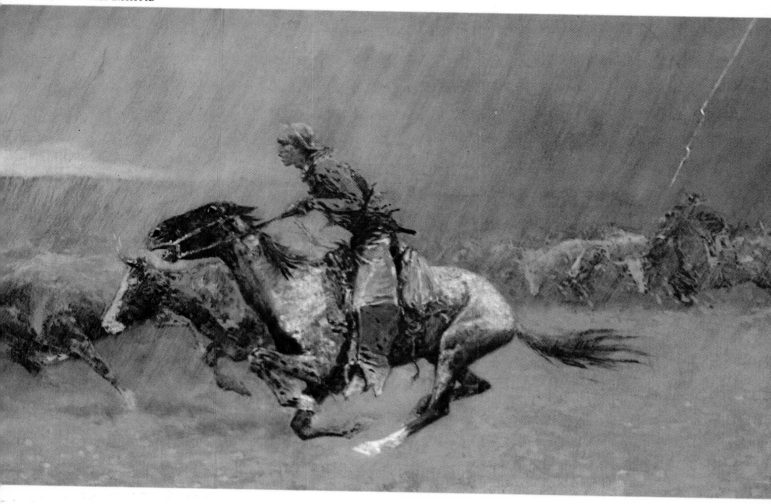

Above: Frederic Remington's Stampeded by Lightning, *an episode in the life of the cowboy*
Opposite: a scout stands guard over emigrant wagons in Remington's The Sentinel *of 1908*
Below: three of Remington's sketches depicting the wrangler's skill and agility in the Old West

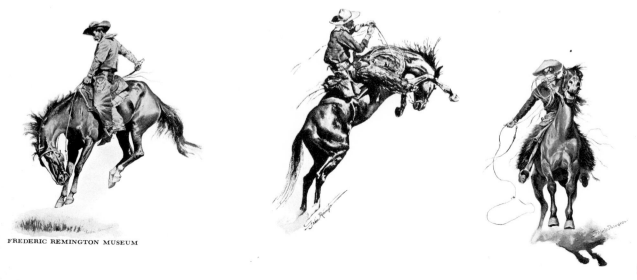

FREDERIC REMINGTON MUSEUM

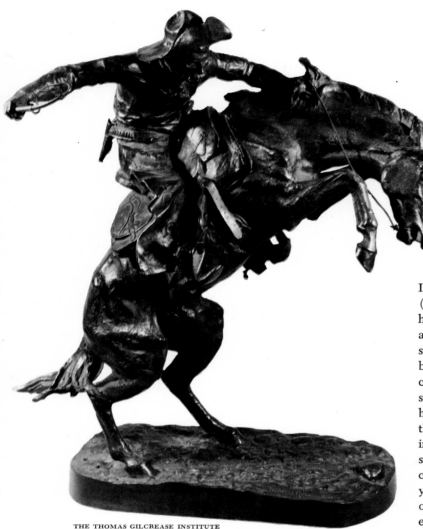

Above: Remington's The Bronco Buster, *the artist's first and one of his best attempts at modeling*

Opposite: The End of the Trail, *modeled by Earle Fraser for the fair held in San Francisco, 1915*

In the legend of the vanished West the cowboy remains (throughout most of the world) a picturesque being of heroic stature. He may have referred to himself as an "ordinary bow-legged human" and been called simply "a man with guts and a horse," but he was by every circumstance a carefully screened and highly conditioned type of man; only such a man, with developed skills, could do a cowboy's necessary work. He might have been drawn to the open range from far parts of the world. As Theodore Roosevelt wrote, cowboys included "wild spirits of every land, yet the latter soon become indistinguishable from their American companions. . . . the passing over their heads of a few years leaves printed on their faces certain lines which tell of dangers quietly fronted and hardships uncomplainingly endured." They were representatives of a regional culture unique in history, and as rancher Roosevelt also observed (in 1885), they would "shortly pass away from the plains as completely as the red and white hunters who have vanished from before our herds." However, Roosevelt later predicted the cowboy would live for all time in the bronze figures of Remington. Roosevelt had just received a cast of the artist's *The Bronco Buster,* which Remington had modeled in 1895 (it was his first essay in sculpture) and which was an immediate popular success. Sculpture, Remington wrote, "is a great art and satisfying to me, for my whole feeling is for form." After the Indian had been completely subdued and pushed aside, guilt and nostalgia led to his re-creation in a new image, as represented by James Earle Fraser's sentimental and sad sculpture, *The End of the Trail*. It is Fraser's most celebrated work, with the exception of his design for the famous buffalo nickel with its Indian's profile on the reverse side.

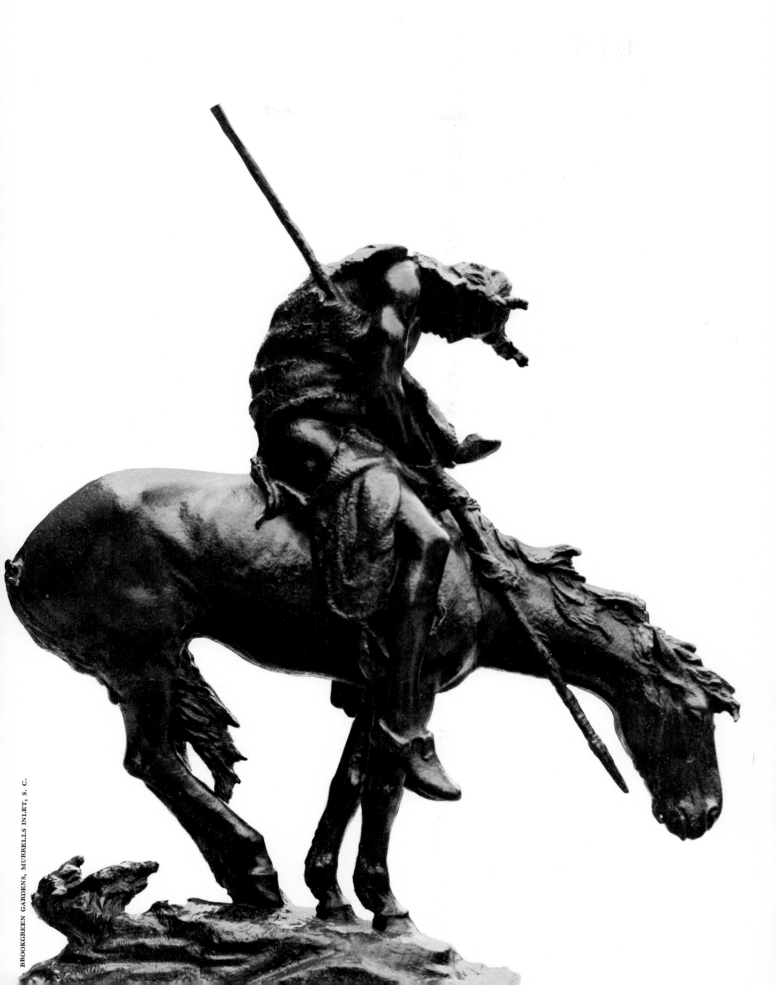

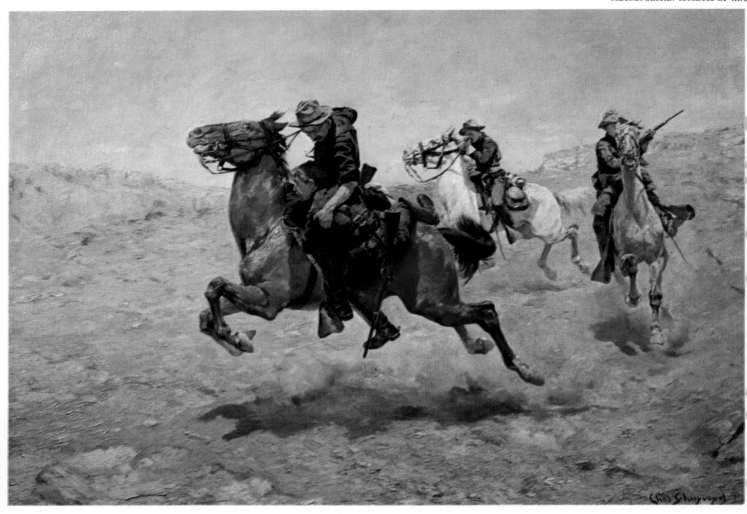

Two other artists are usually associated with Frederic Remington as the major artist-illustrators of the Old West: Charles Schreyvogel and Charles Marion Russell. Schreyvogel had studied for several years in Europe but had small success with his art until, in 1899, he painted *My Bunkie*. The painting was a reconstruction of an episode related to the artist by an Army trooper, in which a cavalry soldier whose horse was in full gallop swung up onto his horse a dismounted companion as other troopers held the Indians at bay. When the canvas was hung (unexpectedly) at the annual exhibition of the National Academy of Design the following year, it received one of the principal awards, and Schreyvogel, previously unknown, became more or less famous overnight. "Unknown artist leaps into fame," it was reported in the art news of the next day. (The painting is now owned by the Metropolitan Museum of Art.) In 1901 he was made an associate member of the Academy. Russell was almost entirely self-taught, as were so many interesting American artists of both the East and the West. He led the life of the West, with the Indians and the cowboys; his early studio was under the stars, beside the night fire of a cattle outfit or in an Indian encampment. He became a lifelong friend of Will Rogers, and like Rogers, he spoke and wrote in the picturesque vernacular of the Old West. The cowpokes with whom he lived and worked and drank paid $5 or $10 for Russell's pictures of the scenes they knew so intimately. When he won public attention his canvases brought him up to $10,000 each.

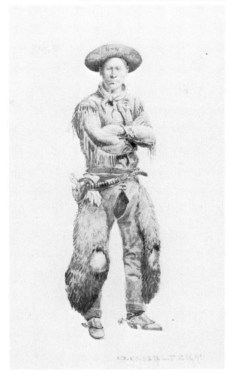

Opposite: My Bunkie, *an episode in a campaign against the Indians, by Schreyvogel*

Right: Horse Wrangler, *by Olaf C. Seltzer*

Below: Russell's painting, When Guns Speak, Death Settles Dispute, *reveals one method of dealing with dishonesty in a card game.*

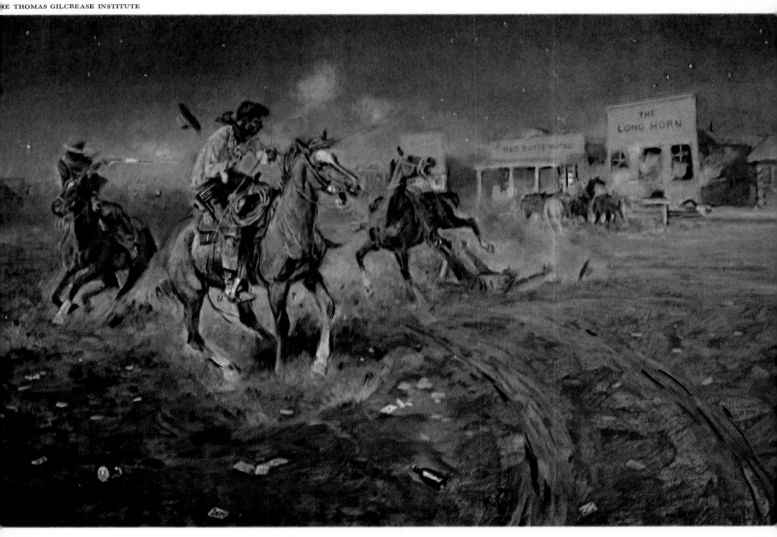

On the evening of February 17, 1913, some four thousand splendidly attired guests thronged the Sixty-ninth Regiment Armory in New York for the much-touted debut of the International Exhibition of Modern Art, more commonly known as the Armory Show. It was no ordinary art opening. The immense drill hall was transformed for the occasion into eighteen octagonal rooms whose walls were festooned with flags and evergreens (the pine tree was the emblem of the show, expressing "The New Spirit"), with yellow streamers suspended from the ceiling. The blaring brass band took a brief intermission while the art patron, lawyer, and major booster of the show, John Quinn, gave the opening address: "This exhibition will be

"291" AND THE ARMORY SHOW

epoch making in the history of American art. Tonight will be the red letter night in the history not only of American but of all modern art." No one could doubt his words. Presented to Americans for the first time was a massive display of paintings and sculpture, representing the most advanced currents in European art—post-impressionism, fauvism, and cubism. Included also was a retrospective of the entire history of modern art, beginning with Goya and Ingres, as well as a similar survey of the development of American art.

Alfred Stieglitz

Although the Armory Show was the first major exhibition of the new trends in this country, the education of at least a segment of the public had begun nearly a decade earlier at Alfred Stieglitz's Photo-Seccession Gallery at 291 Fifth Avenue. When the gallery opened in 1905, Stieglitz limited his battle against convention to the field of photography. Within two years, however, he was championing the cause of modernism in every art medium. "291" soon acquired a reputation as a sort of refuge from the outside world of philistinism and complacency. In this tiny gallery, which one habitué called "the largest small room in the world," aesthetic rebels found kindred spirits, solace, and often sustenance from the pocketbook of its generous proprietor. The coterie of American avant-gardists at Stieglitz's salon included Maurer, Hartley, Halpert, Walkowitz, Marin, Dove, and Weber (discussed individually elsewhere in this chapter), many of whom had traveled abroad and witnessed first hand the revolutions convulsing Paris and other European capitals. The small exhibition mounted at "291" between 1908 and 1911 featured such foreign "movers and shakers" as Rodin, Matisse, Toulouse-Lautrec, Cézanne, Rousseau, Renoir, and Picasso. The ideas proselytized by the Stieglitz circle proved to be too

strong a nostrum for the public to swallow. From the moment of its inception, "291" became the target of journalistic jibes. One detractor, Thomas Haven, described the studio as a "bedlam of half-baked philosophies and cockeyed visions." There were only a few discerning defenders of the new art, of whom Charles H. Caffin was perhaps the most eloquent. Writing in 1908, the critic compared the official world of art with a hennery whose inhabitants basked in self-adulation, laid eggs, and fattened themselves for market. Then Stieglitz happened upon this scene of barnyard tranquillity. "He made flights into far-off potato patches" and "from his wanderings brought back strange ideas . . . possibilities of life hitherto undreamed of by poultry. . . . The roosters he exasperated by his extra-cocky airs: for he declared their complacency had made them careless in their personal habits. . . . He brought them to a pitch of bewilderment . . . by maintaining they ought to make the laying of eggs a personal expression." To sum it up, "He made ructions in the hennery." Such enthusiastic voices were infrequently heard. As late as 1913 Stieglitz could write Gertrude Stein that "One must remember, that there is no real feeling for art, or love for art in the United States as yet." Essentially a private person, Stieglitz was unprepared to carry his crusade to the masses. It remained for Arthur B. Davies to bring modernism into the public eye with the Armory Show.

In December, 1911, twenty-five distinguished New York artists, including Davies, Walt Kuhn, and Elmer MacRae, expressed their dissatisfaction with the National Academy of Design and formed "an association of live and progressive men and women who shall lead the public taste in art

rather than follow it." Officially named the Association of American Painters and Sculptors, its *raison d'être* was tersely stated: "For the purpose of developing a broad interest in American art activities, by holding exhibitions of the best contemporary work that can be secured, representative of American and foreign art." Davies was elected president and immediately began planning an international exhibition that would illustrate modernism in all of its facets. He borrowed considerable funds for this enormous undertaking, and dispatched Kuhn, whom he later joined, to Europe to "collect" for the show. After nine weeks of exposure to "a regular orgy of art," the two men acquired quantities of paintings, drawings, and sculpture on loan from artists, dealers, and private collectors. Back in New York, the show's organizers worked at a feverish pace, making shipping and insurance arrangements, printing catalogues and brochures, selecting works by American contributors, and securing plenty of advance publicity. As Quinn explained it, "New Yorkers are worse than rubes, and must be told . . . our show must be talked about all over the U.S. before the doors open." Two days before the show opened, the approximately thirteen hundred pieces of art were grouped according to historical sequence, nationality, and medium.

With its carefully planned historical survey, the AAPS intended to demonstrate that works which were once considered strange and radical had, over the years, become accepted and even traditional. Thus, they hoped to gain tolerance for the current artistic revolution. Try as they might, however, they could not convince the public or the critics to regard the more outlandish examples as merely another phase in the evolution of art. Coming in a single massive dosage, this telescopic presentation of the modern movement jangled optic nerves and boggled minds. The show provoked reams of copy, ranging from intelligent critiques to the sort of mindless invective penned by one lady poet, who regarded the event as "an excrescence of art," a "disgorging of a curdled imagination," characterized by "bilious and lurid canvases of decomposed flesh." The arch-conservative critic Royal Cortissoz dismissed Cézanne as an ignoramus, Van Gogh as an insane incompetent, and Picasso as an imposter. The most maligned artist was Matisse, for nearly everyone recoiled at his wild use of color and "immoral" distortions. The cubist room, calumnied as the "Chamber of Horrors," stole the show. Exhibited therein was Marcel Duchamp's *Nude Descending a Staircase,* which created a greater furor than any other picture at the Armory. This cubist configuration, translating the female form into a series of flashing shapes and lines, was either regarded as a hoax perpetrated on the public, or as a sure sign that the world was falling apart. Upon

seeing the *Nude* Theodore Roosevelt uttered "Bully!" The former president subsequently wrote that the lady compared unfavorably to his own Navaho rug. Critics variously described the painting as "a lot of disused golf clubs and bags," "a staircase descending a nude," "an academic painting of an artichoke," and "an explosion in a shingle factory." A $10 prize was offered by a newspaper for the best explanation of the *Nude.* The winning entry, a poem, went as follows: "You've tried to find her, / And you've looked in vain / Up the picture and down again / . . . The reason you've failed to tell you I can, / It isn't a lady but only a man."

Despite the controversial nature of the exhibits and the circus atmosphere that prevailed, the Armory Show was hailed by the public and the press as an overwhelming success. During the course of its four-week run in New York, some ninety thousand people— representing a democratic cross-section of millionaires and their chauffeurs, academicians and vanguardists, as well as contingents of critics, reporters, and school children—visited the Armory. And, following its New York stand, plans were made for the show to travel to Chicago and Boston. The *Sun* rhapsodized that the AAPS "has wrought something very like a miracle." The New York *American* informed its readers that the country was at least a quarter of a century behind the times in matters of art, and predicted "when we have digested this exhibition we shall be less stolidly complacent over the achievements of our painters." Even Cortissoz conceded that it was "a fine and stirring exhibition." The show's impact on artists of every hue was immediate and shattering. As a reporter for the *Globe* aptly phrased it, "American art will never be the same again."

STRAINS OF MODERNISM

SHELDON MEMORIAL ART GALLERY

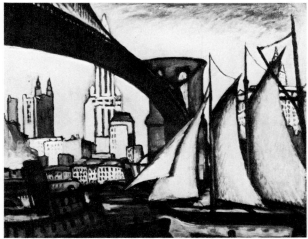

WHITNEY MUSEUM OF AMERICAN ART

By the time of the Armory Show avant-garde American painters had turned away from the realistic representation of people and places and things toward more or less abstract design. To admit that a painted surface had, in fact, only two dimensions, to make a positive asset of that limitation, to create formal harmonies of shapes and colors as ends in themselves, with no close dependence on objective realities, became a new goal. Actually, there was nothing especially novel about such concepts except the extremes to which they were carried. Generations earlier Washington Allston had hoped to create "the poetry of color" that had meaning in itself beyond any literal connotations of subject matter; such paintings, he wrote, "leave the subject to be made by the spectator." In the opening years of this century the art world in Paris was in a ferment of experimentation along these lines. During the first decade of the century great retrospective exhibitions of such revolutionary modernists as Cézanne and Gauguin were staged. The same years saw the birth of fauvism and cubism, with their "wild" exaggerations of color and the reduction of natural forms to flat geometric equivalents. American artists by the score were on-the-spot witnesses to these and other advanced developments. There were at least enough of them living in Paris in 1908 to justify the formation of a New Society of American Artists in Paris, a reorganization of an earlier, more conservative group. Before the Armory Show's revelations in America, these men and others were already following the lead of the European innovators and moving away from traditional realism in their work, as can be seen in the illustrations on these pages. Alfred Maurer, son of the Currier and Ives artist Louis Maurer, tried most of the new isms until, in frustration, he took his own life. Both his *Landscape with Farm* and Arthur B. Carles' *L'Eglise* represent free departures from natural forms, intensifications rather than imitations, of nature, as does Samuel Halpert's *Brooklyn Bridge* in its separate way. Maurice Sterne spent two years in Bali looking to primitive art for a way to invigorate the figurative tradition. All four men were in Paris early in the century.

Above: Carles' L'Eglise, *about 1910*

Right: Bazaar with Coconut Palms, Bali, *painted by Sterne in 1912*

Opposite, top: Alfred Maurer's Landscape with Farm, *painted 1910–11*

Opposite, bottom: Brooklyn Bridge, *painted by Samuel Halpert, 1913*

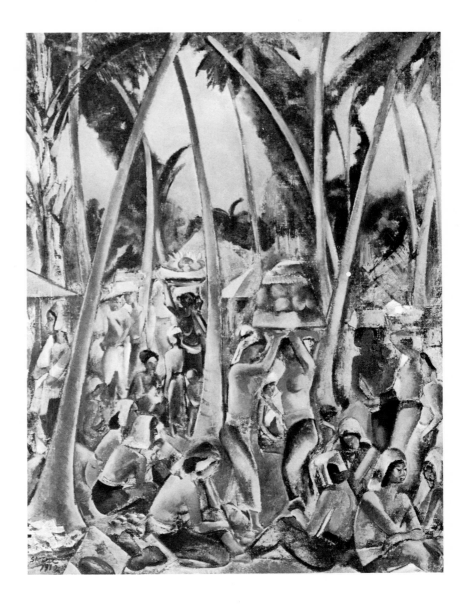

In spite of their flirtation with modernism, Sterne and Halpert later revealed themselves as essentially conservative artists. The sensitive, romantic art of Arthur B. Davies (see pages 270–71), on the other hand, was quite transformed by the doctrines of cubism. Yet, in his *Dancers* the "cubism" is a matter of prismatic facets of color overlaid on simplified but generally realistic figures, rather than on basically structural schemes as Picasso and Braque preached the ism's gospel. After his graduation from Cornell University, Arthur Garfield Dove spent two years in Paris, from 1907 to 1909, and returned to paint the first American abstract picture the following year. He had given up, he said, "trying to express an idea by stating innumerable little facts." And, as one newspaper poet observed of his work, which was rooted in his love of nature, "But Mr. Dove is far too keen / To let a single bird be seen; / To show the pigeons would not do / And so he simply paints the coo." Georgia O'Keeffe never went to France; but she was practically a born artist. When Alfred Stieglitz, whom she later married, first saw her sketches in 1916, he exclaimed, "finally a woman on paper!" She had discovered that she could say things with colors and shapes that she had no words for, and that words were irrelevant to the forms she created. For decades following her first showing O'Keeffe remained one of America's most original and forceful artists.

284

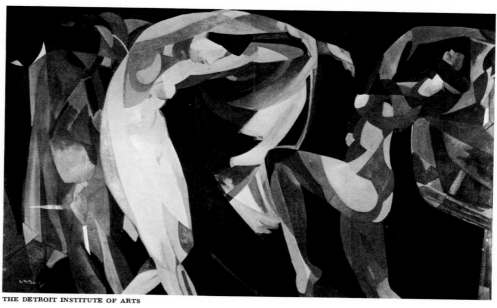

Above: Dancers, *by Davies, 1915–16*

Left: Black Spot, No. 2, *by Georgia O'Keeffe, painted in the year 1919*

Opposite: Plant Forms, *by Dove, 1915*

The patriarch of modernist painting in America was John Marin. From early in this century until his death in 1953, Marin transmuted the topless towers of Manhattan and the rugged coast of Maine into an explosive and lyrical geometry of form and color. He often used water color, as in his *Brooklyn Bridge,* which enabled him more quickly to record his momentary vision of the city or the shore. Abraham Walkowitz was a product of the ghetto who came back to America after several years in Paris to preach the gospel of modern art. As Marin did, and with nervous intensity, Walkowitz caught the vitality and boundless energy of the city in abstract and semiabstract compositions, although he is better remembered for his sensitive and lyrical renderings based on moving figures translated into incorporeal rhythmic swirls. Using water color with the power of oil, Charles Burchfield took woodland and landscape scenes and by manipulating the shapes of trees, plant forms, and other objects, and by intensifying or subduing their colors, he summarized the ageless interplay of natural forces.

COLLECTION OF MRS. JOSEPH S. GERSHMAN, COURTESY ZABRISKIE GALLERY

BERNARD DANENBERG GALLERIES

Above: Dance Rhythms, *a water color painted by Walkowitz about 1920*

Left: Autumn Moon, *a water color by Charles Burchfield, executed in 1916*

Opposite: John Marin's water color of the Brooklyn Bridge, painted in 1910

287

A number of the artists represented in these pages tried various styles during their careers; the work of others changed little over the years; all were influenced by modernist developments abroad. Early in his life Max Weber had known Gertrude Stein and her brothers in Paris, and had studied under Henri Matisse. He quickly assimilated a variety of stylistic manners, and he also learned much from Eastern, primitive, and decorative art. When his cubistic figure studies were shown at the Stieglitz Gallery in 1911, one caustic critic asked, "All the moderns seem to be here, but where are the Webers?" Samuel Halpert told the press that Weber was "the pioneer post-Impressionist in this country." Weber had a correspondingly high opinion of his own work, and when only two of his paintings were accepted for the Armory Show, whereas other artists whom he considered of lesser importance were generously represented, he demanded that more of his work be shown. When he was refused this request he withdrew both his paintings from the exhibit. However, Weber went on experimenting, and as tides of taste changed, his work received a more cordial reception from a substantial public and great respect from members of the art world.

Three examples of the early paintings of Max Weber, largely reflecting the influence of cubism to which he had been exposed during his years in Paris:

Above: Chinese Restaurant, *an impression of a New York City scene, 1915*

Below: Athletic Contest, *painted in 1915*

Opposite: Composition with Three Figures, *painted by Weber in 1910, two years after he returned from Paris*

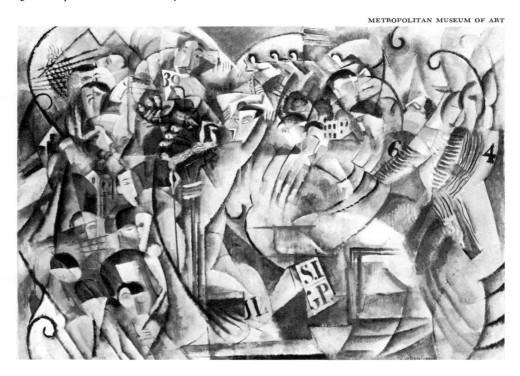

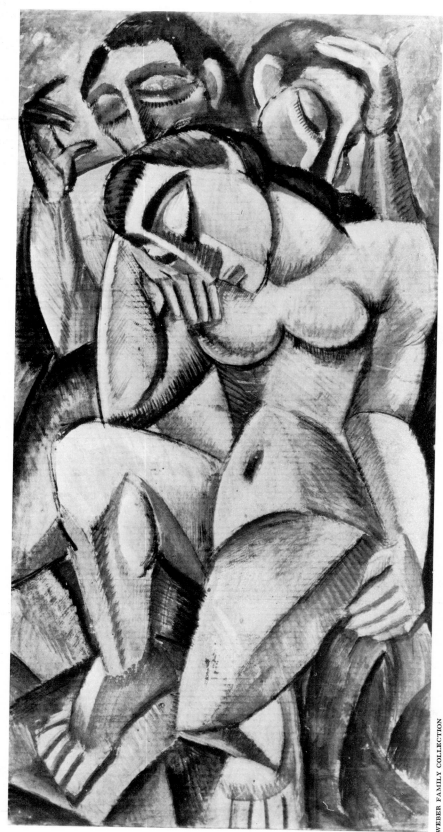

Three works in different styles by Joseph Stella:
Above: Coal Pile, *charcoal drawing, made about 1902*
Below: Landscape,· *pastel made in Europe in 1911*
Opposite: Coney Island, *oil on canvas, about 1915*

A number of the early American modernist painters were immigrants. Maurice Sterne, Abraham Walkowitz, and Max Weber, for example, were all born in Russia. As in years past and in years to come, American art was continually refreshed by such infusions of foreign-born talent from many parts of the world. Joseph Stella came to New York from Italy in 1896, at the age of nineteen, with thoughts of becoming a doctor, but almost immediately after his arrival he turned rather to art. He started this new career as a magazine illustrator. He was commissioned in 1907 to draw impressions of the American steel mills. In his earlier charcoal sketch, *Coal Pile,* he starkly but dramatically suggested the basic power of his adopted nation's industrial plant. Like his immigrant colleagues, he too recrossed the Atlantic, in 1908, to learn at first hand about the excitements that were constantly reinvigorating the arts in France after the turn of the century. It was in Europe, in 1911, that he drew a pastel on paper, *Landscape,* in which he reduced his subject to almost geometrical simplicity of overlapping angles and circles. He also went to Italy on that journey, and there he was impressed by the futurists, a group of artists (and poets) who sought originality at all costs, as against the cult of past tradition; who sought an art that would "glorify the life of today, incessantly and tumultuously transformed by the victories of science." Futurist painters splintered their forms with shafts of light and color to convey a sense of motion and dynamism. When he returned from his first European trip in 1912 Stella found circumstances that enhanced this spirit of movement and urgency in all about him. "I was thrilled to find America so rich with so many new motives to be translated into a new art," he recalled. "Steel and electricity had created a new world. A new drama had surged . . . a new poliphony was ringing all around with the scintillating, highly-colored lights." In all this he saw "the conjunction of worlds"—a conjunction of worlds that inspired him to combine the exciting fragmentation of American life with the timeless Italian theme of the Madonna at the foot of the cross in his canvas *Madonna of Coney Island,* later retitled simply *Coney Island.*

Marsden Hartley's Painting, No. 5, *1914–15, painted in Berlin*

Marsden Hartley was another of the pioneers and leaders of American modernism. His art developed through various phases (see page 307), but his early abstractions already demonstrate his special talent. *Painting, No. 5,* one of several in a series with expressive allusions to German militarism, was produced during World War I while Hartley was living in Berlin. He subsequently explained that he had intended no hidden symbolism in these paintings, that he expressed only what he had seen for purely pictorial effect. Charles Demuth, Morton L. Schamberg, and Charles Sheeler belonged to a group for obvious reasons labeled precisionists. All three of these artists sought to emphasize the basic structure of objects by reducing their forms into geometric planes and volumes defined by ruler-straight lines. As Sheeler wrote, "I sought to reduce natural forms to the borderline of abstraction, retaining only those forms which I believed to be indispensable to the design of the picture." Demuth, according to Marcel Duchamp, "was one of the few artists whom all other artists liked as a real friend, a rare case indeed." He arrived at his characteristic style about the same time as the other two. Schamberg's considerable talent was cut off with his early death in 1918. He and Sheeler were close friends and had traveled together in Europe, and Sheeler always spoke of him with admiration and with gratitude for his inspiration. As earlier remarked, Sheeler was a superb photographer as well as skilled artist, and throughout his career there was a constructive interplay between those two talents. He continued to paint for more than four decades after Schamberg's death, always with the highly controlled, sharply definitive style that he developed as a young man, and that was so highly characteristic of his art.

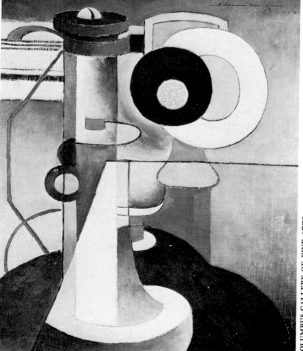

As the second decade of the century closed it seemed from many indications
that Whistler's credo of art for art's sake, not for visual documentation of
realities, was being pushed far toward an ultimate conclusion by some of the more
advanced American artists. During the course of that decade two young Americans,
Stanton Macdonald-Wright and Morgan Russell, both deeply immersed in contemporary
color theories, developed a style they called synchromism (meaning "with color") in
which color and gradations of tone in painting were used to define or refer to
nothing at all, but served as completely nonobjective entities in themselves.
In their paintings, those two artists proclaimed, color—color alone—became "the
generating function." "Painting being the art of color," they stated, "any quality
of a picture not expressed by color is not painting." They issued a manifesto
in Europe before World War I expounding their views, and when they exhibited
their paintings in Munich and Paris in 1913 they were hailed by some critics as
the first American innovators since Whistler. Although their program was short-lived,
it contributed to the development of a nonliteral, completely abstract art.
Another contemporary, Philadelphia-born Man Ray, produced highly advanced
abstractions before he moved to Paris in 1921 and devoted his best and most
original efforts to photography. Ray, in fact, became so famous as a photographer
that his early promise as a painter was all but forgotten; he lived so long
in Paris that people hardly remembered he was an American.

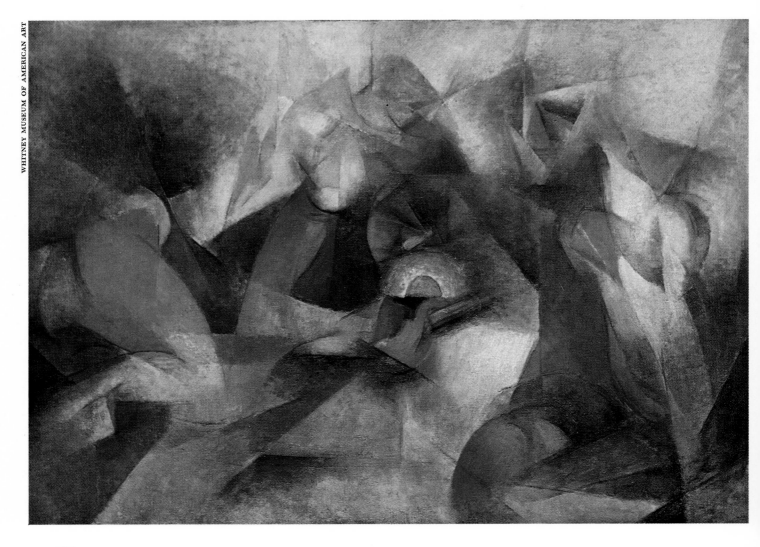

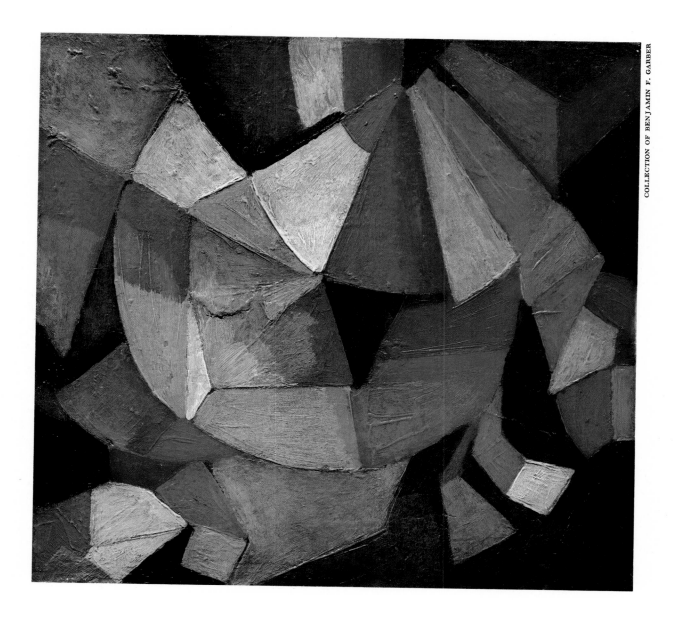

Above: Morgan Russell's Synchromy, *painted 1914–15*

Right: Dance, *painted by Man Ray in 1915*

Opposite: "Oriental." Synchromy in Blue-Green, *painted by Stanton Macdonald-Wright in 1918*

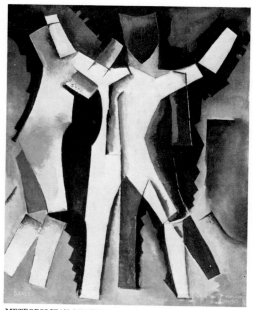

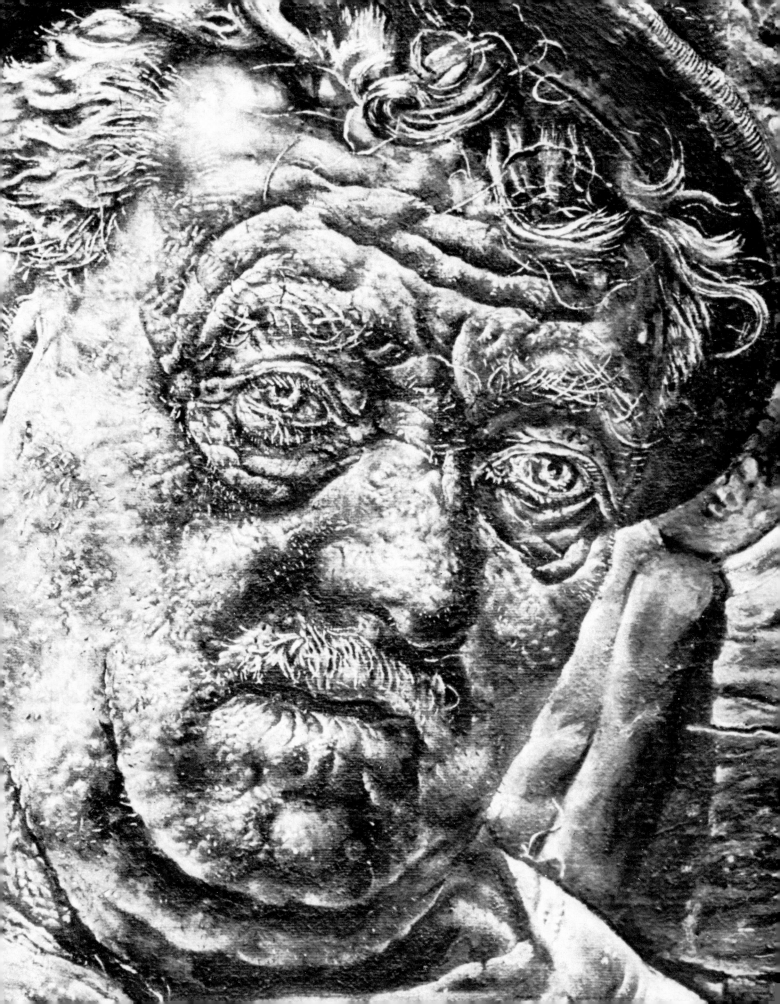

BETWEEN TWO WARS

Opposite, detail of And God Created Man in His Own Image *(above), a painting done by Ivan Albright between 1930–31*

For most of the century following the conclusion of the War of 1812 the United States was primarily concerned with problems of self-development. Confident in its own hard-won independence, the country turned its back on the troubles that throughout that century intermittently disturbed the peace of Europe. The very size of America and its distance from first-rate military powers (while the British navy policed the high seas) provided an immunity from aggression and interference that continued down to the last generation. Few nations in modern history have enjoyed such prolonged and undisturbed security.

It was over the course of those years that the Hudson River school of landscape painting celebrating the American scene developed, flourished, and branched out into accomplishments that won international recognition. From that background also emerged such distinctive talents as Winslow Homer and Thomas Eakins, who depended largely on their native and personal resources and who, quite aside from their patent Americanisms, were among the most distinguished artists of their time. So it seems, at least from this side of the Atlantic, where their works are best known and can best be measured, without chauvinism, against the contemporary works by leading European artists that hang beside them in our American museums.

Not until 1898, when the United States engaged in the "splendid little war" with Spain over the question of Cuban independence, did the nation again become seriously involved in international affairs, and then it took the initiative, displaying its new strength rather than the weaknesses that had dragged the colonies and early Republic into European squabbles of former times. Even so, to most Americans this seemed like an ill-advised but mercifully brief and limited excursion into troubled waters. So, when war once more erupted in Europe in 1914, it was generally considered a remote affair that was no business of ours. Most artists were sympathetic to the cause of France, where so many of them had learned so much; but in general Americans had no wish to become involved in the distant conflict of European nations.

There were critics, connoisseurs, collectors, and some artists in America who welcomed the war abroad as an experience that might well purge the art world

of its more recent follies. To such men of honest opinion but limited vision modern European art was degenerate, anarchic; it brought to this country a subversive, imported ideology that threatened the wholesome, traditional standards of American art; it was, in fact, dangerously un-American. "The men who would make art merely expressive of their personal whim," wrote one conservative critic of the modernists, "make it speak in a special language only understood by themselves, are as truly anarchists as are those who would overthrow all social laws. But the modern tendency is to exalt individualism at the expense of the law." One spokesman of academic preferences even implied that modernism was not only revolutionary, it was immoral and, worse, contrary to the will of God. "War is a good cleanser," wrote still another arbiter of such matters. "We need war. For if war is itself a madness it is also a cure for madness."

In retrospect such diatribes seem ludicrous, almost beyond credence, and neither the war nor the uneasy peace that followed could spare America from the new and experimental developments of modern art. In time to come, indeed, America would become the very crucible in which the most advanced ideas of all were forged. Nevertheless, the war did result in a confusion of values that, among many other things, affected the normal growth of American art. There was a widespread belief, or feeling, in this country that our effective involvement in that European strife should be written off as a necessary, perhaps, but momentary foreign entanglement. Once it was "over over there," as the popular song went, and the world made "safe for democracy," the nation could wash its hands of Europe's perplexing problems and retreat to its accustomed isolation.

Woodrow Wilson pleaded that the United States could not thus summarily cast aside its responsibilities, that it must indeed support the League of Nations, which, he argued, "was the only hope for mankind." He well realized that American participation in the war had pushed this country well out into international currents; that there could be no return to our own sheltered waters, for those broader currents moved with the running tide of history. Even while the voice of the isolationists gained in volume, America was assuming growing economic commitments about the globe, and these could not be easily or wisely separated from national policy.

Wilson's lofty idealism failed to move a large majority of his countrymen. A few years later they turned a more attentive ear to President Harding's call for a "return to normalcy." However, the cynicism and disillusionment that followed the war were anything but normal to American experience. The "great crusade" to make the world "safe for democracy," it became quickly clear, had been just another in a long series of European struggles for power—bigger and grimmer than all such previous conflicts, but in the end just as meaningless—which America had joined with an innocence that had been betrayed. America's disenchantment with European affairs grew with the succeeding years.

America's own performance during those years was hardly inspiring. The spirit of regimentation and self-denial made popular by the war effort had made it possible to write the Eighteenth Amendment and the Volstead Act into the Constitution, restrictions that were almost immediately regretted by a substantial bloc of citizens, who then proceeded to use all manner of illegal devices to

President Wilson appealing for the League of Nations in Mechanics Hall, Boston, Mass., Feb., 1919

quench their thirst. Such unblushing violations of the law by large numbers of otherwise respectable citizens led to sanguinary, almost open wars between the gangs who competed for the profitable trade in strong waters. While it lasted it was a period of lawlessness and corruption at all levels of society unprecedented in American history.

During these same years the distrust of aliens took on new and sometimes ominous forms. Large numbers of those who had been called to the colors with the conscription of 1917–18 were either foreign-born or the sons of immigrants, many of them still with strong attachments to the hostile countries of Europe. But very few of them put the interest of their fatherland before that of their adopted country, as the Germans and their allies had real cause to lament. Nevertheless, it was widely believed that the continuous influx of alien people might threaten the "pure" native breed of Americans who had come to the country in earlier years. In 1921 and again in 1924 and 1929 Congress adopted policies of rigid restriction on immigration. The great Melting Pot was brought to a simmer, and an era of deep significance in human history came to an end.

The "return to normalcy" took a sinister route in the flourishing revival of the Ku Klux Klan during the 1920's. This new Klan was not only determined to keep the Negro in his place, but in a resurgence of nativist sentiment arbitrarily selected for its target other minority groups—recent immigrants, Jews, Catholics, and similar "un-American" folk who did not conform to the ideal of native, white Protestant supremacy. That reactionary spirit was a violent expression of the intolerance toward nonconformism and against liberalism in general that stained the history of the decade. It found one of its most dubious outlets in the trial and electrocution of Nicola Sacco and Bartolomeo Vanzetti, two philosophical anarchists of foreign birth whose conviction and sentence in the face of what many liberals deemed questionable evidence shocked reasonable people throughout the world.

Meanwhile, Calvin Coolidge succeeded Warren Harding in the Presidency and tartly announced from his high office that "the business of the United States is business," one of the better remembered of his limited public utterances—one that fairly expressed a popular opinion that the business community would find its way to fulfill American destiny if left to its own devices, without undue interference from federal supervision. The uninhibited individualism that had long been recognized as the true source of America's well-being was a tradition that could be used as a golden rule, and after the governmental controls, made necessary by the recent war effort, were lifted, the direction of American enterprise was turned back to private management with pious zeal. Speculation in America's future rose to a crescendo that, as seen and described from the White House, led toward unlimited prosperity.

One of Coolidge's less memorable utterances, with which he probably also expressed majority opinion, was voiced in 1925 when the United States received an official invitation to send a representative display of American decorative art to an important exhibition to be held in Paris that year. Coolidge simply replied that America had nothing to contribute. That terse comment, although it may have spoken for the mass of Americans, concealed the wide variety of activity

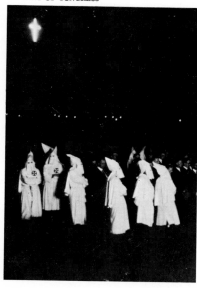

Aspiring Klansmen and bona fide members of the Ku Klux Klan join in an initiation ceremony, 1923.

The isolation dominating Hopper's Automat *of 1927 is conveyed through his unique use of lighting.*

In Albert's Son *of 1959, Wyeth, too, seeks to express an "objective" reality, but by different means.*

that was stirring in artistic circles during the 1920's. If this decade and the next did not constitute a period of great creative accomplishment, it was a period of consolidation and assimilation of past experience—a period in which the native strain tested its skills in many different directions.

Many of the abstractionists who had worked out their individual formulas in the second decade of the century continued to refine their styles over the succeeding decades. Some of them were content with their earlier solutions and continued to paint in their accustomed way, with no radical changes in their approach to art; others endlessly experimented with the hope of finding new and more absolute answers to the artist's problem. On the other hand, during the 1920's and 1930's there was a resurgence of realism in painting. So-called figurative art had, of course, never been submerged by the tide of modernism, and probably never will be. But in the postwar decades it did develop new accents. The best work in this vein reflected the lessons that modernism so insistently preached in a freer use of color and a more strict attention to structural qualities for their own sake. It was hardly necessary to paint abstractly to profit from that freedom and to practice that constructive discipline. With all this, there was a growing emphasis on the *craft* of painting, on technical proficiency in applying paint to canvas.

These points are clearly demonstrated in the works of such artists as Edward Hopper, Walt Kuhn, Reginald Marsh, Franklin Watkins, and innumerable others who painted during these decades. The variety of their output is suggested by the fact that some of this century's most respected and best loved paintings date from these years, along with some that have mostly won only opprobrium with the passage of time. In either case, the subject matter of these artists was principally the American scene in all its diversity, of American people and things and places, fondly or critically observed and clearly recorded. "My aim in painting," wrote Hopper in 1933, "has always been the most exact transcription possible of my most intimate impressions of nature." And here it is well to recall once again that no artist precisely reproduces the reality of the natural world, that all artists abstract from their subjects what they deem the most significant aspects according to their personal vision. This is true even in such meticulously "realistic" works as those of Andrew Wyeth, where every blade of grass and every grain of sand seem to be accounted for. "It's not what you put in but what you leave out that counts," Wyeth has stated.

There was an enormous growth of art consciousness in America during the twenties, a matter emphatically indicated by the fact that sixty new museums were formed between 1921 and 1930. One important phase of that consciousness was revealed in 1926 and 1927 when the collection of modern art formed by the lawyer John Quinn, who had been so influential in the staging of the Armory Show, was auctioned off for $700,000—a sum that shocked both press and public with the realization that modern art was not without its interest and certainly not without its value.

These were, to be sure, the manic years of American prosperity—years when it seemed that anyone could and everyone should be rich. To prosper was virtually obligatory, or so it was intimated in authoritative circles. Then, in the autumn of 1929, the stock market collapsed with a thunderous crash, and the almost

mystical sanctity of American prosperity was unbelievably violated. The Great Depression, which followed, introduced the nation to a period of such suffering as it had not before known. It left the American people outraged and baffled. The miseries of Europe, it had been often contended, were Europe's own fault. But in America this bitter experience seemed like some inexplicable prank of nature.

During those dark years the artist suffered along with his fellow citizens, and like so many of those other unfortunates, he received a helping hand from the national government. In the summer of 1935 the Federal Art Projects of the Works Progress Administration were established, not simply to provide work for unemployed and hungry artists but as well to encourage the development of their skills and to provide a wider public with a new opportunity to become familiar with contemporary American art. This country-wide experiment was launched on a scale and with a purpose that were something new in the world. It was but one facet of a huge public-works program designed to alleviate the human misery that stalked the land. The inclusion of art projects (among them music, theatre, and the minor arts), along with more immediately practical undertakings such as road building and other public construction, was a big departure in a country where patronage of the arts by the government had rarely been heard of.

"Art in America," wrote Ford Madox Ford, "is being given its chance and there has been nothing like it since before the Reformation." Thousands of painters, sculptors, and designers were put to work adorning America, covering the walls of courthouses and post offices with murals celebrating American history and local customs—often with strong overtones of social criticism—and producing easel pictures for small galleries and posters for general display. Among those so put to work, no distinction was drawn as to politics, race, or religion. Thanks to the project, the Negro painter found a chance to prove his merits, along with others of different skin colors—yellow, white, or tawny. Nor were styles regulated. Uncompromising modernists had their day along with their most conservative brothers. Ben Shahn, Philip Evergood, and Jack Levine, among others who would subsequently achieve major status in American painting, were on those relief rolls, as were John Steuart Curry and Grant Wood. It was just one happy consequence of all this that artists were regaining an accepted place in American life—a place they had not enjoyed since the heyday of popular "modern" art almost a century earlier. Many of the younger artists found a beginning for their profession in their own communities instead of leaving home for New York or Paris, as they would have done in earlier decades. And many of those towns and cities spread about the land for the first time experienced the stimulus of artistic activity.

By its nature the WPA program tended to underline the resurgent national feelings that characterized the art of the 1930's, to shed new light on the diversified regional aspects of American culture, and ultimately, to blend these with the more cosmopolitan strains that had for so long influenced the direction of American painting. In published guides to the separate states and some city districts, and in the meticulous recordings of old artifacts and antiques which

Above: ex-servicemen eat a free meal during the Depression, 1931

Below: one of twelve panels executed by H. V. Poor for the Justice Dept. under the auspices of WPA

were other parts of a broad program, as well as in creative painting, an unexpected wealth of local lore was unearthed and brought to public attention. All in all it reflected a desire to understand what was valid in American experience, a search for something more basic and durable than the euphoric aberrations of the 1920's.

This sort of self-appraisal, this emphasis on national identity, was by no means unique to America. In the aftermath of the shattering war other nations also looked inward in a quest of forgotten or hidden virtues of their past or present that might restore pride and self-respect; or, as in the case of Hitler's Germany, justify their supremacy over the rest of mankind. Even France, the most cosmopolitan of societies, was not immune to such chauvinism as it reacted to the shock and dislocation of the war. At its fanatical worst this nationalist sentiment in America was recorded by Thomas Craven in his widely read book, *Modern Art*, published in 1934. He referred to Alfred Stieglitz as "a Hoboken Jew . . . hardly equipped for the leadership of a genuine American expression." As proof of his thesis Craven listed the "un-American" names of the artists Stieglitz had so unsparingly and devotedly supported—Kuniyoshi, Lachaise, Walkowitz, Sterne, Weber, and the others, mockingly referring to such immigrants as "scions of our colonial ancestry!" Unfortunately, the Hitlerian overtones of Craven's criticisms were intended to support the merits of such deservedly popular artists as Thomas Hart Benton, John Steuart Curry, and Grant Wood. All three of those men spoke for the Midwestern heartland of America, for what they considered the grass-roots center of our national culture, the dynamic source of the nation's potential strength, as they saw it. Their work was well received generally, although their reputations have declined somewhat with the passing years.

The commentaries on American life by those three so-called regionalists were bland compared to the protest and satire expressed by a sizable group of other artists. Criticism of the inequities and injustices that disfigured certain aspects of American society was nothing new, but in earlier decades such pictorial demonstrations had been more or less restricted to illustrations in left-wing journals. However, the experience of the Great Depression released a fresh wave of indignation over the plight of the hungry, the dispossessed, and the oppressed people of the land; and a fair number of talented artists took up their brushes in protest against such miseries. As one of them remarked about this uprising of social consciousness, "we were all making a point . . . we had a feeling of confidence about our ability to do something about the world." The famous Mexican muralists José Clemente Orozco, David Alfaro Siqueiros, and Diego Rivera, whose works can be seen on the walls of a number of American buildings, at Dartmouth College and in New York and other large cities, provided outstanding examples of such art and served as a stimulus to American painters.

Ben Shahn, a Lithuanian who came to the United States as a child and became one of the fine stylists of his day, worked with Rivera on the Rockefeller Center murals, which were later destroyed because of their radical implications. Shahn's own paintings in this so-called social realist manner were both militant and thoughtful. Such art is self-limiting to a degree, for it must be literal enough to make its meaning thoroughly clear to its audience; and it must relate to specific

MUSEUM OF THE CITY OF NEW YORK

An interpretation of the spirit of Prohibition, sketched by Rollin Kirby

302

circumstances or events in the frame of a certain time. It was with this realization, no doubt, that Shahn gradually turned to more generalized and symbolical observations of the social scene. Even in his strongest protests, his work was leavened by a sense of irony.

During the thirties the artists' ranks were strengthened and diversified by fresh contingents of recruits from abroad, many of them refugees from the intolerant nationalism of their homelands. George Grosz and Lyonel Feininger fled from Germany. Pavel Tchelitchew came from Russia via France. Then, before and after the fall of France, still others took refuge in New York City. They were a small but important part of the swarm of professional and intellectual refugees—such towering figures as Albert Einstein, Bruno Walter, Erwin Panofsky, Walter Gropius, Mies van der Rohe, Thomas Mann, Bertolt Brecht, and still others—who added such incalculable wealth to American experience. It was thanks to the influx of foreign, notably German, scholars that New York University's Institute of Fine Arts quickly developed into a major center of art studies. "Hitler is my best friend," remarked that institute's director. "He shakes the tree and I collect the apples."

By far, most of the painting done in America during the twenties and thirties was realistic, objective, and nativist in character. Here, as in Europe—but for somewhat different reasons—there were many artists who rejected abstract art, among them men who had studied and practiced it, but who found it wanting for their purposes. That point was made emphatically by Thomas Benton, who in his later years recalled his early adventures with modernism. "I wallowed in every cockeyed ism that came along and it took me ten years to get all that modernist dirt out of my system . . .," he remarked. "In the company of such hardened internationalists as George Grosz, Wyndham Lewis, Epstein, Rivera, and that Stein woman, I was merely a roughneck with a talent for fighting, perhaps, but not for painting—as it was cultivated in Paris." Those others, he complained, were "an intellectually diseased lot, victims of sickly rationalizations, psychic inversions, and God-awful self-cultivations." However, it was the later modernists, not the likes of Benton, who would win the day finally, or so it seems today. At least it can be said that the artist today does not have to make such a flat choice between modernism and traditionalism; there is ample room in the art world for competent practitioners in both camps.

The realism that is so directly in the American tradition did not disappear, although it took on new aspects with changing circumstances. But the advent of the distinguished European refugees and then America's total immersion in World War II introduced a new cosmopolitanism into American art, and the regionalism and the chauvinism of the thirties tended to fade into history. As early as 1936 the Society of Abstract Artists was formed in New York, and an increasing number of painters and sculptors followed the lead of those so-called nonobjective artists. Their broader recognition came in the postwar years. By then the United States was a fully involved participant in the affairs of the whole world. It is doubtful that the nation's whilom isolationism could ever be revived. About the time the United Nations headquarters was established in New York, that city became the art capital of the world.

Fit for Active Service, *by George Grosz, one of his early drawings satirizing the Germans, done in 1918*

Gods of the Modern World, *José Orozco's mural at Dartmouth College, Hanover, N.H., representing the sterility of academic learning*

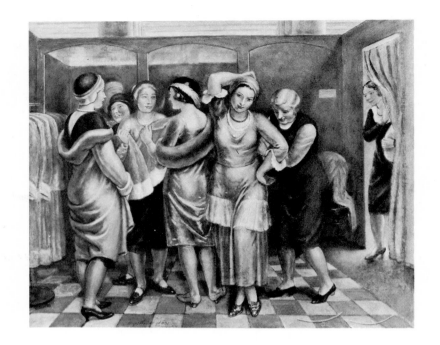

Left: The Fitting Room, *a commonplace city scene by Kenneth Hayes Miller,* 1931

Below: New York's Bowery as it appeared early in the Depression, by Marsh, 1930

Opposite: a view of the New York milieu, the surging crowd at Coney Island, by Marsh

THE FIGURATIVE TRADITION

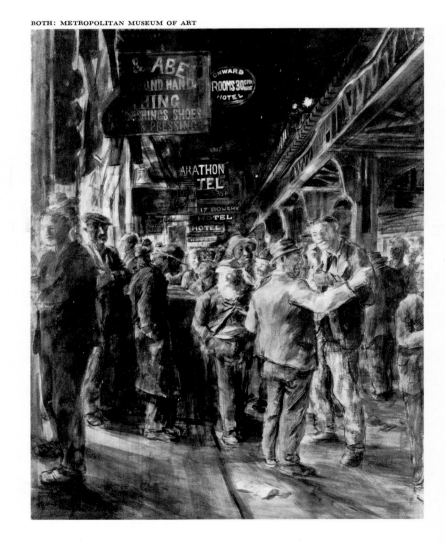

The novel distraction of modernist painting that resulted in so much discussion, controversy, and excitement in the second decade of the present century by no means ended the influences that had been generated by the Ash Can school. In New York during the twenties and thirties a sizable number of artists, stimulated by the electric, teeming atmosphere of the city, continued to find there traditional themes and subjects; they painted these with understanding and enthusiasm, as Henri and his group had done earlier. But they brought to their depictions of homely urban scenes sophistication of technique and coloring learned from the modernists, and in this they may be said to have rounded out and completed the work of The Eight and their immediate followers. These later urbanists have been labeled the Fourteenth Street school, but they were far less a school than an assortment of individualists. Their chief mentor was Kenneth Hayes Miller, who had studied under William Merritt Chase, who taught art effectively for a half century and who thought that Greenwich Village in New York provided "the greatest landscape in the world." Miller was an assiduous student of the old masters, and in his teaching stressed the need for sound craftsmanship. One of his most devoted pupils was Reginald Marsh, whose love of New York in all its crowded turbulence led him to make thousands of sketches of all the passing moments that he witnessed. He recorded everything from Bowery bums to night-club dancers and to the writhing swarms of half-naked bodies at Rockaway Beach and Coney Island— scenes he likened to the great compositions of Michelangelo and Rubens.

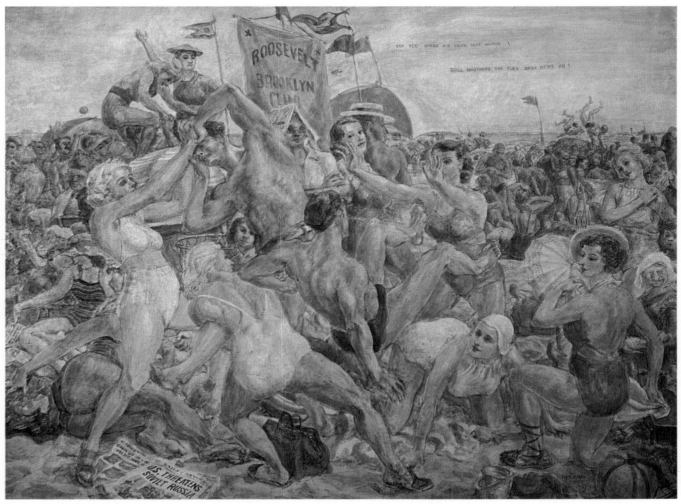

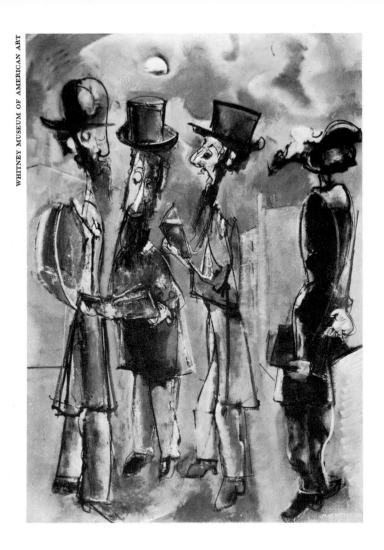

Left: Weber's Adoration of the Moon, *1944*

Opposite: November Evening, *painted by Charles Burchfield in 1934, during his middle period; with such work Burchfield might qualify as another regionalist artist.*

Below: Fishermen's Last Supper—Nova Scotia, *an example of Hartley's later work*

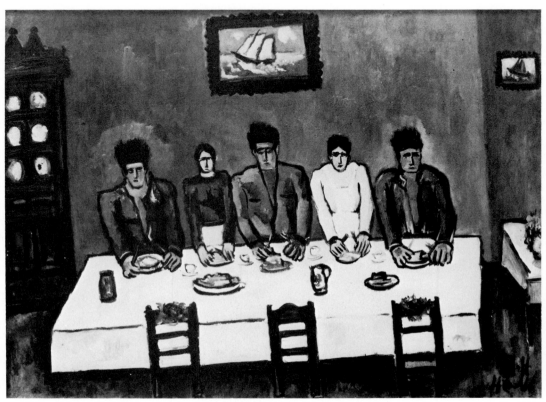

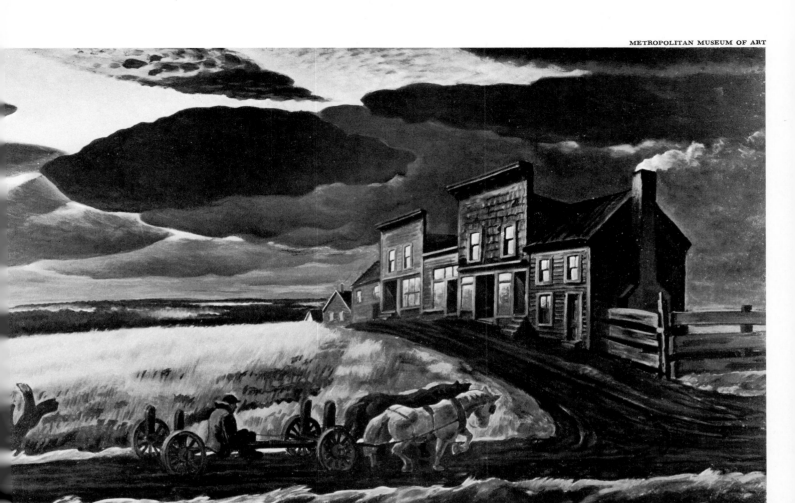

Unlike their contemporaries in Paris, New York artists of the twenties did not
band together in small groups, each with an aesthetic dogma of its own; rather they
went their individual ways, working out their own styles. Thus, Max Weber, who
had earlier steeped himself in various Parisian trends (see page 288), turned to
scenes remembered from his Russian childhood, such as *Adoration of the Moon,* in
which he alludes to the mystical religiosity of Hasidic Judaism—and in a style
totally different from the styles he had experimented with thirty-odd years earlier. That
sort of independent growth was hardly peculiar to the New York art scene. Before
he died in 1943 Marsden Hartley, "the painter from Maine" as he chose to call himself,
moved from his youthful abstractions (see page 293) to highly expressive
subjects in which the tragedy of death at sea is solemnly acknowledged, as in his
Fishermen's Last Supper, painted in 1940–41. Thus also, Charles Burchfield,
constantly searching for means to express his vision of the world, progressed from
the vibrant style of his early water colors (see page 287) toward a more austere
realism, as seen in his *November Evening,* painted in 1934. Of this painting he
wrote, "I have tried to express the coming of winter over the middle-west as it must have
felt to the pioneers. . . ." In the end, still searching for the most expressive
visual truth, he deliberately returned to his earlier, more lyrical manner.
He thought that in the intervening years, roughly between 1920 and 1940, he was
painting too realistically, that he had to recapture his primal imagination.

307

Throughout the twenties and thirties the majority of American artists painted the world about them, its people and things, more or less realistically; not necessarily with the clearly defined objectivity of Copley and Eakins, those titans of American realism, but often with a highly personal, stylized manner. Walt Kuhn, who was a co-organizer of the Armory Show, had a temperamental affinity for the clowns, acrobats, and other entertainers of the circus and burlesque worlds (he was himself an old showman), and he typically represented these performers in reflective, off-duty moods—moods which he caught with startling immediacy and with a bright and dramatic palette. His somewhat younger contemporary, the Philadelphia artist Franklin Watkins, has been called "one of the great portrait painters of our time" (albeit he also painted fresh and charming still lifes, among other things). Watkins brought to his work a wider knowledge of the history of art in all its phases. He was an urbane, cultured man with a highly individual talent, and with a strong interest in human personalities. Of the painting here illustrated he wrote, "I feel portrait painting is a sort of screening of yourself as much as a study of the person sitting in front of you. *Solitaire* was the illustration of a mood of query." He recalled that painting the black, white, and red of the playing cards as a contrast to the green-topped table had given him "an electric excitement of disproportionate emphasis."

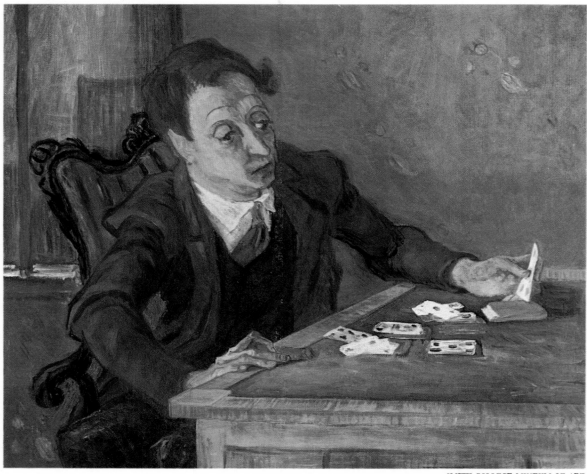

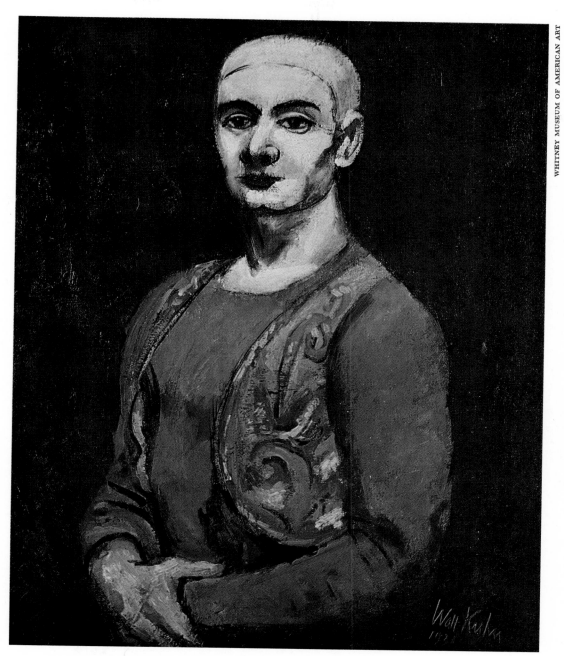

Above: Kuhn's The Blue Clown, *painted in 1931*

Opposite: Solitaire, *painted by Watkins in 1937*

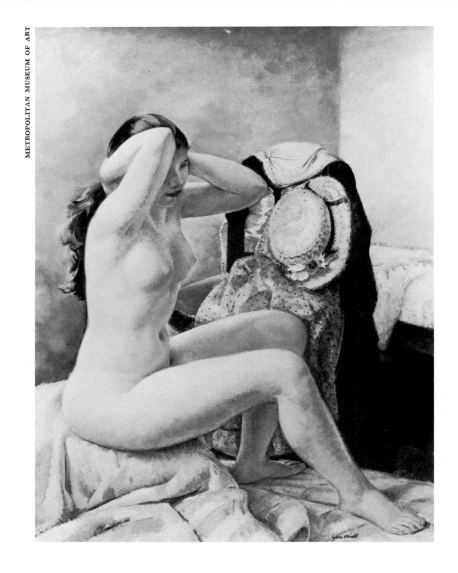

Left: Kroll's Nude, *painted 1933–34*

Opposite: Brook's Ann, *painted 1935*

Below: Nude, *by Isabel Bishop, 1934*

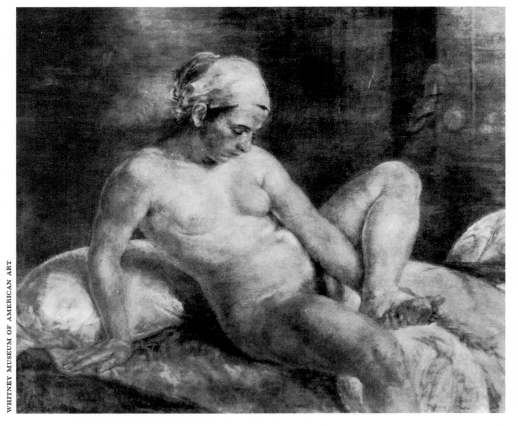

As the art historian Sir Kenneth Clark has written, the nude is not the subject of art; it is a form of art. In the great age of painting and sculpture—during the Renaissance—the nude inspired the greatest artistic creations. To this aspect of art, however, America long remained blind—or blindfolded. As already remarked, John Vanderlyn's lovely *Ariadne* was widely considered an indelicate picture when it was publicly shown early in the nineteenth century. In subsequent years American sculptors (many of them working in Italy) won some freedom in depicting unclothed bodies. Yet, even late in the century, Thomas Eakins was castigated for his insistence on making the nude human figure the basis of his art and his teaching. Such prudishness and prejudice have, of course, long since been outmoded. The resurgent realism and naturalism of the twenties and thirties led figurative painters to the nude as a relatively unexploited resource of American art. In their studies of nude forms Alexander Brook and Isabel Bishop, both sometime students of Kenneth Hayes Miller, show the technical competence that Miller so insistently demanded in his teaching; in the sensuous quality of their brushwork and their subtle modeling of forms they surpassed the work of their mentor. Isabel Bishop's style recalls the sketching technique of Rubens more than three centuries earlier. Leon Kroll's figure, as smooth and still as a statue, studiously posed before the spring finery she has just removed from her opulent body, is typical of the finished artistry that earned him numerous honors in the twenties and thirties.

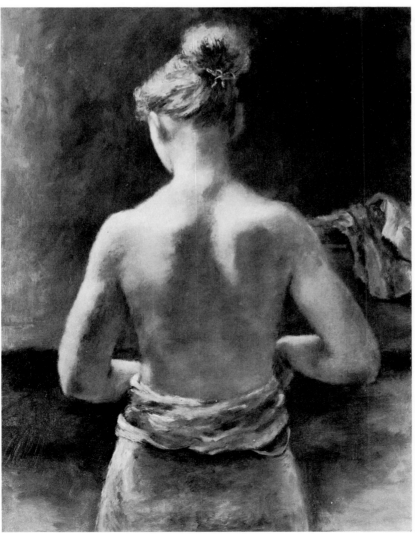

311

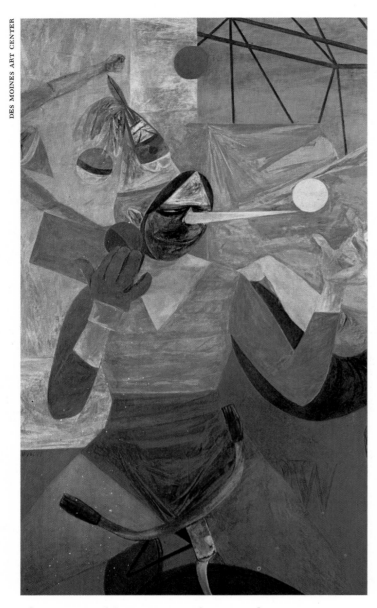

Above: Kuniyoshi's Amazing Juggler, *painted in 1952, shortly before the artist's death*

Opposite: Vaudeville, *by Jacob Lawrence*

Yasuo Kuniyoshi came to the United States from Japan in 1906 at the age of thirteen and subsequently studied with Kenneth Hayes Miller, among others. Jacob Lawrence grew up in New York's Harlem during the years of the Great Depression. In entirely different fashion, the work of each is highly stylized and personal, colorful and exotic, far from the academic naturalism of the artists just discussed. Kuniyoshi studied at the Henri school before working with that great teacher Miller, meanwhile holding a variety of odd jobs from dishwashing to picking grapes to photographing. During World War II he was classified as an enemy alien, although he had vigorously protested against the growing militarism of Japan in the 1930's. "My art training and education have come from American schools and American soil," he wrote. "I am just as much an American in my approach and thinking as the next fellow." True as that may be, Kuniyoshi brought with him an Oriental inheritance that he skillfully blended with his Occidental learning. In the late twenties he went to Europe and enriched his artistic vocabulary through the study of such early Italian masters as Giotto and Piero della Francesca. Before he died in 1953, Kuniyoshi had added a distinctive luminous note to the pattern of American painting, more decorative than profound, but intensely individual. His images evoke fanciful notions of the real world. Jacob Lawrence is no less an independent artist with a strongly personal manner in painting. His very colorful, highly stylized images are as far away from standard academic formulas as are Kuniyoshi's. Lawrence's *Vaudeville,* painted in 1951, is a bright, forceful evocation of the artist's memories of the Apollo Theater in Harlem. The design is almost as flat as a diagram, drawn with an unrestrained vigor that sharply concentrates on an immediate dramatic moment on stage. "I wanted a staccato-type thing," Lawrence recalled, "—raw, sharp, rough—that's what I tried to get." His use of colors is completely arbitrary, bearing no relation to actual models, but mixed and assorted according to his vision.

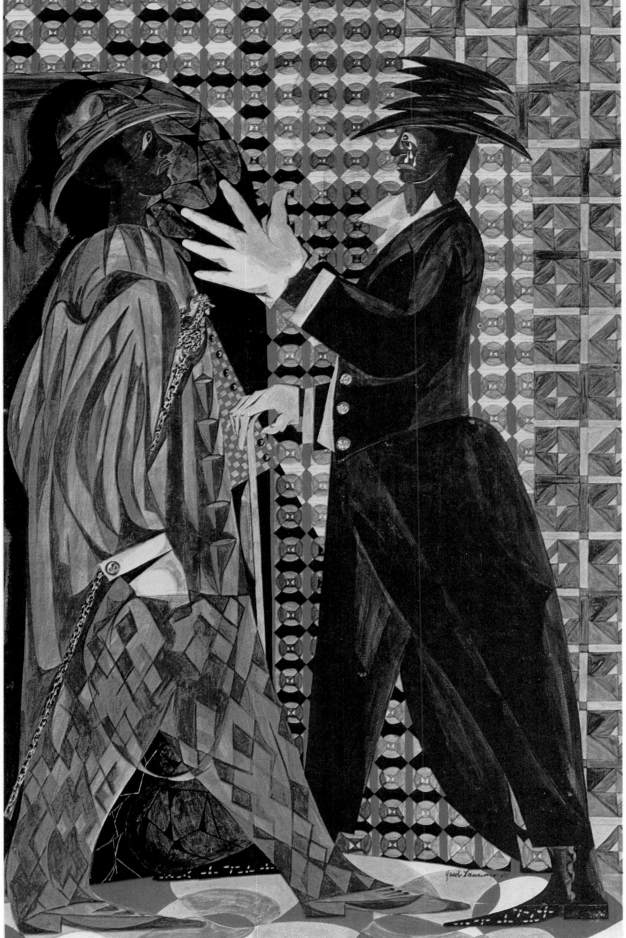

Although as a youth Edward Hopper studied in Robert Henri's art classes (he was a classmate of George Bellows), he later wrote that the only real influence on his painting was himself. Throughout his mature career he remained faithful to his own singular vision of the American scene, the city and the countryside alike. However, he disclaimed any effort to be "American" in his approach to his chosen subjects, as Benton, Curry, and Wood tried so hard to do. "I just tried to be myself," he explained. While disparate major movements and minor fads rocked the art world, Hopper remained an uncompromising realist from the time he began studying with Henri (in 1900, at the age of eighteen) until his death sixty-seven years later. He wasted no time on unnecessary detail in his painting. In nearly all the significant examples of his work, light and the effect of light in all its variations provide the principal dramatic content. He once remarked that he yearned simply to "paint sunlight on the side of a house." There is more to his art than that, of course. The light in Hopper's paintings always underlines the alienation of American life, the isolated and lonely aspects of American experience, although the artist taciturnly disclaimed any intention of creating such effects. Of one painting that strongly suggests those associations, Hopper wrote: "This picture is an attempt to paint sunlight as white, with almost or no yellow pigment in the white. Any psychologic idea will have to be supplied by the viewer." Hopper's success was slow in arriving. He sold one picture at the Armory Show in 1913 for $250, but it was ten years before he made another sale. In time his canvases were bringing from $15,000 to $20,000 each. It was typical of the entirely self-contained nature of the man that even then he chose to live with utmost frugality, abetted in this by his fiercely devoted wife. When the couple died, the Hopper estate was valued at almost a million dollars. Even when he was enjoying his greatest successes Hopper was not certain about the ultimate quality of his works. One painting he thought might be "pretty good," but added, "maybe it's too complete, not suggestive enough."

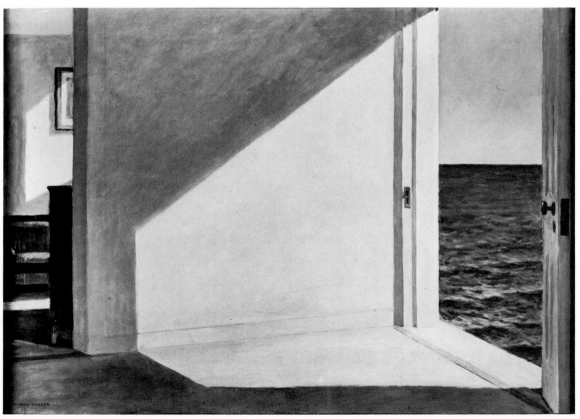

YALE UNIV. ART GALLERY

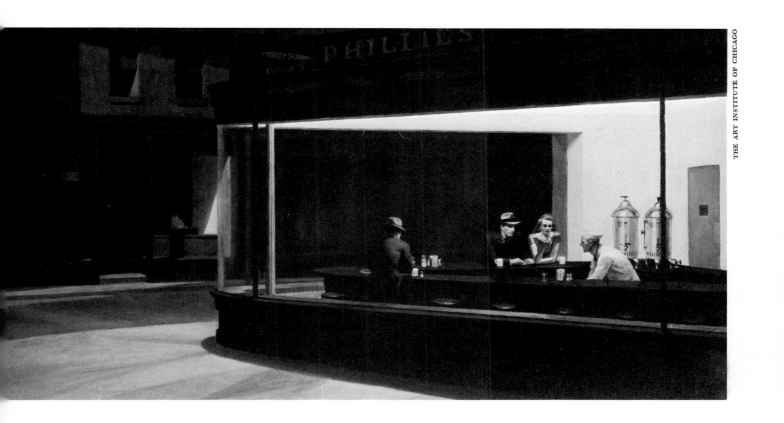

These pictures show how starkly realistic the work of Edward Hopper remained during his career:

Above: Night Hawks, *painted 1942*

Opposite: Rooms by the Sea, *1951*

Right: House by the Railroad, *1925*

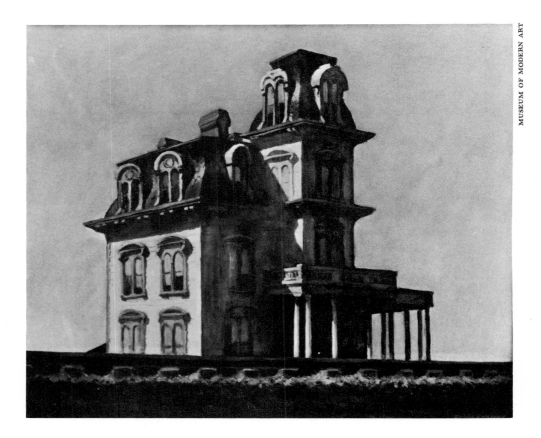

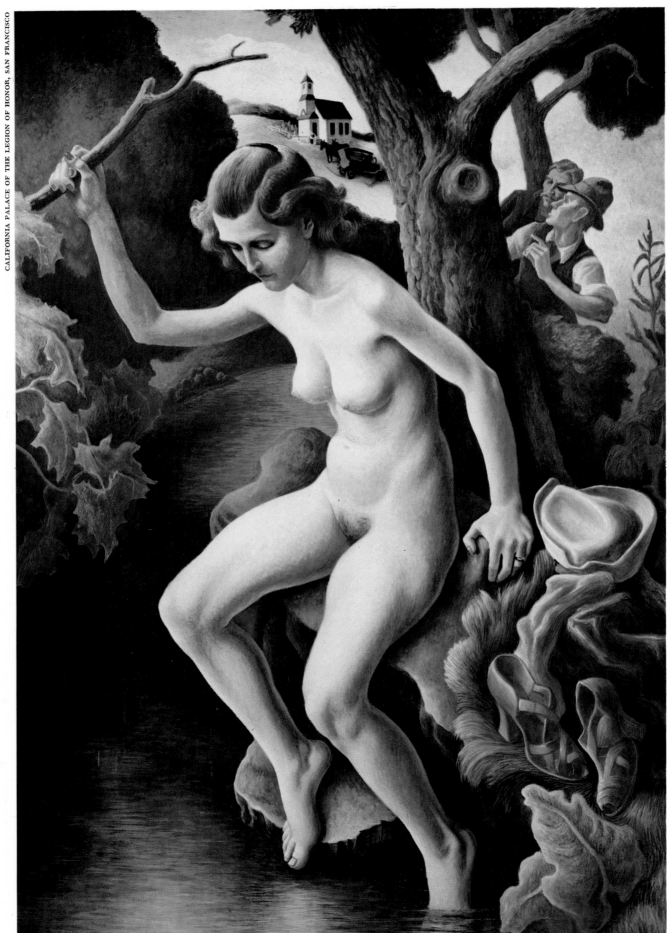

ESSAYS IN REGIONALISM

Above: Benton's Roasting Ears, *painted in tempera in 1938–39*

Opposite: Susanna and the Elders, *painted by Thomas Benton, 1938*

New York City has been the principal art center of the United States for more than a century and a half, both as a "trading post" for wares on the art market and as a focus of creative activity. As a major port of entry into the country for people as well as ideas, it has served as a switchboard for communications between the Old and the New Worlds. However, the nation is so large and diverse in its cultural patterns that no single city, or region for that matter, could speak for all the people all the time. Aside from that, as a broker for alien ideas, New York did not always endear itself to the rest of the country, where inbred, native traditions were more strictly guarded. It was amid such circumstances that the regional paintings of John Steuart Curry, Thomas Hart Benton, and Grant Wood, the three major artists who in their canvases and murals celebrated life in the Midwest, captured public imagination, and won popular approval. Benton was born in Missouri in 1889, the son of a congressman from that state who had come there from Tennessee "riding a horse and knocking the snakes out of his path with a long stick." As a young man the artist had made ritual pilgrimages to New York and Paris, and in the end had found them quarters of effete degeneracy; he chose to return to the more wholesome vistas of America's heartland where his roots were. In his painting *Susanna and the Elders* Benton translates a story from the Old Testament into a homespun Midwestern anecdote, a highly sensual depiction suggesting, it would seem, that this raw, young part of the land was heir to the ages and all their problems. His murals for the library of the New School for Social Research in New York summarized the broad panorama of native American activity, in field and factory, and in all its sections. Speaking of himself, Curry, and Wood, he observed in his autobiography, *An Artist in America,* how the three had revolted against "the general cultural inconsequences of modern art" and could hope that only by participating in the reality of American life could they convey a significant message to their countrymen.

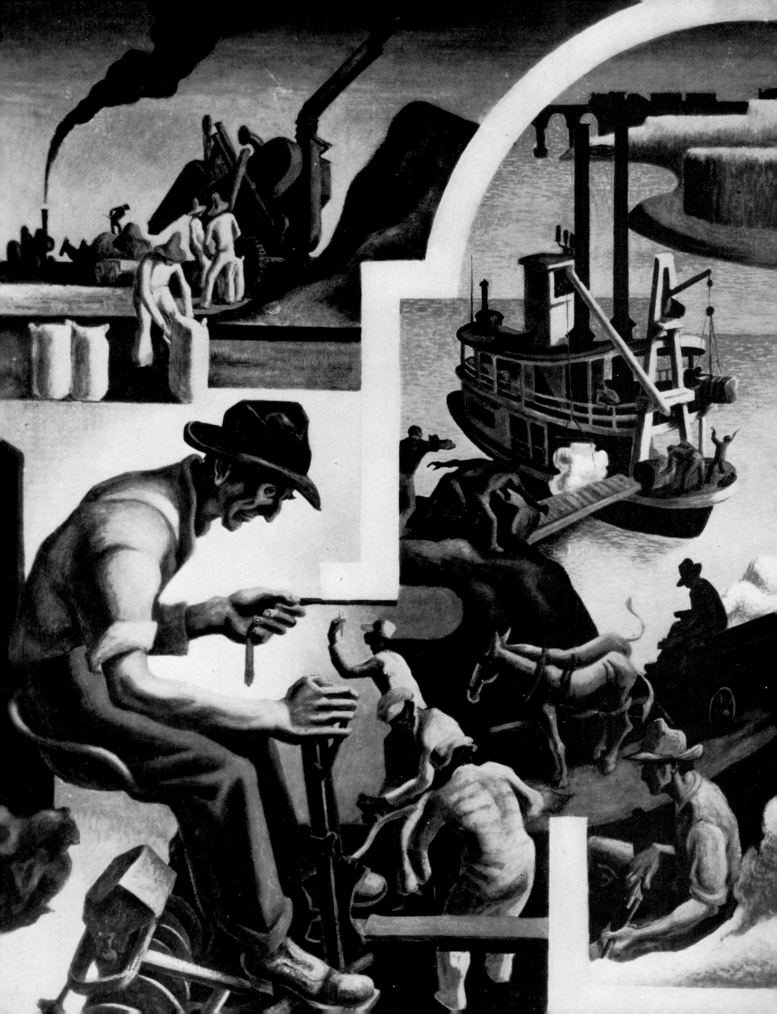

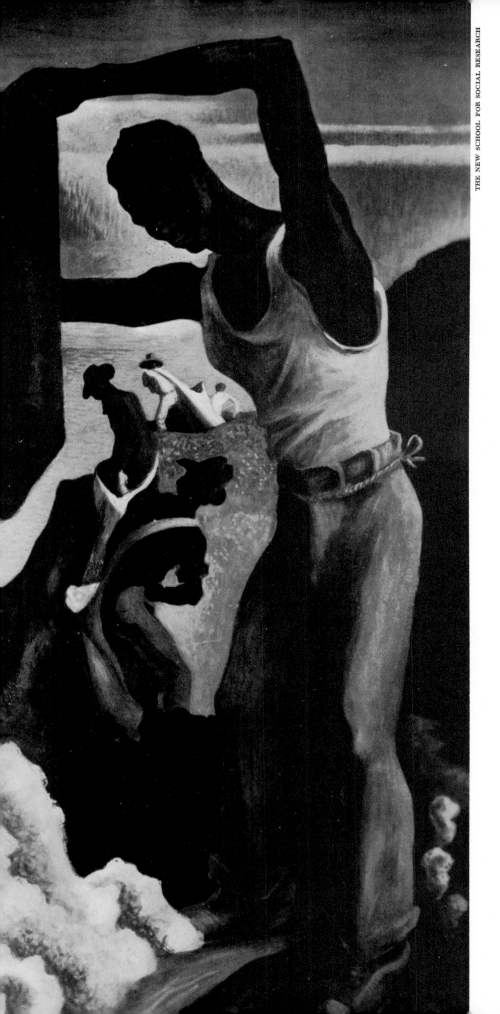

The Old South, *one detail from a series of murals painted by Thomas Hart Benton for the New School for Social Research in New York. Completed in 1930, in the early days of the Great Depression, these scenes depict the diversity and potentiality of life and industry in continental America.*

319

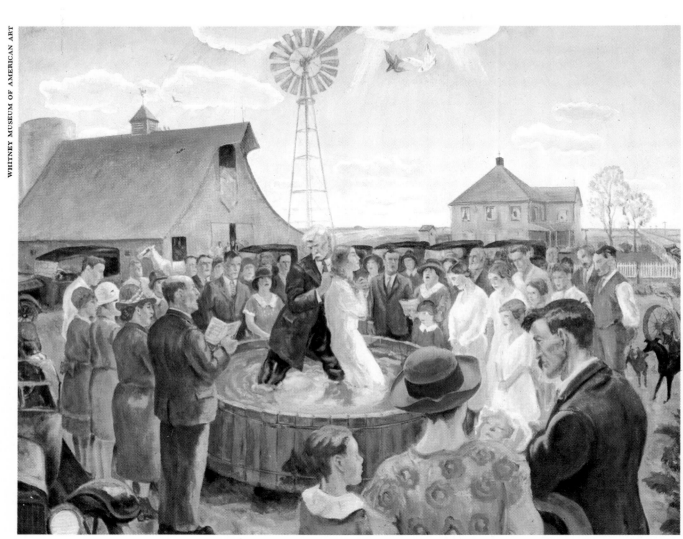

Above: John Steuart Curry's Baptism in Kansas, *an early essay in regionalism, painted in 1928*

Opposite: Hogs Killing a Rattlesnake, *painted in 1930, the year of Curry's first one-man show*

John Steuart Curry was born on a Kansas farm and, as Benton wrote after Curry's death in 1946, he never forgot that fact, nor that his parents were "plain Kansas folks whose lives were spent with the plain, simple, elemental things of the earth and sky. His Art and the meanings of his Art were never cut loose from the background. To this end his ideal was a Kansas audience." Curry managed to spend a year in Paris, and he studied in Chicago and New York as well. However, the focus of his vision remained in fact the Kansas scene, which he tended to view in the dramatic and melodramatic aspects of man's eternal struggle with the forces of nature. In *Hogs Killing a Rattlesnake* he created one of his most vigorous and forceful compositions out of a memory of his childhood. The writhing violence in the foreground is set against a natural scene of tree and earth and sky whose dark, somewhat foreboding rhythms unexpectedly recall the work of Albert Pinkham Ryder. In *Baptism in Kansas,* one of the first experiments of the budding regionalism of the twenties, a country preacher, using a wooden tub filled with water, celebrates the rite of baptism with a young girl as a crowd of the faithful watch and share the emotional excitement of the occasion. Curry's sincerity and his dedication to his chosen themes were strong enough, at least, to earn him a more than passing popularity with the public. In spite of his apparent parochialisms, Curry's lectures to his students at the University of Wisconsin during the last decade of his life were studded with broad perceptions concerning the role of the artist. "Some of us look forward . . . to a great and alive art in the Middle West," he remarked, "but be reminded of this— the great art is within yourself. . . . Your greatness will not be found in Europe or in New York, or in the Middle West, or in Wisconsin, but within yourself. . . ." In a country as large as the United States it was inevitable that regional art would develop, flourish, and then, as time passed, be absorbed into the mainstream of American art. The Ash Can school, concentrated in and about New York, was in fact such a development, and there were others in later years.

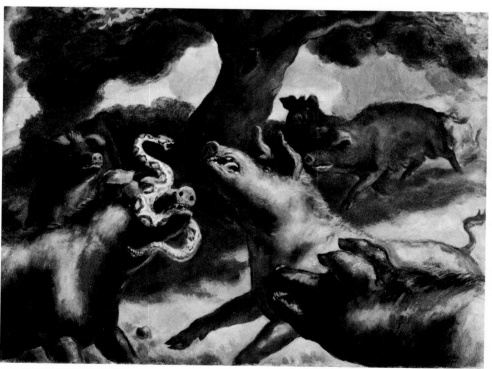

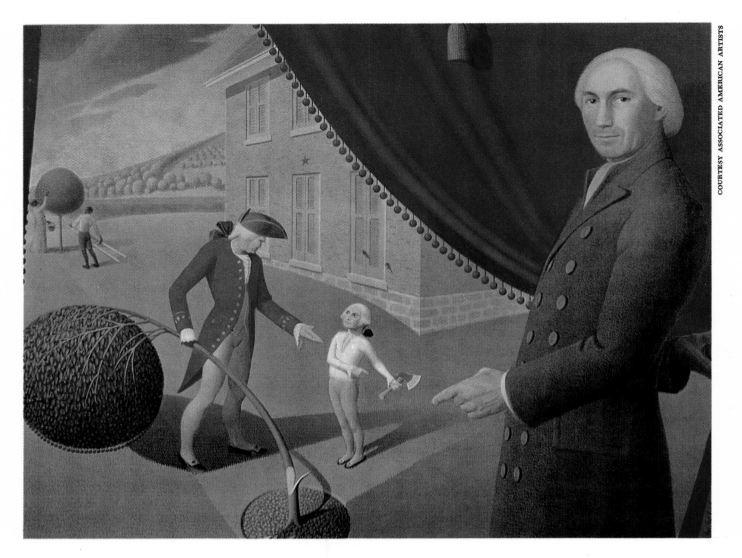

Above: Grant Wood's fanciful version of Parson Weems' fable of George Washington and the cherry tree, painted in 1939

Opposite: Wood's American Gothic, *his most celebrated work, painted in 1930*

In 1930, the year that Curry had his first one-man show at the Whitney Studio Club in New York, Grant Wood won a bronze medal at an exhibition of the Art Institute of Chicago with his *American Gothic*. It attracted considerable attention, and it remains his most memorable painting. On a trip to Europe a few years earlier Wood had been impressed both by the techniques of early Flemish and German masters and by how brilliantly they had recreated images of biblical and mythological subjects in terms of their own contemporary dress and architecture, rich in pattern and detail. It was in the spirit of those late Gothic paintings that he executed his *American Gothic* when he returned to Iowa, using his sister and his dentist as models, standing them fixedly against a frame dwelling in the Gothic Revival style. The picture was originally intended as a satire, but it was painted with affection and with sophisticated technical competence, and became something closer to a heroic characterization of the people and life of the Midwest. Wood's fanciful reconstructions of early American history, as in *Parson Weems' Fable,* are entertaining, in the manner of illustrations, rather than forceful. His essays in satire were not always popular, although with changing times and perspectives they have become more so. When in one of his paintings he grimly caricatured the Daughters of the American Revolution, ladies of that organization protested violently. He wrote a friend, "they are sure that I . . . if the truth were known—am a red and should be deported."

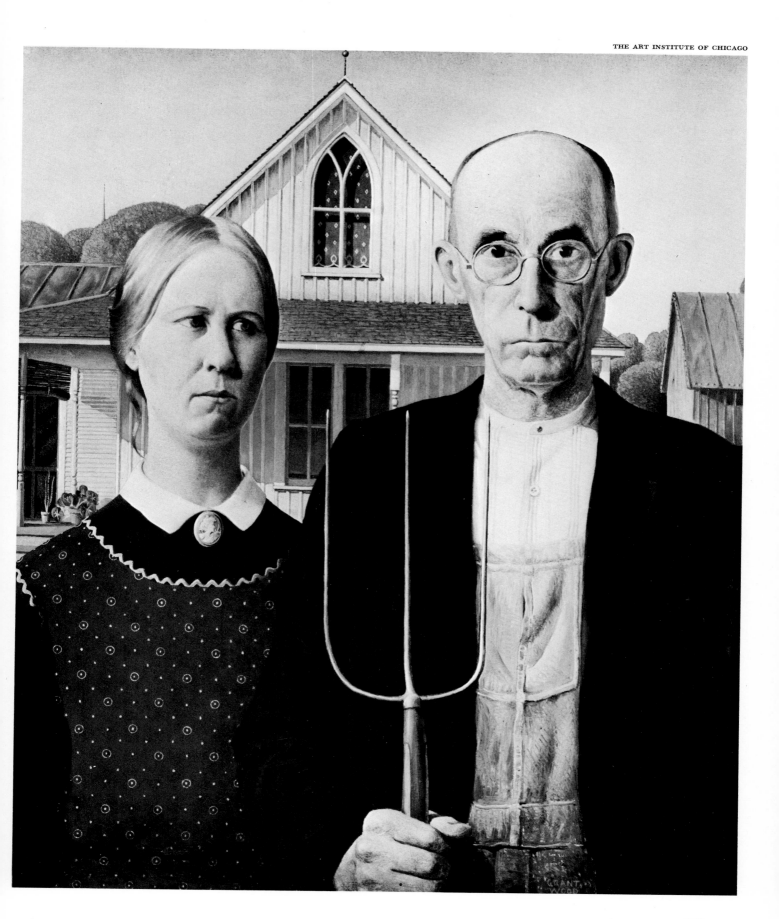

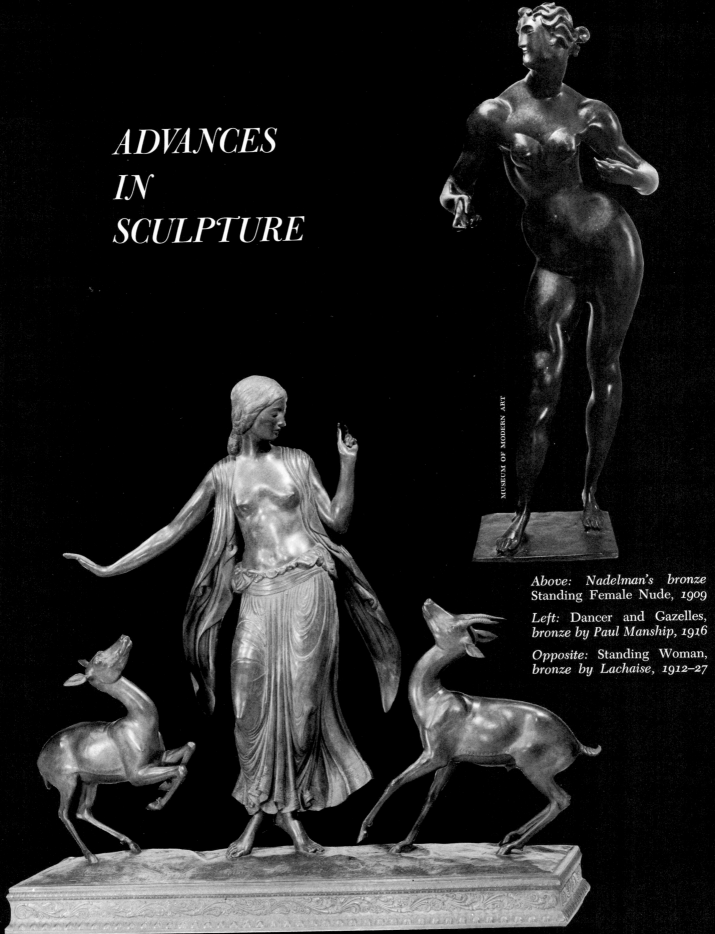

ADVANCES IN SCULPTURE

Above: Nadelman's bronze Standing Female Nude, 1909

Left: Dancer and Gazelles, bronze by Paul Manship, 1916

Opposite: Standing Woman, bronze by Lachaise, 1912–27

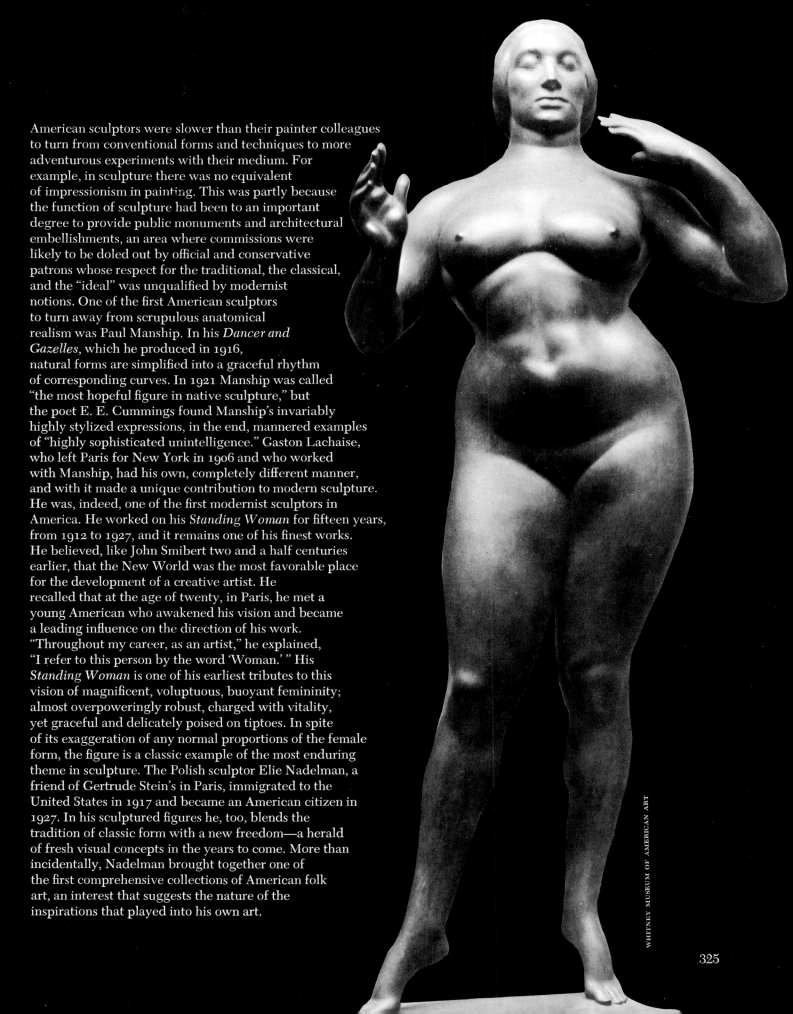

American sculptors were slower than their painter colleagues to turn from conventional forms and techniques to more adventurous experiments with their medium. For example, in sculpture there was no equivalent of impressionism in painting. This was partly because the function of sculpture had been to an important degree to provide public monuments and architectural embellishments, an area where commissions were likely to be doled out by official and conservative patrons whose respect for the traditional, the classical, and the "ideal" was unqualified by modernist notions. One of the first American sculptors to turn away from scrupulous anatomical realism was Paul Manship. In his *Dancer and Gazelles*, which he produced in 1916, natural forms are simplified into a graceful rhythm of corresponding curves. In 1921 Manship was called "the most hopeful figure in native sculpture," but the poet E. E. Cummings found Manship's invariably highly stylized expressions, in the end, mannered examples of "highly sophisticated unintelligence." Gaston Lachaise, who left Paris for New York in 1906 and who worked with Manship, had his own, completely different manner, and with it made a unique contribution to modern sculpture. He was, indeed, one of the first modernist sculptors in America. He worked on his *Standing Woman* for fifteen years, from 1912 to 1927, and it remains one of his finest works. He believed, like John Smibert two and a half centuries earlier, that the New World was the most favorable place for the development of a creative artist. He recalled that at the age of twenty, in Paris, he met a young American who awakened his vision and became a leading influence on the direction of his work. "Throughout my career, as an artist," he explained, "I refer to this person by the word 'Woman.' " His *Standing Woman* is one of his earliest tributes to this vision of magnificent, voluptuous, buoyant femininity; almost overpoweringly robust, charged with vitality, yet graceful and delicately poised on tiptoes. In spite of its exaggeration of any normal proportions of the female form, the figure is a classic example of the most enduring theme in sculpture. The Polish sculptor Elie Nadelman, a friend of Gertrude Stein's in Paris, immigrated to the United States in 1917 and became an American citizen in 1927. In his sculptured figures he, too, blends the tradition of classic form with a new freedom—a herald of fresh visual concepts in the years to come. More than incidentally, Nadelman brought together one of the first comprehensive collections of American folk art, an interest that suggests the nature of the inspirations that played into his own art.

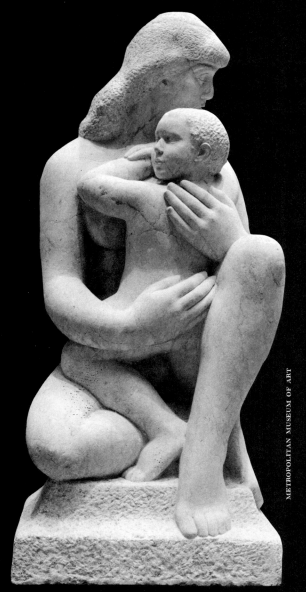

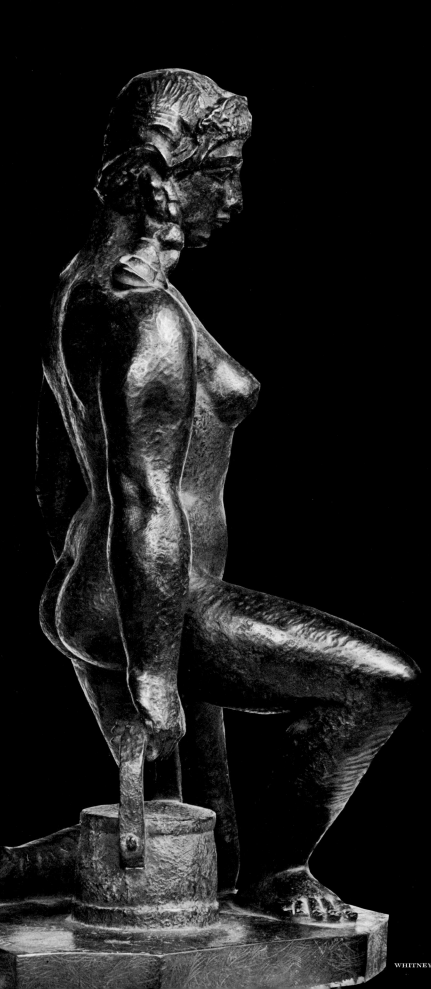

Above: Mother and Child, *carved directly in the stone by William Zorach in the years 1927–30*

Left: Kneeling Figure, *bronze by Laurent, 1935*

Opposite, right: The Cloud, *greenstone figure carved directly in the stone by de Creeft, 1939*

Opposite, far right: Daboa, *an African dancing girl, bronze by Malvina Hoffman, modeled in 1931*

A number of factors contributed to the new freedom in sculpture that
developed over the second quarter of the twentieth century. One was the
dilution of the classical tradition by an increasing awareness of the arts
of other lands and other times than those of ancient Greece and Rome.
"I owe most to the great periods of primitive carving in the past," remarked
William Zorach, a Lithuanian who came to America at the age of four,
"not to the moderns or to the classical Greeks, but to the Africans, the
Persians, the Mesopotamians, the archaic Greeks and of course to the
Egyptians." Another factor was a growing tendency of the sculptors to
work their materials directly, from start to finish, instead of depending
on hired handicraftsmen to chisel or cast their models into final shape.
Zorach's *Mother and Child* was carved directly from stone. José de Creeft,
a Spaniard who lived in Paris for a quarter of a century before coming to
the United States in 1929, also worked directly with his chisel on the stone
of his choosing—and looked back to distant, exotic origins,
Oriental and pre-Columbian, for inspiration. Robert
Laurent came to America from France to add his talent to the
international flavor of the New York scene. His bronze, *Kneeling Figure*,
exploited the textures and structure inherent in that material; he also
worked in wood and alabaster. Malvina Hoffman's *Daboa* represents a
dancing girl of the Sara people of Lake Chad district, Africa. It is a study
for a life-size bronze in a series of ethnological types by the artist.

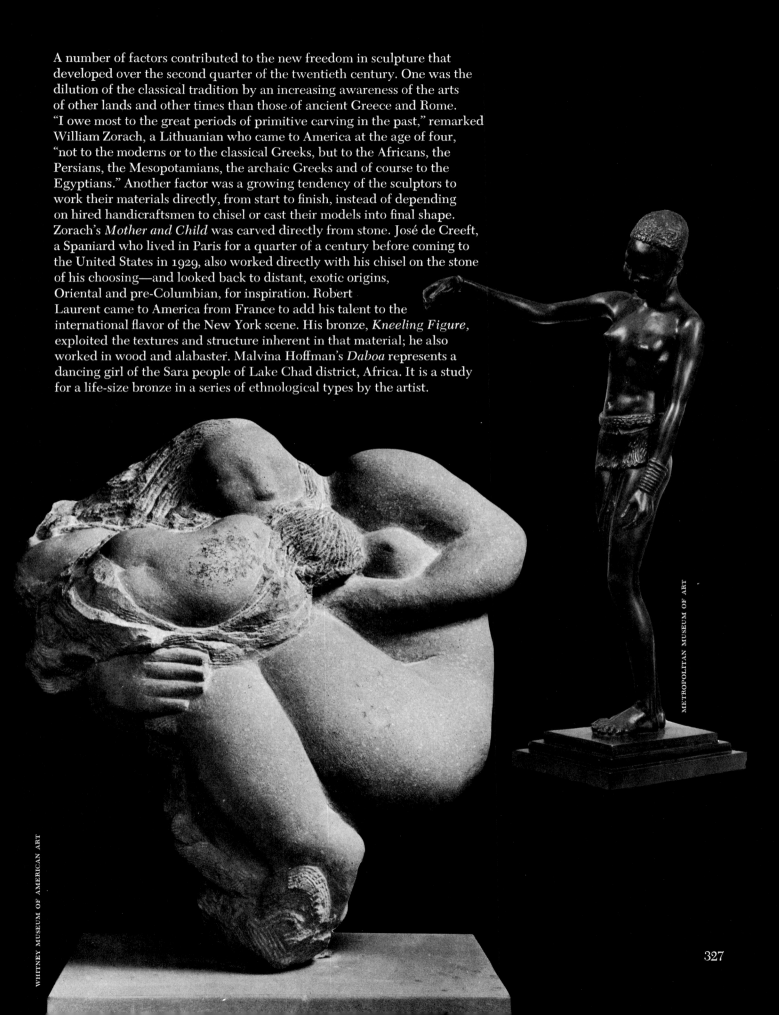

327

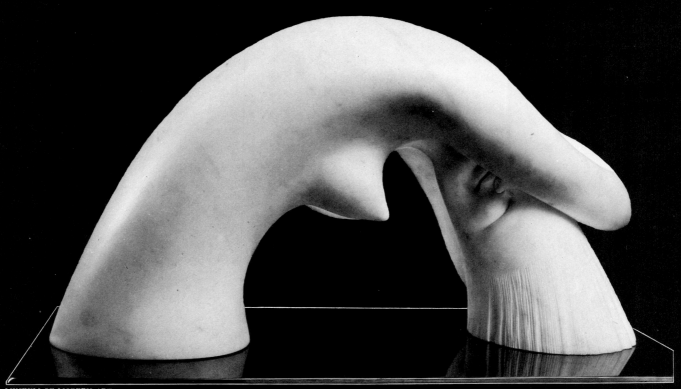

Above: Girl Washing Her Hair, *marble, by Robus, 1940*

Below: Torso in Space, *a figure made of metalized terra cotta and created by Alexander Archipenko in 1936*

Opposite, right: John B. Flanagan's Jonah and the Whale, *made of colored and textured stone in 1937*

Opposite, far right: Seated Gendarme, *a bronze figure in the cubist style made by John Storrs in the year 1925*

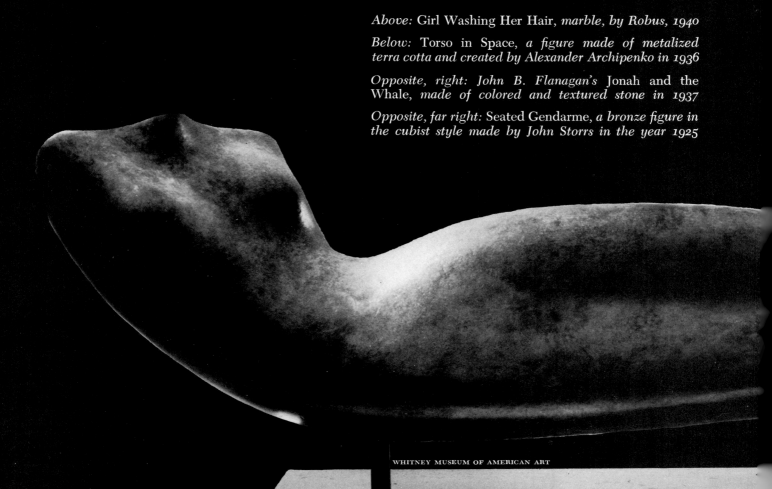

For American sculpture the generation between the two world wars was a period of tension between the established academic tradition and the new liberal trends that were gathering force with the passing years and that were preparing the ground for radical developments following World War II. As already demonstrated in the last several pages, portraiture was losing much of its old importance, and there was a noticeable simplification and abstraction of natural forms in the work of the most significant artists. In *Torso in Space* by the Russian-born Alexander Archipenko, who had sent his sculptures from Europe to the Armory Show but who came to America only in 1923, the female figure is reduced to a sleek, rhythmic curved object, much closer to pure form than to an anatomical rendering. Archipenko was a masterful teacher whose influence in this country was profound. Hugo Robus' *Girl Washing Her Hair* is only barely more realistic and has a similar, simple grace—with a touch of humor. This and the sensuous contours of his forms relate the work of Robus to that of Elie Nadelman. John Storrs' *Seated Gendarme* is rather expressed in terms of planes and masses of cubistic inspiration. He lived much of his mature life in France, where he died in 1956 after having spent several years in a German concentration camp. John Flanagan once wrote that his aim was "to produce a sculpture . . . with such ease, freedom and simplicity that it hardly feels carved, but rather to have always been that way . . . often the design dictates the choice of stone because I like to have them appear as rocks left quite untouched—and natural." This aim he perfectly realized with his *Jonah and the Whale*.

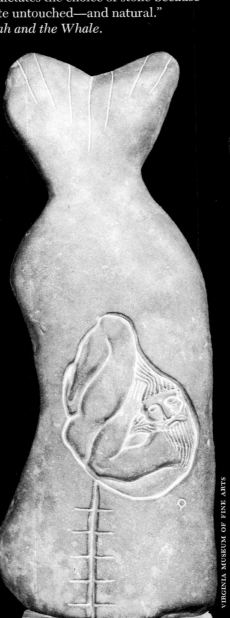

FURTHER ABSTRACTIONS

Above: Upper Deck, *a typical example of Charles Sheeler's work, painted in 1929*

Opposite: Georgia O'Keeffe's Cow Skull: Red, White, and Blue, *painted in 1931*

Thomas Hart Benton's repudiation of modernism and his return to traditional forms of representation was not a unique episode in the recent history of American art. As already remarked, Charles Burchfield also discarded what he termed his early "conventions for abstract thought" (he referred to that "period of degeneracy in my art that I have never been able to explain") for more conventional formulas— although later in life he again reversed himself toward the freer expression of his early years. Both men and others among their contemporaries actually demolished many of their own paintings to rid their minds and sight of those initial "mistakes." However, there were still others who continued to find in modernist trends a hope of future developments, a way of expressing new ways of thinking and feeling that would correspond to the onrushing progress of civilization. As early as 1909 Charles Sheeler, on his European journey with Morton Schamberg, discovered that the machine-made products of modern life were apt subjects for the artist, and over the remaining many years of his life his precise delineations of our man-made environment—the clean, stark, geometric patterns of industrial productions and the angular lights and shadows they create—constituted a major part of his work. (He was also attracted to the equally trim and spare forms produced by Shaker craftsmen and builders.) His painting *Upper Deck* epitomized his intention to paint a subject that had "the structural design implied in abstraction" but that was also presented through the most explicit realistic detail. Georgia O'Keeffe typically chose rather to picture natural forms, but stated in equally precise terms, although in richer colors than Sheeler's subdued palette. Many of her earlier subjects are flowers and details of flowers blown up to heroic proportions. "I'll make them big like the huge buildings going up," she stated. "People will be startled; they'll have to look at them. . . ." And people did. When she moved to New Mexico in the late twenties she began her discovery of new forms to paint in that sun-drenched desert landscape. Her depiction of a dessicated cow's skull placed against an abstract red, white, and blue background is a startling symbol of her attachment to her homeland in the Southwest. In essence, O'Keeffe's style has not changed over the years, although her work became increasingly monumental. She has remained always a staunchly independent individualist.

Patrick Henry Bruce, who with Max Weber had
studied with Matisse in Paris, was another
artist who destroyed most of his own creations.
However, until he gave up painting altogether
in 1932, he remained a confirmed modernist who
tried with agonizing earnestness and daring
improvisation to integrate geometrical, three-
dimensional forms and pure rectangles on the
flat plane of his canvas, using black and
white as colors in themselves rather than as
shading to augment the structure of his
compositions. He was deadly serious in his
efforts. When he thought he had failed, he took
his own life, in 1937, at the age of fifty-six.
Charles Demuth, whose early work has already
been noted (see page 293), was another persistent
modernist whose mature career lasted barely
twenty years. In 1928 he painted *I Saw the
Figure 5 in Gold,* one of his outstanding works,
dedicated to his dear friend, the poet William
Carlos Williams and inspired by one of his poems.
Williams wrote the artist that he thought
it the most distinguished American painting he had
seen in years. "I enjoy it for five or six
distinct reasons," he observed, "color, composition,
clarity, thought, emotional force, ingenuity—
and completeness." Stuart Davis, another highly
individual artist, knew Demuth, and his early work
was very probably influenced by the flat, hard-edged
forms in Demuth's paintings. In *Lucky Strike,*
painted in 1921 when Davis was still in his twenties,
he based its abstract arrangement on the label
of a cigarette package, using numbers and letters
as elements of the pattern. It was one of the
earliest experimental efforts to integrate aspects
of popular, commercial culture with the fine arts.

Above: I Saw the Figure 5 in Gold,
painted by Charles Demuth in 1928

Right: Painting, *by Patrick Bruce, 1930*

Opposite: Lucky Strike, *by Davis, 1921*

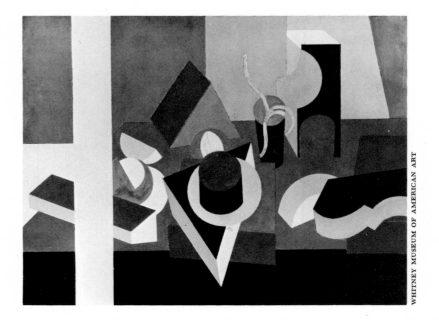

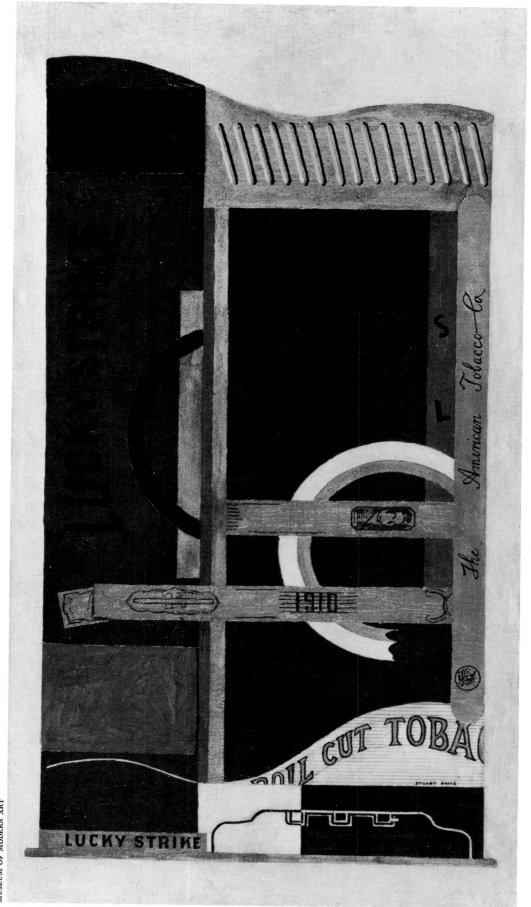

333

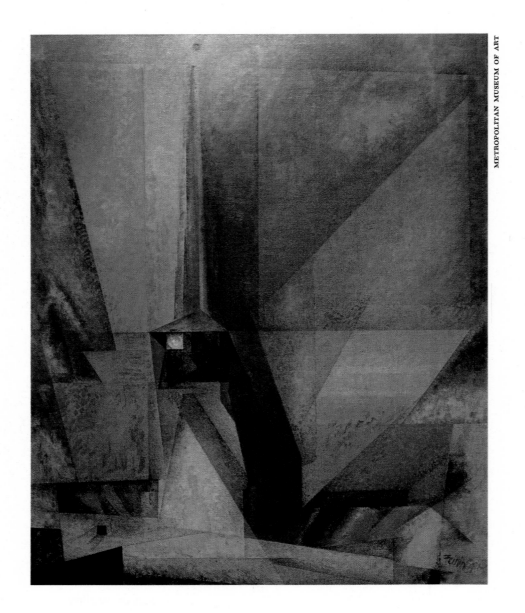

It is difficult and often unrewarding to attempt to fit the varieties of American modernist art into neat categories that relate them to the several advanced schools of French painting to which, nevertheless, they were more or less deeply indebted. Although Lyonel Feininger was born in New York in 1871, he spent some fifty years of his mature life in Germany, returning permanently to the United States only in 1937. He also worked in Paris, and while he was an American painter, he was at the same time an internationalist. The prismatic breakdown of light and color in his *Church at Gelmeroda* defines the spired building at the center of the otherwise abstract, angular composition in a manner that is typical of his sensitive style. Around 1939 Bradley Walker Tomlin, another fastidious artist, began experimenting with cubistlike patterns on which he superimposed illusive, surrealist images of natural forms. This free blending of styles characterizes a significant portion of American modernist art. Tomlin was an incurable experimenter and went on in the 1940's to become a leading abstract expressionist. In her *Paris,* painted in 1949, Loren MacIver presents a panoramic view of that city as seen through an unreal but highly poetic mist of shimmering color. In other painting she has used related techniques in more abstract but still suggestive views of city life.

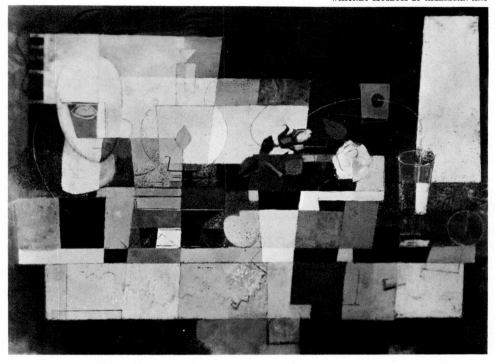

Opposite: Church at Gelmeroda, *by Lyonel Feininger, painted about 1936*

Right: Still Life, *by Tomlin, 1939*

Below: Loren MacIver's Paris, *1949*

In 1934 Mark Tobey returned to Seattle from a visit to Shanghai and Japan (where he had studied Oriental calligraphy and brushwork), convinced that the artist must know both worlds, East and West. He evolved a style he called "white writing" as one effort to bridge the gap between the two disparate cultures—a style in which his light lines are woven across the darker canvas like some sort of indecipherable calligraphic exercise. Tobey called the Japanese aesthetic a matter of hidden beauty; "that which doesn't look like anything, but in time discloses its jewels"—a statement he no doubt considered relevant to his white writing. In the progression of modernism this so-called free-form abstraction was, in general, the successor of the more geometric composition of earlier modernists. Kenneth Callahan, a disciple of Tobey's, is a native of the Northwest, and those two men, with numerous other artists working in that area, represent what can be considered a distinctive regional school of painting, although their individual styles are clearly different. Callahan's aim in his painting, he once stated, was "to project an idea of the mass of humanity evolving into and out of nature. . . ." In his *Revolving World* a swarm of individual forms seems to whirl through space and life in endless and almost violent evolution. Morris Graves, another Northwesterner, has undoubtedly also been influenced by Tobey, as well as by his own studies in Zen Buddhism and of Oriental art. There is mystery and magic in his depictions of strange, unreal birds—"spirit" birds—which seem sad or wry, depending on the viewer.

Above: Transit, *tempera on board, by Mark Tobey, 1948—an example of white writing*

Opposite, top: Revolving World, *a gouache on paper, painted by Kenneth Callahan in 1944*

Opposite, bottom: Morris Graves' Bird in the Spirit, *a gouache on paper, painted in 1943*

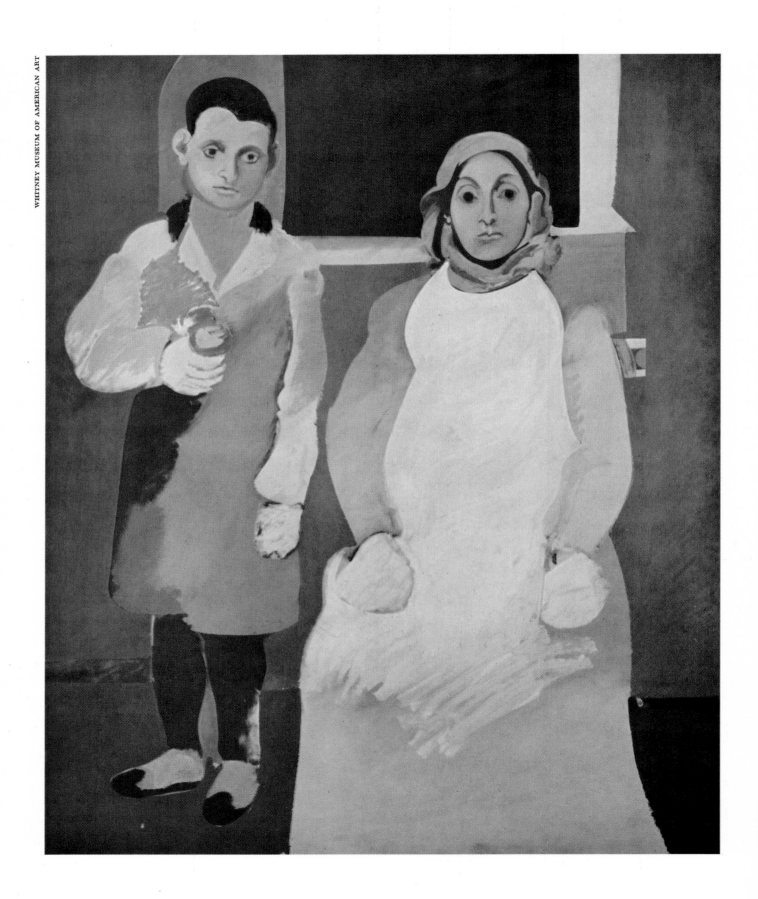

The growing interest in more abstract and nonobjective art led to fresh adventures among artists who, however strongly they were influenced by such developments, still looked to the natural world for their basic subjects and models. Until his death at the age of seventy-two in 1965, Milton Clark Avery remained concerned with representing the human figure. He retained recognizable images in his work, but reduced them to depersonalized flat patterns of color, outlined in sharp, rhythmic contours. Long before he made his first trip to Europe in 1952, Avery was responsible for reminding his American contemporaries of the precedents in such simplified color compositions as Matisse had introduced in France some years earlier. Avery's *Seated Girl with Dog* is such a re-creation of a real image abstracted into simplified shapes, clean lines, and expressive colors. As in his other paintings, landscapes as well as human figures, he here presents an aspect of the familiar world in such stark, decisive, and—withal—agreeable terms that we are prompted to look about us with a fresh eye of our own to find equivalents in our daily, living experience to furnish our mind's eye; an experience in which the accidents of a situation can be eliminated and the meaningful structure of life remains. In the troublesome aftermath of World War II that quest had a peculiar poignancy, which it has by no means lost. One of the basic problems of artists has always been to find and represent basic truths that lie beneath the superficial appearance of things—to enrich the spirit by revealing and emphasizing those underlying values. In a fashion somewhat related to Avery's work, in 1929 Arshile Gorky completed a more or less abstract likeness of himself and his mother, based on a photograph taken when he as a boy in Armenia (he was born Vosdanig Manoon Adoian)—and probably also based on an earlier work by Picasso. Subsequently, Gorky completely freed his painting of any imitative strains, as in the picture reproduced below, and from this freedom evolved a revolutionary style that constituted one of the first major American contributions to modernist world art.

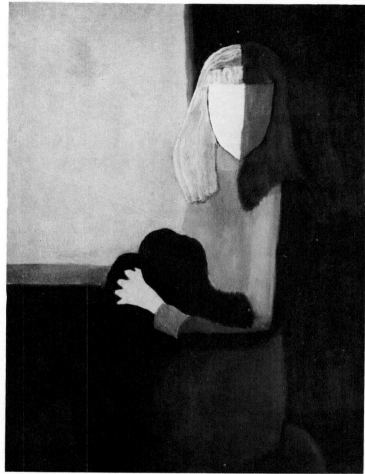

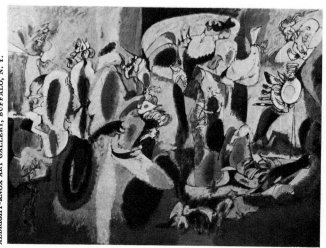

Above: Avery's Seated Girl with Dog, *1944*

Left: The Liver is the Cock's Comb, *painted with freely invented forms by Gorky in 1944*

Opposite: The Artist and His Mother, *a retrospective painting by Arshile Gorky, 1926–29*

339

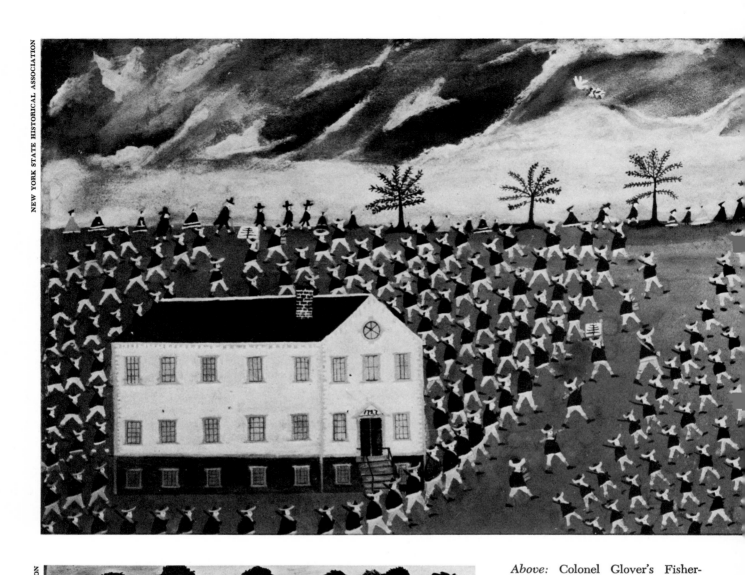

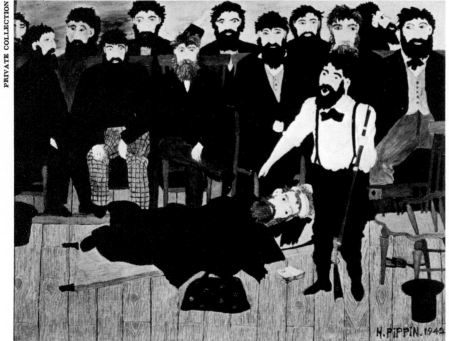

Above: Colonel Glover's Fishermen Leaving Marblehead for Cambridge *during the Revolution, painted by J. O. J. Frost in the 1920's*

Left: Horace Pippin's moving portrayal of John Brown's trial

Opposite: Fountain with Peacocks, *carved by John Scholl about 1910*

340

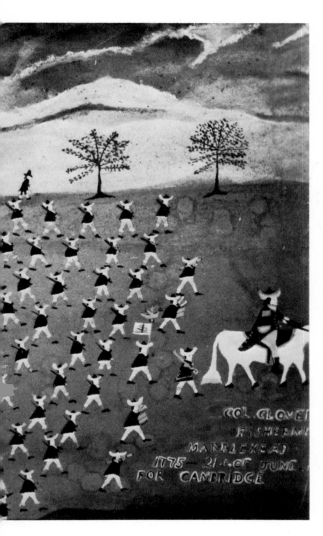

INNOCENTS AT HOME

Alongside the highly sophisticated art forms of the twentieth century, an abiding folk art tradition has persisted in pockets of the nation that have been isolated by geographic, economic, or ethnic factors. Like their predecessors, contemporary folk artists are mainly self-taught. Their work, however, poses solutions to problems that are more varied and exhibits a wider range of expression than anything known to their forebears. Many of these imaginative individuals have taken up brush and paint in their spare time, while others, recalling nostalgic memories, have begun their artistic activity in the leisure of old age. John Scholl of Germania, Pennsylvania, for instance, put aside his farming and carpentry at the age of eighty and devoted the last decade of his life to creating intricate woodcarvings that display such traditional Pennsylvania Dutch symbols as tulips, birds, and hex patterns in a late-Victorian context. Similarly, John O. J. Frost of Marblehead, Massachusetts, began working with ordinary house paints on scraps of pine or wall board in his late sixties. Although suffering from anemia so severe that it caused his fingers to bleed, Frost managed, before he died, to leave a colorful, accurate (he included names and dates), and dramatic record of Marblehead's past. American history also stimulated the Negro Horace Pippin. Several paintings depicting the life of John Brown, in their sympathetic execution and stark simplicity, represent Pippin at his finest. Pippin's belief that "to me it seems impossible for another to teach one of Art" might well apply to all self-taught artists.

341

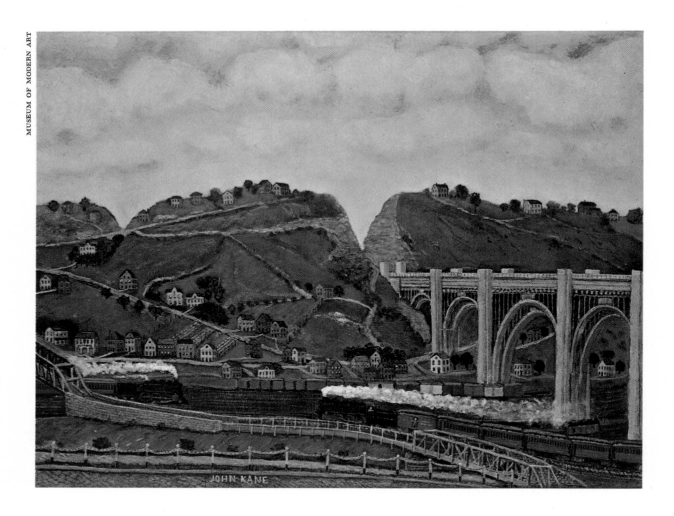

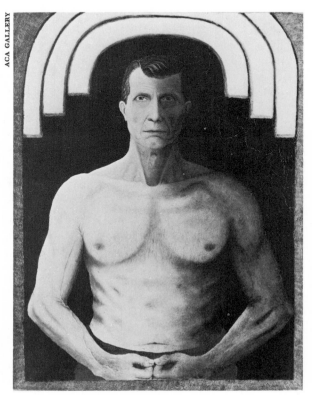

For all its primitive aspects, contemporary folk art is nevertheless a reflection of its age. The vast changes wrought by science and industry upon the American landscape could not help but influence our self-taught artists. Even in the rural reaches of New Hope, Pennsylvania, the painter Joseph Pickett observed the encroachments of the railroad and factory upon the countryside. In his *Manchester Valley*, for example, only the train, multistoried factories, and forty-eight-star flag betray the fact that the scene is not of the Revolutionary period. John Kane in his canvases conveyed the wonder and raw power of the industrial cityscape. The Scottish-born immigrant had settled in Pittsburgh and had pursued a varied career as a miner, steelworker, construction gang foreman, and housepainter. Kane had taught himself to paint on the sides of steel freight cars. He took particular pride in his adopted city and repeatedly painted the epic of its industrial expansion. As he explained his choice of subject matter, "I have been asked why I am particularly interested in painting Pittsburgh. Her mills with their plumes of smoke, her high hills and deep valleys and winding rivers. . . . The city is my own. I have worked on all parts of it, in building the blast furnaces and then in the mills and in paving the tracks . . . the bridges that span the river. . . . Why shouldn't I want to set them down when they are to some extent children of my labors."

Opposite, top: Turtle Creek Valley No. 1 (Westinghouse Bridge No. 1), *painted by John Kane about 1930*

Opposite, bottom: John Kane's self-portrait of 1929, in which he represents himself as a muscular laborer standing beneath an archway made of bent steel ingots

Below: Manchester Valley, *painted by Joseph Pickett*

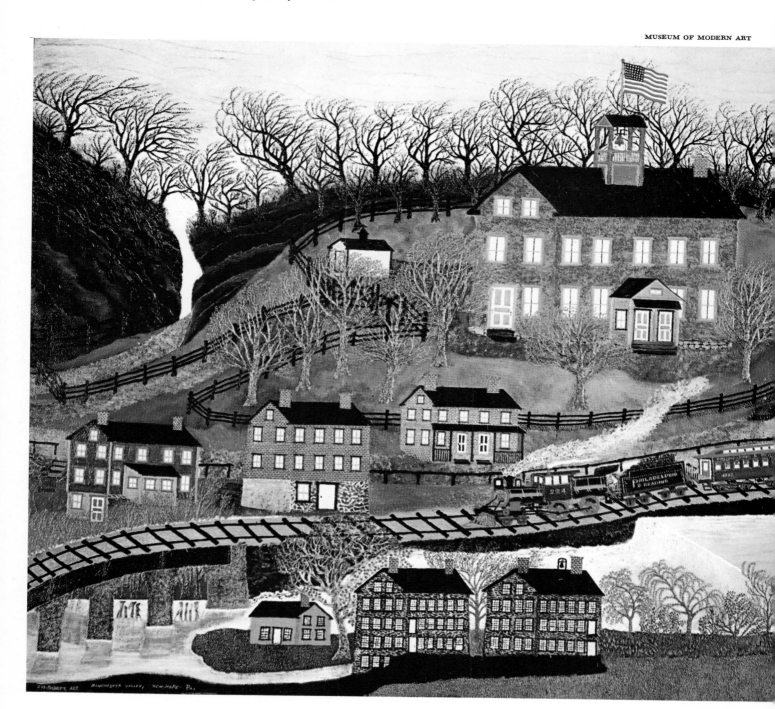

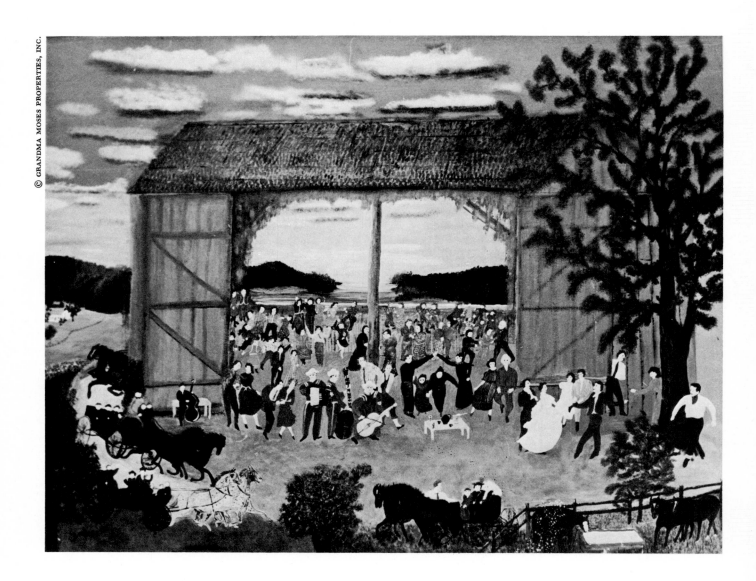

Of the scores of self-taught artists in modern America, only a handful have received
critical notice and public recognition during their lifetime. None has been as
spectacularly successful as the little farm widow from New York, Anna May Robertson
Moses, better known as "Grandma" Moses, who became the nation's most beloved and
most popular painter. At the time of her death in 1961 at a ripe one hundred and one,
virtually everybody possessed at least a second-hand familiarity with her engaging
New England landscapes, reproduced countless times in postcards, Christmas cards,
calendars, and prints. After raising a family and attending to the rigorous chores of
farm life, she began her artistic career at a sprightly seventy-seven. Finding needlework
"worsted pictures" to be too strenuous for her arthritic finger, she sent for Sears, Roebuck's
artist's supplies and busily set about producing more than a thousand oil paintings
in twenty-three years. A firm believer in the work ethic, Grandma Moses stated: "If I didn't
start painting, I would have raised chickens. . . . I would never sit back in a rocking chair
waiting for someone to help me." The paintings of another late bloomer, Clara McDonald
Williamson, evoke a nostalgic vision of life on the Texas prairie. "Aunt" Clara
referred to her "memory pictures" of events in the town of Iredell as "pretty and true,
but not sad." A third recently "discovered" artist, Morris Hirshfield of New York,
drew upon the world of fantasy for inspiration. A retired garment worker, Hirshfield
reveals his former vocation in such works as *The Tiger*, whose shape resembles a cut
pattern, the background and foliage simulating the textures of fine fabrics.

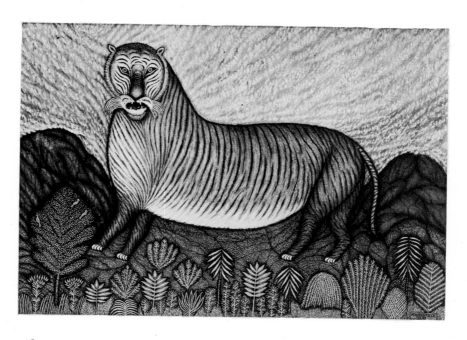

Above: a ferocious tiger, fancifully portrayed by M. Hirshfield in 1940
Opposite: an old-fashioned barn dance, painted by "Grandma" Moses, 1950
Below: "Aunt" Clara Williamson's painting, The Day the Bosque Froze Over

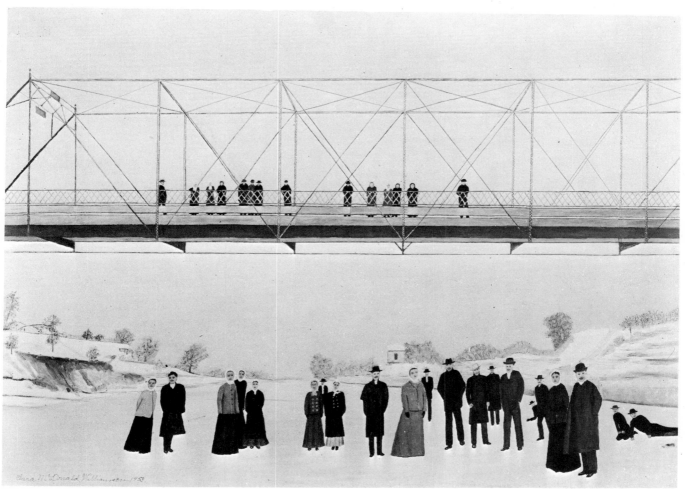

BOTH: MUSEUM OF MODERN ART

SOCIAL REALISM

For centuries past, in other lands, artists have used their brush to protest against the grimness of poverty and hunger, the horrors of war, and the miseries that stem from social injustice. It took the cataclysm of the first World War, the disillusionment that followed, and then the troubled years of the Great Depression to turn American painters toward themes of social criticism. By the middle of the 1930's such themes had become a dominant trend in American art, especially in the large cities. In no other land were artists so outspoken and persistent in pointing out what was wrong with their country, or left so free to do so, even though many were on the Federal payroll. In the 1930's strikes and violence on the labor front called sharp attention to serious imbalances in the nation's economic structure. The adamant refusal of some steel companies to recognize unionized labor led to numerous sanguinary conflicts. A violent outbreak occurred at the South Chicago plant of Republic Steel on Memorial Day, 1937, an occasion that was widely reported in news photographs. Philip Evergood's version of the bloody event, painted with more primitive force than sophisticated draftsmanship, shows in the foreground a defiant worker protecting his pregnant wife from the billies and pistols of charging policemen. Evergood, a New Yorker, attended Eton and Trinity Hall College, Cambridge, and studied in Paris and London as well as New York before joining the WPA Federal Art Project in the mid-thirties. His art takes different forms, but it is always concerned with life and people, and is expressed with strong convictions, albeit with an apparent naiveté that belies his richly cultivated background. His aim was to perform "the prodigious feat of combining art, modernity, and humanity."

American Tragedy, *Philip Evergood's version of an incident during the repression of a strike at a Republic Steel Co. plant on Memorial Day, 1937*

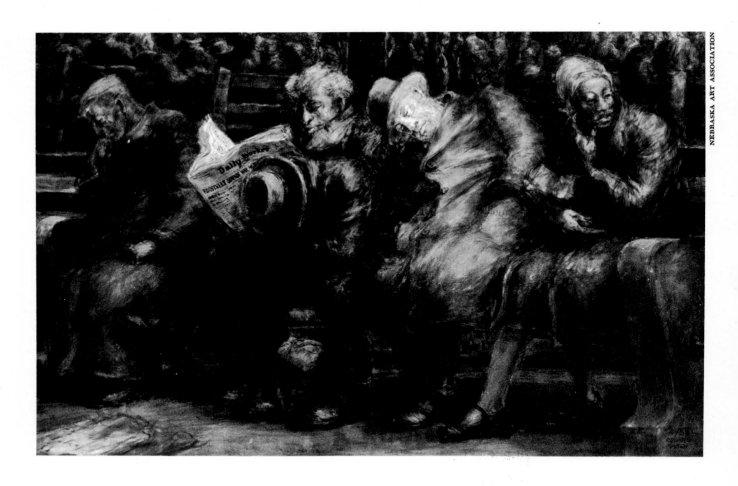

Above: Park Bench, *painted by Reginald Marsh in 1933*

Right: Raphael Soyer's Reading from Left to Right, *1936*

Opposite: Employment Agency *painted by Isaac Soyer, 1937*

Three and a half years after "the great timber cut of 1929," as one writer termed the stock market collapse, the economic plight of the nation remained grave. In his first inaugural address President Roosevelt pointed out that "the withered leaves of industrial enterprise lie on every side; farmers find no markets for their produce; the savings of many years in thousands of families are gone. More important, a host of unemployed citizens face the grim problem of existence, and an equally great number toil with little return. Only a foolish optimist can deny the dark realities of the moment." Evidence of what he referred to was at every hand. The bleakness of the soup and bread lines, the meager camaraderie of the down-and-out, the queues of the still hopeful at employment agencies, all suggested subjects to artists such as had not been common—or at least prominent as they now were—in American experience. Until the government lent a helping hand, artists in general shared the plight of the unfortunates and could easily enough understand the tragic drama being enacted about them, a drama underlined by the ironic fact that America was still a land of plenty. The brothers Raphael and Isaac Soyer, two of three artist sons of an immigrant Russian scholar who settled on New York's lower East Side, in their youth were familiar with poverty and could sympathize with the desperate realities of the thirties. "If the art of painting is to survive," Raphael Soyer observed, "it must describe and express people, their lives and their times." With his attentive eye constantly fixed on the city scene in all its aspects, Reginald Marsh could not avoid the seamier side of life that spread like an ugly, disfiguring stain during the Depression.

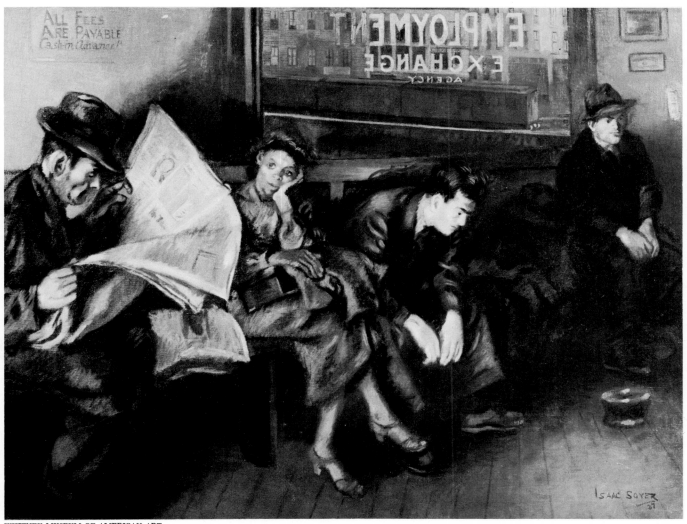

"I hate injustice," Ben Shahn once remarked. "I guess that's about the only thing I really do hate." His long series of commentaries on the trial and execution of Sacco and Vanzetti, painted in 1931 and 1932, brought him recognition as one of the most vehement and eloquent of the protest painters. *The Passion of Sacco and Vanzetti,* one painting in that series, shows the victims in their coffins, the committee appointed by President Lowell of Harvard to assess the evidence piously paying their last respects, and in the background the courthouse where the dramatic trial was held, with a portrait of the presiding judge. With the passing years the bitterness and despair of such paintings of the thirties changed to a more compassionate view of humanity's problems. Jack Levine's *Gangster Funeral,* painted in 1952–53, is less an indictment of criminality than a half-humorous, partly sardonic reflection on human frailty—skillfully rendered by one of the most accomplished figurative painters of his generation.

Opposite: Jack Levine's
Gangster Funeral, *painted in
1952–53, about twenty years
after Shahn's series, portrays
with wry humor and with
highly accomplished artistry
the dead gangster hero and
his admirers, who include
his wife and his mistress, a
policeman, and a politician.*

Right: The Passion of Sacco
and Vanzetti, *one of a series
of twenty-three paintings by
Ben Shahn based on the
theme of the trial and execu-
tion of the two philosophical
anarchists during the Com-
munist-baiting period of the
1920's. Shahn's distortion
and stylization of human
forms intensifies his charac-
terizations of the subjects.*

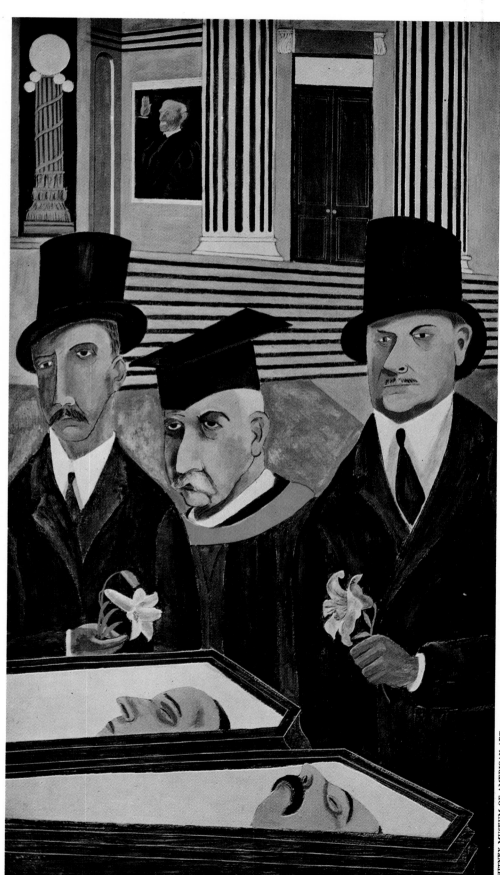

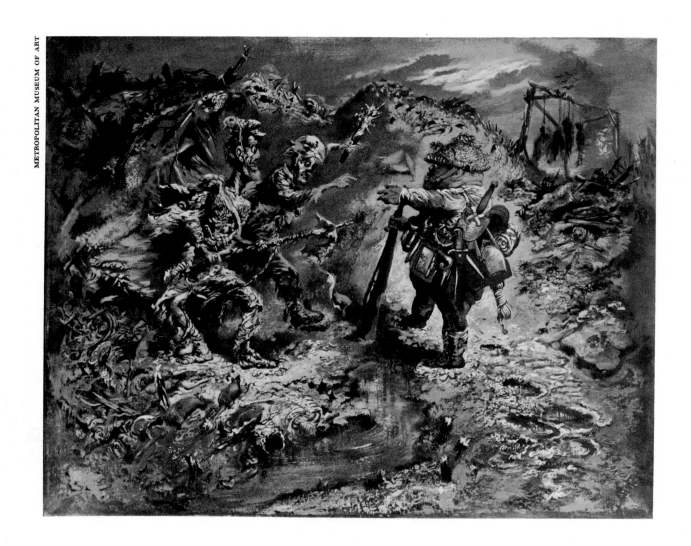

Above: The Ambassador of Good Will, *a satirical painting by Grosz*

Opposite: Air Raid, *by Hirsch, 1943*

In February, 1936, the first Artists' Congress was held in New York City. "We are gathered together tonight for the first time," said Lewis Mumford in an opening address, "partly because we are in the midst of what is plainly a world catastrophe." Hitler's Nazism was rapidly growing in power; Mussolini's Fascists had overrun Ethiopia; civil war was erupting in Spain with the bloodiest consequences— and in America the Depression continued its dreary course. All those developments, Mumford remarked, threatened the basic values of human culture. It was time "to protect, and guard, and if necessary, fight for the human heritage which we, as artists, embody." In 1932 George Grosz had fled to the United States from Germany, where his art was excoriated as Jewish and degenerate. He had served as infantryman in the German army in the first World War, and had savagely satirized the military and the bureaucracy, which he felt were responsible for that monstrous bloodletting. The fact that Grosz used humor with shocking precision to sharpen the horror of his commentaries made them even more frightful to behold. The next war provided further subjects for his mordant observations on human bestiality. In his *Air Raid* Joseph Hirsch pictured the agonizing suspense for those who watched the rain of bombs on helpless people. Just before the second World War erupted, Hirsch had won the popularity vote at the New York World's Fair "American Art Today" exhibition.

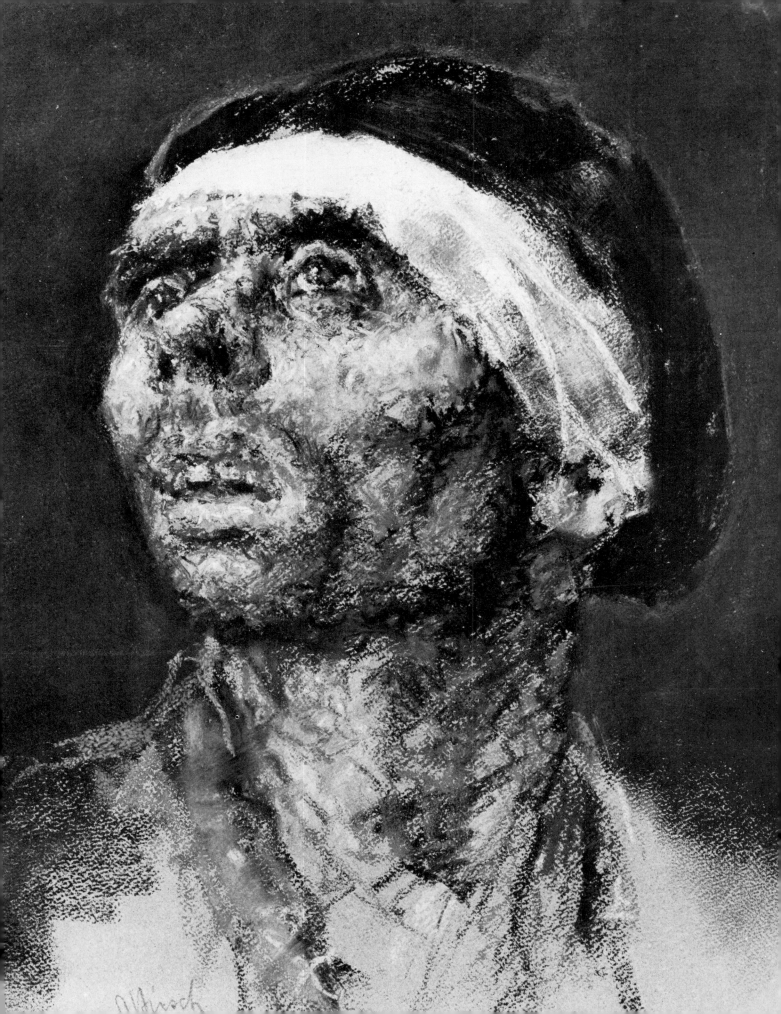

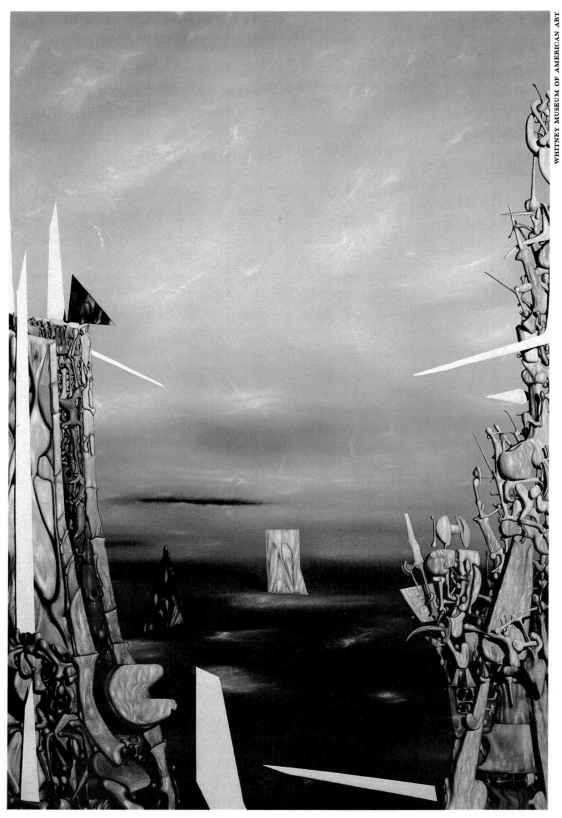

Above: Fear, *by Tanguy, 1949*

Opposite: The Balcony I, *by Kurt Seligmann, 1949–50*

SURREALIST IMAGES

Some four centuries before the "age of Freud" such Flemish painters as Hieronymus Bosch and Pieter Bruegel had projected their innermost fantasies in "diableries and hellscapes" where weird figments played unimaginable parts against implausible backgrounds. In the period between the two World Wars there was a passing effluence of such surrealism in modernist fashion—a fashion born in Paris in the 1920's and encouraged in America by the arrival here of such European refugee surrealists as Yves Tanguy, Kurt Seligmann, and others, and by the sporadic visits and exhibitions of Salvador Dali. It was a strange, abberant movement to have co-existed with the art of the regionalists and the social realists, and its popularity did not long endure. However, in its focus on the subconscious as a motivating force in art it had a fructifying influence on subsequent developments in American painting, as will be seen. Both Tanguy and Seligmann came to the United States in 1939 and made their home here. Tanguy's pictures suggest the landscape of some remote planet in outer space, studded with strange forms representing the fears and hopes that lurk in the deep caverns of the mind. The dreamlike character of such performances is emphasized by the precision and lucidity of the presentation. Seligmann's fantasies have a grotesque theatrical quality. His impulse to paint *The Balcony I,* he wrote, came when visitors gathered on the terrace of his studio. "Seen from below," he explained, "the upper part of their bodies appeared as silhouettes against the sky, reminding me of the various 'balcony scenes' of the masters of the past, of certain statues on churches in Italy, especially of San Michele in Lucca." In his compositions Seligmann transmutes the baroque sculpture of Italy into modern phantasmagorias which defy any reasonable interpretation but which haunt the mind with their suggestions of vaguely human associations.

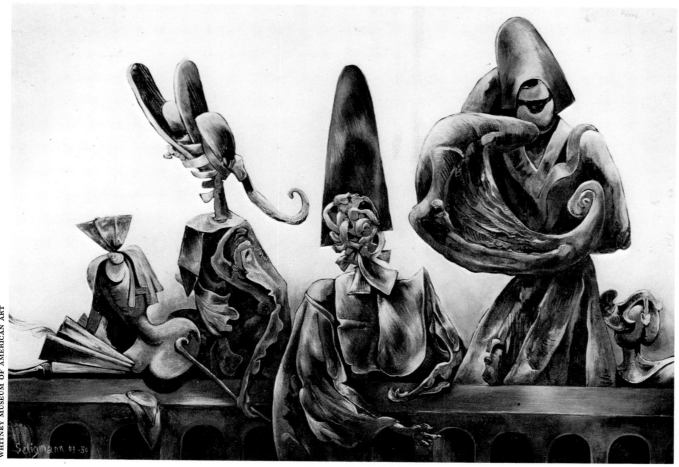

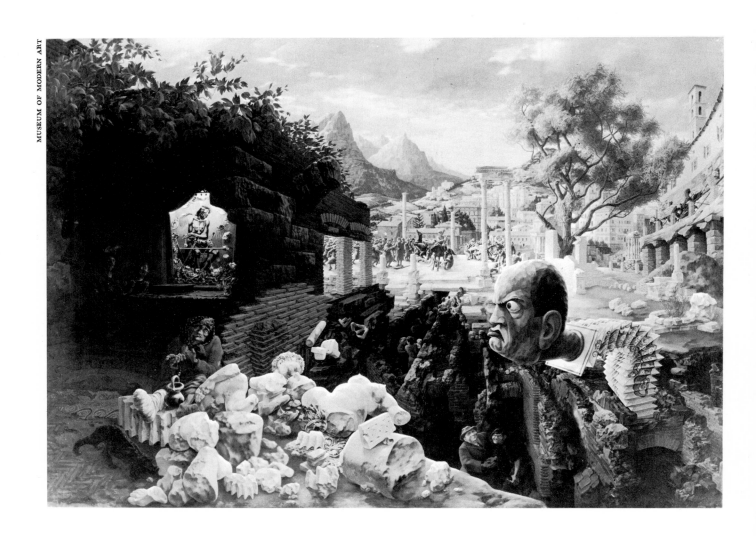

The Russian-born Pavel Tchelitchew came to the United States in the 1930's after
spending some years in surrealist circles in Paris. Like Grosz, Tanguy, and other
artist-refugees of the time, he became an American citizen. This influx of
foreign talent was to have important influences on the development of art in America.
Tchelitchew's *Hide-and-Seek* is an extraordinary combination of recognizable
human forms with tortured expressions and taut gestures, tangled in what could be
construed as a womb of cancerous membranes and blood vessels—and, incongruously,
an occasional plant form. Painted in 1940–42, it is the expression of an anguished
world warring within itself against the elemental fibres of humanity. Peter Blume
was also born in Russia, but came to America as a child in 1911 and had all his
art training here. There is nothing obscure about the message of his *Eternal
City,* a crisply delineated satire, as brilliant in its execution and far more
explicit than anything by Dali, in which a jack-in-the-box Mussolini pops up and out
amid the decayed and corrupted remnants of Rome's ancient glory and current despair.
Federico Castellón was one of the earliest followers of surrealism in this country.
In *The Dark Figure* distorted and dismembered but recognizable shapes torn from normal
contexts, are presented with the almost hallucinatory clarity of some vivid nightmare.

WHITNEY MUSEUM OF AMERICAN ART

Opposite: The Eternal City, *Peter Blume's satirical painting of life in Rome under Mussolini, done 1934–37*

Right: The Dark Figure, *painted by Federico Castéllon in 1938, represents a fusion of past and present imagery.*

Below: Pavel Tchelitchew's Hide-and-Seek, *painted 1940–42. Tchelitchew studied and painted in Kiev, Constantinople, Sofia, Berlin, and Paris; his work was first shown here in 1930.*

MUSEUM OF MODERN ART

Above: Henry Koerner's Vanity Fair, *painted in 1946*

Opposite, top: The Jacket, *painted by Perlin, 1951*

Opposite, bottom: Tooker's Government Bureau, *1956*

Surrealism was in a sense the successor of Dadaism, the art—
or antiart—celebrated notably by Marcel Duchamp, who preached
that the debacle of World War I had destroyed all established
values, aesthetic or moral, and left them meaningless. The
creed held that the only reality was in the imagination, and
this led its practitioner on excursions into unfrequented
chambers of the creative mind. It also led to experiments
in transposing the contents of those innermost, subconscious
provinces more or less directly onto canvas, as an almost
automatic process that by-passes the artist's conscious
awareness. Henry Koerner's *Vanity Fair* provides a panoramic
view of human and social relationships in all their varieties
and at all levels in a single fantastic composition of
bewildering connotations. In *The Jacket* Bernard Perlin
shows a limp, old, and shapeless coat against a variegated
natural background in which, with extraordinary technical
virtuosity, every leaf, pond, spike, and stem is painted in
realistic detail. The unexpected and unlikely contrast of the
formless, dark jacket and the luminous pattern of flora
invites the mind to poetic fancies. George Tooker paints
a different world in his *Government Bureau*, a world in which
depersonalized humanity confronts a faceless bureaucracy in a
bleak architectural setting. A good part of the impact of the
painting is in the stultifying repetitiousness of its presentation.

RENAISSANCE OF PRINTS

Above: Leonard Baskin's expressive wood engraving of 1957, Death of the Laureate

Below: untitled lithograph of 1965 from Jacob Landau's portfolio called Charades

Up until the last generation or so, printmaking in America was largely concerned with the reproduction of existing paintings or the illustration of books and magazines. Then, about the time of the second World War, a number of inventive artists turned to making prints that were creative expressions in their own right. Since they were produced in multiple copies, such original works of art were relatively inexpensive compared with the soaring prices of contemporary paintings; they thereby appealed to a wider, increasingly art-conscious public. There were ample historical precedents for original prints, to be sure, in the works of Rembrandt, Daumier, Whistler, Cassatt, and many others. But the innovative nature of much of the recent work and the growing interest in this field has constituted a renaissance of printmaking in this country. In addition to talented individuals who use both traditional and novel means to achieve highly personal effects, printmaking workshops like Atelier 17, run from 1940 to 1950 by Stanley William Hayter, in New York, and the lithography studio Tamarind, in Los Angeles, instruct artists and keep them abreast of the latest techniques. In general, contemporary prints feature the same freedom of expression that characterizes modern painting and employ virtually every color, material, and technique that can be used alone or in combination. Although lithography, etching, and other traditional methods continue to be popular, America's most valuable contribution to printmaking has been the development of serigraphy, or the silk-screen process, which facilitates the creation of more brilliant colors, larger editions, and larger size prints than ever before.

Above: Night Work, *color wood-cut, by Antonio Frasconi, 1952*

Above, right: Lasansky's My Boy, *color etching and wood engraving*

Below: silk screen entitled The Stove in My Studio on Broome Street, *by Clayton Pond, 1968*

Below, right: Gabor Peterdi's Dark Horizon, *using line etching, aqua tint, engraving, and stenciled color, created in 1954*

MODERN
REALISM

In spite of the persistent modernist dogma that a painting must *be* something
rather than be *about* something; that it should deal primarily in color values, textures,
and "significant" forms as such—or no forms at all; or that it should explore
the unreal rather than the real—in spite of all that, artists have continued to
paint such traditional subjects as the human figure, landscapes, and still lifes
with as much verve and technical competence as any of their abstractionist colleagues.
John Koch paints portraits and genre subjects in a meticulous, realistic style,
with an understanding use of light and atmospheric effects, that recalls the
art of the great seventeenth-century Dutch master Johannes Vermeer. The softly
but clearly defined still lifes of Walter Murch, as in *The Birthday,* owe as much
to traditional approaches to art as to the expressive innovations of modernism;
in short, *what* is represented is quite as important as *how* it is represented, which
keep these agreeable compositions happily within the mainstream of realistic
American painting. To transfer onto a small, flat canvas a convincing illusion of the
natural world in all its space and depth was considered, in the days before photography,
a particular form of magic. All the achievements of photography have not yet
eliminated that particular form of magic in the work of competent artists. It
could be said that good painting is to photography as a poem is to a report.
Although he is best known as a portraitist, in his landscape *Oxbow,* Alfred Leslie
(a second-generation abstract expressionist turned realist) has created a landscape
that rounds out and adds to our pleasure in much the same scene painted by Thomas
Cole more than one hundred thirty years earlier (see pages 102-103).

Above: self-portrait of John Koch at work in his New York apartment with his friends, painters Maurice Grosser and Robert Baker

Right: a preliminary study for The Birthday, *sketched by Walter Murch in 1963*

Opposite: Alfred Leslie's contemporary version of the oxbow of the Connecticut River

Andrew Wyeth's art denies the values of modernism. Although he paints to please himself, his acutely realistic paintings have come as close as those of any other modern painter to pleasing virtually everyone, from the very general public to discerning collectors and museum experts. The meticulously detailed imagery with which he presents his subjects, animate and inanimate, expresses timeless values with bewitching effect. Left, Christina's World, *painted in tempera,* 1948

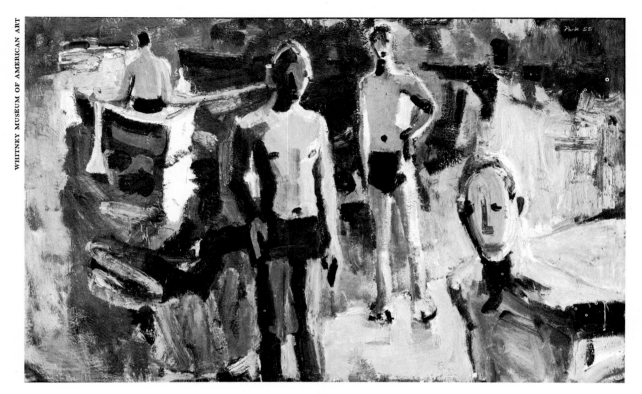

Above: David Park's Four Men, *painted in 1958*

Opposite: July, *painted by Richard Diebenkorn in 1957*

Below: Girl Wading, *painted by Elmer Bischoff, 1959*

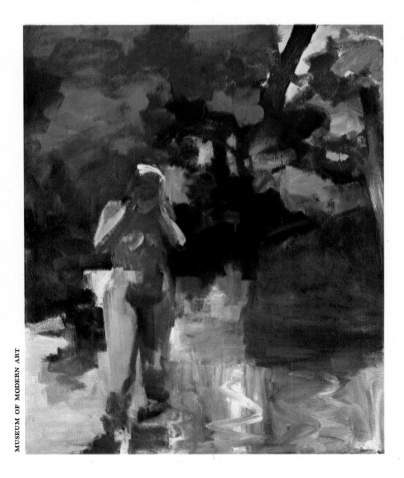

In the 1950's as in the 1920's a number of American artists turned away from abstractionism toward more representational painting (as Leslie and others were to do later). Three San Francisco painters— Elmer Bischoff, David Park, and Richard Diebenkorn— found new interest in landscape and the human figure, bringing to their work the bold and broad brushwork and the strong color of their earlier manner, and in doing so, creating a local or regional style with fresh, new outlooks—a style that attracted national attention. To counter the trend of abstractionism, at the time as strong and pervasive in the West as in the East, was in itself a startling achievement. Park was the first noteworthy artist to make the break, which he did quite abruptly in 1950. His friend Bischoff and then, importantly, Diebenkorn joined him in his defection from the prevailing fashion. It could hardly be said that they represented a "California school"; in their work they transcended the regional style, with its local and topical allusions, practiced by John Steuart Curry, Thomas Hart Benton, and Grant Wood in the Midwest a generation earlier. In their work also there is specific concern with form that is much more closely related to the tradition of Western painting than the semi-Oriental style of such Northwestern "regionalists" as Mark Tobey and Morris Graves.

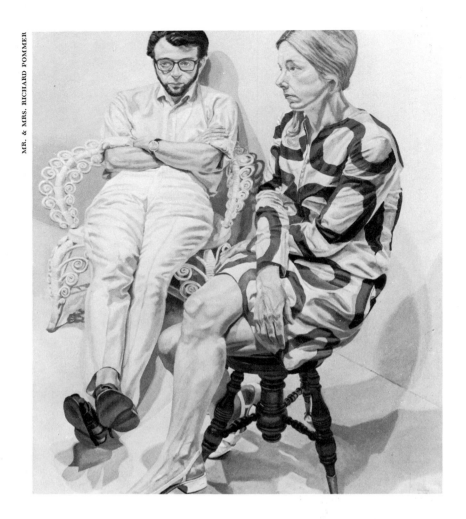

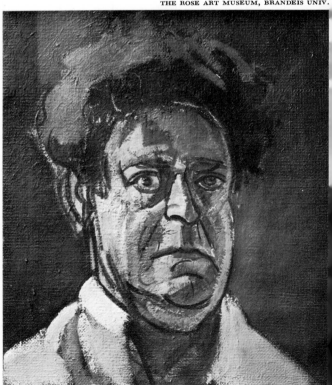

Left: portrait of Mr. and Mrs. Pommer (Linda Nochlin), painted by Philip Pearlstein in 1968

Below: Leland Bell's self-portrait, 1969–70

Opposite: The Sitter, by Larry Rivers, 1956

During the colonial period and in the subsequent decades American artists followed a consistent, more or less uniform style in their painting, according to the fashions of the period and their individual competence. In our own day, subjected to the influences of so many technical and conceptual developments in painting, realism has varied widely in its forms of expression. The insistence on individuality, originality, even novelty has made the art world an arena of sometimes bewildering varieties.

In spite of the strong temptations of abstractionism Larry Rivers has remained concerned with recognizable subject matter in his work. The fusion of realism and abstract expression characteristic of his painting, his skilled draftsmanship, and his use of thinly "washed," almost transparent oil colors are all apparent in his canvas *The Sitter*. Philip Pearlstein's portrait of Mr. and Mrs. Richard Pommer presents a far more explicit version of realism, with vigorous modeling and a muscular energy that, it seems, cannot quite be contained within the limits of the canvas. "I did not mean to become the kind of naive or modest painter of nice pictures the word realist leads some people to expect," he remarked. "I meant to create strong, aggressive paintings that would compete with the best of abstraction." Leland Bell's incisive self-portrait serves as a still quite different kind of reminder of the human concerns that abstractionism tended to exile from the arts.

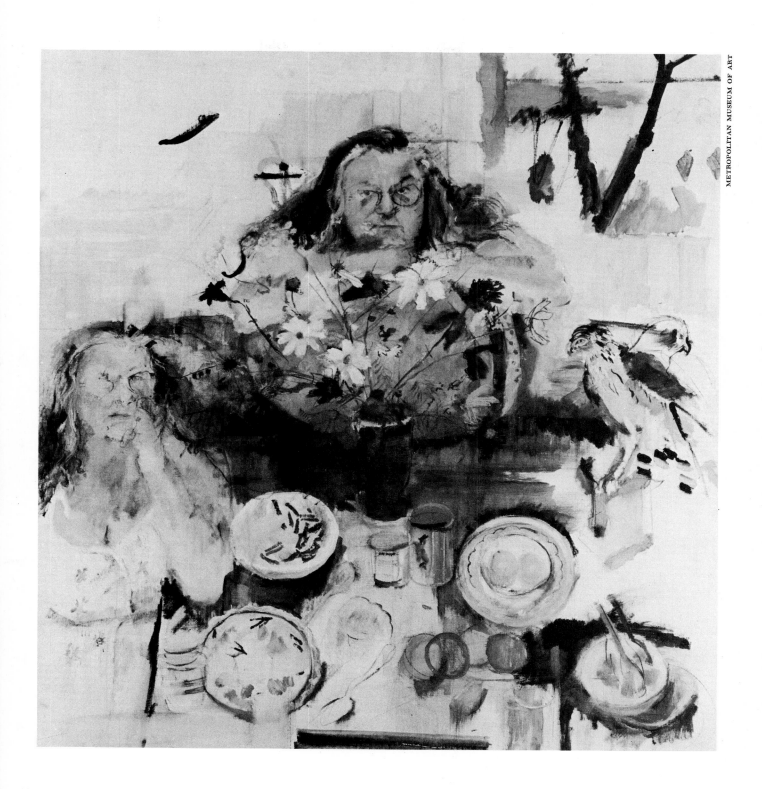

There is nothing new in modernism except its consciousness of its effort;

the truth it has forced us to rediscover is as old as art itself.

—SUZANNE LA FOLLETTE

NEW DIRECTIONS

Opposite, detail of Image Duplicator *(above), created in 1963 by Roy Lichtenstein*

While addressing the nation in his inaugural speech of 1965, Lyndon B. Johnson observed that Americans live "in a world where change and growth seem to tower beyond the control, and even the judgment of men." Although the president was alluding to the ever-escalating pace of social change in the United States, his remark might have been equally well directed to the state of contemporary art in this country. From the mid-1940's until the present day the body of work produced by American artists has been dominated by no single style, ideology, or aesthetic. Rather, the creative output of the last several decades has been in such a state of flux as it has never been before, with artists continually seeking out new modes of expression and perception, and with numerous, rapid, and often violent shifts in direction. Developments and changes that were formerly wrought over several decades, at least, now take place in a matter of seasons, and what the mass media hail as the latest trend one week, may be obsolete the next. The examples of abstract expressionism, color-field painting, pop and op art, and constructed and minimal sculpture on the following pages exemplify only a few of the many styles to be advanced in recent times. Concurrent with the abiding strains of objective realism and figuration long characterizing American art are trends that are extensions—and refinements— of cubism, surrealism, dadaism, and other styles formulated earlier. Other innovations attempt a total break with tradition and ostensibly explore uncharted territory. And, still other styles seem to be little more than catchy fads, concocted by publicity-hungry dealers and artists to captivate a public eager for novelty at any cost. Whether any, or all, or none of these various forms of expression are merely masquerading as modern art, or will have a genuine impact on the future course of art, only history will determine.

From ancient times until well into the twentieth century, the basic aim of art in the Western world has been to reduce the chaos of the universe to significant form. As Aristotle once stated, "In part art completes what nature cannot elaborate; and in part it imitates nature." Even such relatively recent groups as the cubists tried to impose order on the world about them. It was primarily as a result of the cataclysmic events surrounding World War II that artists began to revise their fundamental precepts and devise new approaches to their work that

would express the disorientation and anarchism of the age. These artists did not so much sever links with the past as attempt to restate earlier values in contemporary terms. The wholly new kinds of painting and sculpture to emerge out of the chaos of the postwar period were predominantly abstract and resolutely individualistic. Of these, abstract expressionism was an original and powerful style that during the 1950's catapulted America to leadership on the international art scene. The creative minds that produced the new art were highly eclectic. They tapped seemingly limitless resources—Freud, Jung, the artifacts of virtually every culture, Oriental philosophy, dreams, myths, legends, and various mental processes—for inspiration, and they experimented with a freedom virtually unprecedented. It was almost as if the artist had too many possibilities open to him. He now created any image whatsoever on unprimed canvas, metal, neon, or plastic, using ordinary wall-painting rollers, spray guns, or silk screens to apply synthetic or commercial house paints undiluted out of the can. In short, the elegant brushwork and other indications of patience and skill that have long been the artist's hallmark have gradually been eliminated in favor of semi-mechanical processes. Such revolutions in traditional values have led to a proliferation of unskilled people, of more or less merit, who might paint just about anything in just about any manner and call it art—sometimes deluding the public and potential patrons in the process. And, as a result of the new freedom, even the most outlandish sort of experiment was at least tolerated, if not comprehended, by an upwardly mobile society, desirous of ridding its self-image of any lingering traces of middle-class philistinism and of acquiring an instant patina of culture. Thus, the romantic concept of the avant-garde slowly died in a land where undiscriminating audiences supposedly accepted everything.

After 1960, traditional definitions of art as a disinterested endeavor have become increasingly obsolete. Of the various forms of expression to assert themselves during the decade, more and more represent kinds of art that defy categorization and that tend to be found outside, rather than displayed within, museums or old-fashioned gallery installations. A trend toward synthesis of the arts has constituted one of the major directions of the era. The happening, in which aspects of theatre, music, and dance are combined with characteristics derived from painting and sculpture, quickly captured the public imagination. As Allen Kaprow, one of the developers and leading spokesmen for this phenomenon, explained it, "A Happening, unlike a stage play, may occur in a supermarket, driving along a highway, under a pile of rags, and in a friend's kitchen, either at once or sequentially. If sequentially, time may extend to more than a year. The Happening is performed according to plan but without rehearsal, audience or repetition. It is art but seems closer to life." Mixed media presentations in which the senses were assaulted simultaneously by live action, sound, light, and motion pictures were great popular successes of the period. Kinetic art helped to minimize distinctions between painting and sculpture. Other forms of visual expression to flower in the 1960's ranged from the disciplined rationality of color-field abstraction, systemic, and minimal art to the intentional ambiguity of psychedelic art, which with its vibrant acid colors, bursts of bright light,

Above: Rafael Ferrer's Ice; *blocks melting into autumn leaves on the ramp of the Whitney Museum*

Below: Bruce Nauman is the human gargoyle in Portrait of the Artist as a Fountain, *conceived in 1966*

undulating lines, and surprise images, was produced under the influence of so-called "mind-expanding" drugs.

Today, despite the slight edge that abstract art holds in the American art arena, there exist concurrently many strong and diverting developments. On the one hand, there is a resurgence of figurative art as witnessed at recent exhibitions of sharp-focus realism and other post-pop styles. On the other hand, many artists practicing in the present day appear to embrace a philosophy of nihilism or anti-art, an ideology that traces its origins to dadaism and that attempts to discredit art as a high-minded pursuit. As one of the foremost practitioners of nihilism, the sculptor Robert Morris, remarked, "The static portable indoor art object can do no more than carry a decorative load that becomes increasingly uninteresting." To revivify the art object, nihilists like Morris tried to purge their art of all aesthetic content, and at one point Morris even issued "A Statement of Esthetic Withdrawal" before a notary public, in which "The Undersigned . . . hereby withdraws from said construction a sculpture entitled *Litanies* all aesthetic quality and content and declares that from the date thereof said construction has no quality and content." The trend toward the de-aesthetization of art calls for new materials that are appropriated from the real world, and that have customarily been used for nonartistic purposes. These include dirt, lumber, rocks, electric light bulbs, the residue of the junkyard, and even living children and animals. The diverse forms that nonart has taken differ mainly in the procedures used to bring the finished products into existence. A mountain covered with plastic, furrows plowed in a field, a square sheet of lead placed over a patch of snow, comprise a group of de-aesthetized art objects known as Earthworks. Another form of nonart is embodied in process art, in which either natural or man-made forces alter the original materials in some respect, an illustration of this being Robert Morris' exhibit of tree seedlings growing in a greenhouse at New York's Museum of Modern Art. Still other manifestations of nihilism include random art in which form and content are determined purely by chance, anti-form (*arte povera*) accretions of miscellaneous objects, and conceptual art in which the idea for a work is as, or even more important than the completed art object. More often than not, examples of the latter are accompanied by written explanations in order to facilitate the viewer's understanding. By attempting to eradicate the differences between art and life, and by causing the artist, in the traditional sense, to disappear from the scene, the nonartist, as the critic Harold Rosenberg puts it, tries to "restore to everyone full responsibility for his relationship with the world." Thus, every man becomes an artist, and the universe, one vast museum. Writes Rosenberg, "Instead of representing creative mysteries, the artist becomes a group leader. Collective projects, not the cultivation of individuals, are the aim, and it is sufficient that participants are kept cheerfully occupied." Although there are no final criteria for evaluating these latest manifestations of American art, perhaps the *New York Times* critic Hilton Kramer best summed up the contemporary situation: "This is what the victory of Dada has come to—established culture employing its resources in a vigorous effort to destroy itself."

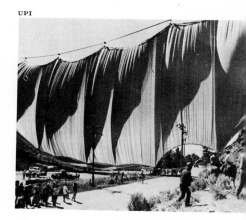

UPI

Christo's ephemeral $700,000 Valley Curtain that was strung across Rifle Gap, Colo. in August, 1972, twenty-four hours before its collapse

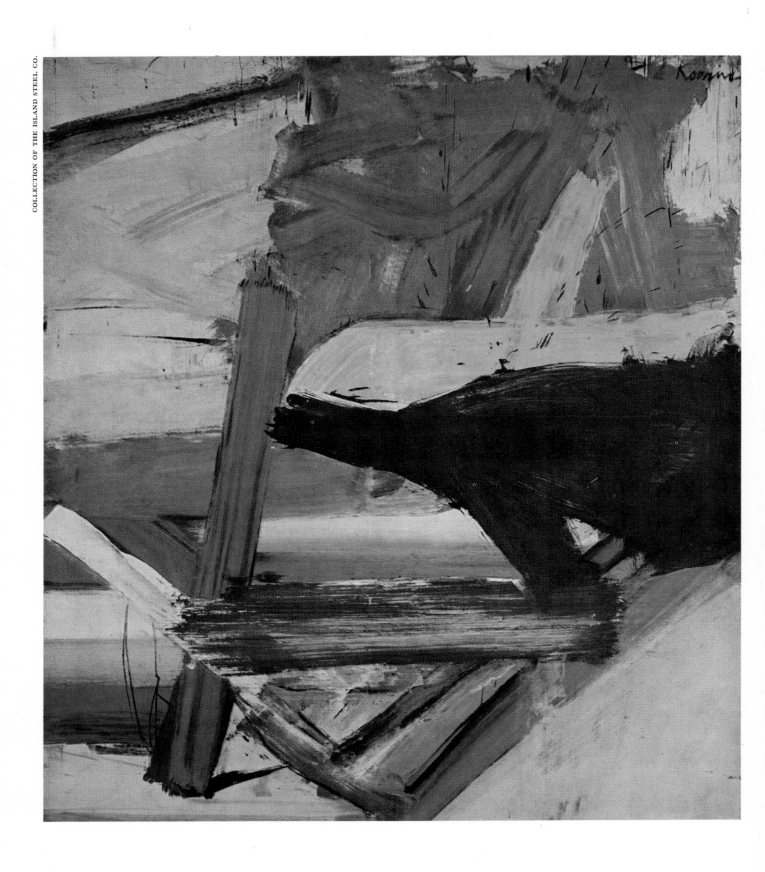

A SUBJECTIVE STYLE

Opposite: Bolton Landing, *painted by Willem de Kooning in 1957, and inspired by a visit to sculptor David Smith's vacation retreat of that name on Lake George*

Below: Hans Hofmann's Fantasia, *1943, revealing turbulent outbursts of color*

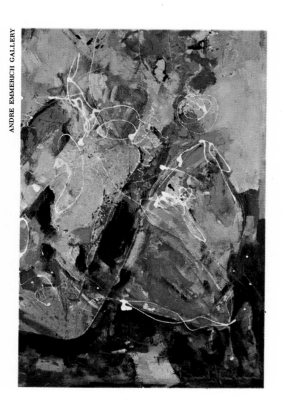

Amid the ferment created by World War II, a group of New York artists developed an original and dynamic concept of painting that, for the first time, placed Americans, rather than Europeans, at the forefront of the modern movement. Referred to variously as abstract expressionism, action painting, the New York school, or the new American painting, this style traces its origins specifically to the early abstractions and theories of Kandinski, the iconoclasm of the dadaists, and the automatic, unpremeditated work of the surrealists, as mentioned in the previous chapter. For all its European antecedents, however, abstract expressionism was at the same time an outgrowth of peculiarly American modes of thinking and feeling. Like contemporary existentialist writers in the United States, abstract expressionists of the 1940's regarded the condition of man as one of estrangement in an increasingly hostile world. Obsessed with the problem of personal freedom, and distrusting everything except immediately felt experience, these artists sought to elucidate the human predicament through an art, grounded in the spontaneous assertion of the individual. Although the manifestations of abstract expressionism are as diverse as the talented men and women who created it, its practitioners in general prided themselves in repudiating tradition, rejecting all systematic approaches to painting, and abandoning the objective image. According to Hans Hofmann, the principal theoretician of the new movement, the abstract expressionist strove to "present" the inner realm of the subconscious, rather than "represent" the outer world of known objects. Similarly, another pioneer of action painting, Jackson Pollock, wrote: "The source of my painting is the Unconscious. I am not much aware of what is taking place; it is only after that I see what I have done." In order to transmit intense emotions to canvas without specific allusion to visual reality, these artists painted as freely as their materials permitted. They literally threw themselves into their work, so that the act of creation itself became the subject of their art. With dramatic gestures of the brush, or even of sticks or brooms, they swirled and dribbled great splotches of color, forming agitated tangles of paint and rude juxtaposed shapes. Few artists have surpassed the Dutch-born Willem de Kooning in the aggressiveness with which he attacked the canvas. De Kooning believed that "Art never seems . . . to be peaceful or pure," and such paintings as *Bolton Landing* demonstrate how he conveyed sheer passion via brushwork and color. To be sure, the new American art was beyond the comprehension of many viewers, and critics predictably received action painting with epithets of "fraud" or worse. Nevertheless, by the 1950's, abstract expressionism had gained international acceptance. The majority of modernists could, by this time, agree with Jackson Pollock that "The modern painter cannot express his age, the airplane, the atom bomb, the radio, in the old forms of the renaissance or any other past culture."

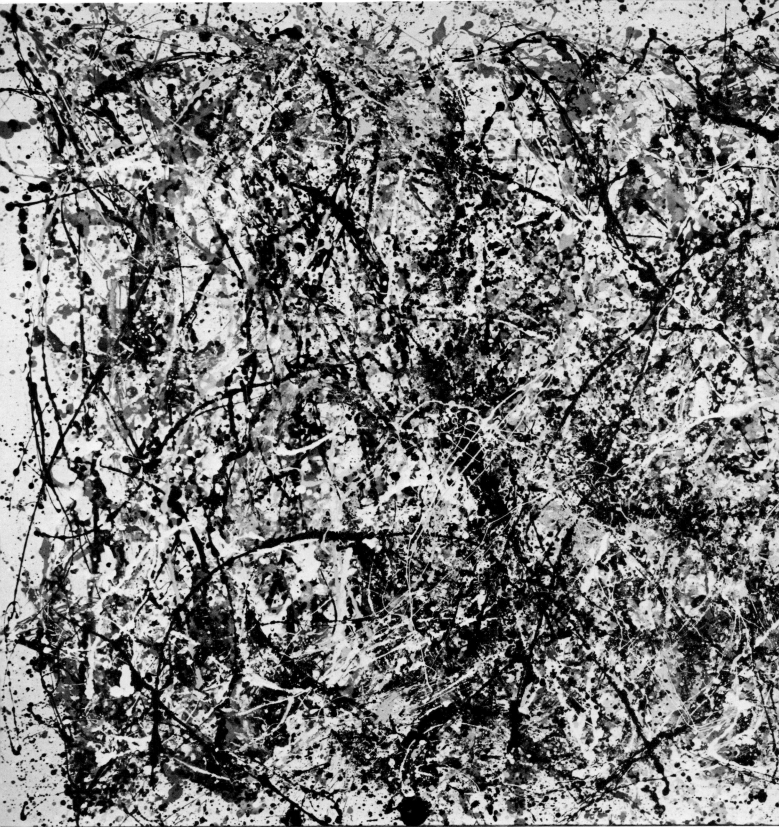

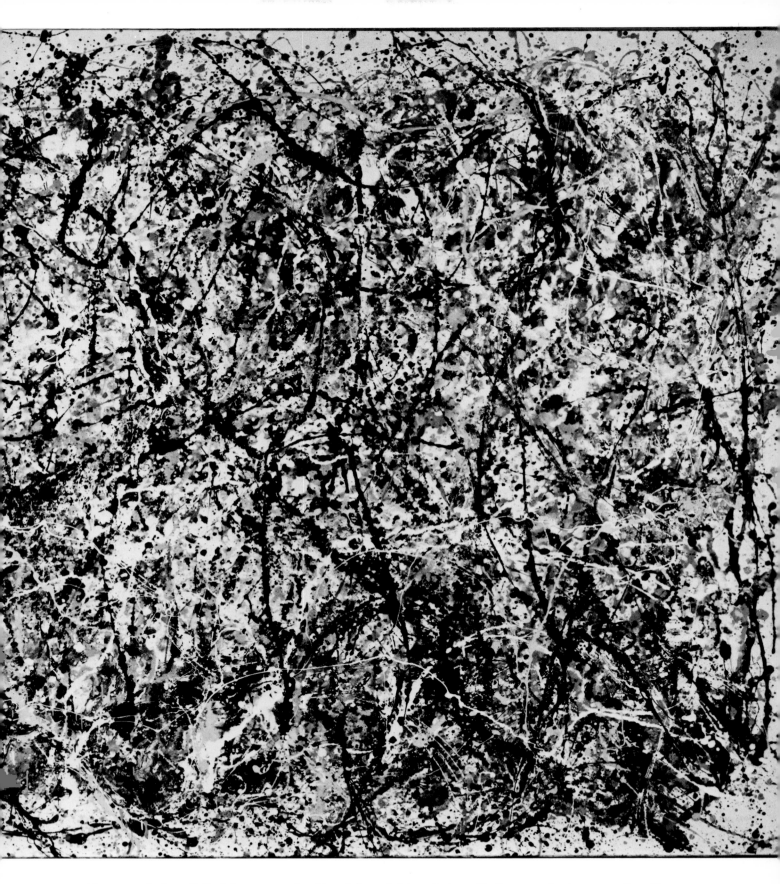

After 1947 Jackson Pollock began creating his celebrated drip paintings. He began such pictures as One, No. 31 *by stretching a heroic-sized canvas out on the floor. This way, the artist explained, he felt "nearer, more a part of the painting. . . . I can walk around it, work from the four sides and literally be in the painting." He then, according to impulse, dribbled strands of color across the vast space. Pollock observed, "I have no fears about making changes . . . because the painting has a life of its own. . . . It is only when I lose contact with the painting that the result is a mess. Otherwise there is pure harmony . . . and the painting comes out well."*

Soon after the action painters renounced traditional artistic conventions in favor of an imageless, intuitive art, other members of the New York school began experimenting with different, though no less expressive forms of abstraction. Rejecting the undisciplined approach of Pollock and his followers, a number of painters gravitated toward the so-called color-field wing of abstract expressionism, which projected abstract images through meticulously controlled effects of color, shape, and line. To Mark Rothko and Adolph Gottlieb, abstract expressionism represented "an adventure into an unknown world which can be explored only by those willing to take the risk." Rothko's paintings reflect this mystical, poetic bent. Typical of his mature style is his *Number 10,* with its hazy-edged rectangles floating in and out of a space of soft, sensuous color. Gottlieb made his personal statement through the use of geometric and symbolic shapes. *Blast I,* in which a disc, suggestive of either a sun or a bomb, hovers over a devastated terrain, seems to evoke the anxieties of the atomic age. To Clyfford Still, art was "an unqualified act," and his distinctive style reveals fluid forms set against a thickly textured background, executed with a knife instead of a brush.

Below, left: Number 10, *painted by the Russan-born Rothko in 1950*

Below: Adolph Gottlieb's Blast I, *a cosmic landscape, painted in 1957; it is part of a series entitled* Bursts.

Opposite: Number 2, *a color-field abstraction painted by the artist and art teacher Clyfford Still in 1949*

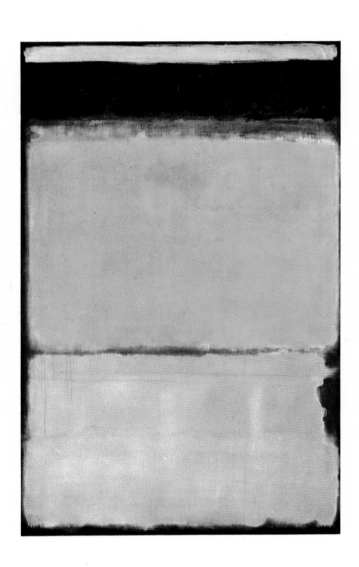

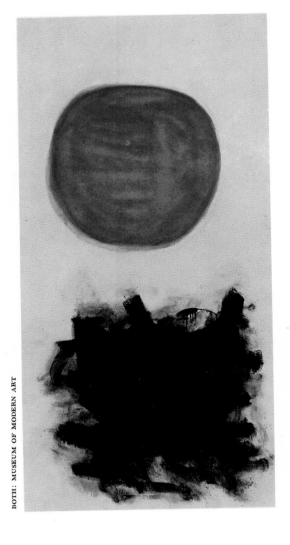

BOTH: MUSEUM OF MODERN ART

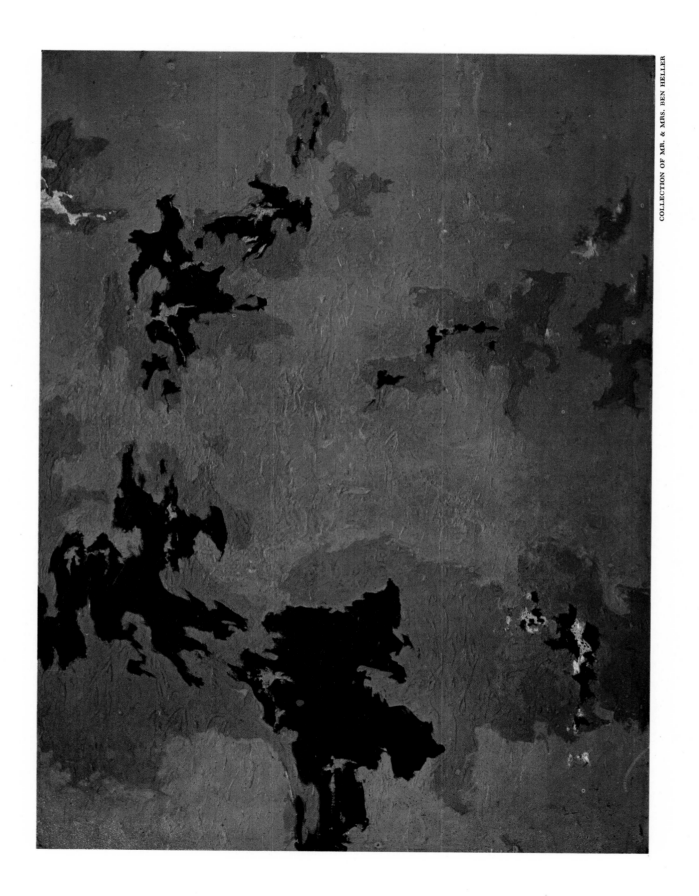

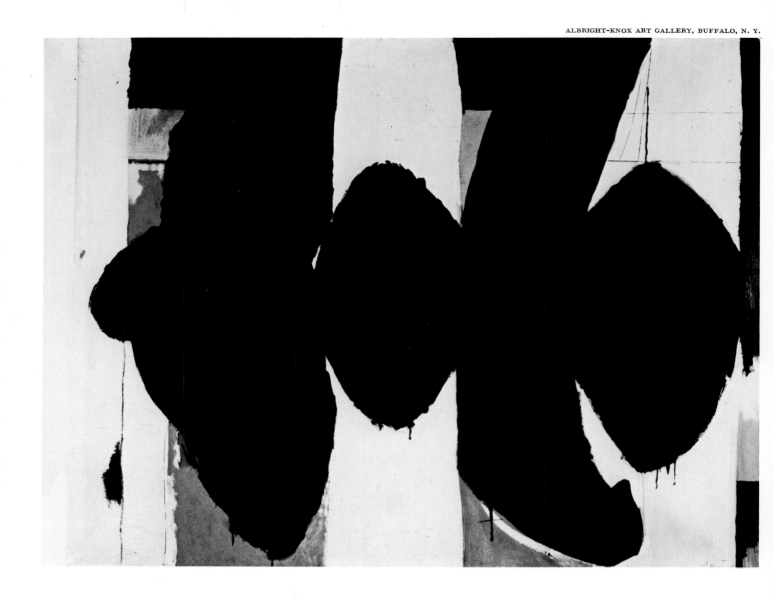

Despite the nonfigurative nature of abstract expressionism, most members of the
New York school created images that evoked associations at many levels of
awareness. Franz Kline, who grew up in a mining town in Pennsylvania, used
cheap commercial paints and house painter's brushes to produce powerful black-
and-white paintings whose gridlike patterns are suggestive of the contemporary
urban landscape. Kline approved of extra-pictorial allusions: "I don't
have the feeling that something has to be completely non-associative. . . . I
think that if you use long lines . . . the only thing they could be is either
highways or architecture or bridges." In an entirely different manner Philip
Guston's brilliantly colored works reflect what one critic called "a dialogue
between the subject and abstract structure." Taking such realistic subjects as
The Mirror as points of departure, Guston fashioned color shapes and masses which
become distinct personalities within the picture space. And, Robert Motherwell's
monumental murals fairly exude Freudian connotations. In a series of paintings
Motherwell expressed his profound emotional responses to the Spanish Civil War
through sexually charged ovoid and vertical images which here represent the
continuous conflict between the forces of life and destruction.

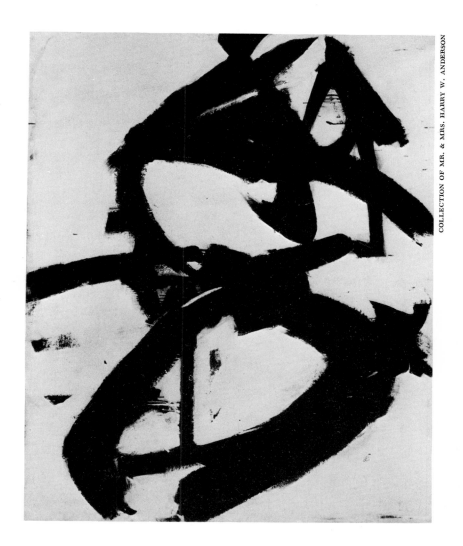

Opposite: Robert Motherwell's Elegy to the Spanish Republic, *created in 1953–54, and one of more than one hundred variants on the same subject*

Right: Figure Eight, *painted by Franz Kline in 1952, suggests both a modern expressway and Oriental calligraphy.*

Below: Guston's The Mirror, 1957

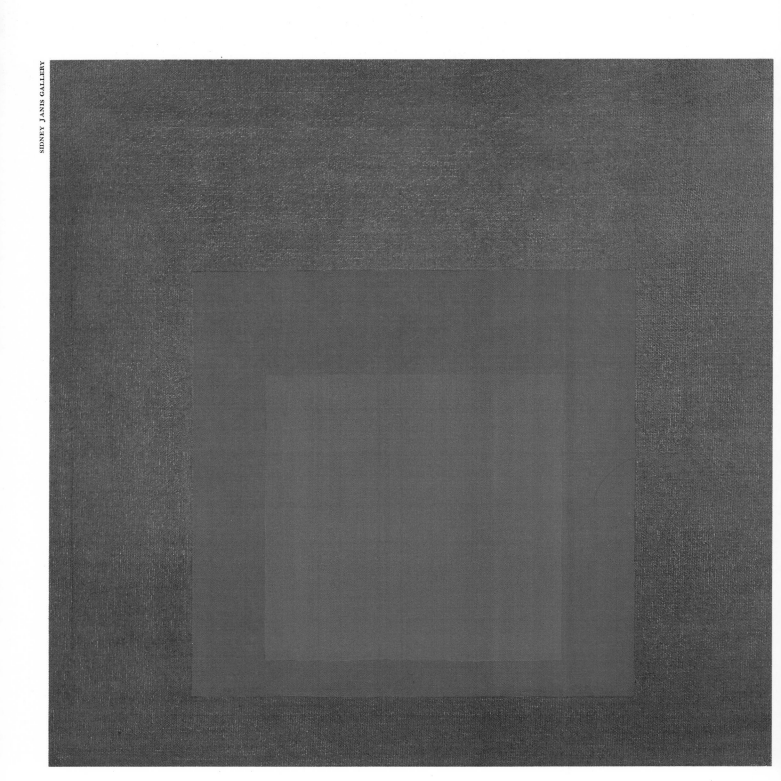

FIELDS
OF
COLOR

Opposite: Josef Albers' Homage to the Square: A Rose, *painted in the year 1964, and a late example of his experiments in color contrasts*

Above: Turnsole, *a typical "bulls-eye" painting by Kenneth Noland*

Below: Noland's Par Transit, *1966*

Although action painting had largely exhausted itself by the 1960's, the possibilities of color-field abstraction, suggested earlier by such artists as Rothko and Still, were further explored during the decade. This new direction—also referred to as chromatic- or post-painterly abstraction, or hard-edge painting—emphasized logic and clarity rather than unbridled emotion. Paintings in the mode feature an openness of design, precise outlines, flat color areas, and, above all, contrasts of pure hue. And, color-field painting re-established contact with the tradition of geometric abstraction that had been introduced to the United States in the 1930's by European refugees. Fleeing Germany in 1933, Josef Albers came to America and taught many years at Black Mountain College in North Carolina, where he directed the art department. There, Albers began his now famous studies of color interactions in a long series of pictures entitled *Homage to the Square*. These experiments immeasurably influenced such color-field artists of the 1960's as Kenneth Noland, a former pupil. Over the years Noland painted successive series of circles, chevrons, diamonds, and stripes to illustrate his belief that "The thing in painting is to find a way to get color down, to float it without bogging the painting down in . . . systems of structure." Around 1965 Noland began using shaped canvases, like an elongated diamond, to effect a total integration of color, form, plane, and perimeter.

383

While the abstract expressionists did not deny the symbolic and psychological implications of their work, the color-field abstractionists purposely denuded their art of all extravisual meaning and stressed, instead, the purely pictorial. As Frank Stella summed up the aim of his color-field colleages: "What you see is what you see." This painter produced some of his most sensational work when still in his twenties. In an effort to relate the structure of a painting to its frame, Stella, about 1960, began cutting holes in and notching the corners of his canvases. Some years later his canvases took on eccentric shapes that appear to break down the distinctions between painting and sculpture. The search for new forms led others, like Alexander Liberman, to conduct bold experiments in geometry. His series of enamels, consisting of discs set on variously colored fields, won considerable acclaim when first exhibited in 1960. And, such artists as Ellsworth Kelly used brilliant plastic-base pigments to create images with razor-sharp contours. After the war Kelly, while on the GI Bill in Paris, had worked with the constructivists, practitioners of an essentially geometric, abstract style of art stressing spatial voids and movement, as well as mass.

Opposite: Frank Stella's Tuftonboro I, *1956*

Right, top: Omega VI, *from Liberman's series*

Right, bottom: painted in 1971, the seventh of fourteen variations in Kelly's Chatham Series

Above: Benjamin Cunningham's Equivocation, *an acrylic on composition board, created in 1964*

Opposite: The Sounding of the Bell, *an eye-catching work by Richard Anuszkiewicz, 1964*

In the mid-1960's groups of painters in America and abroad began exploring forms of art that placed a primary emphasis on optical illusion and other facets of perception. These kaleidoscopic tendencies, many of which seem to bear a closer affinity to mechanical drawing, opticians' charts, and scientific diagrams than to abstract art, are categorized as optical, op, or retinal art. To be sure, the possibilities of optical illusion have fascinated painters in the Western world for thousands of years. During the Renaissance, for instance, the development of linear and atmospheric perspective enabled artists to create illusions of depth on two-dimensional surfaces. This became the conventional method of rendering pictorial space until the present century. Recent research has indicated that various optical phenomena elicit physiological and photochemical as well as psychological responses from the spectator. Heeding what Josef Albers has called "the discrepancy between physical fact and psychic effect," contemporary op artists base their experiments on the premise that no color or shape has a fixed identity, but that anything may take on a different appearance in relation to other elements in a specific context. Current practitioners of retinal art employ almost every known optical device, including refinements of ancient refractive techniques used in halls of mirrors, to make their creations trick, dazzle, and even irritate the eye. Many paint geometric designs in intense hues that set up afterimages in contrasting colors or pulsating halations that seem to expand beyond the confines of the picture frame. Others present precisely delineated, static images that produce sensations of perpetual change and motion. An still others, like Benjamin Cunningham, reduce traditional concepts of perspective to utter ambiguity by using many vanishing points within a single composition, as illustrated in *Equivocation.* Similarly, Richard Anuszkiewicz achieves illusory spatial effects in such works as *The Sounding of the Bell* by reversing the directions of the tiny diagonal lines within each square, and thereby causing the images to advance and recede in unstable relationships.

Above: Ad Reinhardt's trisected Black Painting, *1954–58*
Opposite, top: Frankenthaler's Blue Atmosphere, *1963*
Opposite bottom: While, *executed by Morris Louis in 1959*

A key figure in the development of color-field painting, Ad Reinhardt, who had pioneered in various forms of abstraction since the 1930's, drew largely upon Buddhist philosophy and art for inspiration. In quest of an absolute that would be "breathless, timeless, styleless, deathless, endless," Reinhardt, around 1950, began to purge his art of all associations and extraneous elements. Soon he was producing depersonalized, minimal, monochromatic canvases. From 1953 until his death in 1967, Reinhardt painted "black" pictures exclusively, and his contemporaries derisively dubbed him the "black monk." These works characteristically consisted of interlocking squares painted in low-key greens, browns, and violets, so close in value as to be barely discernible. Painting in a more open, freer manner than the hard-edge artists, the prominent colorist Helen Frankenthaler has created large, lyrical abstractions by adapting many of the methods of Jackson Pollock. Like Pollock, she painted on the floor rather than the wall; she did not retouch spills, blots, and the like, but let them stand; and, she practiced the technique of color-staining raw canvas. Similarly, the Washington, D.C., artist, Morris Louis, tried, in the mid-1950's, to attain maximum opticality by applying successive layers of extremely thin pigment onto unstretched canvas and allowing rivulets of paint to flow freely over the inclined surfaces. The resulting effects were evocative of diaphanous veils of color. In such later works as *While,* Louis painted parallel bands of vivid hues to convey a sense of pure, saturated colors burned into the canvas.

389

OUT OF
THE ORDINARY

In the early 1960's a fully mature style known as pop art burst upon the American scene with amazing vitality and offered still another alternative to abstract expressionism. Returning to recognizable subject matter, pop artists sought their imagery in the everyday environment, and in so doing attempted to expand the traditional vocabulary of fine art. Although the new movement was hailed by a public eager to escape the intellectual rigors of interpreting abstraction, pop art caused quite different repercussions in art circles. That such aspects of popular culture as movies, comic strips, girlie magazines, billboards, and mass-produced packaged goods were now used as subject matter touched off a flurry of negative responses. One critic cried, "Pop's a flop"; the surrealist Max Ernst announced, "Pop art is just some feeble bubble of flat Coca-Cola which I consider less than interesting and rather sad"; and *Time* magazine proclaimed pop "the cult of the commonplace." Only a few astute observers, like the critic John Canaday, understood pop's achievement. "As a deadpan comment on the comic strips . . . Pop has been alternately entertaining and offensive. But it has been important as a return to pictorial subject matter shifted into contemporary focus. . . . Pop as a reference to a visual world familiar to all of us has struck its roots firmly." The forces that led to the creation of pop art culminated in the 1950's when many dissatisfied artists, influenced by the dada masters Marcel Duchamp and Kurt Schwitters, began to re-examine hitherto unchallenged notions about aesthetics. It was John Cage, a composer and teacher at Black Mountain College, who provided the greatest single impetus to the growth of pop art. His belief that even the banal was worthy of serious artistic consideration was instrumental to the development of such pop precursors as Robert Rauschenberg and Jasper Johns. Working in the same New York milieu, these two men began, around 1955, to introduce mundane objects into their paintings. Retaining his expressive brushwork, Rauschenberg constructed "combine," which incorporated three-dimensional objects into the structure of the canvas. Using a different approach, Johns painted numbers, maps, flags, and targets realistically, precisely, and with objectivity. As he explained his selection of subjects: "I was concerned with the invisibility those images had acquired, and the idea of knowing an image rather than just seeing it out of the corner of your eye."

Above: Target, *one of several similar collages, executed in the ancient technique of encaustic by Jasper Johns in 1967–69*

Opposite: Robert Rauschenberg's Canyon, *a "combine" consisting of a pillow and stuffed eagle affixed to a painted base, 1959*

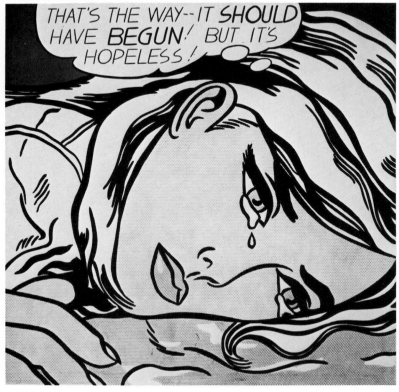

Above: Hopeless, *by Roy Lichtenstein, 1963*

Below: Claes Oldenburg's Hamburger with Pickle and Tomato Attached, *concocted in 1963*

Opposite, top: detail from Rosenquist's ten-foot-high, eighty-six-foot-long mural, F-111

Opposite, bottom: Marilyn Monroe Diptych, *a silk-screen creation by Andy Warhol, 1962*

The major pop artists of the 1960's shared a common desire not only to depict the slick, multiple images of commercial art, but to appropriate its mechanical techniques, glossy colors, and exaggerated scale as well. For all their basic similarities, however, each pop artist worked in a highly personal idiom that became his exclusive domain and no one else's. Claes Oldenburg catered quite literally to American tastes by creating garishly colored, king-sized replicas of hamburgers, sandwiches, and ice-cream sundaes. The questionable identity of these comestibles as art objects led their creator to state, "I'm against the notion that there is a world of art and then a world of real things. . . . I'm more inclined to put the things somewhere halfway. . . . Artists can come in and say, well this is not art, this is a hamburger and other people will . . . say, well, this is not a hamburger, it's art." Roy Lichtenstein made cartoonlike painting his trademark. Simulating Ben Day printing dots to fashion his images, Lichtenstein poked gentle parody at the national nostalgia for the melodrama of the comics. In a more serious vein, James Rosenquist employed methods he had learned as a billboard painter to produce gargantuan murals like *F-111*, in which symbols of warfare are juxtaposed with the prosaic details of everyday life. And Andy Warhol set his stamp on the style by exploiting the mechanical repetition of the silk-screen process. In his *Marilyn Monroe Diptych*, for instance, he evokes the actress' tragic career in a frame-by-frame mimicry of the movie idiom itself.

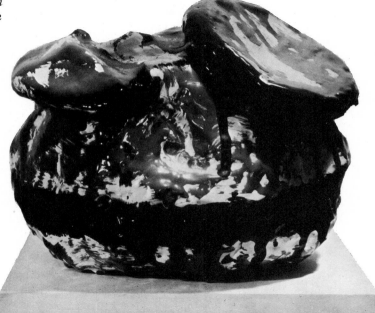

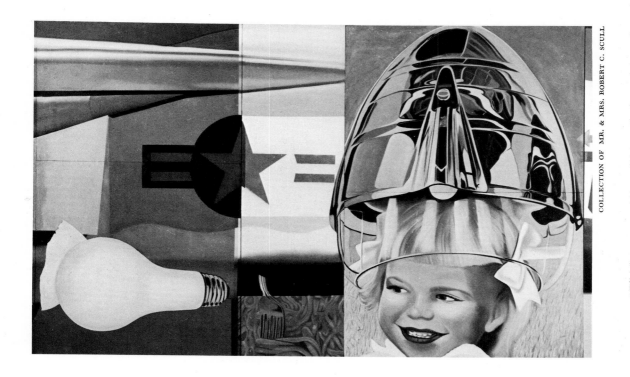

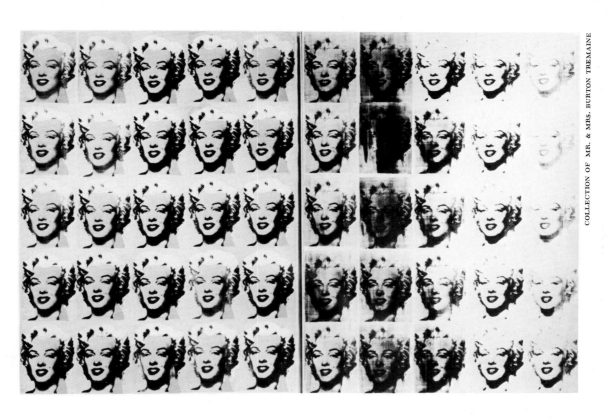

393

DIFFERENT DIMENSIONS

Following World War II, sculpture in the United States assumed new dimensions as it began to utilize modern technology and materials, and incorporate forms that seemed to represent aspects of modern civilization with greater fidelity than traditional sculpture chiseled in marble or cast in bronze. Years after American painters had begun to explore the modern idiom, sculpture in this country remained provincial, academic, and unexciting. Only in the decade preceding the war, with the arrival of such leading, avant-garde refugees as Lipschitz, and the exodus of native talent to study abroad, could a new sculptural aesthetic take root. Constructivism, a style originating in pre-Revolutionary Russia, and involving novel concepts of time and space, was one of the major directions taken by postwar sculpture. It particularly appealed to Alexander Calder, a son and grandson of sculptors, who developed a highly personalized version of constructivism in Paris between 1926 and 1934. About 1930, Calder became converted to abstract and kinetic art when he visited Mondrian's studio later remarking of the static colorful arrangements on the walls, "how fine it would be if everything there moved." Shortly thereafter, Calder created his first delicately balanced suspended mobiles, a term coined by Marcel Duchamp and a form of construction always associated with Calder. Consisting of wire lines and flat, free forms recalling Miro's and Arp's witty, expressive shapes, these compositions were propelled through space in ever-shifting patterns by gentle currents of air. In the same period Calder produced small earthbound relatives of mobiles, called stabiles, which rested directly on the ground. Over the next three decades Calder perfected, refined, varied, and enlarged the prototypes he conceived in the 1930's. His most impressive achievements of the 1960's are giant stabiles, as illustrated by the *Pregnant Whale*, made of thin sheets of metal, bolted together.

Left: The Pregnant Whale, *conceived by Calder in 1963*

Opposite: Calder's Snow Flurries, *a mobile later renamed* 32 White Disks

UGO MULAS

MRS. JULIUS EPSTEIN

At the same time that the constructivists were conducting their formalistic experiments, other sculptors continued to use the human image as their principal expressive vehicle. Discarding naturalistic or idealized modes of representation, these mid-twentieth-century sculptors invested their effigies with every sort of distortion, stylization, simplification, and fragmentation in order to communicate the contemporary human dilemma in which man faces annihilation on the one hand and dehumanization by technology on the other. One of the few artists to impart a dignity to his figures was the Japanese-American Isamu Noguchi, who borrowed from both archaic Greek sculpture and Oriental calligraphy to create the heroic *Kouros*. The archromantic Theodore Roszak conveyed the anxiety of the age in such powerful images as the *Iron Throat*. An intricate assemblage of metal webs and planes, this half-human, half-canine structure seems to utter a scream of agony and terror that illustrates its creator's war "against the current reduction of man's personality to a docile and convenient cipher." Similarly, Leonard Baskin's compelling woodcarvings, like the *Man with a Dead Bird*, reveal a preoccupation with death and decay. Seeing man as "incapable of love, wanting in charity and despairing of hope," Baskin relegates his role as an artist to "limning the horror, the degradation and the filth, I hold the cracked mirror up to man." And, George Segal evoked a sense of modern man's loneliness, alienation, and depersonalization with white, ghost-like images on human scale and cast in rough, unfinished plaster.

Opposite: Iron Throat, *by Roszak, 1959*

Above: Isamu Noguchi's Kouros, *1944–45*

Center: Leonard Baskin's Man with a Dead Bird, *executed in walnut in 1954*

Right: Walking Man, *by G. Segal, 1966*

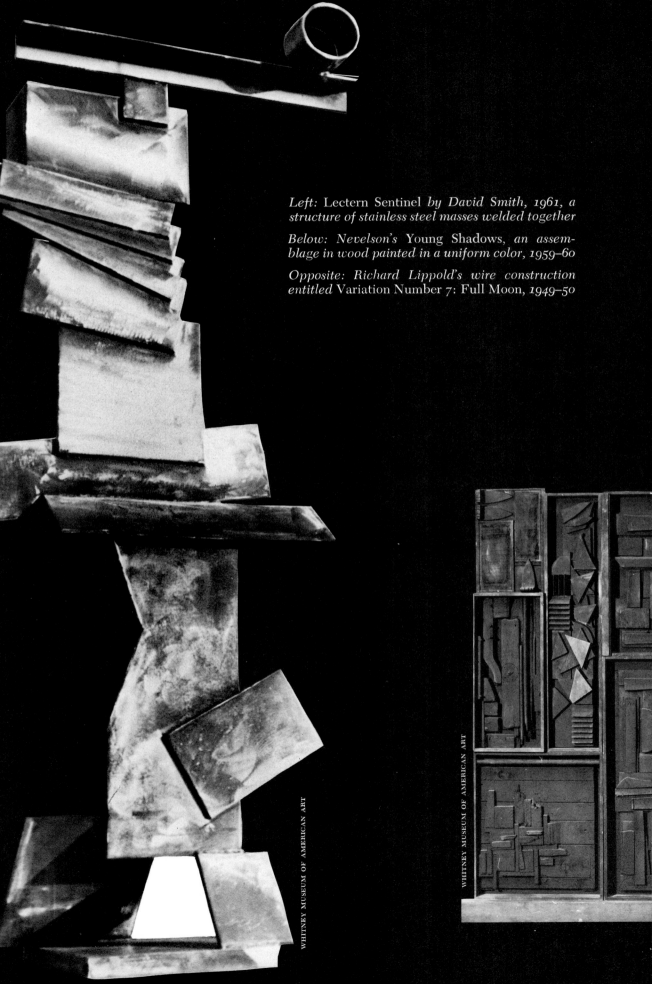

Left: Lectern Sentinel *by David Smith, 1961, a structure of stainless steel masses welded together*

Below: Nevelson's Young Shadows, *an assemblage in wood painted in a uniform color, 1959–60*

Opposite: Richard Lippold's wire construction entitled Variation Number 7: Full Moon, 1949–50

One of the first American sculptors to exploit the vast resources of the machine age, David Smith forged the way for the development of constructed metal sculpture. Making iron and steel his basic mediums, Smith explained that it "possesses little art history. What associations it [has] are those of this century: power, structure, movement, progress, suspension, destruction, brutality." Having learned the techniques of welding and assembling metal parts at various factory jobs, Smith, after World War II, converted his upstate New York studio into a sort of machine shop. Here, in the 1950's, he began fashioning series of related images, which, over the years, became increasingly monumental in scale and conception, as exemplified by the monolithic figurative construction from his *Sentinel* series. Found objects, including pieces of farm machinery, crop up in many of these works. Found objects also appear in Louise Nevelson's relieflike assemblages, composed of boxes fitted together and filled with fragments of furniture, woodwork, and other architectural elements. Although at opposite poles stylistically from Smith, Richard Lippold was just as aware of the artistic potential of modern metals. His exquisite creations consist of glistening metallic threads that catch the light and produce brilliant visual sensations.

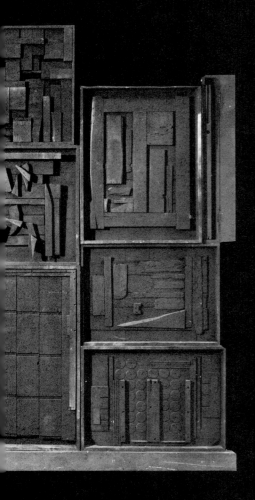

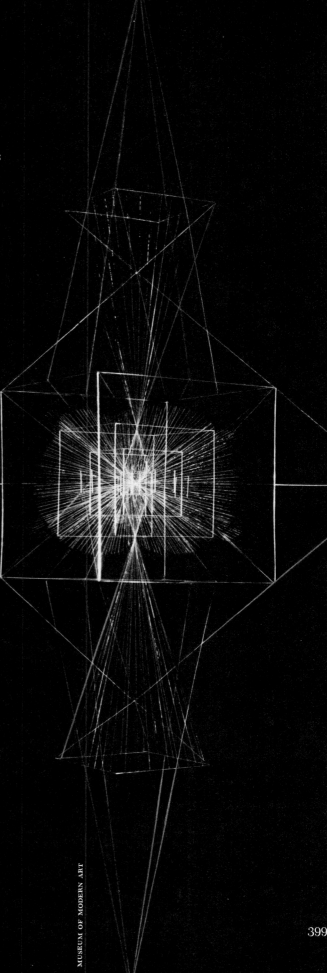

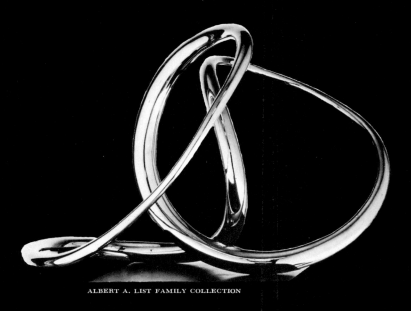

Left: de Rivera's Contruction 2, *created from a chrome-nickel-steel sheet in 1954*

Below: Earth-Forge II, *a "curved convoluted" construction by S. Lipton, 1955*

Opposite, top: Untitled, *primary structure of stainless steel and plexiglass, fabricated by Donald Judd in 1968*

Opposite, bottom: Tony Smith's Free Ride, 1962, *a cube reduced to its essence*

As the color-field painters had offered a viable alternative to the personal gesture of abstract expressionism, so a younger generation of sculptors developed substitutes for the deeply personal imagery of open-welded sculpture. In contrast to the romantic Seymour Lipton, who derived inspiration for his biomorphic figurations of brazed sheet steel in "The bud, the core, the spring, the darkness of earth, the deep animal fountainhead of mans' forces," the constructivist José de Rivera coolly observed of his creations that "The content, beauty and source of excitement is inherent in the interdependence and relationships of the space, material and light, and is the structure." Such elegantly wrought compositions as the linear, tubular, highly polished *Construction 2* represent, according to de Rivera, nothing but themselves. In the 1960's Tony Smith, Donald Judd, and other sculptors carried de Rivera's formalistic premises even further in their experiments with what became known as primary structures. Constructed on a monumental scale, these blunt object sculptures of elementary geometric volumes are meant to be viewed as single, unified entities, rather than arrangements of related parts. Primary structures are generally integrated into a surrounding environment, whether an indoor space or outdoor setting. They are manufactured industrially of modern materials, stress shape and color, and are stripped by their creators of any intentional expressive or symbolic connotations.

With 12 miles of masking tape, 400 gallons of paint, and much back bending, artist Gene Davis created, in the parking area at the Philadelphia Museum of Art, the world's largest painting. The 31,464-square-foot asphalt "canvas" is somewhat ephemeral as a work of art, being open to weather and traffic.

402

ACKNOWLEDGMENTS

The Editors appreciate the generous assistance provided by many individuals and institutions during the preparation of this book. They especially wish to thank the following:

Art in America
Velma Stout

Chanticleer Press
Paul Steiner

Metropolitan Museum of Art
Janet Byrne
John K. Howat
Margaret Nolan
Leon Wilson
Nada Zaporiti

New-York Historical Society
Wilson G. Duprey

New York Public Library
Elizabeth Roth

Time, Inc.
Nell Julliand

Whitney Museum of American Art
John I. H. Baur
Patricia Hamilton

Munson-Williams-Proctor Institute
Edward H. Dwight

INDEX

Numbers in boldface refer to captions for illustrations.